Migrating the Black Body

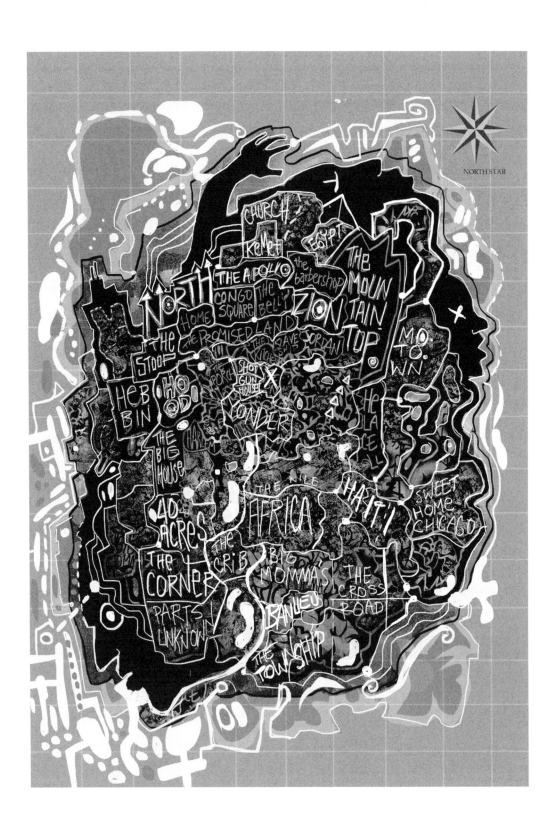

Migrating the Black Body

The African Diaspora and Visual Culture

EDITED BY LEIGH RAIFORD AND
HEIKE RAPHAEL-HERNANDEZ

University of Washington Press
Seattle and London

Copyright © 2017 by the University of Washington Press
Printed and bound in the United States of America
Composed in Unica Pro
21 20 19 18 17 5 4 3 2 1

Frontispiece: John Jennings, *Dark Places*, 2014, poster commissioned for the Migrating the Black Body symposium, VW Foundation, Hannover, Germany, September 2014.

University of Washington Press
www.washington.edu/uwpress

Cataloging information is on file with the Library of Congress.
 ISBN (hardcover) 978-0-295-99956-2
 ISBN (paperback) 978-0-295-99957-9
 ISBN (ebook) 978-0-295-99958-6

The paper used in this publication is acid-free and meets the minimum requirements of American National Standard for Information Sciences—Permanence of Paper for Printed Library Materials, ANSI Z39.48–1984. ∞

Contents

Part 4. Afrofabulation

Plates follow page 70

Acknowledgments

This collection took shape in a four-day symposium marked by intellectual rigor and generosity, by risk-taking and community building. We would like to thank the Volkswagen Foundation for this opportunity that provided us with the chance to develop our ideas in person in the beautiful surroundings of the castle of Herrenhausen in Hannover, Germany; we are especially grateful to Cornelia Soetbeer and Margot Jäckel. A number of symposium participants, whose written work is not represented here, were wonderful interlocutors: Thank you, Tina Campt, Nana Adusei-Poku, Courtney Baker, Erica James, Tobe Levin, Alanna Lockward, Amna Malik, Sylvester Ogbechie, Ilka Saal, Sema Kara, and Cathy Covell Waegner. A special thanks goes to John Jennings for his magnificent poster design.

As the "symposium" became "book," we were fortunate to work with Larin McLaughlin, Whitney Johnson, Jacqueline Volin, Caroline Knapp, and the attentive and highly professional staff at the University of Washington Press. We are grateful as well to the anonymous reviewers for their thoughtful readings and general enthusiasm for the volume.

We have had truly supportive "home teams" at our respective university departments that have ushered this project through all its many stages. Catrin Gersdorf, Eva Hedrich, and Karin Kernahan at the University of Würzburg, Germany deserve a special thank you here. This volume would not have made it to the finish line without the yeoman's labor of our marvelous student assistants, Asia Mott of UC-Berkeley and Molina Klingler at the University of Würzburg (hopefully, one day you two will meet in person).

Our families had to endure many Skype sessions at odd hours and family activity times with us showing up late. Yet, their lively participation in their own ways in the making of the symposium and the book has enriched our work, and our affectionate thanks go to Michael, Maya, Maceo, Don, Markus, Jakob, and Jonathan.

From the start, this project has valued the work of the collective and collaborative in producing as well as articulating a diasporic intellectual formation, and worked to recognize the African Diaspora across difference—of academic discipline, of geo-historical identity, and of visual cultural media. Our final thanks go to the authors in this volume who have made this a dream journey—joyous fellow travelers all.

Migrating the
Black Body

Introduction

LEIGH RAIFORD AND
HEIKE RAPHAEL-HERNANDEZ

In *Against Race*, Paul Gilroy asks, "What forms of belonging have been nurtured by visual cultures?"[1] Gilroy's work in particular has been enormously influential as a model which understands diaspora as a set of transnational connections "rooted" in conceptualizations of common racialized experiences and "routed" through a set of "cultural and political resources black people" draw upon in their struggles against various and divergent forms of oppression. Diaspora then is an "imagined community" that must be forged, constantly made and remade; diaspora not as *a priori* essence but diaspora as labor and practice. "Through such practices," Jacqueline Nassy Brown observes, "differently located blacks transcend national boundaries, creating a mutually accessible, translatable, and inspirational political culture that invite[s] universal participation."[2] The essays in this collection take up these concerns about the "making" of the African Diaspora and ask: How have visual forms enacted such a mutually accessible, translatable, and inspirational political culture? In what ways have visual forms functioned as a "diasporic resource"—as raw material, as ore—among, between, and within transnational black communities?

The collection brings together an international group of scholars and artists to explore the production of blackness and the black body through visual culture in the historical as well as contemporary African Diaspora. We ask: How have visual media—from painting to photography, from global independent cinema to Hollywood movies, from posters and broadsides to digital media, from site-specific installations to graphic novels—shaped diasporic imaginings of the individual and collective self? We are interested in the multiple constellations formed by our key terms: migration and movement; the black body; and visual culture. The essays range in their interest in how black bodies and black images travel; how blackness itself has been and still is forged and remade through diasporic visual encounters and reimagined through revisitations with the past; and how visual technologies themselves structure ways of seeing African Diasporic subjects and subjectivity.

3

The collection was inspired by the excellent African Diaspora studies and visual culture studies scholarship of the last two decades. In offering the essays of this collection now, we work at the intersection of African Diaspora studies and visual culture studies, interdisciplinary scholarly fields which have only recently begun to be in conversation. African Diaspora studies offers a theoretical framework that enables a mode of studying and conceptualizing black people globally, a means of interrogating the condition of movement, migration, and exile of black peoples forged by racial capitalism, New World slavery, imperialism, and colonialism. Within this rubric, African Diaspora studies also considers the process by which black peoples understand themselves as linked, imagined through culture, cultural production, and political movements. While historians and social scientists have attended to the former, cultural anthropologists, literary scholars, ethnomusicologists, and art historians have made vital contributions to the study of culture of/and the African Diaspora.

Elaboration of African Diaspora frameworks in the realm of cultural production has largely focused on literary, aural/musical forms and, more recently, performance. We can think here of the archive from which Brent Hayes Edwards draws in his work *The Practice of Diaspora: Literature, Transnationalism*, which gathers a wide variety of written "texts: fiction, poetry, journalism, criticism, position papers, circulars, manifestoes, anthologies, correspondence, surveillance reports"; of Paul Gilroy's attention to black musical forms, the "jewels brought from bondage," as among the more unique elements constitutive of Black Atlantic political culture, as demonstrated in the foundational *The Black Atlantic: Modernity and Double Consciousness*; or even of Jacqueline Nassy Brown's observation that black Liverpudlians drew upon African American soul music and fashion as the diasporic resources through which they articulated their own identities and identification with the African Diaspora.[3]

Scholarly consideration of visual forms, whether fine art, film, or photography, has lagged behind studies of other cultural forms as a mode of joining up or linking the African Diaspora. Yet, as Caribbean studies scholar Michelle Stephens reminds us, "discourses of diaspora [. . .] mobilize imaginings of the self that operate on an affective and sentimental level."[4] Visual culture's capacity to build or envision community across geographical location, its capacity to engage its viewers on both critical and expressive or emotional registers, would seem well suited to just this sort of mobilization. The collection proposes to explore how visual forms shape diasporic imaginings of the individual and collective self, to trace "the relationship between visual affect and transnational effect."[5]

LEIGH RAIFORD AND HEIKE RAPHAEL-HERNANDEZ

Art history has led the way in thinking about the African Diaspora and the visual, as reflected by the number of art historians we have asked to participate here. Art history offers us the tools of close textual analysis and the history and theory of aesthetics. However, with its focus on individual artists and movements, fine arts/forms, and the elite spaces of the museum and gallery, traditional art history can be limited in its ability to discuss power and politics outside the museum space or to consider how those cultural practitioners not labeled/ordained "artists" produce racial meaning and contribute to such discussions. This has especially been the case with art history's treatment of African diasporic art and artists, which have been largely confined to the margins of the discipline. Visual culture studies alongside art histories that have focused on marginalized subjects have together expanded the boundaries of traditional art history, enabling us to consider "low" or popular cultural forms, like movies, television, and the Internet, and significantly, as scholar Sarah Blackwood has explained, to move "the production of meaning away from the solitary artist toward an understanding of the meaning-making collaboration between producer, viewer, and object."[6]

First waves of scholarship exploring black peoples and visual culture have recovered histories in which cultural productions served as instruments of domination.[7] More recent scholarship has uncovered not only how African diasporic peoples were themselves producers of visual images but also how such cultural forms can foster mutuality and interconnection among marginalized subjects. Here we point to foundational work by Deborah Willis, Shawn Michelle Smith, Kobena Mercer, Tina Campt, and Krista Thompson.[8] Our contributors address both these aspects together; *Migrating the Black Body* is interested in the interplay between black bodies as visual objects and subjects; as visual specters and spectacles and visual spectators; as objects of visual culture and as visual producers in a transnational context.

However, the collection is distinguished not only by its work to bring the fields of African Diaspora studies and visual culture studies together in productive dialogue. It is also our hope to fill gaps in each of these fields by exploring previously unattended routes of diaspora and forced migrations stretching across space, place, and time, as well as considering previously understudied visual cultural forms. We take our title, *Migrating the Black Body,* as a way to consider a long and "unfinished" process of African migrations and the ongoing movements of black peoples globally. Paul Gilroy's concept of "roots and routes" remains generative. Diasporic subjects plant new roots in each encounter. We recognize that there is still

much to be examined in the "old routes" of the transatlantic slave trade and European colonization of Africa and the Western Hemisphere whose legacies remain far-reaching. We feel there remains important work to be done in revisiting the visual regimes of slavery and the slave trade in order to better understand the manifestations of these pasts in the many reenactments/re-memories in contemporary culture and politics. We also consider "new routes," the new immigration waves caused by neoliberal globalization, migrations that have grown stronger and more urgent since the 1990s. We claim that contemporary discourses about globalization must reckon with the historical palimpsest of colonialism and New World slavery, new forms of African Diaspora at once colliding and colluding with old models.

Equally important, *Migrating the Black Body* aims to address lacunae in the study of race in visual culture studies. We recognize the necessity of considering the visual cultures of the African Diaspora before the late twentieth century, where the bulk of scholarship has focused so far. Thus, several essays examine visual culture and the African Diaspora between the eighteenth century and the mid-twentieth century. Additionally, we take this opportunity to examine the articulation of African Diasporic identity in understudied yet compelling visual forms like comic books and propaganda posters, as well as in emergent visual forms like online digital media including YouTube. Placing these everyday but academically overlooked media alongside visual culture studies' more "common" objects (i.e., film, photography, and fine art), we hope these essays will occasion a far-reaching and enriching discourse for further research.

Hoping that the essays contributed would enact these transnational conversations and convergences, we assembled an international group of scholars and artists who hail from the United States, Germany, the United Kingdom, the Bahamas, Sweden, Latvia, and South Africa. With generous support from the Volkswagen Foundation, we were able to convene a four-day symposium in Hannover, Germany, in September 2014 during which we workshopped papers, exchanged ideas, and performed our own work of articulating diaspora. Four major themes emerged from the essays and our conversations at the Hannover symposium and serve to organize this volume.

Part 1, "Making Blackness Serve," explores the ways that images of the black body have been mobilized as vehicles for imperial power. The essays in this section variously take up familiar sites and struggles of African diasporic discourse—the Middle Passage, Haiti—as well as lesser known and understudied locales and histories, including Russia, Sweden,

LEIGH RAIFORD AND HEIKE RAPHAEL-HERNANDEZ

and China. Taken together, we offer a picture of how blackness and the black body have been fundamental tools to imagine modernity, from the seventeenth century to the twentieth, and in geographies where African-descended peoples were the majority, the minority, or even barely registered on a census.

If part 1 considers how the black body as image has been forced to move and made to serve as commodity, as subject, as visual representation, part 2, "Dreaming Diaspora," examines how black bodies moved themselves in efforts to remake the self and in so doing reimagined diaspora. When black people travel by choice, what visions of the individual and collective black body emerge? In these essays we encounter both diasporic longing, that is the desire for connectivity across the black world, as well as diasporic unevenness, what Tina Campt and Deborah Thomas have elsewhere called "the uneven circulation of specific cultural logics that are privileged by particular routings of global capital and that produce important contests over the meanings of blackness, race, Africa, and diasporic belonging itself."[9] While Campt is particularly focused on the gendered logics that enable some (usually men) to travel and disable others (usually women), we are interested here in "the paradoxes of black mobility": inequitable positionalities via nationality, and economy, producing movement that is at once freedom and restriction.

Part 3, "Differently Black," addresses the often rather uneasy discourse about the African Diaspora with regard to new diasporas of the twenty-first century. How do we understand a mobility that seemingly has been voluntarily chosen by its travelers—and the actual challenges of the Fourth Great Migration occurring in the twenty-first century? The essays in this part ask necessary questions about misunderstandings, and sometimes about appropriations, but also illuminate new forms of solidarity occurring between a vast variety of old and new African Diasporas. By focusing on the globalizing notion of the African Diaspora, which has its roots in Western colonial history, they bridge history with the present for a variety of encounters.

Art reception discourses have often wrestled with the question whether art is able to inspire individual recipients of art toward personal agency. And if empowerment through art is possible, how do expressions of art craft identities that are at once "rooted" in the "real" of specific places, times, and circumstances, yet also "routed" through fantasy and surreal imagination that unlock from those real temporalities. The German Marxist philosopher Ernst Bloch's concept of the "not-yet" is helpful here. Bloch argues that art that depicts the "not-yet" by providing its

recipients with glimpses of the "not-yet-become" is able to inspire people to turn their dreams into "revolutionary forward dreaming," thus creating "revolutionary willingness" and personal agency. Basing his theory on the dialectical interaction between the subjective and the objective factor in human history, Bloch argues that an individual is capable not just of dreaming about the future, but also of getting actively and individually involved in social change through the inspiration of art. His theory has often also been called the philosophy from below or the philosophy for grassroots movements.[10]

The essays in part 4 pick up the idea of the not-yet as inspiration for the art recipient in his or her specific locality. In Tavia Nyong'o's essay, "*Habeas Ficta:* Fictive Ethnicity, Affecting Representations, and Slaves on Screen," Nyong'o introduces the practice of "afrofabulation," in which black subjects "[draw] out from the past a myth whose performative power was *larger* than its historical truth or falsity." Drawing on Jose Muñoz's concept of "disidentification," Nyong'o alerts us to the ways that black subjects attempt to "transform cultural logic from within" and point towards "a different modality of existence." Thus the essays in this section each suggest spaces beyond simple binaries of resistance and submission, refuse to either reify or demonize the past, and at once trouble, complicate, and embrace mnemonic practices that imagine alternative futures and futures past.

Notes

1 Paul Gilroy, *Against Race: Imagining Political Culture beyond the Color Line* (Cambridge, MA: Harvard University Press, 2002), 155.

2 Jacqueline Nassy Brown, "Diaspora and Desire: Gendering 'Black America' in Black Liverpool," in *Globalization and Race: Transformations in the Cultural Production of Blackness*, eds. Kamari Maxine Clarke and Deborah A. Thomas (Durham, NC: Duke University Press, 2006), 75.

3 For further details, see Brent Hayes Edwards, *The Practice of Diaspora: Literature, Translation, and the Rise of Black Internationalism* (Cambridge, MA: Harvard University Press, 2003); Paul Gilroy, *The Black Atlantic: Modernity and Double Consciousness* (Cambridge, MA: Harvard University Press, 1993); Jacqueline Nassy Brown, "Black Liverpool, Black America, and the Gendering of Diasporic Space," *Cultural Anthropology* 13, no. 3 (1998): 291–325.

4 Michelle Ann Stephens, *Black Empire: The Masculine Global Imaginary of Caribbean Intellectuals in the United States, 1914–1962* (Durham, NC: Duke University Press, 2006), 15.

5 Maurice O. Wallace, "Moving Images: Transnational Circuits of Race and Photography," roundtable comments, American Studies Association Annual Meeting, Oakland, CA, October 12, 2006.

6 Sarah Blackwood, "Seeing Black," *American Quarterly* 65, no. 4 (December 2013): 928.

7 See, for example, the excellent series *The Image of the Black in Western Art*, eds. David Bindman and Henry Louis Gates, Jr.; also, Jan Nederveen Pieterse's *White on Black: Images of Africa and Blacks in Western Popular Culture* (New Haven, CT: Yale University Press, 1992).

8 See Tina M. Campt, *Image Matters: Archive, Photography, and the African Diaspora in Europe* (Durham, NC: Duke University Press, 2012); Tina M. Campt, "The Crowded Space of Diaspora: Intercultural Address and the Tensions of Diasporic Relation," *Radical History Review* 83 (Spring 2002): 94–113; Kobena Mercer, ed., *Exiles, Diasporas and Strangers: Annotating Art's Histories* (Cambridge, MA: MIT Press, 2008); Kobena Mercer, "Diaspora Aesthetics and Visual Culture," in *Black Cultural Traffic: Crossroads in Global Performance and Popular Culture*, eds. Harry J. Elam, Jr. and Kennell Jackson (Ann Arbor: University of Michigan Press, 2005); Kobena Mercer, "Diaspora Culture and the Dialogic Imagination," in *Welcome to the Jungle: New Positions in Black Cultural Studies* (New York: Routledge, 1994); Shawn Michelle Smith, *Photography on the Color Line: W. E. B. Du Bois, Race and Visual Culture* (Durham, NC: Duke University Press, 2004); Krista Thompson, "A Sidelong Glance: The Practice of African Diaspora Art History in the United States," *Art Journal* 70, no. 3 (Fall 2011): 6–31; Deborah Willis and Carla Williams, *The Black Female Body: A Photographic History* (Philadelphia: Temple University Press, 2002).

9 Tina M. Campt and Deborah A. Thomas, "Editorial: Gendering Diaspora: Transnational Feminism, Diaspora and its Hegemonies," *Feminist Review* 90 (2008): xx.

10 For more, see Heike Raphael-Hernandez, "The Construction of a Concrete Utopian Aesthetic: Concrete Utopian Thoughts in Ernst Bloch's *The Principle of Hope*," in *The Utopian Aesthetics of Three African American Women (Toni Morrison, Gloria Naylor, Julie Dash): The Principle of Hope* (Lewiston, NY: Edwin Mellen Press, 2008): 13–32.

Part 1

Making Blackness Serve

1

Containing Bodies— Enscandalizing Enslavement

Stasis and Movement at the Juncture of Slave-Ship Images and Texts

CARSTEN JUNKER

> The Slave Trade came through the
> cramped doorway of the slave ship.
>
> —Édouard Glissant, *Poetics of Relation*

Early transatlantic abolition has been credited as a social movement that created the emotional climate necessary for putting an end, or at least a legal stop, to the trade in enslaved Africans in the early nineteenth century. But abolition was not merely a social movement; it was also a set of visual and textual practices that "enscandalized" the transatlantic slave trade and slavery in the Americas—in other words, it sought to make audiences see the apparatus of enslavement as a scandal—by drawing on visual and textual depictions of Black bodies on slave ships. This essay considers early abolition in the transatlantic sphere as a framework within which eliciting emotive responses on the part of audiences—such as sympathetic fellow feeling or shame—featured as a central strategy, and it interrogates the specific means and effects of producing and anticipating feelings as they pertain to the depiction of Black bodies on slave ships. In the late eighteenth century, slavers came to be considered "a huge, complex, technologically sophisticated instrument of torture," as slave-trade historian Marcus Rediker has suggested.[1] How, then, did particular visual and narrative depictions of Black bodies on slave ships contribute to making slavers intelligible, and dreaded as such, to respective audiences? To consider this question, this contribution examines broadsides that feature depictions of slave ships as a paradigmatic site for the evocation and distribution of feelings in abolitionist

discourse. It addresses the nexus between images, feelings, and texts, and suggests construing the relation between slave-ship images and texts as a hinge that worked toward mobilizing anti-slavery sentiments among white audiences around 1800.

My approach to abolition is shaped in contradistinction to an understanding of abolition that celebrates it as movement against the slave trade and an expression of Enlightenment humanitarianism and white moral self-aggrandizement. The 2007 celebrations of the bicentennial of abolition in Britain, for instance, can be seen as and have been criticized for affirming abolition as a British national project of which a broad public can be proud. One particular critique, from noted historian of the slave trade Marcus Wood, concerned endeavors of framing abolition as the struggle of a small number of white men.[2] Framing abolition as a white project that granted the enslaved emancipation renders Black agents passive yet grateful recipients of freedom and devalues or makes invisible various forms of resistance on the part of the enslaved. An outstanding figure such as Olaudah Equiano, for example, is only one instance of early abolitionists of African origin who got actively involved in campaigning against the slave trade, and the shape and form his impact took is only one among many others.[3] Resistance among the enslaved began even before they were forced onto the ship. Thus, while I argue in the following that the slave-ship images examined here take part in relegating the enslaved to a sphere of passive victims, it should be noted, following historian James Walvin, that transatlantic enslavement "is the story of enslaved resistance as much as slave-owning domination."[4] Against this backdrop, I turn attention to the ambivalent use of slave-ship broadsides in the campaigns of white abolitionists. Slave-ship broadsides had a decisive impact on the emergence of an abolitionist culture of feelings shaped predominantly by compassion. To assess this impact, I argue, it becomes necessary to examine how feelings among white audiences could be mobilized and directed in specific ways through the intricate linking of images and texts in slave-ship broadsides.

The *Brooks*

No slave ship image is better known or has shaped the historiography of the slave trade and abolition as well as its late eighteenth-century iconography more profoundly than the image of the slave ship *Brooks*.[5] The ship was built in 1781 and named for the slave-trading merchant Joseph Brooks

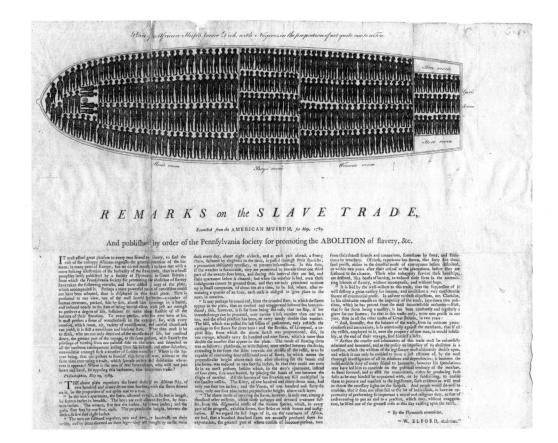

REMARKS on the SLAVE TRADE,

Extracted from the AMERICAN MUSEUM, *for May, 1789.*

And publishe by order of the Pennsylvania society for promoting the ABOLITION of flavery, &c.

1.1.

*Remarks on
the Slave Trade*
(Philadelphia:
Mathew Carey,
1789), engraving.

Jr., who had commissioned it and was its first owner. It made ten voyages until 1804.[6] The famous abolitionist image of the *Brooks* was first printed in November 1788 by the Plymouth chapter of the Society for Effecting the Abolition of the Slave Trade. This group had undertaken great efforts to collect data about the slave trade, and the depiction of the *Brooks* was the result of their effort. The image of the ship was supposed to provide evidence of the realities of the trade and would be redrawn and reprinted several times on both sides of the Atlantic. The broadsheet "Remarks on the Slave Trade" was published by the Pennsylvania Society for Promoting the Abolition of Slavery a year after the first publication of the *Brooks* image (figure 1.1). This broadsheet was roughly eleven by seventeen inches (twenty-seven by forty-two centimeters); Philadelphia printer Mathew Carey produced twenty-five hundred copies of this version alone.[7]

The distribution of the broadsheet with the image of the slave ship followed a well-scripted plan that was part of an intensive campaign, a central aim of which was "to make the slave ship real," which was "accomplished in a variety of ways—in pamphlets, speeches, lectures, and poetry,

for example."[8] In the text-image relation of the broadside, feelings came to play a significant role. As I contend, feelings mediated between image and text and worked toward mobilizing anti-slavery sentiments. In the struggle against the trade in human beings—which was a system based on rational principles, a regime made up of numbers, tables, and calculations for profit—emotions became an increasingly significant strategy of agitation. Abolitionists on both sides of the Atlantic, in both Plymouth and Philadelphia, evoked feelings such as horror and shame among free white men and women and appealed to their compassion for the suffering of the enslaved. This mobilization of compassion drew on the assumption of a shared humanity between the free and the enslaved.

The *Brooks* broadside was deemed highly successful in provoking an emotional response on the part of a larger free public by evoking the violence and terror of the trade. One of the major British protagonists of the abolitionist movement at the time, Thomas Clarkson, corroborated the significance and success of the *Brooks* broadside in stirring up public sentiments against the trade. In the second volume of his *History of the Rise, Progress, and Accomplishment of the Abolition of the African Slave-Trade*, Clarkson writes the following about its putative shock-and-awe effects: "[The] famous print of the plan and section of a slave ship . . . was designed to give the spectator an idea of the sufferings of the Africans in the Middle Passage. . . . [It] seemed to make an instantaneous *impression of horror* upon all who saw it, and . . . was therefore very instrumental, in consequence of the wide circulation given it, in serving the cause of the injured Africans."[9] As Rediker also notes, the image of the *Brooks* "represented the miseries and enormity of the slave trade more fully and graphically than anything else the abolitionists would find. The result of their campaign was the broad dissemination of an image of the slave ship as a place of violence, cruelty, inhuman condition, and horrific death. They showed in gruesome, concrete detail that the slaver was itself a place of barbarity."[10]

In a review of Rediker's book, historian Eric Foner equally underlines the impact that the image of the *Brooks* had. Foner considers the "diagram of the vessel . . . the era's most effective piece of visual propaganda."[11] Introducing the broadsheet with the image of the *Brooks* into public debate was what—with Michel Foucault—may be called a discursive "event" that was incorporated in and changed the course of abolitionist discourse.[12] It provided specific conditions for white audiences to configure their feelings in certain ways, allowing for the possibility of mobilizing their sympathy for the enslaved. Like Clarkson before him, Rediker sug-

gests that the campaigners assumed there was a supposedly inherent power in the image of the ship to evoke emotive responses on the part of white audiences—in essence, unmediated responses to the immense violence and terror to which the trade subjected the enslaved. In this vein, the stillness depicted in the slave-ship image has been read as an indexical sign for the violent subjection of Black bodies.[13]

While the violence inherent in the stillness of the image is a matter of fact, I question the assumption of an inherent power in the image. I argue that it is precisely this power that should be questioned, suggesting that we throw into doubt the assumption that this image necessarily provoked any affective responses on the part of white audiences in the late eighteenth century—were it not for the knowledge they had about its discursive context. I propose an alternative reading of the image that instead focuses on a different aspect of its visual organization: its static orderliness and the lack of chaos and movement that it projects. An audience in our own contemporary moment might be reminded of a barcode used to identify a product. What we see are black markers as signs for contained Black bodies. We see the containment of Black bodies and the containment of chaos, disease, uproar, and emotions. The image shows no affects among its African captives whatsoever, no signs of potential resistance on the part of the enslaved. It appears to naturalize the order of the enslaved aboard the ship. It renders them mute and de-emotionalizes them. By featuring the enslaved as a mass of moveable but static objects, the image contributes to their commodification. While thus, to reiterate, this stillness can conclusively be read as expressing the violence of the so-called Middle Passage, I also emphasize that one reason for the success of the image lay in its latent function of containing this violence—of counteracting the fear on the part of a broader public of the threat of potential acts of resistance among the enslaved aboard the ship. The diagram projected a sense of control over the possibilities of such active resistance of the unfree. With its abstract figures, the image of the ship is rendered tame by state-of-the-art domesticating craftsmanship and appropriation. In that respect, it is comparable to the objects depicted in the plates of eighteenth-century encyclopedism, famously discussed by semiotician Roland Barthes with reference to Diderot and D'Alembert's *Encyclopedia*. Barthes notes: "The Encyclopedic object is . . . subjugated (we might say that it is precisely pure *object* in the etymological sense of the term), for a very simple and constant reason: it is on each occasion *signed* by man; the image is the privileged means of this human presence, for it permits discreetly locating a permanent man on the object's horizon

... what is striking in the entire *Encyclopedia* (and especially in its images) is that it proposes a *world without fear*."[14]

The visual depiction of objects in the *Encyclopedia* served the purpose of inventorying, cataloguing, and thus appropriating them into pre-given classificatory schemas. Similarly, the image of the *Brooks* suits a discursive framework of Enlightenment reason and rational orderliness. While this early version provides a view of the slave deck based on "thumb proportions," the design of later images of the ship "obeys closely the technique for depicting a naval vessel set down in late-eighteenth-century naval architectural guides."[15] With Barthes, we can assume likewise that the depiction of the ship proposed a world without fear. As he notes further, practices of naming and classifying were closely connected to the idea of property and claims to ownership: "Of course, the object's pre-eminence in this world derives from an inventorying effort, but inventory is never a neutral idea; to catalogue is not merely to ascertain, as it appears at first glance, but also to appropriate. The *Encyclopedia* is a huge ledger of ownership; . . . to appropriate is to fragment the world, to divide it into finite objects subject to man in proportion to their very discontinuity: for we cannot separate without finally naming and classifying, and at that moment, property is born."[16]

In the case of the *Brooks*, this thought extends not only to the ship as Joseph Brooks's property; it extends further to include future slave owners' ownership of the Africans to whom the image refers. American studies scholar Sabine Broeck corroborates Barthes's account of measuring, cataloguing, and taking ownership of one's object of study as epistemological impulses of the historical moment of the Enlightenment. She maintains that these principles of measuring, cataloguing, and taking ownership were most representatively manifested in the organizing principles of the transatlantic trade in enslaved people: "To find, to own, to catalogue, to encyclopedize, to collect, to measure: to register and to textualize became the driving sociopsychological, philosophical and epistemological impulse . . . most expressly and meaningfully effected in the trade with African human beings."[17]

The image of the *Brooks*, which has come to indicate more than any other the attempt to abolish the trade, gives expression precisely to this obsession with order, clarity, control, and proprietorship. It shows metonymically the constitutive nexus between cultural techniques of classification and the apparatus of enslavement as a constitutive part of modernity.

There is a paradox, then, between this static image that does not

necessarily yield any affective responses by itself and the broad scholarly consensus then and now that it did indeed create a huge emotional impact. How can this be explained: Does the complete omission of a rendition of feelings on the part of the enslaved in the image leave an emotional void to be filled by its observers? In what ways does the image create a lacuna to be filled with the feelings of audiences that can respond emotionally to what they see?

Stasis and Movement

In order to address the paradox between the stasis of the frozen image and the allegedly strong affective responses among a broad transatlantic public to the broadside, it is instructive to take into account the separation between the image, on the one hand, and the corresponding text, on the other. Foucault uses two analytical categories that are useful for a clarification of this distinction. In a short essay from 1967 titled "Words and Pictures" *("Les mots et les images")*, in which he reviews two books by art historian Erwin Panofsky, Foucault differentiates between "the sayable" of discourse versus "the visible" and argues for the importance of analyzing the relationship between the two: "Discourse and figure have their own existence, respectively; but they entertain complex, interconnected relations. It is necessary to describe their mutual functioning."[18] Accordingly, images provide a different ground for interpreting cultural phenomena than discursive phenomena that are framed in textual form. With regards to the *Encyclopedia*, Barthes similarly notes that "by separating image from text, the *Encyclopedia* committed itself to an autonomous iconography of the object."[19]

With respect to the slave ship *Brooks*, the autonomy of the image implies, for instance, that we read the image in comparison with the concurrent or previous visualized representational forms and norms of shipbuilding and naval architecture mentioned above. Taking up Foucault, we may, at the same time, stress the complex interconnected links between images and words, and may thus interrogate the ways in which the image illustrates the text and vice versa, examining how the text reframes the image in particular ways. This leads us back to the nexus between image, text, and feelings in the *Brooks* broadside. The broadside suggests that a powerful means to mobilize feelings could be achieved by connecting text-based abolitionist interventions with visual material. It is through its linking of image and text that the broadsheet anticipated potential emo-

tive responses on the part of those who read and looked at it, such as shock, awe, horror, and compassion.

Image and text enter into complementary relation here: the text of abolition needs the image of the ship to illustrate the urgency of its agenda because by itself, the text does not create enough of the immediate emotive impact necessary to raise public awareness of the slave trade. The image serves as an illustration for knowledge about the trade of which a broader public had been ignorant up to this point. And while the text is thus complemented by the image of the ship, the image inversely needs an accompanying text to set in motion feelings among its audiences, in order, potentially, to make the observers and readers of the broadside see the apparatus of enslavement as scandalous. The image of the ship was accompanied by the text (and vice versa) from the onset of its publication; consequently, there was never a moment in time when the image emanated no affective abolitionist power, when it caused affective results without the contextual knowledge that the accompanying text provided. In that sense, to separate image and text is an analytic operation; yet it is one that should be made in order to examine the strategies of producing feelings among audiences of the broadside, an effect that results from its text-image relation.

The complementary relation between text and image comes to bear emotional effects in particular with respect to aspects of gender. According to the heading of the image, the broadside shows the "Plan of an African Ship's Lower Deck with Negroes in the proportion of only One to a Ton." In it, 294 figures are "tightly packed and arranged in orderly fashion" in four apartments, labeled from right (the stern of the vessel) to left: "Men's room," "Boys' room," "Women's room," and "Girls room." The "Men's room" shows 120 figures, the "Boys' room" 60 figures, the "Women's room" displays 84 figures, and the "Girls room" 30 figures.[20] It is the *text* that codes the image of the figures in terms of gender differentiation and that thus engenders their humanity. Since gender is considered a human trait and a prerequisite for the "cultural intelligibility" of people as full-fledged human subjects with whom other subjects can empathize, the textual marking of gender makes these figures readable as fellow human beings and thus results in emotionalizing audiences of the broadside.[21]

This strategy of emotionalization—based on the humanization of the figures on grounds of the textual reference to their gender—may also be provoked through an evocation of family relations among the enslaved. The markers of gender on the broadside not only imply a gendered relationality between men and women and boys and girls respectively; they

CARSTEN JUNKER

also imply relations across generations, between parents and children, which suggests familial ties between men and woman as parents, and boys and girls as their children. The evocation of family relations through the text familiarizes readers of the broadside with what they see when looking at the image, making these figures identifiable as fellow human beings. Paradoxically, the commodification of the enslaved as visualized in the image severs their kinship ties. If the dynamics of gender are read through the lens of what has come to be called Afro-pessimist scholarship, our reading of the image-text relation shifts.[22] The text then cannot outdo the cultural work which the image of the enslaved performs by showing signs that make Africans recognizable only as abstracted patterns of parallel lines, suspending them from positions firmly grounded in the realm of the human.

If we take the perspective of Afro-pessimist theorist Frank Wilderson into account, this also holds true for the enslaved in an overall structural sense; Wilderson notes that "the Slave is an anti-Human, [occupying] a position against which Humanity establishes, maintains, and renews its coherence, its corporeal integrity."[23] Crediting sociologist Orlando Patterson's influential 1982 study *Slavery as Social Death*, Wilderson argues that "the Slave" is "void of kinship structure, that is, having no relations that need be recognized, a being outside of relationality."[24] Focalizing the situation aboard the ship through the enslaved, cultural studies scholar Hortense Spillers—on whose work Wilderson partly builds his argument—has famously made a similar point: "Those African persons in "Middle Passage" were literally suspended in the oceanic . . . these captives, without names that their captors would recognize, were in movement across the Atlantic, but they were also *nowhere* at all. Because, on any given day, we might imagine, the captive personality did not know where s/he was, we could say that they were the culturally 'unmade,' thrown in the midst of a figurative darkness that exposed their destinies to an unknown course."[25] Accordingly, the figures in the slave ship image cannot be thought, imagined, or felt for as fellow human beings by the spectators of the image, they cannot be gendered and implicated in familial relations structurally, despite the fact that the text of the broadsheet insists that this is the case.

The significance of the complementary relation of image and text also shows with respect to measuring the outrage of the slave trade in *quantity*, eliciting affect precisely through the ways in which image and text, in their interconnection, address the number of the enslaved and their quantum of suffering. The broadsheet is polysemic in terms of measur-

ing the horrors of the passage in numbers. Its affective impact is therefore potentially ambivalent: in the image, the precise count of 294 visual markers as signs for Black bodies dissolves into a boundless abstraction of what Spillers has called "flesh."[26] The seemingly uncountable number of domesticated lifeless, genderless cargo coincides with a numerical specificity provided by the text. But while the concrete number of slaves given by the text disambiguates the image, it also introduces an ambiguous dimension, the ungraspability of suffering in accounts of numbers: "the Brooks, of Liverpool, a capital ship, from which the above sketch was proportioned, did, in one voyage, actually carry six hundred and nine slaves, which is more than double the number in the plate."[27] This numerical reference in the text of the broadsheet to more than twice the number of people depicted in the diagram endorses the sheer *impossibility* that white audiences will be able to measure and conceive what the text describes as "the horrors of this situation."[28] Further textual descriptions of routines on-board the ship during the transatlantic passage include specifications of numbers that seem to personalize accounts of horror; yet again, these individualized accounts give way to ambivalent abstraction and impersonalized serialization:

> The men are fastened together, two and two, by handcuffs on their wrists, and by irons rivetted [*sic*] on their legs—they are brought up on the main deck every day, about eight o'clock, and as each pair ascend, a strong chain, fastened by ring-bolts to the deck, is passed through their shackles; a precaution absolutely necessary, to prevent insurrections. . . . they are only permitted to come up in small companies of about ten at a time, to be fed, where, after remaining a quarter of an hour, each mess is obliged to give place to the next, in rotation.[29]

The procedure narrated here primarily shows the extent to which the enslavement of persons is mechanized and mass regulated, which makes singular captives disappear into a mass of uncountable dehumanized freight. The broadside, in both its visual and textual dimensions, thus grapples with navigating specific numbers aboard the slaver to measure the immeasurable suffering of the enslaved.

The uncertainty of meaning over the genocidal impact of the transatlantic slave trade also shows in the following passage, which states that forty-five thousand out of the one hundred thousand Africans enslaved each year are killed during or shortly after the passage across the Atlantic,

amounting to a death rate of 45 per cent: "The above mode of carrying the slaves, however, is only among a thousand other miseries, which those unhappy and devoted creatures suffer, from this disgraceful traffic of the human species, which, in every part of its progress, exhibits scenes, that strike us with horror and indignation. . . . Of these [enslaved Africans], experience has shown, that forty-five thousand perish, either in the dreadful mode of conveyance before described, or within two years after their arrival at the plantations, before they are seasoned to the climate."[30]

It is not through the image but through the text that audiences read or hear about the "horror and indignation" to which the movement from Africa to the Americas subjected the enslaved. The subsequent textual passage contextualizes the image within a narrative account of the conditions under which the enslaved are transported across the Atlantic. In this case, again, it is the text that evokes and ascribes a sense of horror to the image: "Here is presented to our view, one of the most horrid spectacles—a number of human creatures, packed, side by side, almost like herrings in a barrel, and reduced nearly to the state of being buried alive, with just air enough to preserve a degree of life sufficient to make them sensible of all the horrors of their situation."[31]

The text makes the slave ship perceivable—readable and thus seeable—as a moving mass grave of the forced African diaspora brought about by transatlantic enslavement. It is supposed to allow its audiences an impossible glimpse or presentiment of what Martinican writer and cultural critic Édouard Glissant has come to call "the abyss": "What characterizes the Africans' situation in [the Middle Passage] is the abyss, the abyss of the unknown, the abyss of the ocean floor, of course, but also the two non-existent shores, the unknown that lies before, the unknown country at which they will arrive; nobody knew what was awaiting these people who were already slaves."[32]

The architects of the *Brooks* broadside hoped to evoke the religious trope of a lost place of origin or, more specifically, of the biblical story of Adam and Eve's expulsion from Paradise (Genesis 3:23–24). Accounts of the expulsion of the enslaved from an Eden-like Africa were a staple and recognizable narrative constituent in abolitionist discourse, one which eighteenth-century abolitionist protagonists like John Woolman and Anthony Benezet or John Wesley made use of when they connected the image of the slave ship to a biblical repertoire of well-known accounts of forced displacement.[33] Retelling the slave trade as a contemporary case of the expulsion from Paradise can be deemed particularly effective in enscandalizing the trade because the enslaved suffer its consequences

by no fault of their own. Unlike Adam and Eve's, the loss of their African places of origin is not self-inflicted. The secularized text of the broadside mobilizes the religious coding of the Middle Passage in implicit ways: "If we regard the first stage of it [the slave trade], on the continent of Africa, we find, that a hundred thousand slaves are annually produced there for exportation, the greatest part of whom consists of innocent persons, torn from their dearest friends and connexions, sometimes by force, and sometimes by treachery. . . . Those who unhappily survive these hardships [of the passage], are destined, like beasts of burden, to exhaust their lives in the unremitting labours of slavery, without recompense, and without hope."[34] The text here may be read as delineating a chronotopic narrative trajectory from a lost Paradise to the deadly plantations, and this makes the slave ship recognizable as a trope in a religious framing of the violent movement of the African diaspora through space and time.

As the above passage shows, the text of the *Brooks* broadside makes ample reference to *movement*. It sets in motion a perception of the ship as moving, and this evocation of movement potentially triggers emotional responses on the part of the viewers and readers of the broadside. The close connection between the evocation of movement and feeling—of motion and emotion—also lies at the heart of the etymology of the term "emotion," from the Latin *emovere*, which indicates mental movement or agitation of the mind. Sixteenth- and seventeenth-century usage also referred to "emotion" as migration and movement from one place to another; in contemporaneous and later usage it signified disturbance, perturbation, political agitation, civil unrest, or public commotion.[35] It is likely that the broadside featuring the *Brooks* helped activate feelings that covered such a broad range of meaning; it mobilized the narrative of an Eden lost to the enslaved, and thus raised demand for the compassion of a white public.

The Vigilante

The iconography of the *Brooks* broadside had a long history and provided a template for numerous other abolitionist broadsides. One example with which it can be juxtaposed is the broadsheet titled "Vignettes descriptive of the Origin and Progress of the Slave Trade," published in London around 1826 (figure 1.2). The sheet features a sequence of four images. Their accompanying descriptions read:

1.2.

Vignettes descriptive of the Origin and Progress of the Slave Trade (London: Harvey and Darton, c. 1826), engraving.

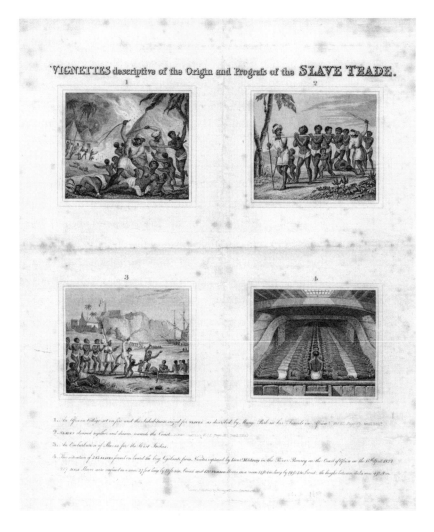

1. An African Village set on fire and the Inhabitants seized for Slaves . . .
2. Slaves chained together and driven towards the Coast.
3. An Embarkation of Slaves for the West Indies.
4. The situation of 345 Slaves found on board the brig Vigilante from Nantes, captured by Lieut. Mildmay in the River Bonny on the Coast of Africa on the 15th April 1822.[36]

This broadside was published fifteen years after Britain had officially abolished the trade and four years after France had declared it illegal. By the time of its publication, the British had positioned themselves on the correct moral side in the issue of slave trading, and this British broadside became a weapon against the ongoing involvement of France in the commerce.[37] Concerning the broadside's visual politics, we can make out a dif-

ference between the first three images and the last: there is movement in vignettes one to three. In the first image, we see a raid in the hinterlands, with men in turbans using considerable violence to seize captives. In the next image, these presumably Arab men abduct Africans—whose suffering is visualized in all clarity in their facial expressions and gestures—toward the coast. This is where the embarkation onto the "brig Vigilante," in the third image, is shown to take place. The first three images project intra-African chaos and assign responsibility and accountability for capturing and trading in the enslaved to Arabs; notably, white slave traders are completely absent from this visual narrative. In the sequence of the images, vignette four depicts the enslaved aboard the French slaver *Vigilante*, and this is marked by an abrupt shift in the mode of visualizing the events. Once the enslaved enter this white-coded space under European control, the previous state of intra-African chaos and terror, of confused noise and violent disturbance, gets contained.

While I have identified that a relation between movement and stasis is being negotiated in the link between text and slave ship image in the *Brooks* broadside, I suggest that here, in contrast, the dialectic between movement and stasis is established in the sequence of the images themselves. The terror derives from the violent abduction of the enslaved as depicted in the first three images. This terror is outside the sphere of influence of any white slave traders or captains. We can read this broadside as a British anti-French propaganda tool; however, it also shows how a European slave ship in early transatlantic abolition is yet again visually constructed as an utterly static space. As in the visual representation of the *Brooks*, the *Vigilante* is depicted as a space under the control of a white European gaze, utterly free from emotion. And yet, this broadside evokes the compassion of its audiences. Albeit in ways different from those of the *Brooks* broadside, it does so by evoking a sense of movement and migration that enslaved Black bodies undergo not only during but also before their violent passage from West Africa to the Americas.

The depiction of the slave ship *Brooks* and numerous slave-ship images following in its wake, then, helped shape the late eighteenth-century and early nineteenth-century cultural coding of compassion as a white abolitionist feeling. As a discursive effect, compassion in return created an "affective community" of white audiences, which had been in the racial making for quite some time.[38] Compassion was the property of white subjects—it allowed them to show their humanity as the bearers of feeling. The *Brooks* allowed them to insist that they were capable of

feeling for others, which afforded them to claim a fully humane character. Literary studies scholar Ian Baucom theorizes this nexus when he speaks of a conceptualization of "humanity signified . . . by a capacity for sympathy."[39]

The case of slave-ship broadsheets also shows that compassion is a feeling that posits differences in hierarchical ways, as it differentiates between those who feel and those who are felt for. Cultural studies theorist Lauren Berlant has noted that compassion "implies a social relation between spectators and sufferers, with the emphasis on the spectator's experience of feeling compassion."[40] While the free are the subjects of compassion, the enslaved are denied feeling for themselves; the latter get positioned outside the sphere of those who are legible as full-fledged human beings: they are contained as a dehumanized movable mass in the static images of the slave ship. It is precisely the fact that any sign of resistance on the part of the enslaved is absent in the images of the *Brooks* and the *Vigilante* which allows the free to respond in shock and awe. They have nothing to fear.

As I have argued, the chronotope of the slave ship itself becomes expressive of white Europeans' and Americans' attempts to establish order, remove from it emotional chaos and suffering, and thus contain violent unrest. It is through the linking of image and text in the broadside featuring the *Brooks* and of a sequence of images in the case of the *Vigilante* that feelings get set free. But these procedures of emotionalization were made by and for a white audience and they came at the cost of the divestment of emotions on the part of those depicted aboard the ship—Black bodies migrated across the sea. The suppression of the feelings of the enslaved and the concomitant denial of their humanity became a device in the service of a historically specific white culture of feeling. In this vein, the slave ship came to stand in for the overall project of late-eighteenth-century abolition: a metonym for the management of white emotions in relation to the refused ascription of emotions to the slave traders' human cargo. In the context of this racialized dynamic and "in the aftermath of the Atlantic slave trade," as Saidiya Hartman has phrased it, the "vision of an African continental family or a sable race standing shoulder to shoulder was born by captives, exiles, and orphans."[41]

Notes

Some of the material in this essay has appeared previously in Carsten Junker, *Patterns of Positioning: On the Poetics of Early Abolition* (Heidelberg: Universitätsverlag Winter, 2016).

Epigraph: Édouard Glissant, *Poetics of Relation*, trans. Betsy Wing (Ann Arbor: University of Michigan Press, 1997), 5. Originally published in 1990.

1 Marcus Rediker, *The Slave Ship: A Human History* (New York: Penguin, 2008), 309.
2 See Marcus Wood, *The Horrible Gift of Freedom: Atlantic Slavery and the Representation of Emancipation* (Athens: University of Georgia Press, 2010).
3 See Olaudah Equiano, *The Interesting Narrative of the Life of Olaudah Equiano or, Gustavus Vassa, the African*, ed. Shelly Eversley (New York: Modern Library, 2004). Originally published in 1789.
4 James Walvin, *Questioning Slavery* (London: Routledge, 1996), 117.
5 See Rediker, *Slave Ship*, 308–42; Cheryl Finley, "Committed to Memory: The Slave Ship Icon in the Black Atlantic Imagination," *Chicago Art Journal* 9 (1999): 2–21; Jacqueline Francis, "The *Brooks* Slave Ship Icon: A 'Universal Symbol'?" *Slavery and Abolition* 30, no. 2 (2009): 327–38.
6 See Rediker, *Slave Ship*, 310–11, 342.
7 See Rediker, *Slave Ship*, 314.
8 Rediker, *Slave Ship*, 308.
9 Thomas Clarkson, *The History of the Rise, Progress, & Accomplishment of the Abolition of the African Slave-Trade, by the British Parliament* (Philadelphia: Brown & Merritt for James P. Parke, 1808), 90, emphasis mine.
10 Rediker, *Slave Ship*, 308–9.
11 Eric Foner, "Demon Cruelty," rev. of *The Slave Ship: A Human History*, by Marcus Rediker, *London Review of Books*, July 31, 2008: 31.
12 Michel Foucault, "The Order of Discourse," in *Untying the Text: A Poststructural Reader*, ed. Robert Young (Boston: Routledge, 1981), 67.
13 For a discussion of stillness throughout the Middle Passage and the violence inherent in that stillness, see chap. 2 of Harvey Young, *Embodying Black Experience: Stillness, Critical Memory, and the Black Body* (Ann Arbor: University of Michigan Press, 2010); for a further recent study of the cultural significance of quiet and stillness in Black culture, see also Kevin Everod Quashie, *The Sovereignty of Quiet: Beyond Resistance in Black Culture* (New Brunswick, NJ: Rutgers University Press, 2012).
14 Roland Barthes, "The Plates of the Encyclopedia," in *New Critical Essays*, trans. Richard Howard (New York: Hill and Wang, 1980), 28, emphasis in original. Originally published in 1964.
15 Marcus Wood, *Blind Memory: Visual Representations of Slavery in England and America, 1780–1865* (Manchester: Manchester University Press, 2000), 26.
16 Barthes, "Plates," 26–27.
17 Sabine Broeck, "When Light Becomes White: Reading Enlightenment through Jamaica Kincaid's Writing," *Callaloo* 25, no. 3 (2002): 826.
18 Michel Foucault, "Worte und Bilder," in *Schriften in vier Bänden. Dit et Ecrits*, vol. 1, trans. Michael Bischoff (Frankfurt am Main: Suhrkamp, 2001), 796, my translation. Originally published in 1967.
19 Barthes, "Plates," 23.

20 "Remarks on the Slave Trade, / Extracted from the American Museum, for May, 1789" (Philadelphia: Mathew Carey, 1789).

21 Judith Butler, *Gender Trouble: Feminism and the Subversion of Identity* (New York: Routledge, 2007), 24. Originally published in 1990.

22 See, for instance, Frank B. Wilderson III, *Red, White and Black: Cinema and the Structure of U.S. Antagonisms* (Durham, NC: Duke University Press, 2010), 58.

23 Wilderson, *Red, White and Black*, 11.

24 Orlando Patterson, *Slavery and Social Death: A Comparative Study* (Cambridge, MA: Harvard University Press, 1982). Wilderson, *Red, White and Black*, 11.

25 Hortense J. Spillers, "Mama's Baby, Papa's Maybe: An American Grammar Book," in *Black, White, and in Color: Essays on American Literature and Culture* (Chicago: University of Chicago Press, 2003), 214–15, originally published in 1987.

26 Spillers, "Mama's Baby," 206.

27 "Remarks," columns 2–3.

28 "Remarks," column 3.

29 "Remarks," column 2.

30 "Remarks," column 3.

31 "Remarks," column 1.

32 Quoted in Manthia Diawara, "Conversation with Édouard Glissant: Aboard the Queen Mary II (August 2009)," in *Afro Modern: Journeys through the Black Atlantic*, eds. Tanya Bason and Peter Gorschlüter (Liverpool: Tate Liverpool, 2010), 59.

33 See John Woolman and Anthony Benezet, *An Epistle of Caution and Advice, Concerning the Buying and Keeping of Slaves* (Philadelphia: James Chattin, 1754); Anthony Benezet, *A Caution and Warning to Great-Britain, and Her Colonies* (Philadelphia: Hall & Sellers, 1767); and John Wesley, *Thoughts Upon Slavery* (Philadelphia: Joseph Crukshank, 1774).

34 "Remarks," column 3.

35 See "emotion" in *Oxford English Dictionary* (New York: Oxford University Press, 2000), accessed September 14, 2014, www.oed.com/view/Entry/612 49?rskey=S23zuc&result=1&isAdvanced=false#eid.

36 "Vignettes Descriptive of the Origin and Progress of the Slave Trade" (London: Harvey and Darton, ca. 1826).

37 See Christopher Leslie Brown, *Moral Capital: Foundations of British Abolitionism* (Chapel Hill: University of North Carolina Press, 2006).

38 See Leela Gandhi, *Affective Communities: Anticolonial Thought, Fin-de-Siècle Radicalism, and the Politics of Friendship* (Durham, NC: Duke University Press, 2005).

39 Ian Baucom, *Specters of the Atlantic: Finance Capital, Slavery, and the Philosophy of History* (Durham, NC: Duke University Press, 2005), 198.

40 Lauren Berlant, ed., *Compassion: The Culture and Politics of an Emotion* (New York: Routledge, 2004), 1.

41 Saidiya V. Hartman, *Lose Your Mother: A Journey along the Atlantic Slave Route* (New York: Farrar, 2007), 6.

2

Russian Blackamoors

From Grand-Manner Portraiture to *Alphabet in Pictures*

IRINA NOVIKOVA

In this essay I discuss a range of images of blackamoors in the visual arts of imperial Russia, from portraiture and paintings of imperial residences to modernist fantasies of racial "blackness" in paintings, theater, and book illustrations. What can these images tell us about the Russian racial imagination of "blackness" and "whiteness," "Africa," and "Europeanness," in the midst of Russian modernization from a regime of autocracy to the period of empire-building, starting in the eighteenth century and lasting into the early twentieth century? How did the iconography of the blackamoor change within the social and cultural context of Russia in this period?

I argue that the visual images of a blackamoor figure offered by the Russian creative elite in different historical contexts communicated modern ideas of blackness/whiteness, Africa and race difference in the society, shaped in "the absence of any easily observable imperialist connection between Russia and the continent."[1] By examining the ways blackamoor figures were used in Russian arts during the nation's aesthetic modernization period, I aim to illuminate the interaction between the blackamoor's iconographic dynamics in representing racial difference and the ideas of Russianness as a national, European, and "white" identity. In my view, these images, from Mardefeld and Adol'skii to Bryullov and Benois, though part of the fashion for such figures in European and Russian art, specifically worked towards Russia's self-identification as a civilized part of European white modernity. This nonexhaustive article invokes and considers a selection of blackamoor images to illustrate that, though these images appear static and unchanging, they underwent visual transformations in terms of race, gender, and sexuality, reflecting

the changes in the aesthetic modernization and in the political ideologies of Russian nation-ness in this long period of time.

1700–1830: Autocratic "Signature" of Fair-Skinned Europeanness

It is a common view among scholars in black studies and in Russian studies that people of African descent were radically scarce in the territories of the empire before Peter the Great launched Russia's modernization.[2] Russia's modernization, partial and selective, was seen as a historical path towards joining "Christian Europe"; however, such a path was limited to nobles, a "terribly narrow stratum of the Russian society."[3]

The first images of a blackamoor that emerged in Russian visual arts have been identified by some scholars as Peter the Great's adopted son Ibragim Gannibal (also known as Abram Gannibal). In two of these paintings, titled *A Portrait Believed to Be Ibragim Gannibal in Childhood* and *A Portrait Believed to Be the General Ibragim Gannibal*, he is shown first as a child, in an Orientalizing costume of an imperial court servant, wearing a turban and a brightly decorated outfit, then as a man of distinguished noble status, in the tradition of grand-manner portraiture. The other existing paintings, such as *Drummer Abram Petrov at the Battle-Field near the Lesnoe Village* (1708) and *Allegory of Peter the First* (early eighteenth century), though less known to the wider public, portray the boy at the battlefield and the emperor himself with his African son. Diplomat Gustav von Mardefeld's watercolor miniature of Peter the Great at the battlefield, entitled *Petr, Russian Tzar, with a Black Page* (ca. 1720) represents Gannibal as an adolescent blackamoor in the conventional posture of filial piety, under protection of the emperor's paternal gesture (figure 2.1, plate 1).[4] This miniature manifests the introduction of Western elements into representations of the imperial figure. The portrait includes the decorative helmet that points to European lineage, emphasized by contrast with the presence of the black page.

With these paintings of the emperor's adopted African son, one is able to detect Russia's still very ambivalent confusion about its own motion towards Europe. The emperor's personal effort of paternal patronage underlines the racialized aspect of Peter's vision to modernize and Europeanize Russian traditional society, which was rigidly divided into *belaya kost'* (literally *white bone*, or aristocracy) and *chern'* (literally *black folk*, or common, unprivileged people). By doing so, he projected racial signification into defining social difference, as the black adoptee's role was to

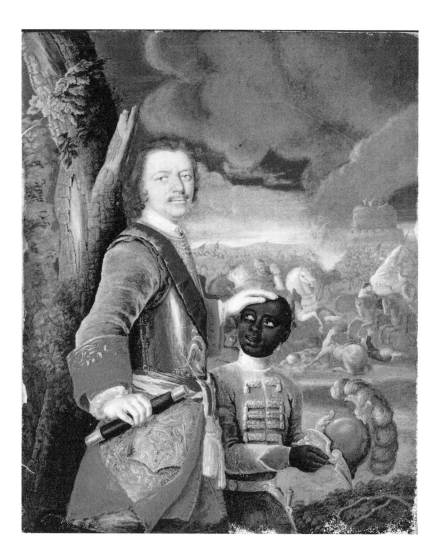

2.1.
Baron Gustav von Mardefeld, *Petr, Russian Tzar, with a Black Page*, portrait miniature of Peter the Great, watercolor on vellum, ca. 1720. In the Victoria and Albert Museum, London, bequeathed by James Jones.

embody in skin color the Russian nobles' social Other: "The very comparison of Russians with savages who need to be subjected to enlightenment came from Peter's epoch. Pushkin's black great-grandfather was adopted from a seraglio in order to delegate a model of new human being to Russian people."[5]

This social context would be gradually refloated in grand-manner portraiture, as I will argue in greater detail further on, moving the blackamoor figure from the centerpiece of Mardefeld's miniature to a human fragment at the edges of Karl Bryullov's romantic paintings in the first half of the nineteenth century. The paternalist affect in this miniature, with the black boy as the central compositional element, the inclusive though ambiguous gesture of both blessing and ownership, would never be repeated again in Russian portraiture with blackamoors. Since the rule of Peter the

IRINA NOVIKOVA

Great, Russian nobility had begun to make possession of a black "child of nature" into a fashion, a means of decorating their households and supplying domestic entertainment. This fashion was supposed to symbolize Russia's transition to modern Europe, albeit without questioning its own system of unfree labour. Ownership of black people by Russian aristocrats did not convey economic benefit; it was a symbol of racial hierarchy as a divine right, of cultural Europeanness, and of social privilege *(humanitas)* granted by the internal rule of serfdom *(anthropos)*.[6]

Well-known sculptures, paintings, and engravings by Western artists invited to Russia in the eighteenth century frequently place a court blackamoor attendant next to the imperial figure, thus following European traditions; examples include *Peter the Great with a Blackamoor* (1705) by Adriaan Schoenebeck and *Anna Ioannovna with a Blackamoor* (1741) by Italian master Bartolomeo Rastrelli (1675–1744).[7] Soon, blackamoors in similar roles appeared on the canvases of Russian painters adopting the conventions of European portraiture and genre paintings that included black people in servile or "filial" roles.[8] These portraits of Russian imperial nobles in which compositional balance includes an image of a little blackamoor tracked with the European visual "consumption of the exotic," which had already elaborated "the system of white portraiture," with its disregard for the personhood of the "nameless servant."[9]

European modern portraiture structured the racial visual order which positions a black servant as a secondary and single figure. The servant remains visible and at the same time "is invisible as subject. The requirement that the servant be both conspicuous and unobtrusive creates an awkwardness amounting to a built-in tension. This difficulty is managed through visual filters designed to produce a selective visibility within a narrow range and to promote acceptance of the servant's status as visible yet not visible."[10] The racial master-servant relationship in European nobility portraits was represented through setting variations as well as through a variety of compositional interactions of gaze, gesture, and emotion. Portraits rendered different degrees of domestic proximity, in a variety of postures, for examply by positioning a black valet on (nearly) the same plane with his patrons, to mediate the affective meanings of his domestication through a "familial" bondage that followed the colonial contact and experience.[11]

A blackamoor boy, petrified in a subordinated position of an exotic page, is exactly a "visible yet not visible" figure in the imperial portraits of Ekaterina I (one by Ivan Adol'skii, 1725–26) and another by an anonymous painter (late 1720s), Elizaveta I (by Georg Christoph Grooth, 1743) and Pavel

(by Stefano Torelli, 1765).[12] Both portraits of Ekaterina I are structured by the visual contrast between the figures and positions of the empress and the little blackamoor, who is lacking in clarity of form and expression, a racial *chiaroscuro* of imperial power in which "race acts as a form of the articulation of the visual."[13] In European portraiture, a black servant's positioning next to a noble white woman was intended to make a visual contrast in skin color; Jan Nederveen Pieterse argues in his book *White on Black* that "in oil paintings the contrast in skin colour which the Moor provides is also a contrast between light and dark. The fair skin of the lady seems radiantly fair by comparison to the Moor's dark skin."[14] In a similar way, the stark visual contrast between the white skin of the Russian empress and the child page's blackness sets up an awareness of the human body, either of ideal whiteness or of its contrary, in the implied viewer's gaze. This type of visual racialization of the body in Russian imperial portraiture actually refracted the binarism of contemporary racial hierarchies, projected into aesthetic feelings and moralizing judgements about corporeal beauty and ugliness. Prince Potemkin made a telling comment upon Russian portraiture of his times, about "those beautiful women painted with a little deformed blackamoor, as a contrast to their shape and beauty."[15]

Adol'skii's portrait of Ekaterina I also contains an important variation of the master-servant composition, one that would be repeated in later Russian imperial portraiture. Post-Petrine Russian portraiture excluded a significant compositional theme that Beth Tobin names, in the British context, the black servant's positioning "within the bosom of an English family."[16] We see it in Mardefeld's miniature, where Emperor Peter's paternal touch is a simultaneous gesture of appropriation, possession, and emotional promixity. In Russian imperial portraiture this direction was aborted, with no further repetitions or variations in the imperial portraiture. Instead, Adol'skii's portrait dignifies Ekaterina as a female subject of imperial status, positioning the insignia of imperial power in her hands, within the larger setting of the male political order—a column, drapery, and an exterior view on an architectural ensemble. The blackamoor boy is distanced from the empress in his reverent subordination and overshadowed in the background plane, so that the viewer can hardly discern the facial features of this black figure, which seem to be shaped into human contours only by the "civilizing" uniform of a court servant. The empress' and the page's hands—white and shapely versus pitch-black and "reptilish"—are positioned in parallel on the cushion, suggesting an uncrossable human gap by means of this visual construction of the racial divide.

The blackamoor boy, though placed into the (uni)form, is clearly detached from the imperial figure of power. The visual parallelism of their postures, in "the absence of any easily observable imperialist connection" between Russia and Africa only mentors its spectators in the sense of existential distance between white master and black attendant.[17]

The black attendant of Russian imperial and noble portraiture became a usable visual image in the adaptive cultural dynamics structured by the rigid and uncrossable social hierarchy of the Russian regime of serfdom. In my view, the iconography of infantilized male blackness in the genre of portraiture, caused by the negative identification and value of the slave body, dovetailed with the Russian elite's racialized views of their own existential difference from the serfs and other kinds of *chern'*, in which being "human" was equated with being "white." As such, difference was, "predicated on the belief in inherent and immutable differences rather than in distinctions based on particular social or environmental conditions. Peasants were just as intrinsically lazy, childlike, and requiring of direction as were blacks."[18]

This kind of racializing, which understood the Russian social hierarchy as an uncrossable human gap positioned Russia's own serfs in what Anne McClintock calls the "anachronistic space" of imperial modernity, in which "colonized people—like women and the working class in the metropolis—do not inhabit history proper but exist in a permanently anterior time within the geographic space of the modern empire as anachronistic humans, atavistic, irrational, bereft of human agency - the living embodiment of the archaic 'primitive'."[19] Dmitrii Fonvizin (1745–92), a famous writer in the time of Ekaterina II, argued that the only factor separating peasants from cattle is the formers' human appearance, and concluding that aristocracy is therefore ultimately responsible for providing the rules of political governance over common people.[20]

Grand-manner portraiture, itself a signature of Europeanization in Russian visual arts, brought race into conversation with other affective ideations of identity in modern visuality such as gender and sexuality. The interplay of imperial masculinity/femininity and sexuality is at the center of several well-known portraits with a little blackamoor created during the eighteenth century. The blackamoor is used in the portraits of Elizaveta I and Grand Duke Pavel to emphasize the masculine essence of Russian autocracy, which in reality lacked men on the throne after Peter's death.[21] The *Mounted Portrait of Elizaveta Petrovna with a Blackamoor*, painted by Grooth (1743), resorts to the masculine symbolics of equestrian portraiture and shows Elizaveta sitting in a manly way on horseback and

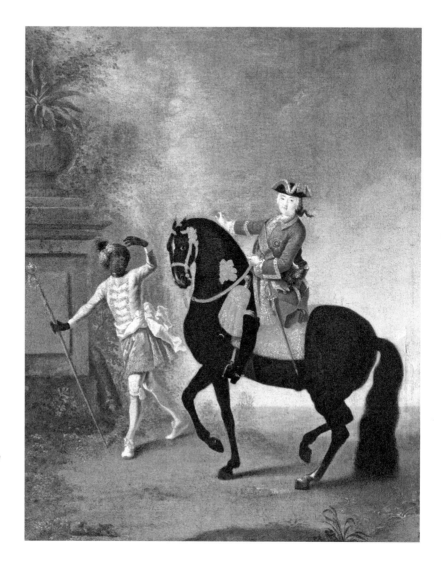

2.2.
Georg Christoph
Grooth, *Mounted
Portrait of Elizaveta
Petrovna with a
Blackamoor*, oil on
canvas, 1743. In the
State Tretyakov
Gallery, Moscow.

looking slightly down at the viewer (figure 2.2, plate 2).[22] This impressive
equestrian portrait glorifies the rule and power of the Russian empress
as a figure who both owns and blesses her peoples.

The background views of this geo-domestic fantasy mark the imagi-
nary distances of Elizaveta's expanding patronage. The gendered fantasy
setting on the blackamoor boy's side and an open sea with a tall sail on the
empress's side suggest the spatial and epistemic horizons of her imperial
power. In terms of looking relations, there is an explicit "epidermic" color
homology between the blackamoor boy and the trained animal rei(g)ned
by the Russian empress. This color "sameness" of both figures in motion
generates a visual analogy between the horse's tamed bodily posture
and the empress's glance at the implied viewer, on the one hand, and on

the other, the attendant's adoring gaze at his glorious master. Thus, the compositional involvement of the painting's implied viewer through the looking relations positions him into the realm of the empress, her imperial governance and her "racial" color. The blackamoor makes way for the empress, moving elegantly, as if simultanously dancing and expressing his fascination with Elizaveta's grandeur and, undoubtedly, with her feminine attractiveness, making her into an unreachable object of his unknown dreams and hidden desires.

The open-space perspective is also used as the background of the *Portrait of Young Pavel I* by Stefano Torelli (ca. 1765). As in the other late eighteenth-century grand-manner portraits of men and boys, the painter prescribes the "blackamoor boy" a symbolic limitation within the visual position of a distance; he is both "colored" and "tamed," *res extensis* to the Russian imperial "worlding" (figure 2.3, plate 3). This portrait employs a black boy for the racialized representation of imperial masculinity. Masculinization of Pavel's image is effected through his resolute gaze at the viewer and his imperial gesture, pointing towards the fleet in the open seas, and accentuated by the submissive and "tamed" gaze of his blackamoor boy page, who has a pretty and soft girlish face. The page's position, oscillating between visibility to the viewer and invisibility to Pavel, indicates his reverent servitude, renders his "feminine" insecurity in need of protection, and allows the viewer to enjoy the white masculine authority of his imperial master.

An early ninteenth-century portrait of Duke Zubov, the favourite of Ekaterina II, by Johann-Baptist von Lampi the Elder (1802), continues to use a blackamoor figure in the compositional function of a servant to a noble master.[23] This repetitive representational strategy of servile emasculated blackness in grand-manner portraiture, from Empress Elizaveta to Duke Zubov, infers "whiteness" as a racially distinctive feature in the visual recognition of the Russian imperial "right to look." In these paintings, the nobles' authority of modern coloniality, be it a geography of serfdom or of territorial expansion, is visually self-evident.[24]

Uniquely, within this genre, the *Portrait of Evdokiya Orlova-Chesmenskaya at the Embroidery, with a Serving Blackamoor* by Jean-Louis de Velly (1780s) presents an ironic challenge to this self-authorizing right to imperial looking and colonial governance, by moving the narrative of the white patroness-black servant portrait to the domestic enclosure.[25] A black attendant—no upward gaze of adoration, no backward position— is an involved central subject, directing his bold gaze downward at his patroness. The countess directs her lingering look at the servant,

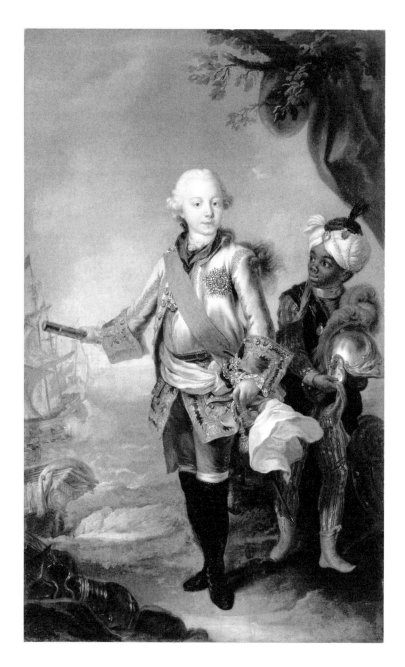

2.3.
Stefano Torelli,
*Portrait of Young
Pavel I*, oil on
canvas, ca. 1765. In
the Hermitage, St.
Petersburg.

accompanying it with a small smile and warmth in her eyes. Her fingers
touch the embroidery fabrics, which are of the same colors as the ser-
vant's clothes, while the black young man shows her a caged white bird.
His positioning interferes with the expected compositional centrality
of Count Orlov's portrait, hanging on the wall. The spatial cohesion of
domestic ideality and idyllic landscape, of home and "worlding" is revised
by balancing the figure of patriachy and empire between the represen-

tational imperatives of portraiture and the compositional margin of the mediated image.

The portrait is placed above the figures of the countess and the black servant, who are looking at each other, but fails to become the composition's privileged element, waived by the interaction of their gazes. Orlov's own gaze is directed outward, and this ironic intensification of his absence from the domestic world and its cloaked plots is echoed in the way in which the pet dog looks at something else outside the frame, embarrassed and uninvolved. Sexual innuendos of the symbolic triangle shatter the racial relationship of dominance and inferiority that is typical in this kind of portraiture; the attendant's position under the portrait of the countess' husband and the sexual symbolism of the bird in the cage allow a variety of subversive views of the blackamoor's presence beyond the meanings of servitude, submissiveness, and appropriated exotics. The transformation of a blackamoor figure into a black male sexual subject, with his right to look, next to his master's portrait introduces a sense of unease regarding white male power, particularly, as the blackamoor's returning gaze intensifies the "demonic" principle of sexual uncertainty.

Romantic 1830-40s: Jolly Pets and Black-skinned "Edges"

Dutch paintings of the late seventeenth century frequently represent the white master with dogs and a black servant. The white master interacts with the dogs and at the same time ignores the black servant, who is lowlier than the pets.[26] As Daniel Dabydeen argues in the context of the British tradition, race power relations were frequently revealed through "a configuration of white master/mistress, dog and black servant" in which a black servant and the dog were positioned as mirror images of each other.[27]

This configuration is central to Karl Bryullov's *Portrait of Countess Yulia Samoilova with Giovannina Pacini and a Little Blackamoor* (1832–34) (figure 2.4, plate 4). Bryullov (1799–1852), a prominent romantic painter, trained in Rome and developed his genre of portraiture during his European journeys and life in Italy.[28] In this famous portrait, Bryullov represents his beloved noble beauty as a figure of mutual adoration by her adopted daughter, a little blackamoor boy, and a dog.[29] The black attendant's touch of the red fabric of her robe (not Samoilova's skin—no direct contact!) and his gaze, both affectionate and timid, reveal his desire for an emotional connection with the other figures of the composition. The dynamic composition is built around Samoilova's posture of welcoming generos-

ity as her hands, open wide, give a sense of love and maternal affection for the adopted girl. Her open posture creates an asymmetrical balance: gesture detaches the attendant from emotional communication and the space of filiation, joy, and empathy that the jolly small dog is allowed to join. Samoilova's gesture of throwing the robe away explicitly renders the little blackamoor's presence, otherwise so close to her, as purely utilitarian. The viewer is encouraged to see his adoring gaze at the white beauty who, in her turn, is indifferent to the presence of a black valet; he is not just separated from her in the background plane, but also fragmented and de-gendered by her robe in the foreground.

The visual fragmentation of a black servant's figure is more elaborated in Bryullov's *Portrait of the Shishmarev Sisters* (1839). The viewer can see only a part of the blackamoor page's body, mainly his hand at the foreground, keeping the reins of horses for the two young women. The attendant's fragmented presence at the edge of the field of vision erases him from looking relations in the times when "looking becomes a more conscious and culturally inflected act."[30] The black body is fixed into one borderline attribute among others, becoming a gendered fragment only to frame the Shishmarev sisters as the legitimate subjects of the painting's visual field.

A more complex visual effect of fragmenting a black male body in the composition is generated in Bryullov's *Portrait of the Volkonsky Children with a Blackmoor* (1843). A black guard looks from the garden into the interior, positioned outside and behind the place in which the children playing with the dog are the centerpiece figures. The viewer can observe only the blackamoor's head and the upper part of his body in a lower plane of the background; he is simultaneously hardly visible, separated by a metal grid, and very close to his master's children. The children do not see the black servant, and their gazes are directed at the viewer, thus, no crossing of the boundary between a noble family and its shadowed servants can be inferred.

The adult blackamoor's explicit separation from the domestic realm of attachments and emotions is accentuated in the gaze triangle, in which the blackamoor's gaze does not seem to focus on the children, in contrast to the convention of a traditional reverent gaze of a little blackamoor page. The effect is of an impenetrable darkness that does not communicate with the viewer's and the children's gazes. This is different from the prior employment of looking relations in which a blackamoor's gaze functions as a sign of submissive reverence and a signature of domestication. In Bryullov's *Volkonsky* portrait, the blackamoor's gaze, though visible to

2.4.

Karl Bryullov,
*Portrait of Countess
Yulia Samoilova
with Giovannina
Pacini and a Little
Blackamoor*, oil on
canvas, 1832–34. In
the State Russian
Museum, St.
Petersburg.

the viewer of the painting, remains undecipherable, thus adding to the cultural anxiety about its obscured meanings. The color of the man's body is harmonized with the color of the dog's head though his eyes do not reflect any light whatsoever, in a stark contrast to the animal's friendly look at its masters. In their utilitarian value, Bryullov's blackamoors as obedient servants are connected to household pets, following the iconographic trope in Western art, though they are placed lowlier than domestic animals, with no communicative or emotional connection.

A change in the looking relations, gaze composition, and visual fragmentation of the black male body brought a significant variation into the

symbolic repertoire and its chain of otherwise similar derivative images of infantilized and subjected male blackness. In Bryullov's range of blacka-moors, finally, only the fragments of the black body that fulfill specific functions (keeping reins, looking after children) are allowed to be visible and at close terms with the painting's subjects, Russian white nobility. A Bryullovian blackamoor figure, adolescent or mature male, is thus reduced to what we might call a "functional fragment," disabled of any way—visual (gaze), haptic (touch), communicative, or affective—to cross the boundar-ies of the intimate familial (civilizational) realm. It is their blackness that affixes to them the racial meaning of "slave," and the fact that enslaved men were not considered "men" by women slave owners in Russia who, as Charles Masson writes in his memoirs, "live from their childhood in the greatest familiary with a herd of their slaves: a thousand of private and even secret services are performed for them by male slaves, whom they scarcely consider as men."[31] This visual deprivation of human integrity and the obliteration of sexual identity places Bryullov's black male "frag-ments" into a state of ontological negation, beyond the cohesive realm of the white conscience and bodily "wholeness" and excluded from the con-trolling racial gaze into the black African matter. They are obscure, insuf-ficient, and finally, objectified, dissected, and degendered in the painting's aesthetic "decomposition."

In both the geo-domestics of imperial portraiture and the family por-traits of nobles, black people's actual presences and experiences in Rus-sia since Peter the Great were visually discounted into repetitive "edge" figures and corporeal "fragments." This gradual but pervasive representa-tional shaping of a functional and *invariable* black "edge" was influenced by the context of serfdom and autocracy. As an adopted visual "sign" of Europeanization in Russian cultural imagination, the blackamoor's journey from the face of filial piety to a visual fragment illuminates the cultural meanings of "humanity" that emerge from the social inequality of Rus-sian society.

Early Twentieth Century: Modernist Blackfaces and Cannibals

Post-Bryullovian Russian portraiture went beyond the established canon, centered on nobles and notable people, and addressed common people of all kinds as well as local authenticity. Such ideas were actively main-streamed through the works of the Peredvizhniki, the Wanderers or Itiner-ants, a group of Russian realist artists that began in the early 1860s, with

the abolition of serfdom. The Wanderers prominently featured the realist genres of national and historical landscapes, social scenes, and social portraiture. This group of young painters rebelled against the academic norms of representing ideal forms and rendered real human bodies, as well as authentic habitats and landscapes, that invite a gaze of Russian difference and of differentiation from Europe. They enabled their viewers' "Russian gaze" in its "authentic capability" to see their contemporaries, from close relatives to common people, in portraits. Uniquely for this wave of cultural nationalism but symptomatically, two little blackamoors emerge in the rear of Vasilii Surikov's canvas *Morning of Streltsy's Execution* (1881), as "signatures" of the Petrine era and its reforms as the tragedy for the Russian nation. These decorative black figures at the back of the carriage are hardly visible to the modern spectator, hidden behind the emperor-Europeanizer's grim presence at the site of Russian people's tragedy.

In contrast, the early twentieth-century Russian modernists saw their art as European, and "the rapprochement with contemporary European culture quite harmonious with Russian national identity" was delivered in their programmatic historicism and retrospectivism.[32] The coupling of a white patroness and her black attendant resurfaced in Alexandre Benois's *Bath of the Marquise* (1906), an eroticized stylization of the bathing marquise and the blackamoor peeping out from behind the bushes. In this painting, Benois (1870–1960) refers to one of the black servant's central functions in Western visual arts—to sexualize the society in which he or she lives.[33] The painter reclaims and reframes the elaborate visual iconography of portraiture through the plot of women-bathers and a form of looking in which an onlooker pries into private moments. The body of the blackamoor is hidden behind trimmed bushes from the viewer's gaze whereas the marquise, a solitary and observed subject, is either quite open to view in one version or, in the other, has only her head visible at the surface of the pond water. The (Freudian) interplay between fragmentation and imagination, between intimacy and distance, is accentuated in the positioning of the blackamoor from an unusual angle, transforming him into the internal spectator. The viewer's expectation for the black attendant's submissive and adoring gaze is not met, as the de-familiariazing use of the bathing plot exposes its masculine voyeurist essence. The emotion whirling in the blackamoor-voyeur's unseen body is metaphorized in the image of two water streams, blatantly sexual and implying excessive attraction and fantasy. The white female object, partially or completely hidden from the spectator's gaze, is recoded into an uncon-

trollable excess of erotic pleasure, subjected—intentionally or not—to the black male gaze, which is positioned between predatorial and serving.[34] His gaze-in-hiding upon the marquise, intersecting with the viewer's gaze, allows for the joint possession of what is seen of the female body at the surface, as "the bather scenes invite the viewer imaginatively to share the perspective of a male voyeur."[35]

Like the *miriskusnik* Alexandre Benois,[36] the poet Anna Akhmatova (1889–1966) alludes to the pairing of a white lady and a blackamoor in her early poem "An Old Portrait" (1911, dedicated to Alexandra Ekster), which is permeated with retroactive aestheticism and stylization, and creates a narrative and visual puzzle:

> Strained you are within the aureate oval
> Of the narrow, antique frame.
> A Negro with a blue fan is behind you,
> Fair-skinned and slender lady.
>
> Girlishly slim are tender shoulders,
> Stubborn and arrogant is your gaze;
> Dimly gleaming tall candles,
> As if at the temple's threshold.
>
> In this solemn hall—
> A zither on the bronze table next to you,
> A rose in a crystal goblet . . .
> In whose fingers is the palette trembling?
>
> For whom have the pitiless lips
> Become a fatal poison?
> The Negro behind you, spruce and coarse,
> Is looking with a sly gaze.[37]

The poem, a modernist attempt to collate a visual image and a poetic text, neither specifies a visual art referent, nor identifies the portrait's female subject or her admiring painter, and the presence of a "coarse" black servant intensifies the plot of erotic intrigue. "An Old Portrait," in Kelly Miller's view, can be read as a coded reference to Mikhail Fokine's ballets *Le Pavillion d'Armide* (libretto by Alexandre Benois) and *Cléopâtre*, establishing "a prominent motif in the poet's oeuvre and also manifest[ing] the poet's early technique of cloaking references to other texts within her

poetry by excluding names."[38] Akhmatova's retrospectivist use of erotic fascination with the servant's black masculinity in "An Old Portrait" dwells on a modernist "vision of history in which the past is hidden or veiled, but never erased."[39] Confusing the reader with its labyrinthine retrospectivism, the poem uses the "blackamoor with a blue fan" to introduce innuendo and a mystery regarding the attitude between the artist and the muse. The poem suggests the painter's desire for an erotic encounter and anxiety about a deadly kiss that injects his jealous gaze and representation of the blackamoor with "coarseness" and "slyness." In his turn, the black servant (or artist in a racial mask?) seems to possess a penetrative male gaze as well, thus turning the white mistress and the implied painter into the objects of his "sly gaze." The implied painter might have died from the "pitiless" muse's deadly kiss, and the fated reader-viewer steps into this sexually and racially transgressive role as a savage, "devouring" the muse in his reading gaze and being "devoured."[40]

Akhmatova's "Poem without a Hero" (composed 1940–62, published posthumously in 1993) contains another reference to a blackamoor figure, this time in Vsevolod Meyerhold's experimental plays of the early twentieth century.[41] Meyerhold's theatricalization of the blackamoor figure transformed it into a blackface servant who provided technical maintenance of the proscenium during performances, appearing directly in front of spectators. In his legendary *Don Juan*, which premiered in 1910, blackfaced "little blackamoors" opened and closed the stage curtains and brought props onto the stage, to "create the atmosphere of the Versailles kingdom." This stream of little "servants of the proscenium" alternated with figures of mature black men onstage; the latter were "cryptically sinister in their images, in black faces with lips glaring red and with bright whites of their eyes, in their demeanour. . . . Adult and little blackamoors represented the world of fate in the play. They belonged to the creatures, living in the dimensions different from the other characters. They were in the know of something, unknown to Don Juan. They were located as if *between* the world of the real characters and infernal forces, forces of hell."[42]

Benois's black voyeurs, Akhmatova's "spruce and coarse" negro, and Meyerhold's stylized blackface actors, while inspired by the figure of "little blackamoor," can all be seen as modernist signposts in a Russian cultural re-folding of racial imagination, "making it new," from filiative plots and familial "edges" to incomprehensible "environments," hidden sexual essences, otherworldly geographies, and instinctual/infernal behaviors.

Alexandre Benois introduced colorific fantasies of an imagined Africa into Igor Stravinsky's *Petroushka* (1911), and Leon Bakst continued this

aestheticization of the black male body, its erotic charge and haptic invitation, in the ballets *Shéhérazade* (1910) and *Le Dieu Bleu* (1912*).* Stravinsky's legendary *Petroushka* presented a primitive blackamoor, sensuous, stupid, and even capable of violence. In Nikolai Evreinov's *Today's Colombine* (1915/1916), the "Negro," a servant of Cassandra, manifests "black" behavior "in the guise of an American Yankee."[43] When this "Negro" remains alone onstage, he "licks his fingers, flares his nostrils, bares his teeth voluptuously, sighs like a steam-engine and flirts with the public seeking its sympathy towards the passion which was aroused in him by Colombine. Little by little his act changes into a full-blown cakewalk."[44]

Russian modernist mediations of the blackamoor figure broke the adaptational dynamics generated in the iconography of Eurocentricity and replayed in the Petrine filiative plot. These theatrical "negroes" recast the blackamoor into an entertaining black male mask and body, at once primitivized and enslaved, transgressive and animalized, sexually indeterminate and predatory. As we have seen, the little blackamoor started as a racial signifier of Europeanization and "whiteness" in grand-manner portraiture. After Bryullov's severe dehumanizing fragmentation, the blackamoor was turned into a renouncing racial "signature" of Petrine reforms in Surikov's historical painting, *Morning of Streltsy's Execution*. Eventually, the blackamoor became a decoration, a function, a blackface figure in avant-garde theater in the period of scientific and anthropological racism, when "black savages" were forced onto stage and into cages of popular entertainment industries in Europe and the Russian empire.

The reincarnation of the blackamoor figure on the Russian avant-garde stage, this time as the African-derived primitive, served for a radical modernist undoing of the bipolar racial opposition of civilized/savage figured in the "humanizing" proximities of the Petrine adoption plot. Modernist fantasies, which distanced male blackness into its "African authenticity," continued the erasure of black (men's) presence in Russia from the social narrative of the empire as having no representational value.[45]

Informed by turn-of-the-century scientific racism and by commercialization of a generic visual construction of race, Alexandre Benois succintly followed this route in his *Alphabet in Pictures* (1904), which visually marshaled this repositioning of the blackamoor figure in the popular imagination. *Alphabet in Pictures* was intended to be used by as wide a range of children as possible, with illustrations for thirty-six letters of the Russian alphabet.[46] It opens with a picture that shows three boys trying to read a book in Russian. One of these children is an orientalized blackamoor (turban, slippers, toothy grin) who appears from behind a curtain,

IRINA NOVIKOVA

as if onstage, and accompanies the book's readers through the alphabet. If Peter the Great's project of Ibragim's adoptive filiation had to be supported by the boy's European education in France, Russian literacy is foregrounded by Benois as an overt marker of national "white" identity at the time of late imperial modernization.

This little blackamoor emerges in the next illustration, which represents the first letter, *A*, where he exemplifies the Russian word *arap,* "blackamoor." This image is less associated with the figures of a reverent servant from the high-manner portraits and more with stereotypes of blackness proliferated through the popular entertainment industries across nineteenth-century Europe and Russia. The image chosen for the letter *Б* is Baba-Yaga. In Russian folklore, Baba Yaga appears as a deformed and ferocious-looking woman, flying above the woods in a mortar, dwelling in a hut standing on chicken legs. She can be a monstrous and hungry cannibal who cooks children, causes storms, and travels around the country with Death at her side. An old witch is also in the center of the illustration for the letter *Б* , exemplified with the word *slasti* (sweets), referring to the Brothers Grimm's famous *Hänsel und Gretel* plot of children's encounter with cannibalism. Later, a feasting African cannibal, devouring a human leg, is shown in a quartet of "ethnographic" pictures, illustrating the letter *E,* exemplified with the words *eda (food)* and *ezda (riding).* This visual connection of the female "unnatural" characters and their infanticidal and cannibalistic narratives with the modern racist fantasy of Africa and its "cannibals" rearticulates black corporeality into a visual sign of monstrosity and otherwordly savagery for a Russian child's gaze.

Under the auspices of Peter the Great, the blackamoor figure started its visual journey as a cultural imitation, dwelling on the edge of domestic landscapes and imperial horizons of portraiture in shadowy or fragmented servitude, thus marking Russian autocracy's "modern Europeanness." Benois's eclectic blackamoor likewise does not leave his duty of a black attendant through the spectacular visual narrative of Russian letters in the *Alphabet*. In his traditional "contour" as the court's little blackamoor, the black child participates in the imperial ceremony for the letter *Ъ*. He again appears for the letter *Э,* in the image of a black valet opening the door of a carriage for fairy-tale elves. A black masque appears on a theater stage for the letter *T* and the word *teatr (theater)*, as Benois's reference to a blackfaced reconfiguration of the Harlequin character from the *commedia dell'arte,* both in the popular Petroushka theater and on the modernist stage of the early twentieth century.

Benois's blackamoor pays an ironic retrospectivist tribute to the tradi-

tion of "court blackamoor" representations in grand-manner portraiture. However, his puppet-like, frozen-smile facial expression invites associations with the popular Petroushka theater and the fairground thrill that had already inspired the legendary ballet *Petroushka*.[47] Nevertheless, the very last image of the alphabet revises the terms of the blackamoor's possible proximity to Russianness: he is moved from the "humanizing edges" of filial service to imperial nobility onto the civilizational borders of the Russian nation as a unified linguistic community. Two monkeys at the blackamoor's legs are holding a jar of incense, *fimiam*, as an illustration for the letter *Фер*. The blackamoor, above them, in the oval frame of streaming incense clouds, is demonstrating his scribbling in the Russian language to the implied viewers: "I learned how to reed [corrected] *read* and write Russian [corrected] *in Russian*." Above him, on the clouds, a Petroushka-looking common man is accepting the letter *Фер* from an ancient Greek god. This illustration emphasizes an orientalist element in the blackamoor's image, while explicitly employing the Eurocentric verticality of civilizational order based on primate/human binarism.

Ideologically, such primers, as an element of popular print culture and education, both advocate everybody's right to read and establish a close relationship "between the system of secondary schooling, propaganda and the concept of imperialism."[48] Modern national coherence is provided by the apparatus and technologies of literacy, and from this perspective, Alexandre Benois's *Alphabet* emphasizes the linguistic community's racial reason and its fixed signifiers, setting them against an African-derived male body displayed in different degrees of its otherworldly kinetics (African, oriental, infernal, half-animal, cannibalistic), thereby making a contribution to the Russian modern invention of the "black savage." *Alphabet*, planned first for the emperor's children and then for a common Russian child-reader, provided images of a little blackamoor as one of central signifiers in this entertaining format of popular—visual and alphabetic—literacy about the world; race, by and through which "modernity comes increasingly to be defined," becomes one of the primer's distinctive features.[49] Furthermore, Benois's "blackamoor puppet," neighboring the "African savage," serves the modernist racial reinvention of Russia through a pedagogy of civilizational "white" superiority and transcendence. He looks belligerent at the start of his journey into the Russian language but by its end looks tamed and placated, in the innocence of learning Russianness.

Notes

1 Maxim Matusevich, "Introduction," in *Africa in Russia, Russia in Africa: Three Centuries of Encounters* (Trenton, NJ: Africa World Press, 2006), 3.

2 Allison Blakely, *Russia and the Negro: Blacks in Russian History* (Washington, D.C.: Howard University Press, 1986).

3 Aleksandr B. Kamenskii, *The Russian Empire in the Eighteenth Century: Searching for a Place in the World* (London: SAGE, 1997), 121. See also Lindsey Hughes, "Russian Culture in the Eighteenth Century," in *The Cambridge History of Russia*, vol. 2, ed. Dominique Lieven (Cambridge: Cambridge University Press, 2006), 67.

4 Baron Gustav von Mardefeld (1664–1729) was a Prussian diplomat and ambassador to Russia.

5 Aleksandr Etkind, "Foucault and the Thesis on Internal Colonization: A Postcolonial View upon Soviet Past," *NLO* 49 (2001): 50–73; accessed October 15, 2015, http://magazines.russ.ru/nlo/2001/49/etkind.html.

6 Irina Novikova, "Imagining Africa and Blackness in the Russian Empire: From Extra-textual *Arapka* and Distant Cannibals to Dahomey Amazon Shows: Live in Moscow and Riga," *Social Identities: Journal for the Study of Race, Nation and Culture* 19, no. 5 (2013): 577.

7 A Dutch painter, Adriaan Schoenebeck, supervised the making of the prints and engravings.

8 David Dabydeen, *Hogarth's Blacks: Images of Blacks in Eighteenth-century English Art* (Surrey: Dangaroo Press, 1985); Allison Blakely, *Blacks in the Dutch World: The Evolution of Racial Imagery* (Bloomington: Indiana University Press, 2001).

9 Beth Fowkes Tobin, *Picturing Imperial Power: Colonial Subjects in Eighteenth-Century British Painting* (Durham, NC: Duke University Press, 1999), 36.

10 Peter Erikson, "Invisibility Speaks: Servants and Portraits in Early Modern Visual Culture," *Journal for Early Modern Cultural Studies* 9, no. 1 (2009): 24.

11 For example, Michiel van Musscher's *A Woman Reading a Letter with a Negro Page in Attendance* (1670), Joseph Wright's *Conversation between Girls, or Two Girls with their Black Servant* (1770), Pierre Mignard's *Louise de Kéroualle, Duchess of Portsmouth* (1682), and Joshua Reynolds' *Prince George with Black Servant* (1786–87).

12 Ivan Adol'skii (after 1686–ca. 1758) was a painter, engraver, decorator, and teacher. Stefano Torelli (1712–84) was born in Bologna; the future king of Poland, Augustus III, brought him to Dresden in 1740, where he painted altar pieces and ceiling decorations. In 1762 he was summoned to the Russian court. Adol'skii's painting is registered with the State Russian Museum in St. Petersburg; a reproduction of the painting can be found at www.virtualrm.spb.ru/index.php?q=img_assist/popup/4504.

13 Alessandra Raengo, *On the Sleeve of the Visual: Race as Face Value* (Hanover, NH: Dartmouth College Press, 2013), 112.

14 Jan Nederveen Pietersee, *White on Black: Images of Africa and Blacks in Western Popular Culture* (New Haven, CT: Yale University Press, 1998), 126.

15 Grigorii Potemkin, *Memoirs of the Life of Prince Potemkin* (London: H. Colburn, 1812), 235.

16 Tobin, *Picturing Imperial Power*, 40.

17 Matusevich, "Introduction," 3.

18 Peter Kolchin, *Unfree Labor: American Slavery and Russian Serfdom* (Cambridge, MA: Belknap Press of Harvard University Press, 1987), 170–71.

19 Anne McClintock, *Imperial Leather: Race, Gender and Sexuality in the Colonial Contest* (London: Routledge, 1995), 30.

20 Dmitry Fonvizin, *Argument on Obligatory State Laws*, in *Collected Works*, 2 vols. (Moscow, Leningrad: State Publishing House for Literature, 1959), 264.

21 *Equestrian Portrait of Empress Ekaterina I* by Georg Christoph Grooth (mid-eighteenth century, Kadriorg Museum, Tallinn) is a typical example of this tradition.

22 Georg Christoph Grooth (1716–49) came to the Russian Empire in 1741; in 1743 he was invited by Empress Elizaveta to supervise and restore the royal painting collections in St. Petersburg.

23 Johann-Baptist von Lampi the Elder (1751–1830), born into a Tirolian family, trained in Salzburg and Verona, became a famous painter of nobility in Austria and in Poland, and later triumphed in the Russian imperial court.

24 Nicholas Mirzoeff, *The Right to Look: A Counterhistory of Visuality* (Durham, NC: Duke University Press, 2011).

25 A hypothesis exists that this painting is the portrait of another woman, Count Orlov's lover Marija Bakhmetjeva. The painter, de Velly, born in Paris (1730–1804), was on contract in Russia in 1754–1804. The painting is registered with the Tretyakovskaya Gallery in Moscow.

26 See Blakely, *Blacks in the Dutch World.*

27 Dabydeen, *Hogarth's Blacks,* 26.

28 Karl Bryullov was a key figure in the transition of Russian painting from neoclassicism to romanticism.

29 Karl Bryullov met Countess Yulia Samoilova in Milan, in the famous salon of Zinaida Volkonskaya, and she became the artist's muse.

30 Sophie Thomas, *Romanticism and Visuality: Fragments, History, Spectacle* (New York: Routledge, 2008), 2.

31 Judith Vowles, "Marriage à la Russe," in *Sexuality and the Body in Russian Culture*, eds. Jane T. Costlow, Stephanie Sandler, and Judith Vowles (Palo Alto, CA: Stanford University Press, 1993), 71.

32 Ilia A. Dorontchenkov, "Russian Art from the Middle Ages to Modernism," in *A Companion to Russian History*, ed. Abbot Gleason (London: Wiley-Blackwell Publishing, 2009), 140.

33 Sander L. Gilman, "Black Bodies, White Bodies: Toward an Iconography of Female Sexuality in Late Nineteenth-Century Art, Medicine, and Literature," *Critical Inquiry* 12, no. 1 (1985): 204–42.

34 Kelly Miller, "Anna Akhmatova's 'An Old Portrait' and the 'Ballets Russes,'" *Canadian Slavonic Papers / Revue Canadienne des Slavistes* 47, nos. 1/2 (2005): 71–93.

35 Kathrin Brown, "The Aesthetics of Presence: Looking at Degas's Bathers," *The Journal of Aesthetics and Art Criticism* 68, no. 4 (2010): 334.

36 *Miriskusnik* is a name for those associated with the Russian modernist World of Art (*Mir iskusstva*) movement, founded in 1898 under the leadership of the legendary ballet impresarios Sergei Diagilev and Alexandre Benois.

37 Translation is mine. The poem was first published in *Common Journal [Vseobschii zhurna]* 3 (1911).

38 Miller, "Anna Akhmatova," 92–93.

39 Olga Matich, *Erotic Utopia: The Decadent Imagination in Russia's Fin de Siècle* (Madison: University of Wisconsin Press, 2005), 24.

40 Wyndham Lewis made his famous statement that "the artist of the modern movement is a savage" in *Blast* 1 (1914).

41 Vsevolod Meyerhold (1874–1940) was an avant-garde theater director, actor, and producer who tried to take acting back to the traditions of the *commedia dell'arte*.

42 Boris Alpers, *In Search for a New Theater Stage* (Moscow: Iskusstvo, 1985), 164.

43 Nikolai Evreinov (1879–1953) was an experimental Russian and French theater director, writer, and theorist.

44 J. Douglas Clayton, *Pierrot in Petrograd: The Commedia Dell'Arte: Balagan in Twentieth-Century Russian Theater and Drama* (Montreal: McGill-Queen's University Press, 1994), 248.

45 Vera Tölz, "Discourses of Race in Imperial Russia: 1830-1914," in *The Invention of Race: Scientific and Popular Representations*, eds. Nicolas Bancel, Thomas David, and Dominic Thomas (New York: Routledge, 2014), 130–44.

46 Images of *Alphabet in Pictures* can be viewed at www.raruss.ru/russian-abc/947-abc-benua.html.

47 See Janet Kennedy, "Shrovetide Revelry: Alexandre Benois's Contribution to Petrushka," in *Petrushka Theater*, ed. Andrew Wachtel (Evanston, IL: Northwestern University Press, 1998), 57–62.

48 J. A. Mangan, "'The Grit of Our Forefathers': Invented Traditions, Propaganda and Imperialism," in *Popular Culture and Imperialism*, ed. John MacKenzie (Manchester: Manchester University Press, 1986), 115.

49 David Theo Goldberg, "Modernity, Race, and Morality," *Cultural Critique* 24 (Spring 1993): 203.

3

Migrating Images of the Black Body Politic and the Sovereign State

Haiti in the 1850s

KAREN N. SALT

aiti has the distinction of being the second republic formed in the Americas and the only nation to emerge from a successful slave revolution. Twelve long years of violent physical confrontations and military battles between rebels and multiple imperial forces brought the nation of Haiti into existence in 1804. Its victorious leaders chose the name of Haiti (a modified spelling of *Ayiti*, the indigenous word for mountainous island) for the new nation, linking its preimperial past to its nation-state present.

The Atlantic world has wrestled with imaging and imagining Haiti since its inception. Illustrations of bloodthirsty slaves avenging themselves on white and purportedly innocent French owners circulated from France to the United States, eliciting all manner of responses from Euro-American viewers (and African diaspora artists)—from condemnation to fear.[1] Yet, what, exactly, was feared? The loss of control over brown and black bodies? The dehumanizing system of enslavement spawned an obsession with destroying black resistance to it in order to continue the engine of plantation economies. Regions from South Carolina to Jamaica responded to the feared "contagion" of the Haitian Revolution by imposing strict laws governing slave behavior and banning cargo from the revolutionary zone. Objects from Haiti (including circulating narratives proclaiming freedom for all people of African descent) were viewed with suspicion.[2]

As the nineteenth century advanced, the voracious Atlantic world turned its gaze and imaging talents to Haiti's national power. For some imagists, this meant that conceptualizations of Haiti tended to emit the

ghostly (or literal) violence of the Haitian Revolution, complete with fantasies of apocalyptic white racial eradication. These fantasies of white removal suggested that black sovereignty—and by extension, black freedom and politics—were threats to the "natural" order of the world. An example of this mindset can be found in Thomas Jefferson's oft-quoted suggestion that free-born and emancipated blacks in the United States pose such a threat to the racial purity of U.S. whites that, for the good of all, they needed to be "removed beyond the reach of mixture."[3]

Critics such as Michel-Rolph Trouillot and Sibylle Fischer have studied these articulations of the threat of Haiti to the Atlantic world. Their work, especially Trouillot's influential *Silencing the Past: Power and the Production of History*, has advanced our considerations of Haiti's conceptual place within the production of radical history (especially within the North Atlantic world) and the promise of freedom inculcated at the beginning of Haiti's birth.[4] Although recent work by Ada Ferrer hints at the wide arc of this representation, continued work needs to be done to consider the ways that Haiti, as a nation, was imaged, especially within Haiti, in the decades after the Haitian Revolution.[5]

Rather than accept narrow constructions of declension or silence, Haitian rulers articulated the nation's power, its rights (as a self-affirmed black nation) to political recognition, and its independence.[6] Although nineteenth-century articulations of black sovereignty in Haiti materialized alongside Euro-American desires in the Caribbean, these articulations provided new tools for the recognition of black bodies, political bodies, and the sovereign representation of both in one black body politic. From the illustrations of Toussaint Louverture that circulated in the early nineteenth century to the circa 1820s images of Jonathan Granville, a mixed-race Haitian cultural diplomat who toured the United States, Haitian officials conceptualized the strength of the nation through images representing the nation's power within the black bodies acting as its proxy. Through these black and political (and politicized) corporeal forms, Haitian officials used multiple circulating sites of critical black production to conceptualize the nation. This production, I argue, extended into other cultural forms, including a set of early photographs and lithographs associated with the last emperor of Haiti, Faustin-Élie Soulouque (r. 1849–59).[7]

According to Tina M. Campt, photography has been an important medium for African diasporic peoples. Campt notes that photos have been used "to document and simultaneously pathologize the history, culture, and struggles of [African diasporic] communities," even as the form also provided "a means for challenging negative stereotypes and

assumptions about black people in ways that create a counter image of who they are, as well as who they might be or become."[8] As visual critics have noted, people of African descent have used the new imaging tools of photography to craft, demand, and express themselves since the earliest days of the medium's creation.[9] In an essay examining the importance of photography to the circulation of black images in the racial climate of the nineteenth-century United States, Deborah Willis notes that nine-teenth-century "[black] photographers began to record images of black people seeking an education, new lives, new identities, new prospects, . . . [offering] positive images of the black experience."[10] Laura Wexler pushes this consideration of black visual culture beyond documentation, noting that for people like Frederick Douglass, photography could remake "the American imagination," and be "a visionary force, offering an important avenue for change."[11]

And this change was not isolated to the borders of the United States. If the medium could offer compelling counternarratives to U.S. themes of scientific racism, it could do similar work in other regions with vastly different histories of exclusion and Atlantic racial slavery. In order to com-prehend the medium's use in the diaspora, we must extend our lens to comprehend its use as a "visionary force" to black figures throughout the African diaspora. Leigh Raiford suggests that "by mapping the vast . . . ter-rain of nineteenth-century photographic representation of the black figure . . . we can begin to reveal the interdependence of the various subordinate archives," and begin to comprehend how these representations shaped and distorted "the social terrain of this period."[12]

This particular book collection offers the perfect opportunity to expand my conceptualization of black sovereignty to ponder the con-nection between visual forms and black political bodies. It provides an important context for imagining black visual culture beyond the borders of the United States. It also offers an archive that has either been dismissed or critically understudied (even if the disregard has been unintentional). In presenting these images, this chapter exposes a wide community of scholars to these works.

In what follows, I discuss the range of views facing Haiti during one particular moment of its political history. This discussion is part of a much larger conversation about image, race, power, and politics in the Atlantic world. In tracing the historical representation and performance of black power through material objects, it offers important analysis of the ways that Haiti negotiated or fought for its political (and black) rights in the nineteenth century.

As a critic interested in the embodiment of black political bodies, I continually search for archives that document this history. This chapter will, I hope, encourage additional archival examinations, including reinvestigations into existing or known material. Through these searchings, we may learn how black nation-states used material culture to chart and demand their sovereign rights. In this essay, I offer a partial glimpse into an archive of black sovereignty curated by Haitian officials and cultural producers for the world stage. In recontextualizing the political moment in which they circulated, this essay illuminates how the last emperor of Haiti, Faustin I, used these visuals to dare to represent and circulate his and his nation's power throughout the Atlantic world.

Vital Black Imperial Matters

Faustin I was born Faustin-Élie Soulouque in 1782. Born into a life of slavery in the then French Caribbean colony of Saint-Domingue, he would fight as a rebel during the Haitian Revolution, but take a position in the background, eventually working in a military capacity for various Haitian governments after 1804. By the late 1840s, he would be the highest-ranking military officer in the nation. Although he held an important position, he was not considered a powerful figure. These facts probably helped battling politicos choose him as a presidential candidate after the sudden death of the sixth president of Haiti, Jean-Baptiste Riché, in 1847. Things would not go as planned. Far from being a controllable puppet, Soulouque would extend his power and control as Haiti's new ruler, and face increasingly fraught diplomatic games as American and European governments circled each other for control of the Caribbean.[13]

Jennie J. Brandon describes the world that Haiti faced at the time of Soulouque's presidency: "An outcast among the nations of the world, not one of which would accord her official recognition, Haiti was beset by demands from foreign governments . . . secession of the Spanish part of the island, a legacy of dissension between the northern and southern districts [and] unrest among the peasants."[14] Soulouque responded to these tensions by violently culling opposition leaders and stifling dissent among the Haitian citizenry. Within a short period after his presidential appointment, Soulouque had become Faustin I, the last emperor of Haiti.

He was immediately attacked in the U.S. press as an imperial fool who could not represent a nation because black bodies could not represent power, liberty, and equality. Ever. Newspaper articles circulated in the

United States and Europe about the coronation. One article in the *Saturday Evening Post* calls into question Faustin I's sovereign power as well as black political action more broadly. Examining the first proclamation of Faustin I, the author argues that it "*might* almost be deemed a burlesque, it is so full of protestations of liberty [and] equality" (emphasis mine).[15] Although the writer uses conditional language, the implication is clear: Faustin I's claims of black sovereignty were absurd.

This was more than just the limited capacity of post-Enlightenment thought to deal with the political reality of a self-avowed black nation in an Atlantic world still fueled, formed, and sustained by racial slavery. Instead of hyping Haiti as being born from an unthinkable revolution or disavowing the nation as a dangerous reminder of the chiasmus-like societal implications of slave rebellions, the *Post* argued that Haiti's political performance of freedom and equality was so unreal as to be a burlesque. The *Oxford English Dictionary* defines "burlesque" as an absurd and exaggerated imitation of comical proportions. In essence, Faustin I's image of himself as a powerful leader was a joke. A number of artists and other media outlets pushed the notion of burlesque to its extremes, representing Faustin I and his nation as an imperial minstrel show for the global masses.

The best example of this type of artwork can be found in the images of French caricaturist and lithographer Charles Amédée de Noé, who created caricatures for the illustrated French newspaper *Le Charivari*, in addition to books, under the pseudonym Cham.[16] In the mid-nineteenth century, publishing political satire in France was dangerous. It was banned by King Louis-Philippe I, who although initially the people's king, became more and more conservative and controlling. By the time the Second Republic began in 1848, caricaturists were able to work more freely, until the arrival of the Second Empire in 1852 under the reign of Napoleon III, Louis-Napoléon Bonaparte, brought strict fines and censorship. According to Elizabeth C. Childs, caricaturists such as Cham and Honoré Daumier articulated domestic issues through a specific foreign black body—Faustin I.[17] Childs notes that identifying Faustin I's body with Louis-Napoléon's "was a well-established racist insult within republican discourse in Paris at the time of the coup d'état of December 2, 1851. During the decade that followed, Daumier and a few of his contemporaries ... continued to parody the regime of Louis-Napoléon ... through the personage of Soulouque ... [as] a means for circumventing the literal minds of the censors."[18] Although compelling, Childs's argument does not fully explain the content of many of the satirical images that shift beyond veiled criticisms of French control and into racial tropes. Rather than a mere

L'impératrice Ourika obligée de souffrir les espiégleries des pages attachés à sa personne.

3.1.

Caricature of the Empress Adelina as the "Haitian Ourika" by lithographer Cham (Charles Amédée de Noé). The caption reads, *"L'impératrice Ourika obligée de souffrir les espiégleries des pages attachés à sa personne"* (the Empress Ourika forced to endure the naughtiness of the pages attached to her person). From Cham, *Soulouque et sa cour: Caricatures* (Paris: Au bureau du journal Le Charivari, 1850), 3. Thanks to Charles Forsdick for assistance with the translation of this material.

substitution of black bodies for white ones (with no outright link to circulating tropes of blackness), these images depend upon the logic of Atlantic racial stereotypes and pejorative assumptions about black political bodies.[19]

Two such images from Cham are startling for the ways that they incorporate notions about the farcical nature of Faustin I's rule and mid-nineteenth-century articulations of biological racism that sought to support slavery and/or defend polygenism.[20] Both images appear in Cham's *Soulouque et sa cour*, published in France in 1850.

The first image that I will focus on does not contain a representation of Faustin I, but another black body, that of his wife, Empress Adelina.[21] While absent from Childs's analysis of the Cham caricatures, Empress Adelina had a starring role in Cham's satire as the legendary Ourika, the late eighteenth-century young Senegalese girl purchased as a slave and sent to live out her days in French aristocratic society. Transported into another world, Ourika remained marked as black and other. She would die in her youth.[22]

The story of the real-life Ourika circulated around nineteenth-century Paris and informed a wide range of literature, including Claire de Duras's anonymously penned novel *Ourika* (1823).[23] Cham's choice to link Haitian Empress Adelina with an infamous Senegalese slave is not a coincidence. In his hands, the newly christened Haitian Ourika plays out a doomed and farcical imperial narrative in which her training as a cultured member of society cannot overcome her racial temperament and disposition. Cham, though, adds additional layers to his representation of the empress.

In one particular image, Haitian Ourika is attended by four servants, all represented as small simians (figure 3.1). They smile disarmingly and crawl all over the empress, who seems startled by their attention. Shoeless and pantless, their dress differs from that of the empress, but their facial features are eerily similar. While this caricature presents Haitian Ourika as a member of the noble class, it also links her lineage with that of her attendants. This becomes clearer throughout the book as Haitian Ourika's initial manners and customs degrade and she begins to exhibit

L'empereur Souloque se promenant dans ses états, suivi de deux aides-de-camp attachés à sa personne.

3.2.

Caricature of Faustin I as "Soulouque" by lithographer Cham (Charles Amédée de Noé). The caption reads, "*L'empereur Soulouque se promenant dans ses états, suivi de deux aides-de-camp attachés à sa personne*" (the Emperor Soulouque walking in a state, followed by two aides-de-camp attached to his person). From Cham, *Soulouque et sa cour: Caricatures* (Paris: Au bureau du journal Le Charivari, 1850), 4. Thanks to Charles Forsdick for assistance with the translation of this material.

more and more of her simian nature. Again, these caricatures draw upon the logics of race regarding black bodies that circulated throughout the Atlantic world. While they may have been used to critique the developing absurdity of French politics, they simultaneously declared that black political (and royal) bodies were always already in that state.

The second image that I want to focus on is a startling one of Faustin I. If this is an attempt at using a surrogate to attack the French crown, it misses its mark. As opposed to invoking a real or imagined francophone persona, this image recalls an entire system—Atlantic racial slavery—and fuses this system with a representation of the political reality within Haiti (figure 3.2).

In this caricature, Faustin I appears in mid-stride on the right-hand side of the frame. He has on a bicorn hat (typically associated with Napoléon Bonaparte), boots, and an overcoat. His hands are positioned behind his back with only one visible to the viewer. Dangling from what is probably a clasped position is some form of chain or rope that stretches upward and encircles the necks of the two men who accompany him. The chains or ropes call up images of the iron collars used to lead, confine, and attempt to control unruly slaves. This is a startling image to connect to the emperor as the two men on leads also have on bicorn hats with plumage. They are not prisoners or men in need of watching. Instead, like the caption that accompanies the image of Empress Adelina, the text identifies these men as military secretaries or assistants who accompany Faustin I on his walk around the nation. Chained and forced, they do Faustin I's bidding and are under his control. Could they be symbols of the ways that everyone is enslaved to a despot? Perhaps. The doubling of political slavery and enforced Atlantic racial slavery (and the disconnection between the two) has been firmly established by critics.[24] That this doubling could be relevant here is a definite possibility.

Yet, the added nod to enslavement as the natural condition of people of color does not disappear. Faustin I may be leading his people into a "dark" era of reenslavement, but because he is a man of color, a former slave

himself, the mixture of racialized and racial-informed "conditions" and "temperament" produce a tangled history that draws upon complex racial legacies of French colonial control and black revolutionary power.[25] When read through this lens, Cham's images of Empress Adelina and Faustin I seem more in keeping with the subtext encoded within pejorative newspaper articles, such as "An Emperor's Toothpick" that appeared in an 1870 edition of *Ballou's Monthly Magazine*, than with some purportedly race-neutral commentary on French restrictions on freedom. As such, these images reinforce the notion that Faustin I's burlesque of empire only reinforces the tendencies of the race.[26] Servile. Simian. Slave. These are the images that translated and migrated across the Atlantic world regarding Faustin I and his nation, and these are the images and the stories that Faustin I will be emboldened to counter by commissioning a set of daguerreotypes that would be transformed into lithographs and compiled into a single volume or album of images. As a "territory of images" organized and arranged by Faustin I, the album is a significant and impressive compilation of black bodies.[27] Regal. Powerful. Political. Faustin I ensured that his reign would be remembered for this set of images, even if critics have only recently rediscovered it.

The Imperial Album of Haiti

Around the same time that Cham and Daumier were circulating images of Empress Adelina as a simian-esque noble pretender, Faustin I was assembling one of the more important contributions of his empire: an album of lithographs derived from daguerreotypes and featuring his coronation, his royal family, and his court. *Album Imperiale d'Haïti* was commissioned by Faustin I to capture his coronation ceremony in 1852; however, it does much more than offer illustrative proof that the ceremony happened (figure 3.3).

According to Joan M. Schwartz, the advent of the use of photographs in the nineteenth century by governments and businesses allowed them to "convey government policy, communicate corporate ideology, construct national identity, shape collective memory, establish symbolic space, and define concepts of self and the cultural other."[28] If we extend Schwartz's argument to Haiti, then, the construction of the album, its circulation of national identity, and symbols of power are just as important as the actual composition of the images contained within it. Coming at an important time in the evolution of daguerreotypes, the album represents

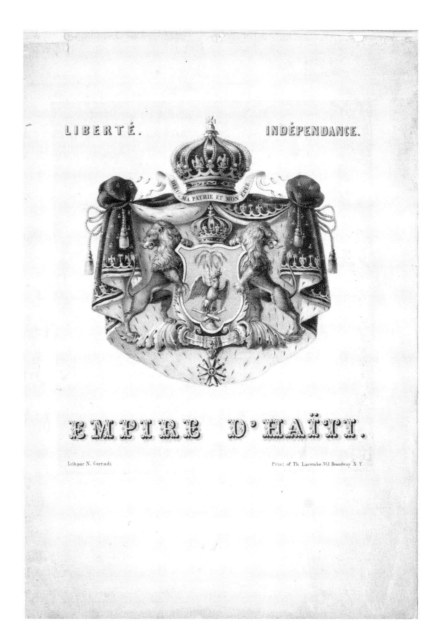

3.3.
N. Corradi, "The Haitian Empire," lithographic plate from *Album Imperiale d'Haïti* (New York: Th. Lacombe, 1852). © British Library Board, HS.74/2132.

both the use of new technological inventions in the recording of black power and the important contribution of blackness as a part of the image content and its capital investiture.

From Frederick Douglass to albums of family members proudly displayed in one's home, people of African descent turned to photography for its abilities to record details of their lives and make visible the achievements of their status, not to mention their humanity. This new and popular form of visualization became increasingly affordable for a variety of economic classes. Albums would be the grand example of the documentary

KAREN N. SALT

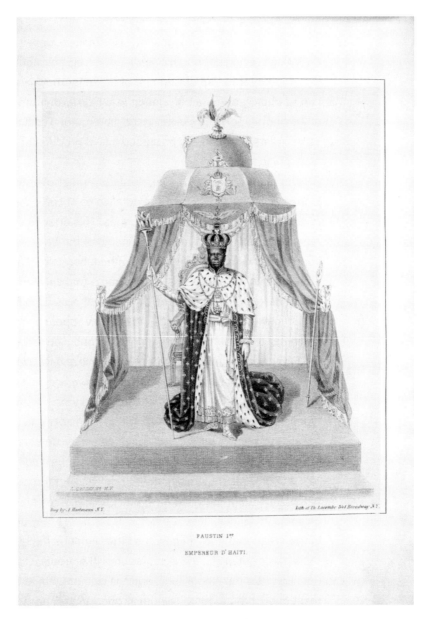

3.4.

Crozelier, after a daguerreotype by A. Hartmann, "Faustin the First, Emperor of Haiti," lithographic plate from *Album Imperiale d'Haïti* (New York: Th. Lacombe, 1852). © British Library Board, HS.74/2132.

FAUSTIN 1ᵉʳ

EMPEREUR D' HAITI.

power of photography to render the black world through the eyes of those who lived it as opposed to the way some racist person had imagined.[29]

In many ways, Faustin I's album would be a product of these shifts. With the increasing technological advancements in daguerreotypes, the processing times were reduced, allowing the image capture to happen in a variety of nonstudio settings. With these shifts in processing came increasing technological abilities that would grant some intrepid traveling daguerreotypists a wide world to record. A. H. Hartmann, whose name appears at the bottom of a number of images in the album, exemplifies

the mysterious, but important lives of these migratory photographers.[30]

A variety of sources suggest that Hartmann travelled extensively in the Caribbean region offering his services as a photographer. Perhaps Faustin I encountered him during one of these journeys and commissioned him to photograph the coronation in 1852. Hartmann would be but one of the photographers involved in the album, along with lithographers and other artists. Their efforts produced a final product that is nothing short of magnificent.

The album is large in size, measuring just over eleven by sixteen inches. This size allows for more detail to be absorbed as nearly all of the images fill the frame of the large pages. This attention to detail involves more than just the images on the inside of the book. The outside cover appears to be some form of cloth with elaborate curl and flower details embossed in the edges of a square frame that surround the book's centered title, elaborately scripted on the cover as *Album Imperial Haïti*. The ten images and one frontispiece that follow appear on heavy stock paper. The detail of each image is staggering. As opposed to the broad strokes of the French caricatures that inflated the nose and lip sizes of Faustin I and Empress Adelina while obliterating any and all detail (such as eyelashes and brow lines), the album's images, derived from Hartmann's daguerreotypes, remain sharp (figure 3.4). Within them, clear facial features, hairstyles, eye shapes, and other specificities are detectable, allowing the portraits to represent people and not amorphous black stereotypes.

Of course, as the images in the book are not the original daguerreotypes, but lithographs that have had additional material drawn on them (in some instances), they are not *exact* copies. Many people had a hand in the creation of the images: the sitters (minus the coronation scene), the daguerreotypists, the lithographers, the artists who drew additional details on/for the lithographs, and the printers. Three lithographers are mentioned throughout the album as offering their services: Th. Lacombe (who is also listed as the printer), P. A. Ott, and N. Corradi. C. Severyn and C. G. Crehen are credited with drawing (with notes of del. appearing after their names.) One additional name, L. Crozelier, is signed against a few images, but is not given a role in the production of the prints. And these were prints meant for reproduction. At least two of the prints include this important detail at the bottom of the page: "Entered according to act of Congress in the year 1852 by A. Hartmann in the Clerks Office of the District Court of the Southern District of New York." There is a presumption here of reproduction and an attempt to make sure that Hartmann's original daguerreotype is registered as his image. Attribution would be

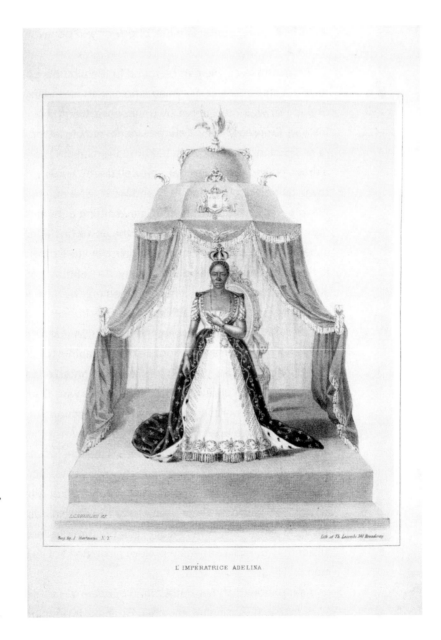

L' IMPÉRATRICE ADELINA

3.5.
L. Crozelier, after a daguerreotype by A. Hartmann, "Empress Adelina," lithographic plate from *Album Imperiale d'Haïti* (New York: Th. Lacombe, 1852). © British Library Board, HS.74/2132.

an important concern for a photographer of his obvious skill. (And one that would have repercussions regarding later knowledge of and about the album.)

With the creative contribution of sought-after French-trained daguerreotypists based in Manhattan and publication in New York (as opposed to in Haiti or Paris), the album packaged an impressive set of portraits of black royalty. Rather than representing colonial peoples or evidence of certain primitive practices, these ten images of Faustin I's coronation, his family, court, and officers, represent an important visual record of black

imperialism that contains a mix of power and benevolence, culture and national identity.

An example of this can be found in the album's portrait of Empress Adelina (figure 3.5). In this image, no simian attendants climb her body. She is not weighted down by unnecessary and exaggerated mimicry. Instead, Empress Adelina stares straight at her viewer, with only her arm raised, just to her waist. Rather than disrupting the image, her arm acts as a draw, pulling the eye to her bejeweled arm, fingers, and the additional royal insignia around her neck and waist. She stands just off-center of the imperial chair on a raised dais in a sitting area most likely set up for the coronation ceremony. She looks the part with her crown atop of what appears to be braided or line-styled hair. Her attire of ermine robes attests to the status of her position in society. As befitting her importance, she stands at the center of the image, framed only by the floor-length drapery behind the chair and the curtains off the dais from its undetailed surroundings before rising to a short, feathered, and ornate dome. This elaborate portrait of the empress positions her as a beautiful black woman of power who rises and moves through a white (and unmarked) world.

No one would dare conflate this empress with Ourika. Different destinies. Different perspectives. Different projections of power. Empress Adelina may have been given this space because of the coronation ceremonies associated with her husband, but the end result of the sitting (and further styling) offers up a persona that aims to silence critics who may have seen in the pejorative images that migrated of Adelina's black body a comic fool parodying imperial majesty. Her stare dares the viewer to see anything simian-like in her visage. Her posture challenges the viewer to misidentify her as a Senegalese slave girl instead of as the royal embodiment of Haiti.

As mentioned above, the *Album Imperiale d'Haïti* contains more portraits than just those of Adelina and Faustin I. In addition to the members of the emperor's royal court (including an image of his brother) (figure 3.6), the album also contains one of the few known representations of Princess Olive that exist outside of the French caricatures (figure 3.7). Although two of the images contain crowd scenes in which details are lost in the jumbled scene of bodies witnessing the coronation of the emperor and his processional, the rest offer close-up and detailed impressions to the viewer, displaying the variety (and complexity) of skin tone, facial features, hair type, names, and rank in Haiti. These ten images and the intricate frontispiece of the nation's crest make up an unparalleled resource for those interested in understanding the migration of images of black state-

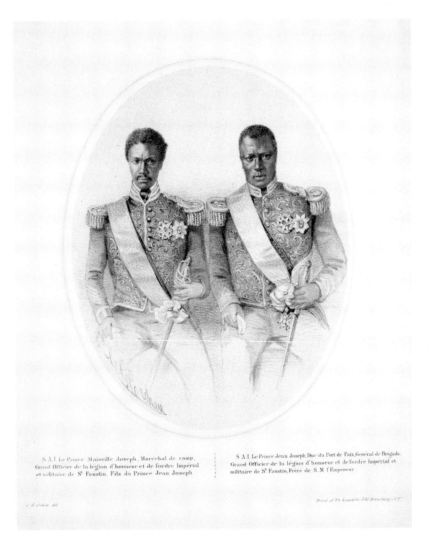

3.6.
C. G. Crehen, after a daguerreotype by A. Hartmann, "His Imperial Highness Prince Mainville Joseph and His Imperial Highness Prince Jean Joseph," lithographic plate from *Album Imperiale d'Haïti* (New York: Th. Lacombe, 1852). © British Library Board, HS.74/2132.

S.A.I. Le Prince Mainville Joseph, Maréchal de camp, Grand Officier de la légion d'honneur et de l'ordre Imperial et militaire de S¹ Faustin. Fils du Prince Jean Joseph

S.A.I. Le Prince Jean Joseph, Duc du Port de Paix, General de Brigade, Grand Officier de la légion d'honneur et de l'ordre imperial et militaire de S¹ Faustin, Frere de S.M. l'Empereur

hood and power. By working with these images, we can now begin the process of slowly building the history and the legacy of this resource and the many skilled artists who brought it together.[31]

Conclusion

The Caribbean essayist, poet, and critic George Lamming has written about thrones and power in the Caribbean. In *The Pleasures of Exile*, Lamming notes that "the first concrete demand" of Caliban's descendants was "a new throne." Immediately, he argues, the rest of the world responds with fatigue and doubt: "The atmosphere soon changes; and the people who once clapped soon adopt an attitude that Caliban is get-

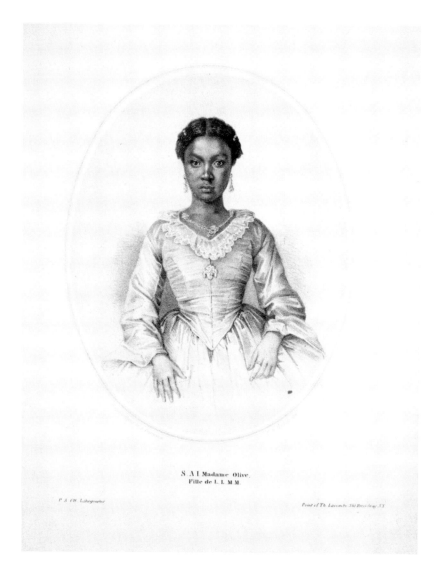

3.7.
P. A. Ott, after a daguerreotype by A. Hartmann (with additional drawing by C. G. Crehen), "Her Imperial Highness Madame Olive, Their Majesties' Daughter," lithographic plate from *Album Imperiale d'Haïti* (New York: Th. Lacombe, 1852). © British Library Board, HS.74/2132.

S.A.I Madame Olive,
Fille de I. I. M.M.

ting tiresome."[32] Lamming ends this passage by noting that Caliban is in dialogue with himself. Yet, that insight is not entirely true. As the above suggests, the power of images and their migratory movement through and within certain racialized spaces means that the flow of information is multidirectional. We have to be polyvocal in order to participate in the multiple dialogues happening simultaneously.

Faustin I perfected a form of polylingualism. He spoke power, spirits, imperialism, and blackness. He spoke against the limitations of Haiti and spoke for the rights of the nation to self-govern and even to invade other countries. In essence, the only limitation to the political role and function of Haiti's black body (and even Faustin I's) was in his own imagination. And as the *Album Imperiale d'Haïti* shows, his ideas were limitless when

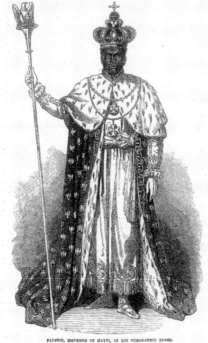

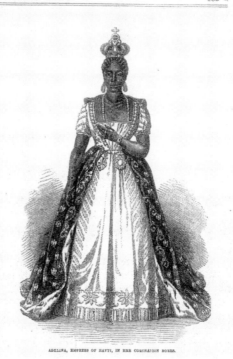

FAUSTIN, EMPEROR OF HAYTI, IN HIS CORONATION ROBES.

ADELINA, EMPRESS OF HAYTI, IN HER CORONATION ROBES.

3.8.

"Faustin, Emperor of Haiti, in His Coronation Robes and Adelina, Empress of Haiti, in Her Coronation Robes," published in *Illustrated London News*, February 16, 1856. These illustrations were copied from lithographs by L. Crozelier that were derived from daguerreotypes by A. Hartmann, *Album Imperiale d'Haïti* (New York: Th. Lacombe, 1852).

it came to projecting images of Haiti the modern nation-state and its sovereign ruler. From his coronation scene among crowds of purportedly ebullient Haitians to the more intimate portraits of his court, this is an album determined to represent Haiti as powerful, modern, majestic, *and* emphatically black to a wide viewership. And we know that the album's images circulated. An 1856 *Illustrated London News* article contains stereotypical text about the negative and foolish empire of Faustin I, but also two impressive, detailed images of the emperor and his wife, Adelina (figure 3.8).[33] These images are not copies of Cham's or Daumier's caricatures, but copies of the images of Faustin I and Adelina from the album. Uncredited, they offer little to link them to the impressive album that contains the original prints. No artists' signatures. No titles or dates. Until now. Now, we can put the story back together and credit the image-makers and the album for offering alternative images of Faustin I's empire and his nation.

Album Imperiale d'Haïti is an important and critical archive of early black images that connotes power, even as it is haunted by the brutal regime that gave it meaning. Each scene and portrait, while totally different from the racist and derogatory French caricatures of Faustin I's

IMAGES OF THE BLACK BODY POLITIC

imperial empire, only occurred because Faustin I made himself emperor and violently extended his control over all Haitian citizens. The images connote controlled majesty and beauty, but they rest, uneasily, alongside a brutal and violent regime of terror that routinely removed dissenters from the empire. No violence permeates the pages of the album, but its aftereffects echo within it.

In addition, his majesty, his status, his sovereign strength elevates him—and by extension his family and court—far above the average Haitian citizen. As such, these might be powerful black bodies on display in the album, but their political representation, as a collective, is one that is imperial in intent. This is a politic that did not include the masses. The album displays this stratification, even as it offers material evidence of a counter-narrative to nineteenth-century representations that linked the nation-state's blackness *and* sovereignty with unstable and volatile power. Until we deal adequately with both discourses—the hauntings and Haiti's black sovereignty—we will only partially see the archives of the black past(s) and will forever misjudge the political futures of people of African descent.

Notes

1 See these works for critiques of this imagery: J. Michael Dash, *Haiti and the United States: National Stereotypes and the Literary Imagination* (Hampshire: Palgrave, 1996); Krista A. Thompson, "Preoccupied with Haiti: The Dream of Diaspora in African American Art, 1915-1942," *American Art* 21, no. 3 (Fall 2007): 74–97; Lindsay J. Twa, *Visualising Haiti in U.S. Culture, 1910–1950* (Surrey: Ashgate, 2014).

2 For more, see Laurent Dubois, *Avengers of the New World: The Story of the Haitian Revolution* (Cambridge, MA: Harvard University Press, 2004).

3 Thomas Jefferson, *Notes on the State of Virginia* (Philadelphia: Prichard and Hall, 1788), 154, http://docsouth.unc.edu/southlit/jefferson/jefferson.html#p138. 4 See Michel-Rolph Trouillot, *Silencing the Past: Power and the Production of History* (Boston: Beacon Press, 1997) and Sibylle Fischer, *Modernity Disavowed: Haiti and the Cultures of Slavery in the Age of Revolution* (Durham, NC: Duke University Press, 2004).

5 See Ada Ferrer, *Freedom's Mirror: Cuba and Haiti in the Age of Revolution* (Cambridge, MA: Cambridge University Press, 2014).

6 For more on the performance of these rights, see Karen Salt, "Ecological Chains of Unfreedom: The Challenges of Black Sovereignty in the Atlantic World," *Journal of American Studies: Special Issue "Acts of Emancipation"* 49, no. 2 (2015): 267–86.

7 Although this essay traces the nineteenth century, the imaging of Haiti continues to the present day.

8 Tina M. Campt, *Image Matters: Archive, Photography, and the African Dias-*

pora in Europe (Durham, NC: Duke University Press, 2012), 5.

9 The scholarship on black visual culture is wide and varied. Two relevant sources include Shawn Michelle Smith, *Photography on the Color Line: W. E. B. DuBois, Race, and Visual Culture* (Durham, NC: Duke University Press, 2004) and Leigh Raiford, *Imprisoned in a Luminous Glare: Photography and the African American Freedom Struggle* (Chapel Hill: University of North Carolina Press, 2011).

10 Deborah Willis, "The Sociologist's Eye: W. E. B. Dubois and the Paris Exposition," in *A Small Nation of People: W. E. B. DuBois and African American Portraits of Progress* (Washington, DC: Library of Congress, 2003).

11 Laura Wexler, " 'A More Perfect Likeness': Frederick Douglass and the Image of the Nation," in *Pictures and Progress: Early Photography and the Making of African American Identity*, eds. Maurice O. Wallace and Shawn Michelle Smith (Durham, NC: Duke University Press, 2012), 18.

12 Leigh Raiford, "Ida B. Wells and the Shadow Archive," in *Pictures and Progress: Early Photography and the Making of African American Identity*, eds. Maurice O. Wallace and Shawn Michelle Smith (Durham, NC: Duke University Press, 2012), 302.

13 For more on Soulouque, see Rayford Logan, *Haiti and the Dominican Republic* (New York: Oxford University Press, 1968); and Laurent Dubois, *Haiti: The Aftershocks of History* (New York: Metropolitan Books, 2012).

14 Jennie J. Brandon, "Faustin Soulouque: President and Emperor of Haiti," *Negro History Bulletin* 15, no. 2 (Nov. 1951): 34.

15 "Hayti," *The Saturday Evening Post*, Sept. 29, 1849, vol. 29, 2.

16 See Robert J. Goldstein, *Censorship of Political Caricature in Nineteenth-Century France* (Kent, OH: Kent State University Press, 1989).

17 See Elizabeth C. Childs, *Daumier and Exoticism: Satirizing the French and the Foreign* (New York: Peter Lang Publishing, 2004).

18 Elizabeth C. Childs, "Big Trouble: Daumier, Gargantua, and the Censorship of Political Caricature," *Art Journal* 51, no. 1 (Spring 1992): 36.

19 There is not enough space here to chronicle France's complex relationship with race, slavery, republicanism, colonialism, and Haiti. All must be comprehended in order to understand how mid-nineteenth-century French viewers would read the likeness of a Haitian emperor and his black political body. For more on these tangled ideas, see Darcy Grimaldo Grigsby, *Extremities: Painting Empire in Post-revolutionary France* (New Haven, CT: Yale University Press, 2002); and Christopher Miller, *The French Atlantic Triangle: Literature and Culture of the Slave Trade* (Durham, NC: Duke University Press, 2007).

20 For more on racial theories of the nineteenth century, see Bruce Dain, *Hideous Monster of the Mind: American Race Theory in the Early Republic* (Cambridge, MA: Harvard University Press, 2009).

21 Cham, *Soulouque et sa cour: Caricatures* (Paris: Au bureau du journal *Le Charivari*, 1850), 4.

22 For the extensive scholarship on Ourika, see Miller, *The French Atlantic Triangle*.

23 See Claire de Duras, *Ourika: An English Translation*, trans. John Fowles (New York: Modern Language Association of America, 1994).

24 This scholarly line of inquiry is vast. A recommended book that works through the scholarship and offers new perspectives is David Brion Davis, *Inhuman Bondage: The Rise and Fall of Slavery in the New World* (Oxford: Oxford Uni-

versity Press, 2006).

25 Anthony Bogues notes that there were two Haitian revolutions: one against slavery and another against colonial control. I have maintained that there was actually a third that is still ongoing: Haitian sovereignty. That, too, is an unthinkable that is constantly in need of negotiating and defending. For more on Bogues's thoughts on the double revolutions, see Anthony Bogues, "Reframing Haiti as an Archive of Freedom," Presentation at the Special Commemorative Session of the UN General Assembly on the Occasion of the International Day of Remembrance of the Victims of Slavery and the Transatlantic Slave Trade, New York, March 25, 2010, www.brown.edu/Departments/Humanities_Center/news/documents/ReframingHaitiforUN.pdf.

26 This Boston-based magazine's response to Faustin I's coronation and reign is typical of the time. See "An Emperor's Toothpick," *Ballou's Monthly Magazine* 32, no. 6 (1870): 507. For more on this and other circulating material on Faustin I's reign, see Karen Salt, "Brokering Knowledge in an Age of Mid-recognition and Ignorance; or, Displaying Haiti to the Masses," in *Spaces of Global Knowledge: Exhibition, Encounter and Exchange in an Age of Empire*, eds. Diarmid Finnegan and Jonathan Wright (Farnham: Ashgate, 2015), 187–207.

27 This term is borrowed from Sekula. For more, see Allan Sekula, "Reading an Archive: Photography between Labour and Capital," in *The Photography Reader*, ed. Liz Wells (London: Routledge, 2003), 443–52.

28 Joan M. Schwartz, " 'We Make Our Tools and Our Tools Make Us': Lessons from Photographs for the Practice, Politics, and Poetics of Diplomatics," *Archivaria* 40 (1995): 42.

29 See Willis, "The Sociologist's Eye," for more.

30 I would like to thank Darcy Grimaldo Grigsby and Leigh Raiford for providing me with access to information on A. H. Hartmann. I would especially like to thank Darcy Grimaldo Grigsby for the chance to read a version of her forthcoming *Art History* essay, "Cursed Mimicry: France and Haiti, Again (1848–1851)." The helpful and always supportive curatorial team of the Americas at the British Library provided additional material, advice, and information regarding the album.

31 The full album is available in the British Library. Additional single prints of specific lithographs are available for viewing at the Schomburg Centre for Research in Black Culture in New York.

32 George Lamming, *The Pleasures of Exile* (London: Allison and Busby, 1984), 84.

33 "His Imperial Majesty Faustin, Emperor of Hayti," *The Illustrated London News*, Feb. 16, 1856, 186.

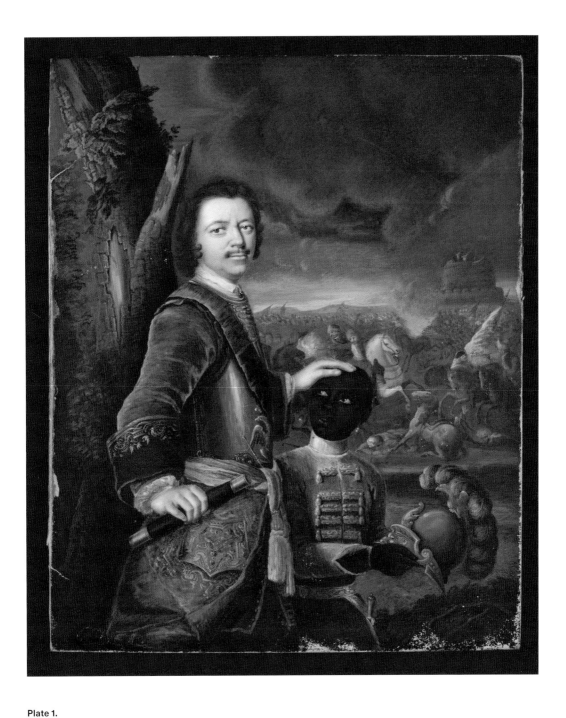

Plate 1.
Baron Gustav von Mardefeld, *Petr,
Russian Tzar, with a Black Page*,
portrait miniature of Peter the Great,
watercolor on vellum, ca. 1720. In the
Victoria and Albert Museum, London,
bequeathed by James Jones.

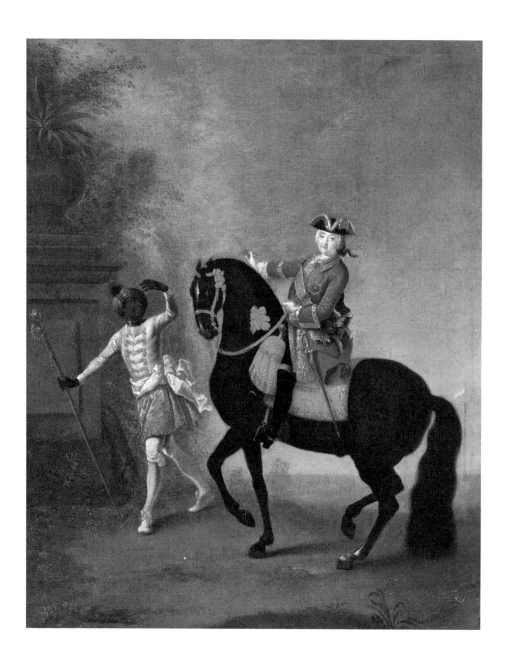

Plate 2.
Georg Christoph Grooth, *Mounted
Portrait of Elizaveta Petrovna with a
Blackamoor*, oil on canvas, 1743. In the
State Tretyakov Gallery, Moscow.

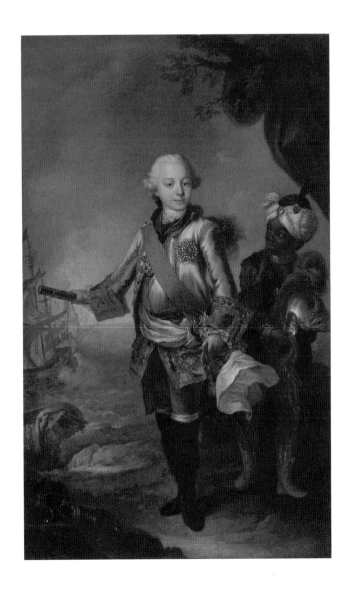

Plate 3.
Stefano Torelli, *Portrait of Young Pavel I*, oil on canvas, ca. 1765. In the Hermitage, St. Petersburg.

Plate 4.

Karl Bryullov, *Countess Yulia
Samoilova with Giovannina Pacini
and a Little Blackamoor*, oil on
canvas, 1832–34. In the State Russian
Museum, St. Petersburg.

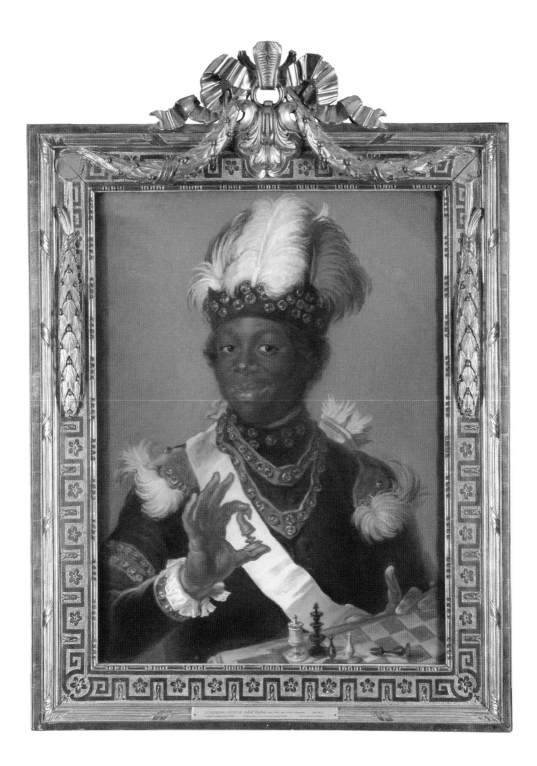

Plate 5.
Gustaf Lundberg, *Portrait of Adolf Ludvig Gustaf Albert Couchi, Known as Badin*. NMGrh 1455. Courtesy of the Nationalmuseum, Stockholm, NMGrh 1455.

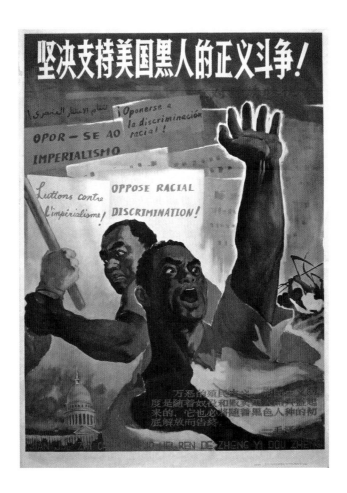

Plate 6.
*Resolutely Support the Just Struggle
of Black Americans against Racism!
(Jianjue zhichi Meiguo heiren fandui
zhongzuqishi de zhengyi douzheng!)*,
poster, 1963. Courtesy of the
collection of Pierre-Loïc Lavigne.

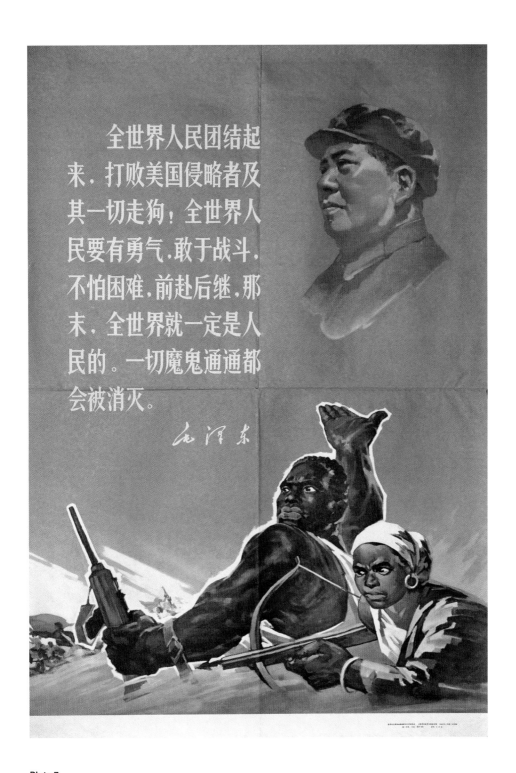

Plate 7.

Long Live Unity of World People!
(Quan shijie renmin tuanjie qilai!),
poster, 1973. Courtesy of the
collection of Pierre-Loïc Lavigne.

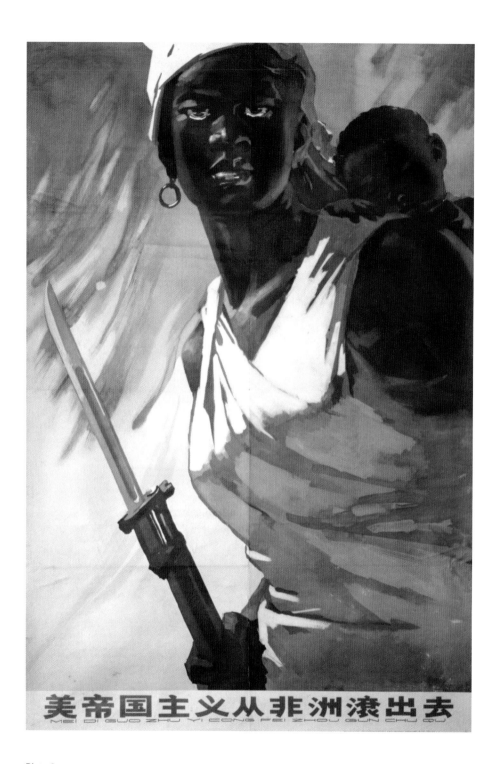

Plate 8.

U.S. Imperialism Get Out of Africa! (Mei diguo zhuyi cong feizhou gun chuqu!), poster, 1964. Courtesy of the collection of Pierre-Loïc Lavigne.

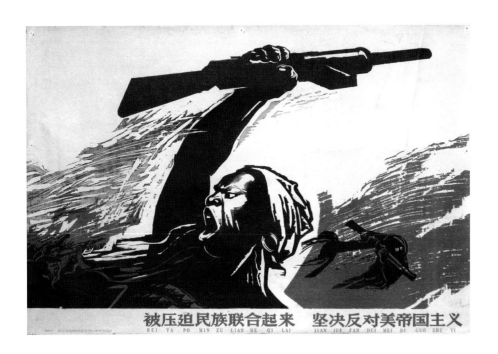

Plate 9.

Oppressed Peoples, Unite to Resolutely Fight against U.S. Imperialism (Bei yapo minzu lianhe qilai jianjue fandui mei diguozhuyi), poster, 1964. Courtesy of the collection of Pierre-Loïc Lavigne.

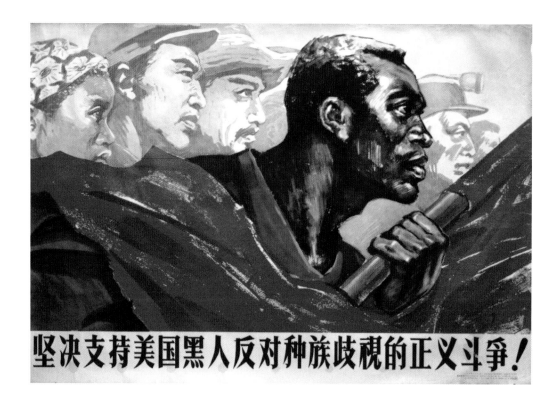

Plate 10.
Resolutely Support the Just Struggle
of Black Americans against Racism!
(Jianjue zhichi Meiguo heiren fandui
zhongzuqishi de zhengyi douzheng),
poster, 1963. Courtesy of the
collection of Pierre-Loïc Lavigne.

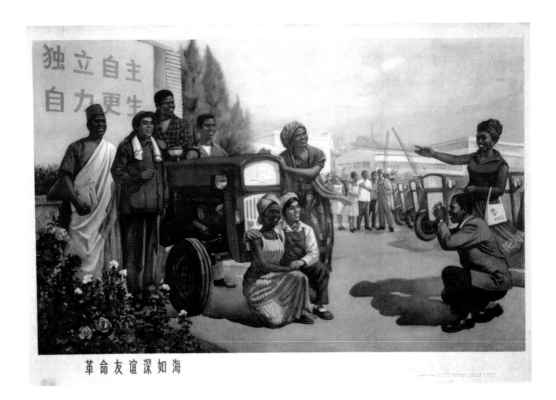

Plate 11.

Revolutionary Friendship Is As Deep As the Ocean (*Geming youyi shen ru hai*), poster, 1975. BG E15/581, Stefan Landsberger Collection, International Institute of Social History, Amsterdam.

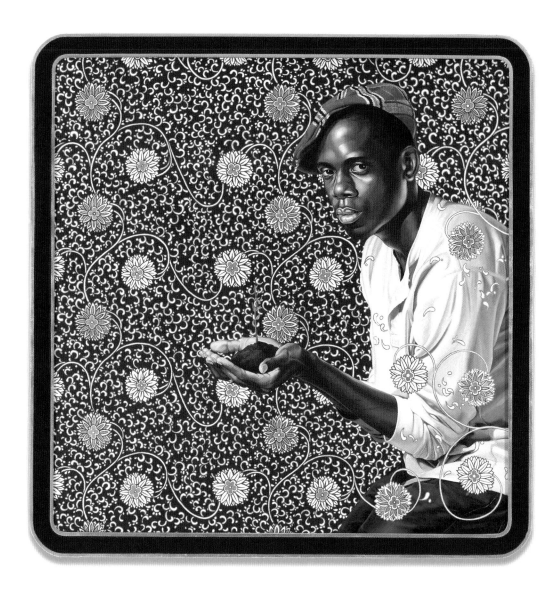

Plate 12.
Kehinde Wiley, *Encourage Good Manners and Politeness; Bright Up Your Surroundings with Plants*, oil on canvas, 60" x 60", 2007.

Plate 13.
Romuald Hazoumè, *Dream*, installation (photograph mounted on wood; boat made from plastic canisters, glass bottles, corks, cords, letters, photographs), 2007. Collection Neue Gallery, Kassel. Photograph courtesy of October Gallery, London. © Yinka Shonibare MBE. All Rights Reserved, DACS /Artists Rights Society, New York, 2015.

Plate 14. Yinka Shonibare, *Gallantry and Criminal Conversation*, mixed media, 2002. © Yinka Shonibare MBE. All Rights Reserved, DACS /Artists Rights Society, New York, 2015.

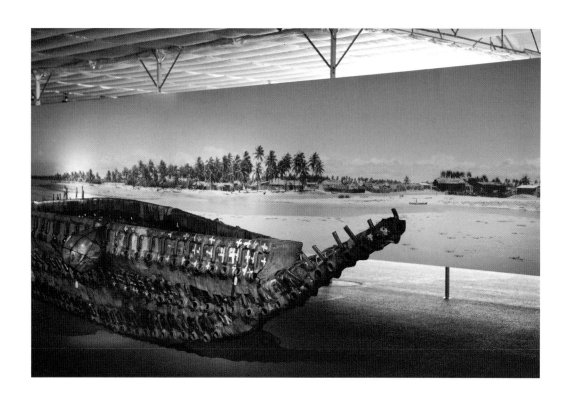

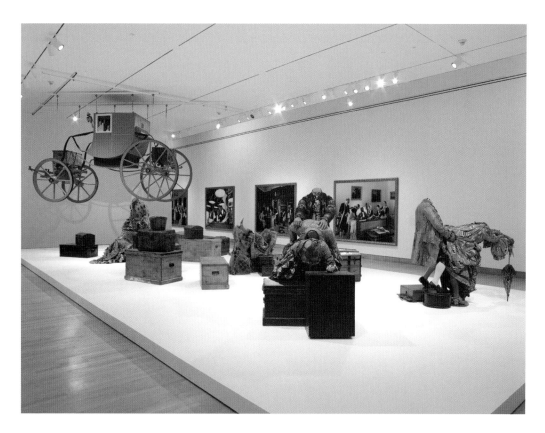

Plate 15.
Terry Adkins,
Meteor Stream,
installation,
American Academy
in Rome, 2009.
Courtesy of the
Estate of Terry
Adkins, Brooklyn.

Plate 16.
Joy Gregory,
"Bridge of
Miracles, Venice,"
from *Cinderella
Tours Europe*,
1997–2001. Fuji
crystal archive
print. Courtesy of
the artist.

Plate 17.
Jonathan Booysen,
twenty-five years
old. Photograph by
Rushay Booysen,
from *Coloured: A
Collage of a Hybrid
Society,* 2010.
Reprinted with
permission of the
artist.

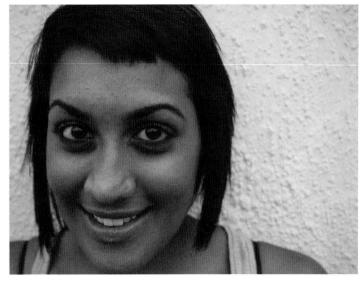

Plate 18.
Alka Myburgh,
twenty-three years
old. Photograph by
Rushay Booysen,
from *Coloured: A
Collage of a Hybrid
Society,* 2010.
Reprinted with
permission of the
artist.

Plate 19
Sean Plaatjies,
nine years old.
Photograph by
Rushay Booysen,
from *Coloured: A
Collage of a Hybrid
Society,* 2010.
Reprinted with
permission of the
artist.

Plate 20.
Videographer
Jack Sowah at the
Uptown Mondays
dancehall, Kingston,
2010. Video still by
Krista Thompson.

Plate 21.
Dancers from
the M.O.B. group
performing in the
video light, Santa
Cruz, Jamaica,
2009. Photograph
by Krista
Thompson.

4

Playing the White Knight

Badin, Chess, and Black Self-Fashioning
in Eighteenth-Century Sweden

JOACHIM ÖSTLUND

> Only few tell their story of their life truthfully. This is because
> of pride, selfishness, fear, sometime shyness, the protection
> of friends. These five reasons often hinder truth that should be
> told. But the one who writes these lines, shall not falter, on the
> road to truth, and to make a fool of the reader. The color of the
> one who writes is not the same as on what he writes on, but
> never the less, the same as the color of the lines.
>
> —Fredrik Adolf Ludvig Gustav Albrecht Couchi

The thoughtful words of this epigraph were written by Fredrik Adolf Ludvig Gustav Albrecht Couchi, commonly known as Badin, one of the few black Africans living in Sweden during the eighteenth century. In the text, he captures his life in a metaphor, centered on the colors of black and white, imaginable from the black ink on the white paper. He tells us that his black identity is more than his written words; his blackness is even visible in ink marks on the page. By doing so Badin offers a provocative example of how black identity could be expressed, and even more, he proposes that the text itself belongs to the realm of visual culture. Badin is the most famous African in Swedish history, mostly because of images that were made of him during his lifetime. Thanks to his own writing we are also informed, as shown above, of how he reflected on his "role" of being black. This chapter discusses the place of blackness in eighteenth-century Swedish visual culture with Badin as the central mirror for and maker of these ideas. The key issue in this essay is the question of subjecthood and how to identify situations, in written text and in visual

culture, when racial stereotypes, simplistic generalizations, and denial of individuality are challenged.

Yet, how did Badin end up in Sweden and what is his story? During the eighteenth century's "triangular-trade," Africans were also brought to Europe, primarily to England. While many European countries did not participate in the legal system of slavery, at least not on European soil, enslaved Africans were brought to these countries too, often by returning sailors or military and government officials to satisfy fashionable tastes among the royals and aristocrats. Sweden also had its share in the trans-atlantic slave trade—even if the number of Swedish slave ships was so small that it is not even represented separately in the Trans-Atlantic Slave Trade Database at Emory University. A few Africans were imported to Sweden to be kept in elite households or as symbols of status among the wealthy. During the eighteenth century, some twenty black individuals lived in Sweden serving as musicians in the army or as household servants. Some among them were free blacks. One of the most famous was Badin (1747/1750–1822), the Swedish "court-Moor," who as a young boy came to Sweden as a gift to the queen from a Danish statesman.

At the royal castle in Stockholm, this young enslaved boy became an experiment in upbringing; he was allowed to roam freely at the castle, uncorrupted by larger society. During the age of Enlightenment in Europe, questions of upbringing were intensely debated among intellectuals. The Enlightenment reformed society and meant, among many things, major changes for the treatment of children. Concepts of the human mind as a *tabula rasa* at birth were promoted by philosophers such as John Locke (1632–1704) and Jean-Jacques Rousseau (1712–78). Locke argued that children should be provided with the best possible setting to increase their development and improve their education, while Rousseau contended that humans are born good but become corrupted by society. For the Swedish queen, Badin became a tool to test Rousseau's teachings. In this sense Badin's life in Sweden is a story that uniquely captures both the European Enlightenment and the transatlantic slave trade. Badin became a well-known character in the capital of Sweden and an appreciated person in the royal family. He married a Swedish woman, became a ballet dancer, a book collector, and a member of a number of intellectual societies. In the year 1775, his status was confirmed when the leading pastelist in Sweden, Gustaf Lundberg (1695–1786), made a portrait of Badin as a smiling gentleman playing chess. This fascinating portrait can still be seen today at the National Museum in Stockholm, Sweden, and 240 years later, the image of Badin still has the power to capture the imagination of many viewers.

JOACHIM ÖSTLUND

From a historical point of view, the persona of Badin is a product of the eighteenth century, a result of an economic system, the slave trade, that had the power to move people across the globe, and of a cultural system, the Enlightenment, that had the goal of transforming the social and inner life of man. In this regard, Badin was not unusual. In many societies, black servants symbolized imperial power, such as eunuchs in the Ottoman Empire and blackamoors at royal courts throughout Europe. In Badin, we are presented with a Swedish example.

This essay centers around two questions that are related to the topic of black self-fashioning. The first question is concerned with the representation of Badin in Swedish eighteenth-century visual culture, especially with Lundberg's image of Badin and the social roles Badin was given in the portrait. I explore how Badin was framed by visual artists of the time and how Lundberg's image countered other contemporary representations of Badin. The second question is concerned with Badin himself, and how he expressed his own identity in the few textual fragments left from his own writing. I consider how Badin reflected upon questions of identity and his role of the black Other.

Badin's story has been told by a number of writers throughout history, ranging from Swedish royals during Badin's time to novelists such as August Strindberg, Carl Forsstrand, and Magnus Jacob Crusenstolpe.[1] In 2006, two well-known Swedish authors, Ylva Eggehorn and Ola Larsmo, simultaneously published books telling Badin's story.[2] Art historians Merit Laine and Carolina Brown, specialists in Gustaf Lundberg, have written about the ideals and techniques used by Lundberg when he painted Badin.[3] In his book, *The Past Is Not Dead*, Allan Pred analyzed a variety of representations of Badin from the 1840s through the 1990s, showing how racialized stereotypes of Badin have endured.[4]

Today, there is a growing body of literature on visual representations of African people in Europe.[5] In a recent study, Bernth Lindfords argues that while researchers wish to investigate how African people felt when they were represented in pictures, we cannot hear them speak for themselves, but can only speculate about such matters.[6] This is also true for Badin: today we have no information about how Badin felt before audiences. But Badin speaks for himself in other contexts. In his notebook we can read his thoughts about his life in Sweden—from daily life to existential thoughts on being black in a white culture.[7] Previous research on Badin has discussed questions of identity. Whereas Laine and Brown analyzed the artistic techniques of Lundberg and how cultural attributes and gestures are given to Badin, Pred considered how Badin has been defined by

artists and writers as the racial "Other." Considering how the presence of Africans in eighteenth-century Sweden raised questions about national and racial identity, this essay contributes to a growing discourse on black self-fashioning. Inspired by Richard Powell's method and way of seeing in his book *Cutting a Figure: Fashioning Black Portraiture*, my aim is to "move between interrogations of the black subject's self-perceptions, the black subject's and the artist's projected sense of the depicted black figure, and the black subject/black figure as a conscious and deliberate vehicle in art and cultural discourse."[8] My intention is to demonstrate how selected images of the black figure challenged established Enlightenment identity perceptions. When Lundberg painted Badin, Badin became included in Lundberg's gallery together with other renowned and high-ranking Swedes. This meant in turn that the concept of a Swede changed to a more multi-layered identity. Taken from this perspective, Lundberg both highlights Badin's difference/otherness and disrupts easy classifications of what/who counts as "Swedish."

Before one can look at Badin, one has to ask about other Africans, their lives and their perceptions, in eighteenth-century Sweden.

Africans in Europe

During the sixteenth, seventeenth, and eighteenth centuries, Africans represented only a small fraction of the population in Europe. In France there were several thousand, a few thousand were in the Netherlands, and several hundred were scattered throughout Germany, Scandinavia, and Russia. Nevertheless, Africa and Africans played a significant role in helping Europeans to define themselves, primarily through their role as symbols of European achievement rather than in their own right.[9] This becomes evident in the writings of central Enlightenment figures such as Carl Linnæus and Immanuel Kant.

Carl Linnæus (1707–78), the famous Swedish botanist, identified five varieties of humans: *Americanus*, *Europeanus*, *Asiaticus*, *Africanus*, and *Monstrosus*. These varieties were based not only on perceived morphological differences, but also on behavior and culture. Africans were described as "black, phlegmatic, relaxed; *Hair* black, frizzled; *skin* silky, *nose* flat, *lips* tumid; crafty, indolent, negligent. *Anoints* himself with grease. *Governed* by caprice."[10] While no explicit hierarchy was described for these types, the descriptions made it quite clear that Europeans were supposed to be the better. Europeans were described as: "Fair, sanguine,

brawny. *Hair* yellow, brown, flowing; *eyes* blue; gentle, acute, inventive. *Governed* by laws."[11]

Immanuel Kant (1724–1804) wrote in "Observation on the Feeling of the Beautiful and Sublime" (1764) that "Negroes of Africa have by nature no feeling that rises above the trifling," and that not a single one of them, even among them who have been set free, has "presented anything great in art or science or any other praiseworthy quality."[12] Even if there were opposing Enlightenment opinions on the subject, this evaluation of the ability of blacks was dominant among the leading Enlightenment thinkers. In the writings of Linnæus and Kant, Africans were presented as a group lacking the ability to break free from its own (lack of) history and culture. Of importance is how Enlightenment philosophy codified and framed the human in racial categories in which "reason" and "civilization" became synonymous with "white" people. But how stable were these ideas? Could they be challenged by real-life examples like Badin's? Badin's life clearly did not fit into the description of Africans offered by Kant.

In Sweden, there were other voices offering differing views on Africans. For example, according to the writings of the Swedish mystic and seer Emanuel Swedenborg (1688–1772), the "African race" was "in greater enlightenment than others on this earth, since they are such that they think more interiorly, and so receive truths and acknowledge them." Further, Swedenborg held the belief that a hidden African Church existed whose members apprehended unmediated truth. These ideas had an impact on Swedish society and for the abolitionist cause.[13]

The actual lived experiences of blacks in Europe were not limited to just servile roles. Free blacks living in the southern edge of Portugal and in Spain owned houses and worked as day laborers, midwives, bakers, farm laborers, footmen, and innkeepers. Similar experiences can be noted in Northern, Central, and Eastern Europe. Still, it also became fashionable for the wealthy to employ blacks as house servants and in ceremonial roles as military musicians.[14]

This is also true for Sweden. The arrival of Africans in Sweden is connected with the Swedish long-distance trade. African slaves were bought by naval officers, admirals, and captains. Information about these purchased individuals is fragmented, and there has never been any in-depth research on them. Nevertheless, one could conclude that the majority of Africans in Sweden were men. Officially, they would not have lived as slaves in Sweden, as the system was illegal. They were allowed to travel, to marry Swedish women, to establish families, and to have their own households. Around twenty names can be counted during the eighteenth

century. Many documents note the Christening of "Moors" as an important religious event. The mention of the presence of nobles at these occasions implies that these were also important social events. Africans were baptized and given traditional Swedish names or names from the Swedish royal family.[15]

Badin's life resembles that of many other "blackamoors" in Europe during the early modern period. People of African origins were present at most European royal and aristocratic courts where they performed a variety of roles, from stable-hand to prince. As a result of the European involvement in the slave trade to the Americas, their numbers steadily increased over the years. People of African descent were both a source of cheap labor and exotic symbols of power and wealth. Life at court also meant that some blacks took advantage of the opportunities available, either through education or through military pursuits. For example, João de Sa Panasco (fl. 1524–67), who began as a court jester in Lisbon, went on to become a gentleman of the household, a king's valet, and finally a member of the prestigious Order of Santiago. Juan Latino (d. 1590) grew up in the household of the Duke of Sessa in Granada and eventually became a published author and lecturer at the University of Granada. In the Netherlands, Anton Wilhelm Amo (1703–59) became a philosopher, with degrees from the University of Halle and Wittenberg. Abraham Hannibal, at the court of Tsar Peter I (1672–1725) in Moscow, became a military engineer and a major general.[16] These black slaves-cum-citizens were a sign of social prestige and distinction in a cosmopolitan court as well as symbols of empire building.

Badin: His Own Story

Like other Africans arriving in Sweden, Badin was baptized and given a Swedish name. The names given to Badin—Adolf Ludvig Gustav Fredrik Albert Couchi—were typical royal names that showed to which social context he belonged. Commonly, however, he was called Badin, which means "mischief-maker" or "trickster." Of all the names he was given, it was Badin he chose when he wrote letters, as an *ex libris*, and as a signature in his notebook. In all likelihood, the word lost the initial meaning after a while and turned into an ordinary surname.

According to Carl Forsstrand's study of famous eighteenth-century characters in Stockholm, there is conflicting information about Badin. It is believed that Badin was born either in Africa or on the Danish island Saint

JOACHIM ÖSTLUND

Croix in 1747 or 1750 and was bought by a Danish captain, who brought him to Europe and gave him to the statesman Anders von Resier. When Resier came to Sweden in the beginning of 1760, he gave Badin as a gift to the Queen of Sweden, Louisa Ulrika of Prussia. At the castle of Stockholm, Badin was subjected to a social experiment. The queen had founded a science academy where the origin of man and civilization was discussed. With Badin she saw an opportunity to test the theories of Rousseau and Linnæus. Before the experiment she instructed him in Christianity and taught him to read and write. The experiment meant that he was allowed to live entirely according to his own will and judgment and as a playmate of the children of the royal family. Different diaries at the time described how he ignored titles, talked rudely to the nobility, ridiculed religion, and teased the children of the royal family.

The next known phase in his story begins on December 11, 1768, when he was baptized in the chapel of Drottningholm Palace in the presence of the royal family. As an adult, he became a butler to the queen and, after her death in 1782, to the Princess Sophia Albertina. Badin married twice, first Elisabert Svart (d. 1789) and then Magdalena Eleonora Norell, both white Swedes, but died childless. Badin lived together with Svart in Stockholm and the couple had two maids in their service. The name Svart means "black" in Swedish, but there is no information whether she acquired this name because she married Badin. The name Svart, however, was not common. In the church records, Badin is listed as "moor" for the first wedding, and as "tailor" for the second.[17]

Badin died on March 18, 1822. After his death, Badin's library, according to contemporary estimates consisting of some eight hundred volumes, was sold in Stockholm. This makes him one of the first recorded book collectors of African origin in Sweden. In one of his books he wrote: "Belongs to the farmer Adolf Ludvig Gustaf Albert Couchi. He was born among thralls, but when the lightness came, he wished to die as free."[18] Apparently, he valued books in his life, identified himself as a farmer and a devout Christian. The "lightness" most likely refers to his baptism, meaning that the concept "free" refers to spiritual, rather than social, freedom. In this inscription, the name Badin is not mentioned. Further information about Badin's reading is offered by his Bible where he made many notes and underlinings, especially in the books of Isaiah, Ezekiel, and Jeremiah. Apparently these books, which mainly center on topics such as dreams of return, captivity, and lamentation, caught his interest the most.[19]

Badin was one of the few black intellectuals in Sweden in the eighteenth century. According to his contemporaries, he wrote satirical

poems together with the famous Swedish poet and songwriter Carl Michael Bellman, and it has been confirmed that he was elected to the orders of Par Bricole, Svea Orden, Timmermansorden, and the Freemasons. Information from the archive of the Timmermansorden tells us that Badin was an active member. But he never reached the highest grades in the order (X, XI, and XII) and there is no evidence that he got any formal position. Badin participated in plays at the French Theatre in Bollhuset in Stockholm and he is listed as a ballet dancer for the 1769–70 season. He played the main part in *Arlequin Sauvage* during the 1770–71 season, a play in which a "savage" meets civilization, and appeared in an erotic play written by Marivaux. He had several titles, such as chamberlain, court secretary, ballet master, and "official." His contemporaries described him as an intelligent and reliable person with self-confidence. He was very loyal to the royal house.[20]

There are only a few pieces of information left by Badin's own pen: a birthday poem, an autobiographical statement written as a member of the Par Bricole order, a letter for application of money to the Freemason order, and his notebook.[21] The poem was written on October 8, 1764, and the notebook covers the years 1802 to 1807. Other sources for Badin are his baptism protocol (birth certificate), his estate inventory, and some information from the archives of the Timmermansorden.[22] What kind of writer do we meet and what does he tell us about himself in these sources?

Badin's birthday poem, addressed to Princess Sophia Albertina in 1764, according to the memoirist Carl Forsstrand (1854–1928), is of interest because Badin's past in his original homeland is made imaginable in relation to his new home. The poem presents a past other than the story of him being a slave; instead, the poem defines Badin as "one of the Black People." Referring to scholar bell hooks's notion of the "oppositional gaze," one might see the poem as an example of how the dominated person struggles to assert agency by manifesting himself as "I" and as a person who also gazes at the other, at "this country's customs":

I, one of the Black People
Unfamiliar with this country's customs
Make a wish from my heart
To our Princess too.

But I cannot enough describe
what good I wish for her,

JOACHIM ÖSTLUND

Nothing more than that she will be satisfied,
Many ages ahead.

<div align="right">Badin v. undt su Sveinefurdt[23]</div>

The signature is a joke: the phrase *"v. undt su"* is a playful use of the noble titles "of" and "to," and the name "Sveinefurdt" might refer to the German city Schweinfurt or might mean literally a passage for pigs over a ford. Badin positions himself as the other, as an outsider, but in the context of a congratulatory poem. He is not one of them, he is unfamiliar with birthday celebrations, but like everybody else, he wants to send his greetings. At the same time, the "stranger" in the poem has the writing skills of the poet. The black Other also represents civilization and artistic competence, clearly contesting the racial stereotypes of Enlightenment thinkers such as Kant and Linnæus. In the end, his signature contests—and perhaps even ridicules—the aristocratic culture and their interest in titles.

In his autobiographical statement, which he wrote while a member of the Par Bricole order, there is no room for jokes. Instead, Badin offers a glimpse of his self-reflexive thinking by raising the question of his identity. The statement could also be seen as related to the debate over the value of truth that was part of the Enlightenment's mission of freeing the world from a morass of falsehood. Importantly, for Badin the question of his own truth, and inner self, includes his black identity:

> Few are those who recount the events of their life with honesty. The reason is pride, self-interest, fear, sometimes shame, [or not wishing to] expose friends. These five points most often prevent the truth from being seen where it ought to be. But he who writes these lines shall attempt not to stumble in truth's pure way and thereby deceive the reader with his tales. The color of he who writes does not resemble that of what he writes upon, but well resembles that of what he has written with. During his childhood he was nursed to imbibe the wild in man and thereby embarked into a world of trials. His life resembled that of the wild animals, until it was corrected. That was me in the years 1762 to 1771.[24]

One might wonder what Badin had in mind when he wrote these lines. Clearly, the black color of his skin was of importance for him, something that he wanted to point out as inseparable from the story of his life. Taken together with the comment in the second part about his upbringing, one could imagine that Badin is referencing the idea of *tabula rasa*, the child

as a blank state. Maybe Badin is trying to create a parallel between the blank state and the white unwritten paper, as a reference to the society and culture he has been raised in, and the black ink as his life-story, inseparable from his black skin—a fact that is unchangeable. Again, one can only guess the meaning of these words. His behavior, though, was something else. Badin was "corrected," he tells us, after the period that "resembled the wild animal," during the years 1762–71. But on the other hand, his wild behavior is explained as a result of how he was raised in his childhood (that is, as a result of the society in which he was raised, as Rousseau would argue). We might consider this as a counter-argument against how black Africans were labeled as inhumane or uncivilized "by nature" by many contemporary thinkers.

Beginning in 1802 and ending in September 1807, the notebook consists of day-by-day notes of importance, poems, geometrical models, mathematical calculations, detailed descriptions about changes in the weather, and quotations from the Bible. Badin also comments on contemporary political issues, like the need to erect a statue at Gustaf Adolf Square in Stockholm to honor Crown Prince Carl Johan Bernadotte. In many cases the notebook offers practical glimpses of ordinary life; for example, he advises how to mix "turpentine with water from the sea," or includes notes about nails, while the next page might consist of comments on the different meanings of letters of the alphabet. Unfortunately, many notes are barely readable (figure 4.1). It seems likely that the book had different functions in different periods and that the notes were meant for Badin's eyes only.

Badin expresses different emotional modes in his notebook: there are many entries about spiritual love, poems on the beauty of flowers, about friendship. We cannot be sure if these notes are written as comments about his own feelings or if he had collected these sentences during his readings or at discussions taking place when he participated in activities as a Freemason. Nevertheless, he writes them down because he finds them important. One final example from the notebook, written around the year 1807, shows a Badin who pictures his life in a much more negative way than previously. In 1807, he was around sixty years old and penned the following reflections on his situation in life: "When I felt that I became a Subject; I wanted to know to where I was destined; I Found that it was not for Myself I wanted to know, For whom I was destined to? Then my inner being Felt that I was Destined to my God, For my King, for my Neighbor, and for the Aid of my enemies; and as a Human, I Found out that the Last cause to my Existence on Earth, Turned into Something unsavory; that

4.1.

Pages from Badin's notebook. Uppsala University Library, Uppsala, X252:a.

aroused a conflict in me, which still endures."[25] Again, we see the language and arguments of an intellectual pushing the question of his identity, but in a rather critical way. One could ask why some of the words are capitalized and if the enemies are an expression of a Christian ethos or some particular persons he had in mind. What is revealed is that Badin expresses the turmoil of an inner self that has been changed, corrected, and taught to live a new life by being educated with Swedish patriotism and Christian faith. But still, something in him resists or struggles. Perhaps these words are related to a dramatic change in Badin's life, to something that turned out badly, written by a person who is unsure of his belonging in the social and cultural world. At the end of Badin's life, there is also evidence that his economic situation was strained. On April 9, 1819, he wrote an application for financial support to the Freemason order. In the letter, Badin presents himself as an intellectual, as a member of the order, supporting his argument that giving him money is the correct thing to do for supporters of "the Age of Enlightenment."[26] By referring to the cultural standards of "the Age of Enlightenment," Badin manifests his engagement with the Enlightenment's thinking and language.

These are the few examples available where we hear Badin speak for himself. He appears as a reader and a thinker, searching for answers about truth and his black identity. He even puts his life and his social roles into critical perspective. How do these aspects fit into the visual representations that his contemporaries made of him? Did he appear as a unique individual and a thinker? Four drawings of Badin serve as a context to get a better understanding of the portrait of Badin by Gustaf Lundberg.

Badin in Swedish Visual Culture

When it comes to representations of blacks in Europe, the use of images is a formidable source to analyze how experiences and attitudes of black

4.2.

Drawing of Badin as a jester by Jean Eric Rehn (1717–93). From Allan Pred, *The Past Is Not Dead: Facts, Fictions, and Enduring Racial Stereotypes* (Minneapolis: University of Minnesota Press, 2004).

and racialized people were shaped. By analyzing these visual representations, it is possible to get an understanding of systems of iconography and pictorial strategies related to questions of loyalty, assimilation, and cultural identity.

The most famous picture of Badin, currently on view at the National Museum in Stockholm, was painted in 1775 by the Swedish pastelist Gustaf Lundberg, a leading portraitist in Sweden for almost forty years. Lundberg found his clients among the members of the royal family, the nobility, and the wealthy, educated middle class. It is believed that the queen ordered the portrait of Badin. Lundberg has been described as an artist of integrity and a masterly portrayer of beauty. For male sitters the large majority of Lundberg's repertoire encompassed the elite: kings, princes, officers, councilors of the realm, clergymen, poets, and men of fashion, many with military allusions.[27] How then did Lundberg capture Badin's unique story of being a former slave, a Rousseauian experiment in upbringing at the royal castle in Sweden, and finally an intellectual? Before we turn to Lundberg's portrait, other images of Badin need to be discussed as they enable us to see the alternative that Lundberg's portrait offers.

Badin caught the attention of other artists from the upper levels of society. Four of these drawings picture Badin in the role of a jester, a farmer, and as a member of the Freemasons. [28] Of interest are the ways that Badin is variously presented: Is the goal of the artist to capture Badin as a person or to picture Badin mainly in his social stereotypical role? Two pictures by Jean Eric Rehn (1717–93), architect and later professor at the Academy of Art in Stockholm, shows Badin in the role of the jester, ready to entertain. In general, Rehn's pictures often took the form of "friendly caricatures." This is also true when it comes to Badin. In the first picture, Badin is barely visible in a scene at the royal court, together with Queen Louisa Ulrika, with her personal reader to her left, and the court sculptor

4.3.

Badin à cheval revenant de sa champagne (Badin on horseback returning from his country lands), sketchbook drawing, c. 1796–97 by Johan Tobias Sergel (1740–1814). From Allan Pred, *The Past Is Not Dead.*

and his work to her right. The painting set at the queen's court is rather neutral and without any clear intention of stereotyping. The reader and the sculptor play the roles of overweight aristocrats and the sculptor even bears some resemblance to a pig, if one looks at his feet, face, and hand. Badin seems to be almost dodging into the center of the image. His big smile and the way he tries to get the attention of the queen, or maybe the viewer, dominates. His skin color is not entirely black, but his facial expression is clearly contrasted against the seriousness of the other individuals in the picture. One could see the picture as a caricature, not only of Badin, but also of the court culture in general. Badin's wild interception underscores the impression of the court as a bizarre environment crowded with bizarre individuals.

The second drawing by Rehn shows Badin in full view (figure 4.2). In the picture it is difficult to guess Badin's age because he is depicted with both childish and adult attributes. His body seems to be small, but he is dressed in adult clothes and he shows the bulging belly of an aristocrat. We also note that the face is not given a clear personification and the facial expression is rather neutral. Clearly, this is the jester, ready to entertain or react on command.

Johan Tobias Sergel (1740–1814), a well-known cartoonist and a neoclassical sculptor who specialized in classical mythology, depicted Badin as a farmer riding a horse. Sergel became famous for his "not-so-idealized" caricatures of the nobility and the royal family in everyday life situations. In the picture, Sergel has given Badin big lips and the look of a

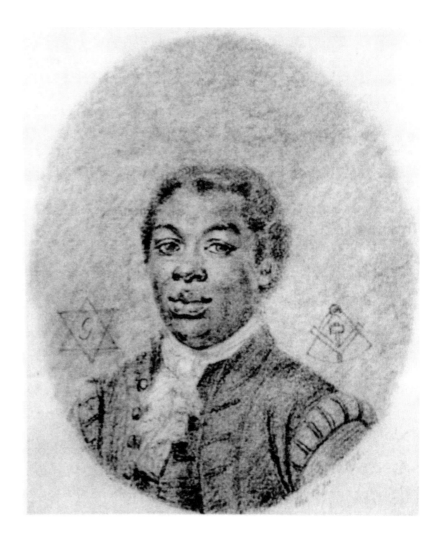

4.4.
Badin as a member of a fraternal order, sketch by Anton Ulrik Berndes, 1784. From Allan Pred, *The Past Is Not Dead*.

farmer on a somewhat shabby horse (figure 4.3). Badin's posture is slightly bent, and he has a bulging belly. Badin is depicted as a rather playful or even unruly black African.

The third picture differs from the previous two in that now, Badin is depicted as an individual with a confident facial expression. This "Freemason portrait" was dated by its artist, Anton Ulrik Berndes, on July 15, 1793 (figure 4.4). Berndes was an engraver, miniature painter, and art writer. Compared to Lundberg's image, Badin is not depicted as a trickster, but instead as an intellectual belonging to a prestigious order in Sweden. Accompanying the portrait is a celebratory poem telling his story:

> Born among slaves he wandered among them;
> till the approach of light drove away darkness:
> and then it was that transported its luster and warmth,

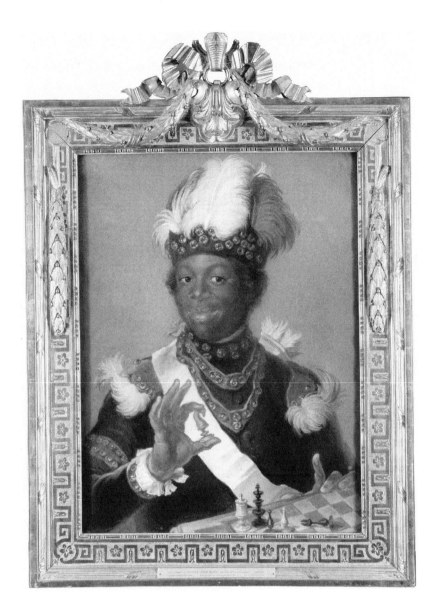

4.5.
Gustaf Lundberg,
*Portrait of Adolf
Ludvig Gustaf
Albert Couchi,
Known as Badin.*
Courtesy of the
Nationalmuseum,
Stockholm, NMGrh
1455.

Adolf Ludwig Gustaf Fredrik Albert Badin Couchi,
Wished to die as one truly free.

According to the poem, Badin was born a slave, but nothing is mentioned about his having been taken into captivity by Europeans and later bought by a Danish captain to be offered as a gift to the Swedish queen. Clearly, the ex-slave is put into an ideological framework where he is in need of civilizing Christian enlightenment. His Christian name means that he finally experienced "luster and warmth" and the possibility to "die as one truly free."

These four pictures show how Badin could variously be framed—as a jester, a farmer, and a Freemason. Looking at the picture made by Gus-

taf Lundberg, one quickly recognizes two of these roles, the jester and the Freemason, blurred into one (figure 4.5, plate 5). Lundberg made this portrait in his studio in 1775, when Badin was around twenty-eight years old. This portrait was most certainly commissioned by the Queen Louisa Ulrika, and art historians also believe that the queen chose the pastel Moorish costume that Badin wears. The composition of the picture raises provocative questions: Why is Badin depicted as a chess player holding up the white knight and smiling towards us? Who is the other player? Is it the viewer? Why is the black chess piece turned over? How should we understand Badin's posture, his gestures, and his clothes? Why is the color blue so strongly represented? Many of these questions can be answered by Badin's own life story, as well as the ideals in contemporary Swedish portrait culture. Of importance, however, is also the status of Lundberg. Because of his reputation in Sweden, his portraits did not just reflect prevailing ideals, but also helped shape and uphold them, as Laine and Brown have argued.[29]

Lundberg is credited in Swedish art history as introducing the rococo portrait. His goal was to reproduce likenesses, and to this day his portraits exert a major influence on views of the people and culture of eighteenth-century Sweden. Lundberg has been described as an artist of integrity, anxious to maintain the quality of the portrait. Many of his customers also complained about the lengthy process of becoming depicted.[30] Lundberg's reputation as a master portrayer of beauty came from his technique, reinforcing his characterization of his subjects. He placed emphasis on natural elegance, reflecting the aristocratic ideal during the eighteenth century. This is most clearly seen in his manner of rendering texture and tints of the facial skin. Smooth, light, and blended tones were used for younger men and women, while rougher texture and stronger coloring were used for elderly men. In his portraits, Lundberg used pastels, a medium criticized during the eighteenth century because it was associated with femininity. However, the feminization of rococo and pastel images was not a dominant feature of the Swedish reception of portraiture until the later part of the century.[31] Therefore, one should be careful not to interpret sexual analogues into the image, as some authors have done with Badin's raised finger.[32]

Badin is depicted in the role of a chess player, thus emphasizing his intellectual and social abilities. The chess-playing situation can be seen as a visualization of Badin's role at court, in society, and in relation to racial theories and conventions of the day. In the picture, Badin is holding up the white knight with a quiet smile. Knocked over on the board is the black

bishop, *le fou noir*, reminiscent of Badin's original role of the fool, *le fou*. Holding the white knight, *le cavalier blanc*, representing education, virtue, and religion, he conveys a message about his new, transformed identity. By displaying the white knight to the viewer, Badin not only actively comments on his new role, but also counteracts and upholds racial theories at the same time. Why is this black bishop, *le fou*, holding the white knight in his hand? Is it Badin who is knocking down his old identity, the black fool? The binary oppositions of black and white presented by thinkers like Linnæus and Kant are tested in a playful way, forcing the viewer to ask questions about these cultural symbols.

The way Badin is holding his hands is also of interest. For Lundberg, the human hand held great importance in his portraits because the hand and its movements are used to express the character of the person. The more slender-limbed and graceful these hands are, the more graceful and noble the character is, according to Lundberg. That was also the characterization he gave Badin. Static body gesture and the expression of confidence were also attributes Lundberg gave to men. Males were, compared to women, painted as individuals. All women were given the same gestures, taken from dancing manuals and fashion books.[33] In the picture Badin looks the viewer in the eye, expressing confidence with his quiet smile, and with his body's posture in total control. The head is held high. His left hand points to the viewer, asking for attention to what he is doing and what he has become.

A significant proportion of Lundberg's images of male royals and noblemen have military allusions. Many of them were young patriotic officers who were great admirers of the Swedish martial hero Charles XII. For them, the traditional Carolinian officer was the epitome of Swedish male virtues. To satisfy this Swedish male ideal, Lundberg used blue coats for his royals and noblemen, but at the same time added an aristocratic refinement to them. This was done to distance the nobles from the real Carolinian officers. The same symbolically and politically charged color is used on Badin's Moorish dress, making him a Swedish patriot but without the association to the virtues of the Carolinian officer.

In comparison to the drawings of Badin by Rehn, Sergel, and Berndes, it becomes evident that Lundberg is trying to tell another story. Where Rehn and Sergel mainly reduce Badin to a rather stereotypical representation of a farmer and a jester, Lundberg's image aims to capture Badin's personality, the fine manners of a Swedish gentleman, and the playfulness related to his position as a servant at the castle. One could also argue that the color-coded distinctions, set up by racial theories and by

Rehn's and Sergel's drawings of Badin, are blurred in this image. By giving Badin the posture and the confidence attributed to European gentlemen, the portrait contests distinctions between the civilized and the inferior, the European and the African. Even with the trickster image of Badin, the viewer is not presented with a representation of a black African as a humble servant; instead, Badin is included in the gallery of the Swedish elite.

Conclusion

The life of Badin and the portrait by Lundberg together offer a powerful narrative of the black migrated body. Even if Sweden only played a minor role in the slave trade, the existence of Badin and the portrait by Lundberg show that Swedish royals, like other elites in Europe and the Ottoman Empire, perceived black Africans as status symbols for their power and imperial ambitions. For that reason alone, one cannot get away from the fact that the story of Badin, in the main, is an unhappy story. Even if Badin was highly appreciated at the court in Stockholm and may have lived a happy life, much of eighteenth-century Swedish black-white relations were shaped by the experience of slavery.

Badin made an impact on his contemporaries, and there are shifting representations of him in journals, novels, and images. In earlier research, these representations have been analyzed in regard to questions about the construction of the racial Other. Yet, questions about how Badin countered these attitudes or how he perceived himself have not received the same attention. Even if Badin is silent about his feelings about his portraits, he is not silent about his identity.

Badin was also the reason that black Africans became visible to a much greater degree in Sweden in drawings and in art. At the same time one should not forget that the eighteenth century had its carnivalesque and vulgar popular culture, which nobody escaped the gaze of, as evidenced by artists like Rehn and Sergel. When Badin is stereotyped and racialized, he also becomes part of this vulgar tradition. The same thing happened with famous white Swedes, who are pictured as animal-like, ugly, and fat, in silly postures, and in often vulgar situations.

In Lundberg's contribution to the image of Badin, two roles were combined, the jester and the gentlemen. Even if Badin is shackled here to his social role of the trickster, the viewer meets the gaze of a confident man who has the determination to win. The chess-playing situation can be seen as a visualization of Badin's role at court and in society: when Badin

is holding up the white knight, smiling, he is both visualizing racial theories and counteracting their color-coded distinctions. The image might at least make the viewer consider these distinctions in a new way. If we compare Lundberg's portrait of Badin with the drawings by Sergel, Rehn, and Berndes, the level of subjecthood varies: from an almost complete denial of any individuality in Rehn's picture, which depicts Badin as a racially stereotyped jester who seeks attention from the queen, Badin turns into the elegant and cunning chess player in Lundberg's portrait, who is very much aware of his ambiguous status in Swedish society and plays with the viewer in this regard. Clearly these images both intersect and contradict each other. Even if Lundberg's portrait presents Badin as a trickster, dressed in an aristocratic outfit and arranged with an intellectually cunning posture, the image should be recognized for being the first visual representation of a black African living in Sweden—an individual with a unique personality and history.

Notes

1 Magnus Jacob Crusenstolpe, *Morianen, eller Holstein-Gottorpiska huset i Sverige* (Stockholm: L. J. Hjerta, 1840–44); Carl Forsstrand, *Sophie Hagman och hennes samtida: Några anteckningar från det gustavianska Stockholm* (Stockholm: Wahlström & Widstrand, 1911); Hans Alfredsson, "Svart spelar vit. Gustaf Lundbergs porträtt av Badin," in *Porträtt, porträtt: Studier i statens porträttsamling på Gripsholm*, ed. Ulf G. Johnsson (Stockholm: Årsbok för Statens konstmuseer, 1987), 33, 85–88.

2 Ylva Eggehorn, *En av dessa timmar* (Stockholm: Albert Bonniers, 1996); Ola Larsmo, *Maroonberget* (Stockholm: Albert Bonniers, 1996).

3 Merit Laine and Carolina Brown, *Gustaf Lundberg 1695-1786: En porträttmålare och hans tid* (Stockholm: Nationalmuseum, 2006), 239.

4 See Allan Pred, *The Past Is Not Dead: Facts, Fictions, and Enduring Racial Stereotypes* (Minneapolis: University of Minnesota Press, 2004).

5 See Jan Nederveen Pieterse, *White on Black: Images of Africa and Blacks in Western Popular Culture* (New Haven, CT: Yale University Press, 1992); Jean Vercoutter and Hugh Honour, *The Image of the Black in Western Art*, vol. 4 (Cambridge, MA: Harvard University Press, 1989); Jan Marsh, *Black Victorians: Black People in British Art, 1800–1900* (London: Lund Humphries, 2005); Simon Gikandi, *Slavery and the Culture of Taste* (Princeton, NJ: Princeton University Press, 2011); Kenneth Morgan, "Faces of Perfect Ebony: Encountering Atlantic Slavery in Imperial Britain," *Journal of American History* 99, no. 4 (2013): 1220.

6 Bernth Lindfors, *Early African Entertainments Abroad: From the Hottentot Venus to Africa's First Olympians* (Madison: University of Wisconsin Press, 2014).

7 Badin, Badins anteckningsbok, X252a.

8 Richard J. Powell, *Cutting a Figure: Fashioning Black Portraiture* (Chicago: University of Chicago Press, 2008), 13.

9 Allison Blakely, "Problems in Studying the Role of Blacks in Europe," *Perspectives* 35, no. 5 (1997): 1.

10 Carl von Linné, "The God-given Order of Nature," in *Race and the Enlightenment: A Reader*, ed. Emmanuel Chukwudi Eze (Oxford: Blackwell Publishers, 1997), 13.

11 Linné, "Order," 13.

12 Immanuel Kant, "On National Characteristics," in *Race and the Enlightenment: A Reader*, ed. Emmanuel Chukwudi Eze (Oxford: Blackwell Publishers, 1997), 55.

13 Adam Lively, *Masks: Blackness, Race, and the Imagination* (Oxford: Oxford University Press, 2000), 41.

14 Blakely, "Studying Blacks in Europe," 1.

15 The following Africans have been found from notes in parish records, newspapers, and pass registers. PARISH RECORDS: Ervalla kyrkoarkiv, Husförhörslängder, SE/ULA/10219/A I/8 (1816–25), No 140; Bredahls ägor, Johan Petter Bergström and his wife "the Negress" Eva Johanna, born 1785 at the Coast of Guinea. Their son Frans Joseph was born in Örebro, December 12, 1813. German congregation in Stockholm, baptism, May 5, 1706, Carl Friedrich, "*ein mohr*"; Karlskrona amiralitetsförsamling, October 17, 1786, "a Moor (no name) baptized with the name Carl Ludvig"; Otterstads vigselbok, December 28, 1793 (Otterstad E: 1 sid 21), note on the "*Africannen*, a clarinet player named Johan Jacobsson"; Födelseboken Björkö C: 2, June 20, 1783, "a female Moor Daphne baptized at the age of twenty with the name Friderica Dorothea" and January 1, 1785, "the Moor Wicto, baptized at the age of twenty-five with the name Johan Gustaf"; Mönsterås dödsbok, 1803, "Adolf Ludvig, a Moor from Guinea, baptized by Melin in Mönsterås, deceased in Drakenäs"; Landsarkivet i Lund, Skårby församlings födelse-och dopbok 1786–1824, volym CI: 3 (år 1786), December 1786, "the black heathen" Paulus Zephyrin, born in Africa, baptized"; Storkyrkoförsamlingens kyrkböcker/Mantalslängd 1835, notes on Antoine Zamore alias Charles Antoine Francois "La Fleur" Zamore (1736–1814), drummer in Hertig Carls regiment on horse, as well as notes on the "moors" Robert Spirman and Carl Gustav Abrahamsson alias Richard Abramsson (1760–1838). NEWSPAPERS: *Inrikes tidningar*, June 28, 1773, the Moor Benini, from Guinea, baptized with name Joh. Fredr. Reinhold; and *Inrikes tidningar,* June 5, 1776, the Royal Moor Vulcain baptized in the Royal Church in Stockholm with the names Gustaf, Ludwig, Magdalena, Carl, Hedwig, Fredric, Albrecht. PASS REGISTERS: Göteborgs och Bohus läns Länsstyrelse (1783–89, 1798–1820), December 1, 1787, note on the American seaman and "Negroe" Johannes Thefilus.

16 Miranda Kaufmann, "Courts, Blacks at Early Modern European Aristocratic," *Encyclopaedia of Blacks in European History and Culture*, vol. 1 (Westport, CT: Greenwood Press, 2008), 163–66.

17 Forsstrand, *Sophie Hagman*, 134–35.

18 Forsstrand, *Sophie Hagman*, 136–37.

19 Forsstrand, *Sophie Hagman*, 137.

20 Forsstrand, *Sophie Hagman*, 123–37.

21 Badin, bouppteckningsnummer III: 673/1822, Stockholms Rådhusrätt, Stockholm city archive. Badin's birth certificate, Biographica minora, Badin, Adolph

L (Couchi), 1747–1822. De la Gardieska samlingen, Lunds universitetsbibliotek. Badin's application to Freemasons, April 9, 1819, Biographica minora, Badin, Adolph L (Couchi), 1747–1822. De la Gardieska samlingen, Lunds universitetsbibliotek. Par Bricole archive, DIj:1, Biografiska uppgifter, 1789–1910, no. 3, inventory 1451, SSA, Egenhändig biografi av Badin (transcribed copy, 1791). Badin, Badins anteckningsbok, X252:a.

22 Badin, bouppteckningsnummer III:673; Badin's birth certificate; de la Gardieska samlingen. Badin's application to Freemasons, April 9, 1819.

23 For original text of poem, see Forsstrand, *Sophie Hagman*, 136. Translation of lines 1–4, from "Gustav Badin," Wikipedia, https://en.wikipedia.org/wiki/Gustav_Badin, accessed June 20, 2016; translation of lines 5–8, mine. bell hooks, *Black Looks: Race and Representation* (Boston: South End Press, 1992), 115–31.

24 Par Bricole archive, DIj: 1, Biografiska uppgifter, 1789–1910, no. 3, inventory 1451, SSA, Egenhändig biografi av Badin (transcribed copy, 1791). According to Wikström, the texts were written between late 1807 and early 1810; Lars Wikström, "Fredrik Adolph Ludvig Gustaf *Albrecht Badin*-Couchi: Ett sällsamt levnadsöde," in *Släkt och hävd: Tidskrift* 1 (1971): 275. Translation of lines 1–5 from Pred, *The Past Is Not Dead*, 8; translation of lines 6–8, mine.

25 Badins anteckningsbok, X252:a, translation mine.

26 Badins ansökan till Frimurarorden 9/4 1819. De la Gardieska samlingen, Lunds universitetsbibliotek.

27 Laine, *Lundberg*, 239.

28 Pictures taken from *NF-Nytt* Medlemsblad för den nordiska första St Johannislogen, nr 1, januari 2004.

29 Laine, *Lundberg*, 239.

30 Laine, *Lundberg*, 239.

31 Laine, *Lundberg*, 244.

32 See Eggehorn, *En av dessa timmar*, 58. The present-day tendency to interpret an erect finger as an obscene gesture has also been commented on by Ola Larsmo; see Larsmo, "Skuggan av Badin: Några dagboksanteckningar av Gustaf IIIs 'morian'," *Bonniers litterära magasin* 6 (1996): 5.

33 Laine, *Lundberg*, 179.

5

Making Blackness Serve China

The Image of Afro-Asia in Chinese Political Posters

ROBESON TAJ FRAZIER

Use the past to serve the present, make the foreign serve China.

—Mao Zedong

Chinese art was reaching out to the African liberation movement and to the black liberation movement. . . . The posters, along with other things coming out of China at the time, were part of the "vibe." They were ubiquitous. They symbolized the height of revolution.

—Kathleen Cleaver

Just three weeks before the 1963 March on Washington for Jobs and Freedom, in front of an audience of African emissaries, China's leader Mao Zedong declared his support for the black American civil rights movement. "The American Negroes will be victorious in their just struggle," he remarked. "We," Mao said of the world's nonwhite populations, "are in the majority and they," referring to the U.S. power structure, "are in the minority."[1] In the weeks that followed, the Chinese government echoed Mao's proclamation through various activities—holding extravagant demonstrations and rallies, showing films about U.S. racial oppression, staging theater productions celebrating black antiracist and anticolonial activism and self-defense, cabling petitions to the U.S. State Department, and playing activist-artist Paul Robeson's 1941 rendition of *March of the Volunteers (Yiyongjun jinxingqu)*, China's national anthem.

Another practice where these expressions of solidarity were shaped was via *xuanchuan hua,* state-sponsored propaganda posters.[2] Hundreds of these Chinese posters depict different groups of African descent

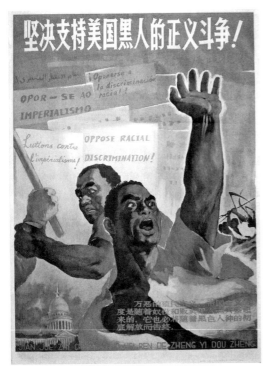

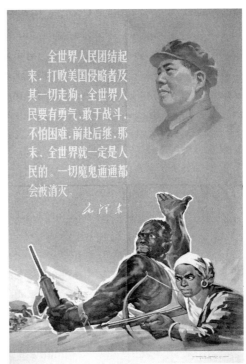

marching alongside other populations in opposition to American and European imperialism; armed with weapons and torches ablaze, storming political institutions and opposing Western military interventions in the Third World (see *Resolutely Support the Just Struggle of Black Americans against Racism!* [*Jianjue zhichi Meiguo heiren fandui zhongzuqishi de zhengyi douzheng!* 1963]; figure 5.1, plate 6); being trained in guerilla warfare tactics and making use of Chinese-supplied artillery and development aid; and working alongside Chinese laborers and doctors in modernizing once-colonized societies. These posters, according to Black Panther Party communications secretary Kathleen Cleaver, were not just symbols of China's internationalist ethos: they were efforts by the nation-state to reach "out to the African liberation movement and to the black liberation movement," to build relations of connection, support, and respect by identifying and cultivating shared meanings, experiences and values. With this and other visual imagery China's leadership explicitly portrayed itself as the torchbearer of the earth's most economically and politically wretched, placing the middle kingdom at the forefront of a worldwide movement against capitalism and Euro-American empire; one can find an example in *Long Live Unity of World People!* (*Quan shijie renmin tuanjie qilai!* [1973]; figure 5.2, plate 7).

These posters were moreover essential instruments of the Chinese government's ideological arsenal, representational mediums through which the Chinese state sowed and cultivated the seeds of its domestic and foreign policies among different publics. In one vein they were a mode of educating and indoctrinating Chinese citizens and foreigners with the growing power of Chinese communism, the leadership and philosophical dogma of China's supreme leader, and the idea of the Chinese revolution as a counterforce to American capitalism and antiracism. In another vein they served as a site to strengthen China's relations with the world, particularly with developing countries and political movements in Africa and racial minorities in the United States. From these multiple narratives, what ultimately took shape was an image of an alternative future of Cold War international relations and cross-cultural traffic—one where Chinese-black and Chinese-African coalitions and self-reliance, as well as the necessity of black liberation worldwide, were at the center. Yet underlying these images of solidarity was a paternalist, and at times, stereotypical and narrow perception of African and black American social movements, and a rigid commitment to ensuring and expanding the coercive power and influence of the Chinese Communist Party (CCP).

In what follows, I examine the politics and aesthetics of several of these posters. My objective is to use them as a guide to explore the unique features of China's outreach to Afro-diasporic political movements from the 1950s to the 1970s and the role that pictorial representations of blackness and Afro-Asian solidarity played in the Chinese government's dual projects of state-building and increasing its geopolitical influence. I argue that creating and distributing representations of black political struggle and Afro-Asian alliance helped the CCP amplify its narratives of a China-led Third World global movement, and was a way for the CCP to discipline Chinese citizens and shore up domestic sentiment and commitment to the CCP's ideology and policies.

I then close this essay by considering artwork by contemporary painter Kehinde Wiley. In a recent series of paintings Wiley appropriates Chinese Cold War political posters as a canvas to stage a different kind of Afro-Asian transnational fusion and connection than that articulated by Mao and the CCP. I contend that what animates Wiley's work and the Chinese state's political posters and propaganda—beyond their project of drawing connections between China and black people elsewhere—are the contradictory and complex features of China's relations with different black publics and Chinese representations and discourses of blackness. It is these complicated, yet problematic and intriguing fea-

tures of both Chinese political posters and Wiley's art to which I now turn my attention.

China's World Revolution

From the onset of the CCP's acquisition of state power and establishment of the autonomous People's Republic of China (PRC) in 1949, the party-state devoted numerous resources toward advancing China's influence and relations with Third World governments, national liberation movements, and socialist parties. China's ability to withstand U.S. forces during the Korean War, its willingness to challenge American hegemony in East Asia during the Formosa Strait Crisis of 1954–55 and 1958, and its efforts to develop a nuclear arsenal were persuasive reminders that China was no mere Soviet pawn but rather a sleeping giant whose power was to be realized, in part, by forging close relations with anticolonial and anti-imperialist movements worldwide.

One of the first sites where China began solidifying these relations was at the Bandung Asian-African Conference of 1955. There, the Chinese delegation encouraged the attendees to "seek common ground" and "peaceful coexistence" with China "rather than emphasize [their] differences." "Let us, the Asian and African countries, be united," Premier Zhou Enlai asserted.[3] In the years that followed, China echoed these claims, most especially after its relations with the Soviet Union dissolved. China would ultimately exploit this divide with the Soviets as means to distinguish and export its brand of communism and to differentiate its model of global power from that of the United States and the Soviet Union. Unlike the Soviets, who privileged class critique over antiracist ideology, Mao and the CCP were more keen on positioning racial discrimination and anti-blackness as central facets of American democracy and empire. Racism, the CCP alleged, was a Western disease that had not taken hold among Chinese people.[4]

Chinese-produced political posters helped circulate and buttress this narrative of China as an ally of antiracist, and moreover, black movements worldwide. Generally inexpensively printed and issued in large quantities for mass consumption, this political iconography was ever-present in most spaces of Chinese life—public and private—and was frequently shipped to foreign territories in bulk. What cannot be downplayed is the domestic influence of these posters. With literacy rates in China at just over 43 percent at the start of 1960s, the posters' utility as pedagogical

instruments and disciplinary apparatuses to define and circulate meaning about communism and being Chinese was unmatched.[5] Straightforward in message and content, the posters transmitted the party-state's ideology in what appeared to be an uncomplicated, easily graspable way. They, furthermore, empowered Chinese publics with an accessible vocabulary and aesthetic means to decode, make sense of, and more rarely, contest the dynamics that were vibrating within Chinese domestic life and geopolitics.

Even prior to the PRC's establishment, the CCP privileged art as a crucial mode of educating Chinese citizens about socialism and galvanizing them behind the party's mission to transform China into a classless society and communist nation-state. In May 1942 at the Yan'an Forum on Literature and Art, Mao outlined what came to be the CCP's general position on the role of art in producing a revolutionary communist culture. There, he rejected the idea of art for art's sake and instead maintained that artists and writers should produce art that empowered society's most marginalized populations. According to Mao, it was this kind of art that could direct the consciousness of the most exploited and underserved sectors of society toward the task of eliminating the inequalities, class divides, and structural divisions that permeated Chinese life. Mao asserted that what China and other countries oppressed by capitalism and Western empire required was a "revolutionary culture" and a "cultural army"—a creative force able "to ensure that literature and art fit well into the whole revolutionary machine as a component part, that they operate as powerful weapons for uniting and educating the people and for attacking and destroying the enemy."[6]

The CCP consequently adopted socialist realism as China's official art style. In contrast to Western styles of art and representation that glorified the lives and culture of aristocratic elites, socialist realism lionized the working masses and revolved around the teleology of communism's advancement. The government's privileging of socialist realism, however, had a severe impact on Chinese art and Chinese artists. Artists were compelled to forgo older traditional styles of Chinese art and more modernist Western approaches for that of socialist realism, a shift that hindered many Chinese artists' talents, creative output, and political views. Pictorial art that did not correspond with the government's mission and standard was subsequently deemed as bourgeois and as obstructing national development, and consequently eradicated, with the government instituting controls on the kinds of works artists could produce.

The political posters depicting black political struggle and interracial solidarity emerged within this cultural climate and out of the aforemen-

tioned government rubrics. Although the posters varied in technique, composition, and color, what unified them was the CCP's iron hand of control. All posters were subject to the party-state's approval; artists could receive severe punishment, imprisonment, or worse for producing posters that did not adhere to the CCP's mandate. The government modified numerous laws, rules, and regulations and gave tax breaks to factories that produced revolutionary art.[7]

Political posters thus were part of the CCP's culture of power. They were a cultural product utilized by the party-state to politicize aesthetics and standardize the discourses and practices these aesthetics might produce among both Chinese and non-Chinese publics. Scholars Harriet Evans and Stephanie Donald explain that posters were "a dominant visual discourse—complementary to, but distinct from, other official discourses" in "educat[ing] the mass public in ideological values defined by the authoritarian party-state."[8] Posters therefore worked to display and help produce new political subjectivities, that is to say "socialist ideal types" that people were encouraged to identify with, emulate, and perceive as models of citizenship, personhood, and political agency.[9] Craig Clunas, scholar and curator of Chinese art, explains that in Chinese political posters, "There is no denying that visual images . . . played an important role in fixing and structuring ideological positions, rather than merely representing what was happening in a chaotic society."[10] Yet, it is also important to note that the political posters also "contain a diversity of aesthetic qualities and symbolic references, indicative of a range of cultural and social relationships." As Evans and Donald point out, these posters "were [therefore] not simply 'propaganda'—but [rather constructed] alternative possibilities . . . [as well as] inconsistencies and tensions."[11]

Friendship, Peace, and Gendered Borders

During the latter half of the 1950s, many of the posters that centered on international themes or depicted images of internationalist and interracial solidarity were framed largely through discourses and aesthetics of peace, unity, and multiracial harmony. These images' representations of international coalition and political struggle usually revolved around three persons of color—one white, one Asian, and one black—standing together, arms linked or over each other's shoulders to signify unity (see for example, *People from All Over the World, Unite and Protect Peace!* [*Quan shijie renmin tuanjie qilai, baowei heping!* March 1959]). Often,

somewhere in the image was a dove, the universal image of peace and love, long life, and pacifism. And if the image did not include a dove, then it included flowers, the latter being made to signify "friendship." The posters' emphasis on "peace" and "friendship" was to some degree an echo of Zhou Enlai's calls for Asian-African "peaceful coexistence" at Bandung. It enabled the CCP to link itself discursively with the 1950s' global anti-war and nuclear disarmament movements, and situate China politically beyond the rigid communist slant often associated with the Soviet Union. This notion of solidarity was also frequently framed through the concept of *youyi* (friendship), a term that over the course of the Cold War was utilized regularly to describe China's relations with foreign governments and political movements, particularly those based in Africa.[12]

Friends from Afar Are Coming to Visit (*You pengzi yuanfang lai* [1961]) is organized around the aforementioned themes, the poster displaying a large multiracial and multinational group who convene inside a Chinese courtyard. In the distance beyond the courtyard, the viewer sees a prairie with an electric tower and smoky factory—signs of China's ability to merge the traditional with the modern, the peasantry with industrialization. With doves flying around them, the group of more than forty persons conveys a gleeful and exuberant disposition—they are portrayed as emblematic of the new subjectivities of global working-class and rural multiracial unity and internationalism being shaped in the Cold War context. Surrounding all of them are plants and flowers—one of the most prominent being the plum blossom (*meihua*), which symbolizes grace, perseverance, beauty, and hope, and denotes friendship; it is one of the three plants (pine and bamboo being the other two) identified in Chinese literature and art as "the three friends in winter" (*sui han san you*), plants/friends that have been able to endure hardship of the cold and whose vitality can help regenerate life.[13]

However, far less subtle is the poster's depiction of gender; the collective showcased in the image is organized into various smaller groups, each of which is organized around primarily gender and age. The middle-aged men are placed together at the center—this group is composed of five men representing different ethnicities and races. Three of these men (the African, Chinese, and European/American) stand with their arms locked, their trio replicating the triad schema of racial internationalism detailed above. Behind this group and to their left and right sides are other groups of people, mainly composed of women, elders, teenagers, and young children, who chat with each other. A woman stands next to the group of men at the poster's center; she looks directly at them and is

engaged with what they are doing and saying, almost as if she is a member of their mini-collective. But the men don't appear to be looking at her or including her in their discussion. Alongside the placement of these men at the image's center and their intercommunication only with each other, the men's obliviousness to the woman suggests that they have a particular authority over the context; the image replicates patriarchy and its institutionalization in political discourse.

Despite the CCP's "Women Hold Up Half the Sky" edict—which held that women's liberation *(funü jiefang)* would only be achieved via a communist revolution and women's equal entry into the public sphere of production, collective toil, and state leadership—numerous 1950s posters framed Chinese and non-Chinese women as disconnected from what were assumed to be the typical actions and activities of men—military warfare, political leadership, arduous industrial labor, et cetera. However, this is not to say that women were excluded from the party-state's narratives of service to the nation and socialist internationalism, and positioned primarily in spaces and identities, such as the household, that have been conventionally gendered as feminine. In contrast, certain posters of this era did focus on women as the agents of political struggle and in these depictions black women played an important role.

Frequently organized around the aforementioned triad schema of racial internationalisms, 1950s era posters employed the terminology of friendship and depictions of female interracial comradeship as means to portray anticapitalist solidarity. *The Flower of Friendship Is Blooming Everywhere* (*Youyi hua kai bian tianxia* [1950]) and *The Friendship Flower Blooms Everywhere* (*Youyi huaduo chuchu kai* [September 1957]) are examples. In these posters the women and their surroundings symbolize interracial and international coalition, pacifism, tranquility, and the possibility of reshaping the global inequality through nonviolent means. However, embedded in these images' depictions of internationalism and racial solidarity were CCP policies and strategies aimed at controlling and regulating women's roles within Chinese society. For instance, all three women in these posters wear dresses, what can be considered modern feminine apparel, which contrasts with the rather desexualized industrial work clothing the CCP and Asian communist governments encouraged women to wear. Male bodies, on the other hand, by the late 1950s and onward were usually portrayed in posters as donning industrial overalls, clothing associated with labor-unions and working class struggle, or wearing clothing associated with the specific Third World country from which they were supposed to be from. The representations of women,

scholar Harriet Evans points out, were part of the party-state's "'prettification' campaign of the mid-1950s, which attempted to encourage women back into 'the home' by appealing to their interests in fashion and bodily appearance." Evans elaborates: "Drawing attention to women's bodily and sartorial features as the posters did was a symbolic means of perpetuating the impossibility of women's access to the serious world directed by male revolutionaries."[14]

Posters from the 1960s offer a vastly different portrayal regarding women's contributions to a China-led global anticapitalist and antiracist movement. The representation of international class struggle and racial solidarity through metaphors of peaceful, nonviolent multiracial harmony was replaced with images of armed self-defense and radical antiracist political revolution. This was a product of various factors: the growing escalation of the Vietnam-American war, and elsewhere the inauguration of national liberation struggles and revolutionary communist parties; China's development of its first nuclear weapon; and China's efforts to distance itself discursively from the Soviet Union's representations of international working-class solidarity. In these new images of global revolution, the Third World was portrayed as a growing revolutionary force, composed of both men and women, who through insurrection, revolt, and guerrilla warfare were on the verge of defeating capitalism and white supremacy. One should keep in mind that these posters' depiction of female revolutionary agency were not the exception in the 1960s, but rather a feature of a good portion of the CCP propaganda produced during this time period, images of women that broke with previous period's gender stereotypes.

Whereas the earlier era's portrayal of women's subjectivity was far more hegemonic and revolved around a standardized representation displaying different kinds of women involved in nonviolent activities, numerous posters of the 1960s were organized around specific references to black women, particularly African women. Wu Min's *U.S. Imperialism Get Out of Africa!* (*Mei diguo zhuyi cong feizhou gun chuqu!* [1964]; figure 5.3, plate 8) and *Oppressed Peoples, Unite to Resolutely Fight against U.S. Imperialism* (*Bei yapo minzu lianhe qilai jianjue fandui mei diguozhuyi* [1964]; figure 5.4, plate 9) are examples. The posters display black women armed and prepared for guerrilla warfare, and carrying children on their backs. The women in these images are, moreover, portrayed as the backbone of the political struggles and liberation movements that are weakening American and European empire.

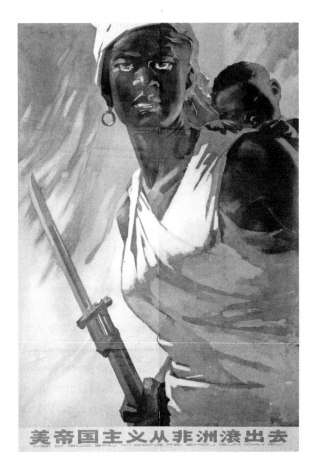

5.3.

U.S. Imperialism Get Out of Africa! (Mei diguo zhuyi cong feizhou gun chuqu!), poster, 1964. Courtesy of the collection of Pierre-Loïc Lavigne.

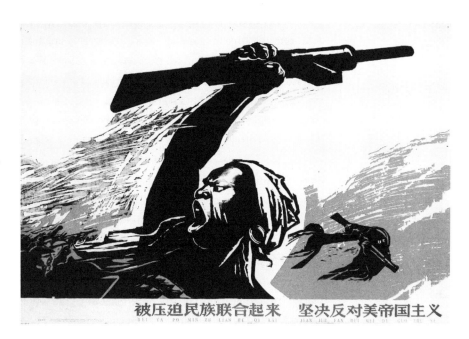

5.4.

Oppressed Peoples, Unite to Resolutely Fight against U.S. Imperialism (Bei yapo minzu lianhe qilai jianjue fandui mei diguozhuyi), poster, 1964. Courtesy of the collection of Pierre-Loïc Lavigne.

Maoism and the Unevenness of Afro-Asian Friendship

Along similar lines as the above posters, other 1960s-era posters had a more explicit tone of armed self-defense and violence. But also more vibrant was their communist undertone. For instance, in many of these images the people displayed were positioned facing or charging in a left-ward direction. Moreover, the multiracial groups portrayed in many of these posters were frequently shown clasping copies of *Quotations from Chairman Mao Zedong* (*Mao zhuxi yulu* [1964]), what came to be known globally as "the little red book," the book held in their left hand, over their heart. Underlying these images of international solidarity was lionization of Mao and his communist model: the political posters were one facet of many deployed to create an international cult of personality around Mao.

A poster issued in conjunction with Mao's 1963 statement commemorating the U.S. black freedom struggle displays the faces of a multiracial group who charge ahead, the collective heading towards some prospective site unavailable to the viewer's eye (figure 5.5, plate 10). At the group's center is a black man. While the collective's other members are colored uniformly in golden hue, this man is depicted with more dynamic and vibrant colorization. His skin is brown, his shirt is darkish grey, his wide neck bulges with muscle (denoting strength and the urgency of the collective's cause), and his hands grasp a red flag, the flag's edges flowing above the man's right shoulder. To the man's left is a black woman, the lone female in the image, her chin partially covered by the flowing red flag.

Ultimately, this image suggests a discursive link between black struggle, world revolution, and Mao's political thought. For example, the multiracial group signifies the Third World and the red flag is emblematic of the international left. Also evident is the poster's masculine portrayal of internationalism; even with its inclusion of a radical woman, the poster's depiction of cross-cultural multiracial coalition is still organized primarily around male bodies and signifiers of the global proletariat as uniformly male. But underlying these visual references to race and multiracial Third World coalition is a centering of Mao's communist ideology and visions of world revolution. The image's caption, *Resolutely Support the Just Struggle of Black Americans against Racism!* (*Jianjue zhichi Meiguo heirende zhengyi douzheng!* [1963]), for instance, is taken from Mao's 1963 statement in support of civil rights. Furthermore, the poster visually positions black struggle and global anti-imperialist struggle within the CCP's Third World Marxist ideology, specifically within Mao's theory of world revolution *(shijie geming),* where he privileged "the countryside" as the seedbed

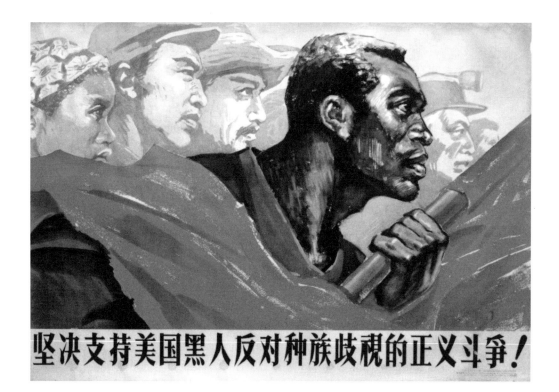

坚决支持美国黑人反对种族歧视的正义斗争！

5.5.

Resolutely Support the Just Struggle of Black Americans against Racism! (Jianjue zhichi Meiguo heiren fandui zhongzuqishi de zhengyi douzheng!), poster, 1963. Courtesy of the collection of Pierre-Loïc Lavigne.

of anticapitalist systematic change. For Mao and other Chinese officials, the category of "the countryside" represented both Chinese peasants, who were identified as principal agents of change in China, and the larger Third World, a force that Mao argued would inevitably crush the city-like dominance of Euro-American capitalism and imperialism.[15] Situating the black man and woman alongside what look like working-class and rural populations from other parts of the globe, the poster thus portrays black Americans as members of this subversive global force.

These themes were at the center of China's political posters concerning African anti-imperialist liberation movements and development projects cultivated by newly independent African governments. From 1961 to 1971, China extended aid to sixteen African countries, efforts that helped produce vast African support for China's admission as one of the five permanent members of the UN Security Council in 1971. Although Chinese aid to Africa never matched the levels supplied by the United States and the Soviet Union during the Cold War, China went to extensive lengths to increase its political ties to Africa. The PRC trained insurgent groups, liberation armies, and dissident-led rebellion forces and offered many countries unconditional, interest-free loans with easy repayment schedules and top-quality equipment and experts for infrastructure development.

One of the most revered of these aid projects to Africa was the Tanzania Zambia Railway Authority (TAZARA, or Tanzam Railway). China's agreement to finance and construct the 1,160-mile railroad project, which connected Zambia's copper belt to Tanzania's ports, was China's flagship project in the continent. Running from Dar es Salaam to Kapiri Mposhi, and constructed by tens of thousands of Chinese and African workers, the railway began construction in 1970 and was completed in 1975, two years ahead of schedule.[16] Through discourse and imagery, the CCP positioned the railway as a transnational Afro-Asian project and symbol of Third World solidarity and resistance. The railway, they argued, would untangle Zambia from its dependency on earlier established transportation systems to the south, routes dominated primarily by Rhodesia and South Africa, and open up the region to new investment and trade.

The poster *Serve the Revolutionary People of the World* (*Wei shijie geming renmin fuwu* [1971]), for instance, displays a Chinese worker laying a wooden beam that will ultimately become part of the TAZARA railway. In the distance behind the worker, one sees Chinese and African laborers and technicians who together plot out the railway's construction. Referencing Mao's widely celebrated speech "Serve the People" (*Wei renmin fuwu*, 1944), the juxtaposition of the poster's caption and the depiction of an upright, determined Chinese worker in Africa suggest that nothing can outweigh collective and consistent action and sacrifice over time, most especially when done for the sake of populations struggling for humanity and equality. In this image "the people" denote the union of China and Africa against both Soviet and American geopolitical power and economic influence. Furthermore, the placement of rail lines throughout the plush African countryside signifies the role that Chinese technical aid and manpower can play in modernizing Third World countries and providing Third World populations with the technical know-how to become economically independent and self-reliant.

Other CCP posters replicate this portrayal of China as an ally and mentor to Africa and a conduit for African economic and technological development. *Revolutionary Friendship Is As Deep As the Ocean* (*Geming youyi shen ru hai* [1975]; figure 5.6, plate 11) employs the image of a group of Africans taking a picture with two Chinese workers in front of a Chinese-produced red tractor to articulate the value of Chinese aid to Africa; in the background one sees another group of people of color being given a tour of this tractor lot by a Chinese guide. Behind the first group of African visitors, on the left side of the poster, is a slogan that reads "Self-Reliance" (*zili gengsheng*), a term frequently employed by the Chi-

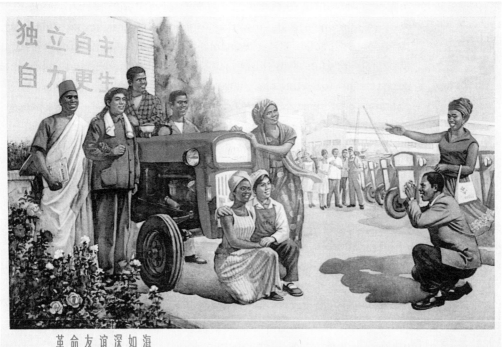

独立自主
自力更生

革命友谊深如海

5.6.

*Revolutionary
Friendship Is As
Deep As the Ocean
(Geming youyi
shen ru hai)*, poster,
1975. BG E15/581,
Stefan Landsberger
Collection,
International
Institute of
Social History,
Amsterdam.

nese state to distinguish its model of support to the developing world
and from what China ruled as the imperialist model of dependency and
neocolonialism instituted by the United States and its allies on developing
countries.[17] *The Feelings of Friendship between the Peoples of China and
Africa Are Deep (Changzhoushi gongnongbing meishu chuangzuo xuexi-
ban gonggao* [1972]) and *Seas and Oceans Are Not Separated, the Silver
Needle Passes on Friendship (Chongyang wu zuge yinzhen chuan youyi*
[1971]), on the other hand, position China's "barefoot doctors"—a common
term for medical personnel who worked outside cities and who brought
medical care and health services to Chinese peasants, and later to rural
populations in African countries—as individual examples of China's sup-
port for African development. Framed ubiquitously as a Chinese female
doctor, the "barefoot doctor" was made to symbolize the value of China's
efforts to aid Africa at the grassroots level. Through these images, China
was portrayed as doing more than just bringing edifices and instruments
of modernization and development to Africa; China, it was argued, was,
more importantly, helping to sustain African lives and promote healthy
living on the continent.

These images were not void of contradiction. *The Feelings of Friend-
ship between the Peoples of China and Africa Are Deep (Zhong, Fei ren-*

min qingyi shen [1972]) portrays an African woman with her baby and two doctors, one Chinese and the other African. While the mother and child represent, respectively, the continent and the need for patriotic defense of the continent's future, the juxtaposition of the black and Chinese doctors suggests that to nurture and sustain the continent's health requires international partnerships. By training Africans in medical care and extending health-care assistance to African peoples, Chinese aid, the poster relayed, was helping to safeguard the lifeblood of Africa.

Yet what is also signified is China's paternalist outlook toward African development and modernization. The Chinese government was comfortable portraying itself as an ally, supporter, and defender of African sovereignty. On the other hand, China rarely, if ever, inversely depicted African nations in similar terms—that is, as defenders of China and as populations with something important to offer China regarding knowledge production, cultural exchange, and geopolitical strategizing. This narrative of Africans as under Chinese tutelage and China as transporting Africa toward modernity has been prominent since the 1970s, with China frequently depicted as a "shepherd of a flock of African parties."[18]

The "Chairman Mao" pin/badges that the barefoot doctors wear in the aforementioned posters underscore this identification of the barefoot doctors with Chinese technology, Chinese aid, and Mao Zedong as heroic saviors of the Third World. The poster *Chairman Mao Is the Great Liberator of the World's Revolutionary People* (*Mao zhuxi shi shijie geming renminde da jiuxing* [1968]), for example, revolves around an indirect reference to Mao. While the image's caption refers to Mao by name, nowhere can Mao's face be found within the image except in miniscule form on the cover of the book the African guerrilla soldiers read. But this is the point. In the soldiers' hands is a copy of one of Mao's works of essays. Through this device, the African soldiers are displaced as the subjects of the poster's narrative, and at the center of the poster is the power of Mao's ideas and his leadership of a world revolution.

A similar aesthetic takes shape in another poster; however, this poster is far more explicit in its projection of Mao's relationship to Africa. Just as all of the men in the previous image converge around Mao's writing, the poster *Savior* (*Qiuxing* [April 1968]) displays an African family and a Chinese barefoot doctor who collectively stand beneath a poster of Mao. Mao's clothing and portrait are embroidered in red, a symbolic border that symbolizes both his radical communist praxis and the coming transformation of the world brought by communist struggle. The arm of one of the family members, a toddler, stretches out to touch Mao's face. The

image of Mao seems just within the child's grasp, which conveys a short-ened distance and potential connectivity between Mao and the group of people. Yet, simultaneously, through scale and color Mao is positioned as larger than life; he is framed as being bestowed with power and influ-ence superior to those of the group that admires his image. For one thing, Mao's face is convincingly bigger than everyone else's, and while the group looks directly at him, he looks directly to the left side of the poster, as if he is privileged with seeing some future unobservable to the African family positioned below him.

This depiction of Mao is a reminder of the unequal power relations and biased cultural narrative and discourse of Chinese-African relations that China circulated throughout the Cold War—that is to say the nar-rative of China as stewards for Third World anticapitalist upheaval and Africa as the quiet beneficiary awaiting China's superintendence. And unfortunately the shelf life of this narrative has outlasted the Cold War. Downplayed is the fact that it has actually been Africa that has "serviced" China over the past forty years, particularly with access to raw materials, minerals, and markets to dump surplus Chinese products and surplus Chinese labor, most of which works to the detriment of African products and the development of human capital and skills in Africa.

The World Stage: China

By the mid-1970s, the Chinese government's alliances with various repres-sive governments and political regimes (the Nixon administration in the United States, Muammar al-Gaddafi in Libya, the shah of Iran, Moham-mad Reza Pahlavi, the Pol Pot–led Khmer Rouge in Cambodia, Mobutu Sese Seko in Zaire, and the apartheid regime of South Africa) and China's reluctance to support leftist struggles and national liberation movements in Ceylon (Sri Lanka), Chile, Puerto Rico, Oman, Palestine, Bangladesh, Portugal, and Angola exposed the CCP's rightward political shift toward global capitalism and détente with U.S. hegemony. With this shift in policy also came the demise of China's outreach and support for Afro-diasporic political movements and causes.

Although the CCP continued to produce and circulate Chinese political posters over the course of later decades, the iconography's significance as emblems of global revolution waned. Yet, in recent decades many of these past images have been recycled with new uses and meanings, most centrally in sites and conversations far detached from Mao and the CCP's

initial intentions. Today they are circulated as profitable commodities, memorabilia, objects of academic study and popular consumption, and kitsch reminders of the romantic ideals, disastrous policies, and atrocities of a political leader and society that current government and sectors of society assert is no more.

An interesting example is American painter Kehinde Wiley's 2007 exhibition, *The World Stage: China*, a series of paintings that the artist produced after being invited to open a studio in Beijing.[19] *The World Stage: China* remixes Cultural Revolution political posters and propaganda. Various black American subjects and commentary replace the figures and content portrayed in the original posters; in addition, their bodies are backdropped by imperial-era Chinese textile patterns. Wiley maintained that the works were stimulated by his interest in the connections between the historical representations of black male identity within American culture and that of Chinese nationality in Cold War China. He found in the original Chinese posters "a correlation between the ways in which African American identity has and continues to be manufactured and manipulated by both the media and society, and how Chinese national identity was distorted during the Maoist era."[20] The invented realities and narrow and stereotypical group identities instituted by American media and culture and Chinese political posters were, therefore, a productive starting point to offer an alternative, albeit one that was aimed at being neither corrective nor uplifting.

In a similar vein as the Chinese political posters examined throughout this essay, Wiley visually stages a romantic image of blackness and Afro-Asian connection, fusion, and cross-cultural flow. By shifting the context of black American men's representation to that of China, and the content of Chinese Cold War propaganda to that of depictions of current-day black men, he visually portrays (and moreover demonstrates through his own brand of entrepreneurialism, intellectualism, celebrity, travel, and multimedia cultural production) a cosmopolitan and diasporic subjectivity and sensibility that is centered around the ongoing flow and compression of culture, ideas, and physical bodies. One can therefore liken Wiley and *The World Stage: China* artworks to cultural anthropologist Arjun Appadurai's theorizations about the new relationships to history, place, national identity, and difference through which populations in diverse settings currently bend culture to their own versions of identity, community, and the world. *The World Stage: China* thus serves as a stage, of sorts, for Wiley's ongoing project of artfully reimagining and representing a mobile black male subject and cosmopolitan subjectivity that moves in and out of dif-

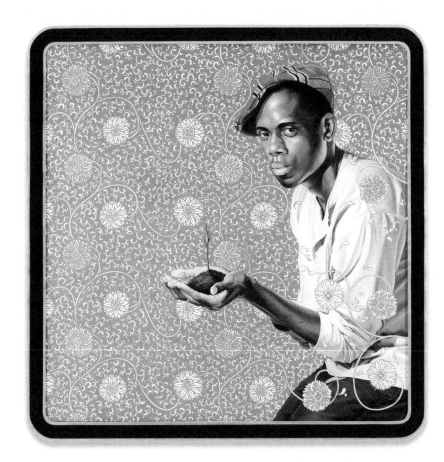

5.7.
Kehinde Wiley,
Encourage
Good Manners
and Politeness;
Bright Up Your
Surroundings
with Plants, oil
on canvas,
60" x 60", 2007.

ferent contexts of history, geography, culture, and art and who expresses alternate pathways of citizenship, identity, movement, representation, and power.

Take, for instance, the painting *Encourage Good Manners and Politeness; Bright Up Your Surroundings with Plants* (figure 5.7, plate 12). Inspired by a 1982 poster with the same title *(Wenming limao luhua meihua)*, Wiley replaces the Chinese woman featured in the original image with a young black man; the latter's posture, pursed-lips, and tranquil gaze, as well as the plant he balances in his palms, mirror that of the Chinese woman depicted in the original image. In so doing, the black male subject conveys a similar grace, angular beauty, and calm seriousness as the Chinese woman. Wiley's painting, therefore, brings into light, and more importantly, challenges and alters the stereotypical depiction of black men as hypersexual and overly aggressive.

The title of Wiley's painting, moreover, not only refers to the original Chinese political poster from which the artwork is based, but also to the 1998 policy instituted by then-Chinese President Jiang Zemin that

attempted to rhetorically distance the Chinese government from the atrocities and social incivility of Cultural Revolution-era China. This ingenious layering of multiple signifiers in the painting—most centrally, imagery from Maoist-era China with that of political rhetoric from post-Mao-era China—enables Wiley to subtly gesture the viewer toward considering the melding of capitalist consumerism and state ideology/rhetoric of socialism in current-day China. Via Wiley's play with Chinese political posters, what is illuminated is the decreasing political utility of such explicit representations of socialism by the Chinese party-state, yet the expansive and untapped popular uses and value of such cultural relics amid China's increasing stature within global capitalism.

According to writer Paul D. Miller, aka DJ Spooky, Wiley's representations of Afro-Asian cultural flow, decontextualization, and compression provide viewers with "a new kind of literacy that pushes how we read a painting to the edge Wiley's painting takes place *beyond the edge*."[21] Influenced by this thinking I presume that the edge of *The World Stage: China* series denotes more than just China's contradictory collusion with global capitalism and Western culture and media's reductive representations of black Americans. For me, Wiley's China series calls to mind the state-sanctioned representations of black liberation and racial solidarity that animated Chinese political posters of past eras, as well as the current-day inequalities and repression experienced by different black publics in China. Like the Chinese-produced political iconography of blackness that precedes it, Wiley's repurposing of Maoist posters demonstrates how blackness is taken up in service of social and political ends in current-day China; we are subtly made privy to how China's representations of and relations with different communities of African descent continue to sit in an uneasy tension, in which certain black subjectivities are privileged over others. From this standpoint, *The World Stage: China* may also be a signpost to the different discourses and representations of black subjectivities and bodies that are present within contemporary Chinese popular culture, business, trade, and everyday life.

Over the last two decades, China has witnessed a gradual, but nonetheless significant, growth of several black public spheres composed primarily of African American, Afro-European, and African technical, financial, educational, athletic, and creative labor; African foreign exchange students; and African immigrant traders and business persons working in the import-export economy. All of these groups have described experiencing racial discrimination. Yet it is the African immigrant communities residing in southern cities like Guangzhou and Shenzhen who

have received the harshest treatment. They are frequently targeted as drug dealers, criminals, "illegal" immigrants and undocumented workers, unappreciative recipients and exploiters of Chinese aid, and as diseased carriers of syphilis and HIV/AIDS who are "polluting" the "pure" blood of Chinese people. Moreover, many of them find their lives circumscribed and repressed by visa authority officers, media portrayals, unfair labor practices, police raids, and the growing social and economic class divides brought forth by the power of transnational capitalistic forces in China. In response to this repression, there have been mass public eruptions by many of these Africans, the most prominent examples in Guangzhou in 2009, 2012, and 2013. Simultaneously, the growing class of black American and Afro-European professionals in China is periodically depicted in Chinese media and government discourse as examples of the success that can be found within Chinese cultural and economic life. In such portrayals, China is portrayed as a new space of "possibility" for foreign actors of different racial and ethnic backgrounds, which works in service of promoting an image of China as a postcommunist state that is culturally inclusive, cosmopolitan, and postracial.

Thus, beyond the simple aesthetic similarities between Wiley's *The World Stage: China* series and Maoist posters of past times, what also connects this imagery are the complex black subjectivities, realities, and geopolitical investments that underscore China's relations with different black publics over the last sixty years. Like the Chinese political posters that he appropriates and repurposes, Wiley's art indirectly calls attention to the economic and social contradictions and disadvantages, as well as the dreams and racial projects of connection that have encompassed China's past and ongoing relations with different groups of African descent. Nearly forty years after his death, Mao's proposal that China "use the past to serve the present, make the foreign serve China" continues to reverberate with extraordinary force.

Notes

Epigraphs: see Tina Mai Chen, "Use the Past to Serve the Present: The Foreign to Serve China," in *Words and Their Stories: Essays on the Language of the Chinese Revolution*, ed. Ban Wang, 205–26 (Boston: Brill, 2011), 208; Lincoln Cushing, "Kathleen Cleaver Interview by Lincoln Cushing, August 2006," in Lincoln Cushing and Ann Tompkins, *Chinese Posters: Art from the Great Proletarian Cultural Revolution* (San Francisco: Chronicle Books, 2007), 19.

1 Mao Zedong, *Statement Supporting the Afro-American People in Their Just Struggle against Racial Discrimination by U.S. Imperialism, August 8, 1963* (Peking: Foreign Languages Press, 1963).

2 On *xuanchuan hua*, see Julia Frances Andrews, *Painters and Politics in the People's Republic of China, 1949–1979* (Berkeley: University of California Press, 1994); Melissa Chiu, *Art and China's Revolution* (New Haven: Yale, 2008); Cushing and Tompkins, *Chinese Posters*; Harriet Evans and Stephanie Donald, *Picturing Power in the People's Republic of China: Posters of the Cultural Revolution* (Lanham: Rowman and Littlefield, 1999); Stefan Landsberger, *Chinese Propaganda Posters: From Revolution to Modernization* (Amsterdam: Pepin Press, 1995); and Stefan Landsberger, *Chinese Posters* (Munich and New York: Prestel, 2009).

3 "Speech by Premier Chou En-Lai to the Political Committee of the Asian-African Conference, April 23, 1955," *New York Times*, April 25, 1955.

4 The CCP's contention that the Chinese did not hold racist antiblack outlooks contrasts with the history of Chinese ideologies and constructions of race and negative perceptions of blackness. For more information on this, see Don J. Wyatt, *The Blacks of Premodern China* (Philadelphia: University of Pennsylvania Press, 2009); Frank Dikötter, ed., *The Construction of Racial Identities in China and Japan* (Honolulu: University of Hawaii Press, 1997); Frank Dikötter, *The Discourse of Race in China* (Stanford, CA: Stanford University Press, 1992).

5 See Cushing, *Chinese Posters*, 10.

6 Mao Zedong, *Talks at the Yan'an Forum on Literature and Art, May 1942* (Ann Arbor: Center for Chinese Studies, University of Michigan, 1980). Also see Mao, "On New Democracy (January 1940)," *Quotations from Chairman Mao* (Peking: Foreign Language Press, 1966), 199.

7 Harriet Evans and Stephanie Donald, "Introducing Posters of China's Cultural Revolution," in *Picturing Power in the People's Republic of China: Posters of the Cultural Revolution*, eds. Harriet Evans and Stephanie Donald (Lanham: Rowman and Littlefield, 1999), 4.

8 Evans and Donald, "Introducing Posters," 2, 4.

9 Harriet Evans, "Comrade Sisters," in *Picturing Power in the People's Republic of China: Posters of the Cultural Revolution*, eds. Harriet Evans and Stephanie Donald (Lanham: Rowman and Littlefield, 1999), 65.

10 Craig Clunas, *Art in China*, 2nd ed. (Oxford: Oxford University Press, 2009), 219.

11 Stephanie Donald and Harriet Evans, "Afterword," in *Picturing Power in the People's Republic of China: Posters of the Cultural Revolution*, eds. Harriet Evans and Stephanie Donald (Lanham: Rowman and Littlefield, 1999), 140.

12 For more on the role of "friendship" discourse within Sino-African relations, see Jamie Monson, *Africa's Freedom Railway: How a Chinese Development Project Changed Lives and Livelihoods in Tanzania* (Bloomington: Indiana University Press, 2009), 26–29; Philip Snow, *The Star Raft: China's Encounter with Africa* (New York: Weidenfels and Nicolson, 1988), 166.

13 See Hong Jiang, "The Plum Blossom," *Epoch Times*, February 28, 2012, 22; Hung-yok Ip, *Intellectuals in Revolutionary China, 1921–1949: Leaders, Heroes and Sophisticates* (London: Routledge, 2005), 103, 110.

14 Evans, "Comrade Sisters," 73–74.

15 Mao's privileging of the countryside was also echoed in Chinese military commander Lin Biao's concept of a "people's war" *(renmin zhanzheng)*; see Lin Biao, *Long Live the Victory of the People's War* (Peking: Foreign Languages Press, 1965), 24.

16　On the TAZARA railway, see Elizabeth Hsu, "Zanzibar and Its Chinese Communities," *Population, Space and Place* 13, no. 2 (2007): 113–24; Monson, *Africa's Freedom Railway*; and David Hamilton Shinn, *China and Africa: A Century of Engagement* (Philadelphia: University of Pennsylvania Press, 2012).

17　Melissa Fay Lefkowitz makes a similar point about this poster. She, moreover, situates China's articulation of helping to cultivate African "self-reliance" within China's Cultural Revolution-era domestic policy that "obligated workers to self-sufficiently produce grain." She asserts that consequently the "double-layered meaning of 'self-reliance' represents a transnational relationship between the Africans and the Chinese workers along policy lines." Lefkowitz later draws connections between the poster's representation of a diverse cast of Africans (the group members are dressed in different kinds of garb—Muslim, traditional, and Western dress) and China's rhetoric about and portrayals of China's fifty-five ethnic minorities *(shaoshu minzu)*. She maintains that the poster's depiction of African diversity perpetuated the discourse of China's domestic brand of multiculturalism, a discourse that worked simultaneously to legitimize Chinese ethnic minorities as part of the nation while simultaneously emphasizing their difference from China's Han majority. See Melissa Fay Lefkowitz, "Revolutionary Friendship: The Image of the African from Mao to Now (1955–2012)," M.A. thesis, Harvard University, May 2012, 14–17.

18　Shinn, *China and Africa*, 64.

19　For more on Wiley, see Kehinde Wiley, *Kehinde Wiley* (New York: Rizzoli, 2012).

20　Quoted from Kehinde Wiley's website, http://kehindewiley.com/works/the-world-stage-china, accessed April 8, 2015.

21　Paul D. Miller, "Painting by Numbers: Kehinde Wiley's New World Portraiture," in *Kehinde Wiley: The World Stage-China*, ed. Kehinde Wiley (Sheboygan, WI, Los Angeles, New York, and Chicago: The John Michael Kohler Arts Center, Roberts and Tilton, Deitch Projects, and Rhona Hoffman Gallery, 2007); my italics.

Part 2

Dreaming
Diasporas

6

The Glamorous One-Two Punch

Visualizing Celebrity, Masculinity, and Boxer Alfonso
Teofilo Brown in Early Twentieth-Century Paris

LYNEISE WILLIAMS

In less than two minutes, Alfonso Teofilo Brown knocked out Roger
Fabrègues in their December 1, 1926, bout in Paris. It was the phe-
notypically black Panamanian boxer's second fight in Europe since
Brown's arrival in mid-October 1926. Boxing fans at the Salle Wagram
were eager to see the unusually slender, 5-foot, 10-inch, 118-pound fighter
after his European début on November 11 had resulted in a decisive third-
round knockout of French flyweight Antoine Merlo. "In the atmosphere of
a gala," exclaimed sportswriter R. E. Bré, with "elegantly dressed women
and formally attired men in smoking jackets," there was "a knockout in
the air!"[1] By the time Brown—born in Colón, Panama, and arriving in Paris
after three years in New York City honing his boxing skills—became World
Bantamweight Champion in June 1929, a title he held for nearly a decade,
he had been prominently featured in the popular French sports weekly
Match L'Intran. In fact, Brown had been in Paris a mere four months
when he graced the cover of the innovative magazine, an offshoot of
L'Intransigeant, a conservative evening newspaper with four hundred
thousand subscribers.[2] Brown's immediate embrace by Parisian audi-
ences was complicated by their attraction to him in large part because
they perceived him to be the "embodiment of primal black physicality . . .
the polar opposite of the effete intellectuality of white civilization," which
they ascribed to black boxers generally.[3]

In what follows I focus on two images of Brown: a photomechanical
reproduction that appeared in *Match L'Intran* in 1926 and a sketch that
appeared in *L'Intransigeant* in 1927. Significantly, examining the photo
from *Match L'Intran* generates new ways of working within the prevailing
assumptions that blacks were exotic and less than human. The maga-

zine breaks with established visual conventions of cartoonish, monstrous, threatening, athletic powerhouses used in depictions of African American and African boxers. Instead, for Brown, the magazine employs visual strategies of glamour and uses a reproduction process associated with images of aesthetic value to portray him as a personality and a celebrity of desirable manliness—albeit an inhuman figure, even if he is exalted.[4] Indeed, we see here an important shift in the imaging of black male bodies in mass production, where codes of beauty are inextricably linked to inhumanity. In the same moment that Parisians caricatured and denigrated their African colonial subjects, they portrayed Brown as an attractive celebrity, implying a supposedly race-neutral stance.[5]

Match L'Intran represented the boxer as a modern surface comprising rich tonalities that increased the aesthetic possibilities of phenotypically black skin—albeit in a complicated way. In thinking about Brown's skin as surface, I take my cue from Anne Anlin Cheng's contention that skin is "a remarkably layered construct."[6] *Match L'Intran*'s staff photographers represented Brown as a fluid veneer, manipulated and adjusted through a variety of visual languages and technologies for consumption by his fans. They pushed the technology not only to recognize the tonality of phenotypically black skin but to endow it with an aesthetic value previously reserved for white celebrities. The tropes of glamour photography situated Brown as a figure to be idolized, admired, and desired. The use of rotogravure, a cutting-edge photomechanical printing process that rendered photography's broad range of tones on inexpensive paper in bulk quantities, enabled the photographer's work to be translated into mass-produced images of high optical fidelity, and moreover, made it possible for Brown to be visualized as a modern surface. *Match L'Intran* represented Brown and his idiosyncratic appearance, gestures, and movements as a new form of the male body, male glamour, and male sexuality.

Match L'Intran's images of Brown were critical to his status as a celebrated sports figure. Out of nine of the magazine's covers featuring phenotypically black men, Brown appeared four times—more than any other person of color during its eleven years of publication.[7] *Match L'Intran* was the most popular sports weekly in France during this time. Its large format (eleven by seventeen and a half inches, oriented vertically) distinguished it from its chief competitor, *Le Miroir des Sports*. The portion of the cover devoted to images (twelve by ten and a half inches) was nearly the same as the overall size of *Le Miroir des Sports*.[8] The sports weekly primarily featured European men and women. The few black figures to be pictured, all of whom were male, appeared for the most part in its boxing section.

Photography and the Visualizing of Personality

Brown's depiction is all the more remarkable in light of photography's tacit biases. Richard Dyer has observed that photographic media "assume, privilege and construct whiteness. The apparatus was developed with white people in mind . . . photographing non-white people is typically construed as a problem."[9] Using carefully registered lighting effects and detailed retouching, *Match L'Intran* illuminated Brown's phenotypically black skin, and added strategic highlights that resculpted his physiognomy. Avoiding an extreme, overall bleaching of black skin, the magazine preferred an extensive range of tones that excluded any deep grays that approached inky black. For Brown, the lightest tones used in his early images in the magazine approximated those of phenotypically white skin.[10]

On the cover of *Match L'Intran*'s February 1, 1927 issue, tight close-ups featuring the heads of Brown and French boxer Edouard Mascart fill the space of the image, emphasizing their faces rather than the arms and legs that activate boxing (figure 6.1). Brown's lively eyes are open and engaging. Flecks of white, generated by the reflections of the photographer's lights, activate the dark color, and draw the viewer's eyes in his direction. His mouth, which bears signs of retouching, is open and inviting.

This image of Brown and Mascart, defined by faces, is situated in conversation with portrait publicity and glamour photography related to the cinema then ascendant in the United States. These genres emerged between 1910 and 1913 simultaneously with the motion-picture fan magazine.[11] By the 1920s film-star portrait photography, informed by photographs produced for Broadway, featured lively representations of character and personality using innovative and imaginative lighting techniques that expressed emotion and personality within a frame that was at once glamorous and minimalist.[12] Characterizing this style, which was epitomized by influential still photographer Jack Freulich, as "effective glamour minimalism," David S. Shields has observed that "the images—busts most of the time—presented faces, a clothed upper body, a wall, or aurora of light The artistic photographer could manage the studio rapport that enables a personality to bloom on a face."[13]

Portrait publicity shots, note Robert Dance and Bruce Robertson, were the "life blood" of fan magazines in the 1920s.[14] Technical innovations in lighting and cameras, as well as a desire to register personalities, made portrait publicity shots "the single most important vehicle for promotion and establishment of cinema personalities."[15] The radiance of the soft-

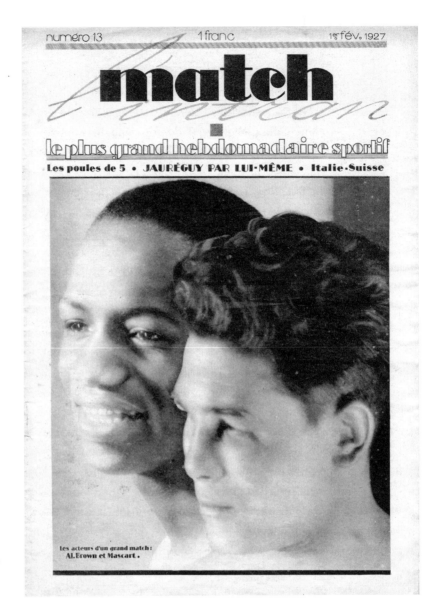

6.1.
Alfonso Brown
and his opponent,
Edouard Mascart,
after Brown's
victory. Cover
photograph, *Match
L'Intran*, no. 13,
February 1, 1927.

focus effect, firmly in place by 1915, communicated ideas about glamour emanating from bodies.[16]

U.S. and French films and their overlapping visual cultures were part of the larger context of *Match L'Intran.* The sports weekly and its parent newspaper, *L'Intransigeant*, shared headquarters on 100 rue Réaumur with a five-hundred-seat movie theater, Les Miracles.[17] Indeed, the general editor of both newspapers, the film aficionado Leon Bailby, published a weekly film supplement entitled *Pour Vous L'Intran* out of the same offices beginning in 1928.[18] *Match L'Intran* integrated images of celebrities from both Hollywood and French cinema into its reporting. Photographs of

popular U.S. and Parisian film stars had appeared in the pages of the sports weekly since its beginnings in 1926.[19]

To return to the image: most of Brown's face is enveloped in a shimmering pool of light, one of the ways that this image defies or at least elides the usual racial categorizations of the era's mass-market publications. Through lighting and retouching, his complexion largely matches Mascart's. The radiance emanating from his face's right side nearly washes out all the contours of his nose and mouth. Brilliant light, dissolving the bridge of his nose, pools across the right side of his face. Brown's lips would fade away if not for the touch-up lines. Using careful staging, brilliant illumination, strategic cropping, and retouching, the sports weekly transformed Brown: *not* into a human being but into a magnetic celebrity and personality who transcends humanity. While this may seem like a compliment, it isn't: in a setting where black male bodies were viewed and depicted as inhuman, *Match L'Intran* misses the mark of endowing blacks with the same humanity it granted to nonblacks.

The sheer fact that *Match L'Intran*, a mass-circulated publication, imagined Brown in the visual language of glamour, however, *is* revolutionary. To do so required that they set aside the perspective that phenotypically black skin could only support the notion of blacks as "savage." Other boxers, such as African American heavyweight George Godfrey, were in fact treated this way by the magazine.[20] Remarkably, *Match L'Intran*'s studio photographers' diverse tonal range in their portrayals of Brown demonstrate a degree of understanding regarding the negotiations required to articulate phenotypically black skin. They may have been striving for a new image of an "exotic," but in the process of depicting Brown this way, they ventured beyond photography's designed capability of articulating only white skin. Moreover, they moved towards the faithful portrayal of phenotypically black skin rather than continuing to represent it as distorted.

Brown's broad smile, made legible through the technology of lighting and retouching employed in celebrity portraiture, contributes to the image's surface appeal. His parted lips expose gleaming white teeth. Intense lighting almost dissolves this fluid surface into a sheet of whiteness; and yet modifications of brighter whitening on each of his teeth and around his lips gently enunciate his expression.

Smiling faces on the covers of *Match L'Intran*, with images filling all twelve by ten and a half inches of the cover, monumentalized particular sports figures and marked their celebrated status. Smiles on the faces of both men and women, while not ubiquitous, were not uncommon in

LYNEISE WILLIAMS

Match L'Intran. They appear throughout each issue of *Match L'Intran,* sometimes animating the faces of cover figures, and more often in the numerous images within the weekly.

In the context of *Match L'Intran,* the smile encouraged viewers to engage in sports, signaled athletic triumph, and gave access to sports' most celebrated figures. Inside the same issue of the sports weekly featuring Brown on the cover, a photomontage with the caption *"Plein air, Danse, Liberté"* (Fresh Air, Dance, Freedom) features white women with toothy grins engaged in various sports. The individual image captions—*"La joie de l'équitation"* (The joy of horseback riding), *"La joie du mouvement"* (The joy of movement)," and *"La joie de vaincre"* (The joy of winning)"—deliver inspirational messages to readers about the benefits of sports.[21] On the cover of the magazine's second issue, cyclists Georges Wambst and Charles Lacquehay smile widely, in celebration of their triumph in a major Berlin competition.[22]

But the smile on a phenotypically black face carries racially coded meanings, resonating with imagery featuring the exaggerated smile or "grin" signifying servility and intellectual simplicity that was circulating in France at this time, borrowed from U.S. minstrel performances and its visual language. Historically the smile of the "happy darkey," as Saidiya Hartman has pointed out, legitimized the violence of slavery.[23] In addition, the image of a smiling African *tirailleur,* depicted in a widely disseminated advertisement for Banania breakfast cereal, as well as on the product itself during the 1920s, symbolized the domesticated and contained status of the African "savage" (figure 6.2). Thus the black male smile is not reserved for victory and triumph. It can allude to slavery's violence, or be the marker of an uncivilized person; and it suggests commodity, the possibility that through this gesture the viewer might own, or at least easily access, the black male body. Brown's smile, modified for its presentation to sports audiences, is related to these commodified smiles. But only to a certain extent.

Here technological strategies prevent a direct connection to the exaggerated grin of minstrelsy. What they create instead is a tension—between the hyper-visibility of minstrelsy's broad, toothy grin and the grandiose visibility of the celebrity photograph's codes of beauty and desire. The concentrated band of lighting extending from Brown's forehead to his chin minimizes the color contrast between dark phenotype, lips, and white teeth. This lighting strategy undermines the sense of hyperbole we find assigned to the blackface minstrel's mouth as well as that of the *tirailleur*—a critical component of the trope's ability to demean

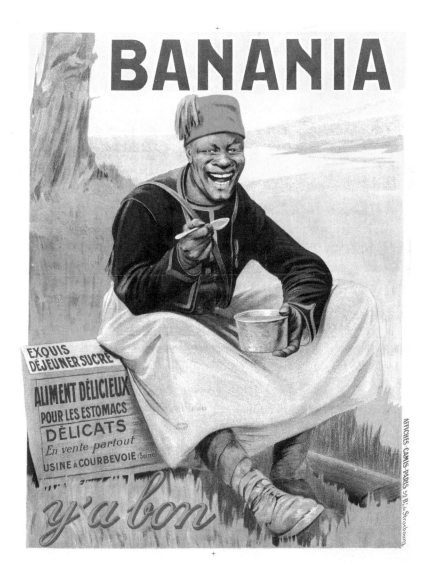

6.2.
Giacomo de
Andreis, publicity
poster for Banania,
1915, color
lithography on
paper, seventy-
nine by fifty-nine
centimeters.
Bibliothèque
Fornay, Ville de
Paris, HF 172913. ©
Bibliothèque Fornay,
Paris.

and to generate humor. Instead, meticulous lighting and detailed retouch-
ing softens the visual presence of Brown's mouth.

Brown's smile is rendered as a subtle, elegant orifice that emits light
and amplifies the wattage of his glowing visage. This is an expression
of seduction. Brown smiles flirtatiously at someone (not the viewer) out-
side the pictorial field. His parted lips expose gleaming white teeth and a
hint of tongue. One can almost feel the breath from his open mouth. The
viewer is drawn in and simultaneously pushed away. Rather than distance
Brown from his viewers by way of minstrelsy's repelling exaggeration,
Match L'Intran's studio photographers have generated distance through
strategies associated with celebrity. The boxer's twinkling eyes, open

mouth, and radiant smile invite the viewer's emotional connection but the ethereal quality of the light keeps them at bay. Brown is both an aspirational and unattainable image for the viewer. Constructed as a radiant celebrity, he is a surface that is inhuman—not debased like the slave or the minstrel, but exalted, superhuman, heroic.

Rotogravure and the Photomechanical Reproduction of Surface Appeal

Rotogravure printing was crucial to Brown's representation in *Match L'Intran*. This breakthrough technology was the first printing process with the capacity to photomechanically reproduce photography's wide range of tones on mass-production presses. It did so on cheap matte paper, which allowed the inexpensive mass production of high-quality images. Subtle gradations from the lightest greys to the darkest blacks, which had been impossible to achieve in halftone, the prevailing mass-production process, were fully realized in rotogravure.[24] As graphic design historian Michel Frizot writes, "Rotogravure made it possible to feature a large number of high quality large scale as well as small photographs, cheaper and easier to lay out in bulk."[25] *Match L'Intran* used this new photomechanical process well before it was widely adopted: in 1926 only two other publications, both devoted to the theme of World War I, had used it.[26] The emergence of photo newsmagazines such as *Vu* in France and *Life* in the United States would have been impossible without this technology, of which *Match L'Intran* was an early adopter. Publications in Germany and the United States had employed rotogravure beginning in 1910, but *Match L'Intran* is conspicuous for its use of the technology in images of phenotypically black men.[27]

The rotogravure process distinguished *Match L'Intran* from popular rival sports publications such as the newspaper *L'Auto* and the weekly *Le Miroir des Sports*.[28] Rotogravure takes its name from the photogravure printing process, which allowed high-quality photographs to be reproduced in a way that preserved their most subtle details. Between 1903 and 1917, photogravure was associated with U.S. photographer Alfred Stieglitz's internationally circulated magazine *Camera Work*, in which Stieglitz positioned the photograph as an artistic expression in and of itself. Rotogravure adapted the photogravure process for mass production using rotary presses. Images were etched onto a cylinder rather than the flat plate used in photogravure. Rotogravure's ability to translate photography's creative

possibilities was showcased by *Match L'Intran*, in the process conferring aesthetic value onto sports imagery. *Match L'Intran*'s photographers' deep investment in negotiating the tones of phenotypically black skin could only be realized in mass-produced images *because of rotogravure*. Rotogravure created an iconographic shift, enabling *Match L'Intran* to visually encode new ways of imagining phenotypically black men. Their representations in the sports weekly circulated widely throughout 1920s and 1930s France, its colonies in Africa and the Americas, and beyond.[29] Brown was at the center of this dissemination of imagery.

The groundbreaking spirit of *Match L'Intran* was not limited to rotogravure. The sports weekly's staff took full advantage of new creative processes in the forms of graphic design generated by the rotogravure printing process: chiefly the layout, where photographic positives and text printed on cellophane could be arranged freely and flexibly. *Match L'Intran*'s inventive use of graphic design to present an image-based product articulated a new visuality for sports. Considering that "cameras and lighting were developed taking the white face as the touchstone," as Dyer points out, then *Match L'Intran*'s use of rotogravure in portraying the phenotypically black Brown are even more compelling choices, since the technology makes apparent the way lighting and retouching not only bring him into being in the image but also code him as desirable.[30] Taken together, these innovations undergirded the significance of the surface in the making of Brown's modern image and his fashioning as a celebrity.

Destabilizing Racial Hierarchies

A critical component of Brown's surface appearance is his semi-profile position on the cover of *Match L'Intran*'s February 1, 1927 issue. This pose, which Mascart also takes, summons the specter of early twentieth-century pseudo-science and its use of photography to justify white, European racial dominance. *Match L'Intran* at times gave voice to such ideas, as in physical culturist Elie Mercier's article *"L'hérédité . . . son peril . . . sa gloire"* (Heredity . . . its peril . . . its glory) in its second issue. Mercier discussed what he regarded as the positive impact of sports on heredity and the national body. He argued that "for as little sensitive to some noble sentiment he might be, modern man must strive not to aggravate the defects received, to avoid acquiring others and to cultivate the qualities that allow a species not to become extinct, a race to multiply, develop, refine their dominant characteristics."[31] Mercier supported his ideas with

a sketch that directly referenced German zoologist Ernst Haeckel's argument about the environment's significant impact on organisms. Haeckel's biological theories had a racist tenor that, as Daniel Gasman reminds us, "became one of the most important formative causes for the rise of the Nazi movement."[32]

On the cover Brown is positioned slightly higher than Mascart, perhaps suggesting his role as victor in their recent bout. Mascart's lower placement on the picture plane undercuts any reading of Brown as racially inferior. With his thick curly hair, angular jaw, and straight nose, Mascart would seem to uphold contemporary notions of racial typology and "biological inheritance" and, by extension, the superiority of white European, in this case French, civilization. But a closer examination reveals that the photograph simultaneously destabilizes this reading.

Brown's mobile visage, with its radiant smile and twinkling eyes, looks to the future while Mascart's references toward classical Greece, fixing the boxer and France as static symbols of the past. Mascart's profile position recalls the similarly positioned Hellenistic Greek bronze statue *Boxer at Rest* (330 BCE) (figure 6.3). Before and after the First World War, Greek sculpture was employed to undergird aesthetic ideals for men and was touted in French physical-culture literature.[33] "Physical cultural publications," notes Joan Tumblety, "featured schematic sketches of posed Classical Greek figures with 'ideal' proportions overlaid with mathematical measurements."[34] *Match L'Intran* encouraged notions of a classical ideal in its use of a sculpted Greek discus-thrower as the centerpiece of a photomontage entitled "The Perfect Athlete Must Have . . ." in its May 10, 1927 issue.[35] But given Brown's active countenance, Mascart's alignment with the sculpture suggests stagnancy, almost to the point of death.

Yet Brown occupies less space on the page than Mascart. The Frenchman's expansive exposure, however, comes at a cost, since his facial details disclose less-than-ideal markers resulting from his encounter with Brown in the ring. Brown had soundly defeated Mascart in the fifth round before a packed house at the Cirque de Paris on January 25, 1927, and Mascart's facial bruises echo those on the sculpture's visage, and complicate interpretations that would exalt his supposed white and French supremacy. Mascart's heavy brow eliminates almost all visible traces of his eyes. The right eye is completely hidden. An odd, patchy, and unnatural shadow extending from his hairline to the middle of his cheek minimizes a blacked eye. Rounded upper and lower eyelids meet, indicating their swollen state. The slight downward tilt of his head and the large, darkened area at the corner of his eye, blending into the shadow

6.3.
Hellenistic bronze statue, *Boxer at Rest,* 330 BCE, probably inspired by the style of Lysippus. The seated boxer wears a *kynodesme* (loincloth) and *himantes oxeis* (leather gloves); this detail shows his mangled face. Museo Nazionale Romano (Palazzo Massimo alle Terme), Rome.

on his nose, also distract from his bruised eye. On close inspection are evident lines of retouching to lighten Mascart's eyelids, the area underneath his eyelids, and the space next to his eyes—all rendering the bruise and swelling less noticeable. Even the curling effect of his cauliflower ear—a well-known hazard of boxing—has been minimized and somewhat remodeled by retouching.

The articulation of bruises and deformities, and the efforts to erase these wounds on Mascart's face, create visual tension. Boxing's varied markers may be subdued, but they need to be detectable to communicate classic Greek notions of manly character and to validate Mascart's efforts in the ring—despite his overwhelming loss.

Mascart's closed lips, the evidence of his boxing, and the visual links to a Greco-Roman masculine ideal align him only with the past, not the present or future. Mascart is imprisoned by his body, by time, and by the

LYNEISE WILLIAMS

borders of the image. In contrast, Brown is a new model of manhood and celebrity who is freed of boxing's markings and accouterments. He transcends bodily strictures. Breaking the fourth wall, he looks beyond the image frame. Brown, the celebrity, gazes into the future, and exists there.

Performing Glamour

If glamour represents "an experience that moves one out of the material world of demands, responsibilities and attention to productivity, and into another, more ethereally bound, fleeting, beautiful, and deadly," then an earlier sketch of Brown suggests that *Match L'Intran*'s editors and writers viewed him as attractive, enchanting, and otherworldly.[36] They expressed attraction to him in comments that are sometimes erotically charged. Captivated, mesmerized, they link him to royalty and insist on his power over them. These impressions also undergird the strategies of glamour employed on another cover image of Brown, this one from 1927.

In this sketch, which appeared in *Match L'Intran*'s parent newspaper, *L'Intransigeant*, the artist Delaval represents the boxer as lean, stylishly adorned, and engaged in graceful movements that confer the mantel of glamour on Brown, albeit uneasily (figure 6.4).[37] Delaval, not unlike the cover photographer, subdues and erases the markers of boxing on Brown, imagining him instead as an attenuated, androgynous, stylish, and flirtatious figure. Brown, in profile, wears a long, high-collared robe and a large cap that shadows his face, suggestively downplaying, perhaps, his skin tone. Evoking the values of gracefulness and elegance associated with the French term *longiline*, Brown adroitly balances on a single toe in his narrow, spotless shoes. As in the cover photograph, Brown's skin color is rendered unstable by a large cap, casting shadows over his face. His phenotype is again a manipulable surface to be played with.

The lean muscularity of Brown in the sketch also resonates with the lightly muscled body type that was de rigueur in sports in this historical moment. "The heavy muscles of the Herculean circus strongman," contended Joan Tumblety, "were passé; rather, the 'more refined silhouette' of Belvedere's Apollo was better suited to contemporary lifestyles."[38]

Visual markers in the sketch recall accounts in *Match L'Intran* that focus on Brown's grand entrance into the ring during his first two French bouts. When, in November 1926 Paul Olivier, sports reporter for both *L'Intransigeant* and *Match L'Intran*, described Brown as "very Fifth Avenue" as he entered the ring, he both alluded to the boxer's sartorial choices and

Demain : Mascart contre Al. Brown

LA REUNION
DU CIRQUE DE PARIS

Nous voici à la veille de ce match Mascart-Al. Brown, qui constitue de bien loin la plus remarquable rencontre qu'on ait vue depuis longtemps à Paris.

Un combat de Mascart est toujours un véritable événement. L'homme est éminemment populaire et il a attiré, au cours de ces dernières années, les plus grandes affluences partout où il a combattu. Demain, il ne faillira certainement pas à la tradition, d'autant plus qu'il aura en face de lui cette autre vedette étonnante qu'est le noir Américain Al. Brown.

De ces deux hommes rompus aux batailles les plus dures et habitués aux adversaires les plus difficiles, lequel triomphera et de quelle façon ? Les avis sont partagés, mais une plus grande majorité se forme autour d'Al. Brown auquel on prédit de plus grandes chances de victoire. Marcel Nilles fera sa rentrée au cours de cette réunion et il sera opposé au nouvel espoir poids lourd Giverny. Les autres rencontres verront aux prises les mi-lourds Pailleux et Luneau, puis Jimmy Brown et Argotte, et enfin Jeannot contre Biron. — PAUL OLIVIER.

AL. BROWN
croquis de Delaval

6.4.
Alfonso Brown proceeding to the ring for a match. Sketch by Delaval, in Paul Olivier, "Demain: Mascart contre Al Brown," *L'Intransigeant,* January 24, 1927.

explicitly tied Brown to the popular walking style of Parisian models, called "the Fifth Avenue."[39] Three weeks later in December, René Lehmann devoted the majority of his extended article on Brown's bout to cataloguing Brown's attire and movements. He wrote: "Al Brown enters wearing a white cap pulled down over his right brow and a purple robe, while jumping up and down. He jumps like a sparrow then climbs into the ring responding to the hungry crowd, jumping in place. Brown takes off his robe, and covering his shoulders is a brightly colored rough-hewn cotton shirt like one would see in America in the home of blacks in Virginia."[40] Lehman presents Brown as graceful and unthreatening. He notes the way the boxer's performance extends into the ring itself. Disrobing takes center stage as Brown reveals layers of clothing. There is no mention of skin here. Brown's body comprises textile surfaces and sharp movements rather than the flesh of humanity.

Reporter C. A. Gonnet evoked royalty, speed, and harmony to elevate Brown's image above that of his nondescript entourage and the audience, but did so seemingly as the result of ethnographic scrutiny. "Al Brown," he remarked, "in a regal blue robe with silver acorn patterns, surrounded by trainers, assistants, and sparring partners," approached the ring with a "war dance, gazelle legs, fatigue free," before revealing "sculpted shoulders; a torso where the ribs and muscles fit together harmoniously" as he began the round.[41] Coincidently, a reporter from the *New York Amsterdam News*, an African Ameri-

can newspaper, portrayed Brown's entry in this same bout in dramatic detail, noting that "Brown came into the ring in an elegant dressing gown of sky-blue silk with silver tassels leaping in with the litheness of a Black panther, while Cuthbert entered rather timidly, dressed in a dark brown robe resembling a soldier's overcoat."[42] Again, a larger-than-life, supernatural being is evoked by this shimmering panther.

In the sketch, Delaval androgynizes, even feminizes Brown's body, visually aligning its attenuated elegance with strategies similar to those employed on female figures in the Fashion section of the same issue.[43] A curved line caressing Brown's buttocks sexually objectifies him. This contour of shapeliness codes his difference as a feminine disruption within the dominant phallic symbolism of the vertical text column. By configuring Brown's body to be tidily inserted into the column structure of the newspaper page, Delaval conceives a new imagination of black male bodies in French society, one distinct from the "savage": lightly muscled, lithe, contained, feminized, unthreatening, and elegant.

Conclusion

Match L'Intran cast Alfonso Brown's phenotypically black skin as a fluid surface they manipulated to communicate new messages about modern male bodies in early-twentieth-century France. Generating a new, profitable presentation for the "exotic," phenotypically black Panamanian, staff photographers gestured away from mimicking the visual tropes of the "black savage" and minstrelsy caricatures, fashioning him instead as unique and appealing. They borrowed strategies from celebrity portrait and publicity photography to situate Brown as an ethereal figure. In doing so, they failed to faithfully reproduce the tonalities of phenotypically black skin that would render the boxer as human. A wider range of photography's subtle tones, reproduced via rotogravure, enabled *Match L'Intran* to lighten the appearance of Brown's skin, modify his physiognomy, and encode this phenotypically black man as ideal and desirable.

Perhaps Brown's origins in Panama rather than in a former French colony, as well as France's efforts to define itself against the United States, where Brown launched his boxing career, rendered the pugilist, in the eyes of *Match L'Intran*, favorable for celebrity status and new definitions of masculinity.[44] In this complex French conception of the ideal, which engaged the visual language of celebrity, glamour, beauty, and ideas about masculinity, all of which were linked with rotogravure, *Match*

L'Intran accomplished much more than making the slender-figured Panamanian boxer look like a winner. They made a mass audience in Paris want to *be* this image of Alfonso Brown.

Notes

1 R. E. Bré, "La Salle Wagram," *Match L'Intran* 5 (December 7, 1926), 6.
2 Léon Bailby was the editor of *L'Intransigeant* from 1906 to 1932. A radical nationalist, Henri Rochefort, the newspaper's founder, served as editor from its beginning in 1880 until 1906.
3 Theresa Rundstedtler, *Jack Johnson, Rebel Sojourner: Boxing in the Shadow of the Global Color Line* (Berkeley: University of California Press, 2012), 169. Brown was one of many phenotypically black boxers in Paris during the early twentieth century. The majority of these pugilists, who began migrating to France in 1907, were African Americans in search of greater opportunities in the ring outside the United States. Boxers were prominent figures in the Parisian landscape before the large numbers of entertainers, musicians, and soldiers arrived at the beginning of World War I. Jack Johnson, Aaron Lester Brown, "The Dixie Kid," Sam MacVea, Sam Langford, Joe Jeanette, Eugene Bullard, and Bob Scanlon were among the U.S. boxers who relocated to France. See Rundstedtler, *Jack Johnson*; William A. Shack, *Harlem in Montmartre: A Paris Jazz Story between the Great Wars* (Berkeley: University of California Press, 2010); Bennetta Jules-Rosette, *Black Paris: The African Writers' Landscape* (Urbana: University of Illinois Press, 1998); Craig Lloyd, *Eugene Bullard: Black Expatriate in Jazz-Age Paris* (Athens: University of Georgia Press, 2006); Georges Peeters, *Monstres Sacrés du Ring* (Paris: La Table Ronde, 1959); and Claude Meunier, *Ring Noir: Quand Apollinaire, Cendrars, et Picabia découvraient les boxeurs nègres* (Paris: Plon, 1992). Michel Fabre pointed out that boxers were a "highly visible group" in Paris by 1910, where at least three training teams of black boxers prepared for Jack Johnson's arrival in 1913. He asserts that "boxers were the first encounter with African-American culture for many Parisians"; see Michel Fabre, "The Ring and the Stage: African Americans in Paris Public and Imaginary Space before World War I," in *Space and America: Theory History Culture*, ed. Klaus Benesch and Kerstin Schmidt (Amsterdam: Editions Rodopi, B.V., 2005), 521–28.
4 Similar, but not identical, visual strategies were used by *Match L'Intran* in their depictions of two black Cuban boxers on March 7, 1933 and September 26, 1933.
5 I have explored the ways that Black Latin Americans were situated in the highest position of the hierarchy in Parisian's index of blacks in the early twentieth century. See Lyneise Williams, *Black and Latin: Representations of Black Latin Americans in Paris, 1855–1932* (forthcoming 2017). For a full discussion of France's construction of racial identities in the early-twentieth century regarding African Americans, see Ch. Didier Gondola, "'But I Ain't African, I'm American!' Black American Exiles and the Construction of Racial Identities in Twentieth-Century France," in *Blackening Europe: The African American Presence*, ed. Heike Raphael-Hernandez (New York: Routledge, 2004), 201–15.

6 Anne Anlin Cheng, *Second Skin: Josephine Baker and the Modern Surface* (Oxford: Oxford University Press, 2012), 7.

7 The *Match L'Intran* covers featuring people of color were all boxers except for the cover with the image of U.S. sprinter Jesse Owens, August 11, 1936. The issues with boxers of color on the covers were February 1, 1927, Al Brown (Panama) and Edouard Mascart (France); November 1, 1932, Len Johnson (United States) and Marcel Thil (France); November 15, 1932, Al Brown and Milou Pladner (France); March 7, 1933, Kid Tunero (Cuba); September 26, 1933, Kid Chocolate (Cuba); October 1, 1933, Marcel Thil and Kid Tunero; February 20, 1934, Al Brown and Young Perez (Tunisia); January 8, 1935, George Godfrey (United States); October 1, 1935, Joe Louis (United States). Two of those covers employed the same image used in different contexts. Brown's appearance on the cover of *Match L'Intran* in February 1927 was the first time in the publication's history that boxers were featured on the cover. *Match L'Intran* published 423 weekly issues from November 1926 to December 1936.

8 *Le Miroir des Sports*'s dimensions were 13³⁄₈ inches by 9½ inches.

9 Richard Dyer, *White: Essays on Race and Culture* (New York: Routledge, 1997), 90.

10 Lightening Brown's skin may suggest that he was viewed as culturally "white" and more European than other blacks from Africa and the United States, based on French assumptions about the shared so-called "Latin blood" supposedly in his Spanish American ancestry. I explore this idea in Williams, *Black and Latin*.

11 The American magazines *Photoplay* and *Motion Picture Magazine* debuted in 1911.

12 David S. Shields, *Still: American Silent Motion Picture Photography* (Chicago: University of Chicago Press, 2013), 59.

13 Shields, *Still*, 170.

14 Robert Dance and Bruce Robertson, *Ruth Harriet Louise and Hollywood Glamour Photography* (Berkeley: University of California Press, 2002), 88.

15 Dance and Robertson, *Ruth Harriet Louise*, 88.

16 Shields, *Still,* 13.

17 Later, Leon Bailby, general editor of *Match L'Intran* and *L'Intransigeant,* opened a larger cinema house, Les Miracles-Lord Byron, on the Champs-Elysées. See Colin Crisp, *The Classic French Cinema, 1930–1960* (Bloomington: Indiana University Press, 1997), 220.

18 *Pour Vous L'Intran* was edited by Alexandre Arnoux, film critic of *L'Intransigeant*. Bailby served as the owner and publisher.

19 A photomontage in the second issue of the weekly featured French film actors Jane Renouardt, Maurice Chevalier, and Yvonne Vallée. They were used as examples of the benefits of the sporting activities they engaged in. See *Match L'Intran* 2 (November 16, 1926), 10.

20 See cover, *Match L'Intran* 439, January 8, 1935.

21 See *Match L'Intran* 13, February 1, 1927, 10.

22 *Match L'Intran*. 2, November 16, 1927. Prior to the February 1, 1927 issue featuring Brown, there were only three issues in which faces appeared prominently on the cover. Of those three covers, only one features smiles on the faces. Brown was the first phenotypically black person to appear on the cover of *Match L'Intran* as well as the first phenotypically black person with a smile on the cover of this sports weekly. African American boxer Joe Louis was

featured on the cover of the October 1, 1935 issue in an image showing three-quarters of his body; in it he is seated in a relaxed position, wearing boxing shorts, with his taped hands in his lap and a smile on his face.

23 See Saidiya V. Hartman, *Scenes of Subjection: Terror, Slavery, and Self-Making in Nineteenth-Century America* (New York: Oxford University Press, 1997), 27.

24 The impact of halftone process and rotogravure process on the reproduction of phenotypically black skin has not been explored. I will address the way these photomechanical processes effect reproductions of this skin color in a forthcoming article.

25 Michel Frizot, "Photo/graphics in French magazines: The Possibilities of Roto-gravure, 1926–1935." Paper presented at Photo/Graphisme conference, Jeu de Paume, Paris, October 20, 2007.

26 The photographic magazines *J'ai vu* and *Le Miroir* began in France in 1914. See Frizot, "Photo/graphics," 7.

27 In 1910, the *Freiburger Zeitung* of Freiburg, Germany was the first daily news-paper in Europe to incorporate the rotogravure process. In the United States, the *New York Times* included a section completely printed in the rotogravure process in 1912. Forty-seven American newspapers included sections in their Sunday issues printed in the rotogravure process by the end of World War I. See "The Rotogravure Process and the Use of Pictorials in Newspapers," Library of Congress, http://memory.loc.gov/ammem/collections/roto-gravures/rotoprocess.html. Considering perceptions of blacks—men and women—in Germany and in the United States during this period, I believe *Match L'Intran*'s 1927 cover featuring Brown may be the first mass-produced publication to reproduce a phenotypically black person in rotogravure.

28 *L'Auto*, the daily sports newspaper, was a text-based publication with few, small images. Its horizontally-folded dimensions, seventeen by twelve and a half inches, are the exact size of the vertically oriented *Match L'Intran*, which distinguished itself by its emphasis on photography.

29 Below the information on the weekly's mailing address it states prices for *"Paris, Seine et Seine-et-Oise, Départements et colonies, Etranger." Match L'Intran* 13, February 1, 1927, 13.

30 *Match L'Intran* 13, February 1, 1927, 90.

31 *Match L'Intran* 3, November 23, 1926, 13.

32 Daniel Gasman, *The Scientific Origin of National Socialism: Social Darwinism in Ernst Haeckel and the German Monist League* (New York: Science History Publications, 1971), xxii. Gasman's examination of Haeckel's social Darwinism can also be found in Daniel Gasman, *Haeckel's Monism and the Birth of Fascist Ideology* (New York: Peter Lang, 1998). Stephen Jay Gould concurs with Gasman, noting that Haeckel's biological theories "contributed to the rise of Nazism"; see Stephen Jay Gould, *Ontogeny and Phylogeny* (Cambridge, MA: Harvard University Press, 1977), 77–81.

33 Joan Tumblety, *Remaking the Male Body: Masculinity and the Uses of Physical Culture in Interwar and Vichy France* (Oxford: Oxford University Press, 2012), 34–35.

34 Tumblety, *Remaking the Black Body*, 34.

35 *Match L'Intran* 27, May 10, 1927, 2.

36 Judith Brown, *Glamour in Six Dimensions: Modernism and the Radiance of Form* (Ithaca, NY: Cornell University Press, 2009), 5.

37 Paul Olivier, "Demain: Mascart contre Al Brown," *L'Intransigeant,* January 24, 1927, 4.

38 Tumblety, *Remaking the Black Body*, 114.

39 Paul Olivier, "Ecrit au bord du ring," *Match L'Intran,* November 23, 1926, 6. For more on the "Fifth Avenue" style in fashion, see Caroline Evans, *The Mechanical Smile: Modernism and the First Fashion Shows in France and America, 1900–1929* (New Haven: Yale University Press, 2013), 125.

40 Rene Lehmann, "Brown Brothers and Co.," *L'Intransigeant*, December 3, 1926, 4.

41 C. A. Gonnet, "Le 'numero' d'Al Brown," *L'Intransigeant*, November 19, 1928, 5.

42 "Record Crowds at French Capital See Al Brown, Holder of National Boxing Association Bantamweight Title, in Action," *New York Amsterdam News*, December 5, 1928, 7.

43 *L'Intransigeant,* January 24, 1927, 4.

44 Richard Kuisel argues that France shaped its identity in part by defining itself against the United States and its treatment of African Americans; see Richard Kuisel, *Seducing the French: The Dilemma of Americanization* (Berkeley: University of California Press, 1993). I am exploring this idea further in relation to Brown's positioning as a celebrity in a new book project.

7

The Here and Now of Eslanda Robeson's *African Journey*

LEIGH RAIFORD

> My African trip was one of those grand dreams come true. . . . I think
> every Negro who can, should go and look and listen and learn. We
> have a grand heritage from Africa, as a race, and it is shameful that
> we are not interested in it, and almost wholly ignorant of it.
>
> Pauli is enthralled.
>
> —Eslanda Robeson

In May 1936, Eslanda Goode Robeson set off on a three-month tour of South Africa, Uganda, and the Belgian Congo. Equipped with luggage, notebooks, a Cine-Kodak (sixteen millimeter) camera and a Rolleiflex twin-lens reflex camera ("You can't take too many pictures," her husband, Paul, had told her), she was also accompanied by her eight-year-old son, Paul Jr.[1] An African American woman born to a middle-class, erudite, Washington, DC, family at the turn of the twentieth century, Robeson is perhaps best known for her marriage to celebrated singer, actor and activist Paul Robeson, whose career she managed throughout her lifetime. However, Eslanda Robeson, or Essie, as she was called by friends and family, was also an anthropologist, the author of three nonfiction books, and a committed anticolonial and antiracist activist.[2] Robeson's trip, the first of three she would make to the continent in her life, came as she was studying anthropology at the London School of Economics (LSE), and marked her effort to experience Africa firsthand at once outside of and through the framework of dominant anthropology. Emboldened by brewing anticolonial struggles, and inspired by her own growing diasporic consciousness, she undertook this journey as at once intellectual fieldwork, political reconnaissance, and family vacation.

From this trip, Robeson produced a travel memoir entitled *African

Journey, published by the John Day Company in 1945. This work presented an affirming understanding of Africa and its people from the unique vantage point of an African American woman, while also fostering political and cultural connections among black diasporic subjects. *African Journey* accomplishes this work not only through writing that is at turns, elegant and assertive, droll and acerbic, but also through the proliferation of Robeson's own photographs. The book is further distinguished by the presence of her son, Paul Robeson Jr.—Pauli, as his parents affectionately called him—who plays a central role in the narrative and appears in nearly a quarter of *African Journey*'s sixty-six photographs. As one reviewer wrote, "Ostensibly the experiences of the wife of Paul Robeson on an African tour in 1936, this book develops a special interest far beyond that of the usual travel book because of the character of Pauli, the Robesons' small son. . . . Pauli is revealed as a percipient, charming boy whose mature observations and reactions to the unknown are perpetually satisfying."[3] Essie's own research trip is filtered in part through Paul Jr.'s eyes and experiences. Essie records Paul's observations nearly as often as she records her own. This is their shared journey.

This essay explores the role photography played in elaborating Robeson's anthropological vision and political platform, as expressed in *African Journey*. I ask, how did Essie Robeson *see* Africa in and as image and text? What forms of diasporic identification and belonging might have been nurtured through the presence of her son, Paul Jr., as a photographic subject? How do different registers and genres of photography—anthropological field images, family and tourist snapshots—collide and collude to produce a distinct photographic archive of an African continent on the verge of decolonization?

Through its mix of anthropology, travel narrative, and family photography, *African Journey* disrupts what we might call the backward-looking impulses of each of these three genres. By "backward-looking," I mean here a fixation with finding primitives, with romanticizing the past, with feverishly documenting and recording; and with the racial projects—anthropology, diaspora, and photography in the early twentieth century—that bound these together. Robeson writes against a dominant strain of academic anthropology—and racial science more broadly—that understood racial hierarchies as the natural outcome of the arrested development of groups deemed culturally and biologically inferior. *African Journey* also does not fall prey to the expressions, burgeoning in the Harlem Renaissance, of "diaspora," and "homeland," which embraced Africa primarily as a site of cultural heritage and prelapsarian

glory rather than as a living, breathing place in struggle and in formation.

And in her experimentation with different registers of photography, ranging from individual and family portraiture to still lifes of everyday objects to landscape, Robeson calls on the medium to push beyond its ability to record what theorist of photography Roland Barthes has called the "that-has-been," seeking instead to document a diasporic encounter in the present.[4] Indeed, Robeson's photographs in *African Journey* refuse an anthropological imperative to photograph primitives, in this case Africans, as biological subjects whose bodies function as "visible signs" of transhistorical racial essences. Her images wrestle as well with a tendency to photograph other cultures "in the past," in a fixed timeless but not present place, that is, both within and against what visual anthropologist Elizabeth Edwards has called the "ethnographic picturesque."[5] Similarly, by focusing her camera on modern technology and Western dress as well as traditional tribal artifacts, and importantly by including herself and Paul Jr. within her African frames, Robeson resists African American ideas about their "eternal bond" to an unchanging Africa that "is always there."[6] To follow literary scholar Kenneth W. Warren, rather than "mak[ing] coincident only an African past to an African American present," Robeson's photographs open space to consider "the relationship of Africans to black Americans" in 1936.[7]

A Grand Dream Sets Sail

African Journey is structured as a day-by-day diary of Essie and Paul Jr.'s summer abroad. Over the course of three months, Robeson observed the suffering and resistance, dignity and degradation, of the people she encountered. *African Journey* is bookended by Robeson's italicized assertions of African humanity. The book is dedicated to "the brothers and sisters, who will know whom I mean." And the narrative's concluding paragraph is a single, italicized sentence: *"Africans are people."* In a global political and cultural climate that dismissed African peoples as primitive, and eminently exploitable, such a contention bordered on the revolutionary. What lies in between the opening dedication to a self-selected family and the closing affirmation of African humanity are Robeson's descriptions of modern cities, ancient yet complex native lifestyles, and African locals who were either educated and worldly, or poor and dignified. Her hope for the book was that it would "take folks right out to Africa with me, talking all the way there and all the way back. So you could know the folks,

7.1.

Map depicting route of entire trip, from Eslanda Robeson, *African Journey* (New York: John Day, 1945). Courtesy of Robeson Family Trust.

hear them talk, and see what I saw."[8] Essie did not want to shy away from what she saw. Nor did she want to embellish suffering. Rather, she chose to look and write with political commitment and human solidarity, always aware of her unique and privileged position.

This was an ambitious trip to be sure: via steamship and boat, car and train, seaplane and airplane, Essie and Paul Jr. traveled to seven different countries or territories (figure 7.1). They were hosted by numerous friends and acquaintances they had met in England, mostly through academic and activist circles, African and white alike. The Robesons visited mis-

sion schools and colleges, the mines of Johannesburg, the marketplaces of Madeira and Mombasa, and colonial metropoles, as well as various townships, reserves, provinces, and villages. While in South Africa, Essie attended the All-African National Convention in Bloemfontein, a gathering of four hundred delegates from all over South Africa organizing against new legislation aimed at further disenfranchising the native population. The last month was spent in the Uganda's Toro province, where Essie conducted her "anthropological field work on cattle culture in Uganda."[9] The journey home to London took nine days, "All a dream and a nightmare," writes Essie, "because I was ill."[10] When they arrived in London on August 25, Essie was taken off the airplane on a stretcher and removed immediately to the hospital but recovered quickly.[11]

The challenges of traveling through Africa during this time were made more difficult by the fact that these travelers were a black/American woman and her only child. Yet this was offset by the privilege they enjoyed as the wife and child of one of the most internationally recognized and beloved black men of the moment, and by the kinds of social and political connections such status afforded them. However, while these perks certainly eased Essie and Paul Jr.'s journey, they by no means prevented physical illness or racist encounters, nor did they ensure safe passage (through the dangers of air travel, for example). On their visit to Mbeni in the Belgian Congo, Essie, Paul Jr., and their traveling party were initially denied rooms at a Belgian-owned hotel. "After considerable pressure from our D.C. [District Commissioner], and a lot of *'distingué'* and 'important' on his part against the *'noir, noir,'* the owner" relented and escorted the group to what Essie described as rooms "scarcely fit for animals."[12] Paul Jr. recognized this as a pyrrhic victory and remarked, "This is what we get when we are black and important. Wonder what we'd get if we were unimportant."[13] We might understand Robeson as navigating the bounds of her own mobility: traveling as a free black person to South Africa where "natives" could not move without official papers, journeying as an American of means on roads traversed by desperately impoverished displaced Africans, or entering spaces designated for men-only as a woman, still often requiring the intervention of colonial officials or "big men."

Anthropology

The field of anthropology provided Essie a route into the African continent. While this may seem strange, such an approach was born of Robeson's

own political disposition and "New Negro consciousness," a movement with a vibrant and active wing in the social sciences. While the social sciences broadly offered African American intellectuals a framework for addressing social problems, anthropology in particular presented "a way of documenting and celebrating their African heritage."[14] It also provided some critical distance and perspective while enabling its practitioners to travel to black communities near and far. In this way, black anthropologists like Zora Neale Hurston, Arthur Fauset, Katherine Dunham, Jomo Kenyatta, and Eslanda Robeson were able to study and experience themselves and their cultures, to forge diasporic connections in an "objective" manner, "validated" by academic sciences.

Robeson's methodology was further nurtured by her training at LSE under Bronislaw Malinowski. Malinowski emphasized "cultural relativism," the idea that "we" Westerners might learn from other peoples.[15] Further, the anthropology program at LSE offered a rigorous course of study in African languages, history, culture, and geography. For her part, Robeson embraced anthropology for the real-world encounters it enabled and relied upon. Understanding the field as a form of "dynamic interpretation," Robeson described anthropology "as the study of man and his relation to his fellow man, and to his changing environment. Thus it includes the study of primitive man under primitive conditions, of modern man under modern conditions, of human relations, race relations, of education, of social institutions."[16] She recognized it as a field that encouraged one to truly engage human existence both synchronically and diachronically.

Robeson, however, recognized the limits of anthropology, particularly as it had been practiced by her (white male) predecessors. In Kabarole, Essie asked her hosts directly "what they thought of visiting anthropologists, and how they liked being 'investigated.' They smiled and said they were vastly amused, and would often take the searching and impertinent questions as a game, giving the most teasing, joking, and fantastic answers they could think of." As one chief declared, "White people are not interested in us. They only want to take away our land and our cattle, and make us pay taxes. Why should we tell them our sacred history, and the details of our social organization?"[17] Such an admission invites her readers to question some of anthropology's truth claims and underscores the discipline's work in building European empires and as a "handmaiden of colonialism."[18] Simultaneously, Essie positions herself here as an "insider," a foreigner but as a diasporic subject, one who might be trusted with "tribal knowledge." She reveals the "hidden transcripts" of her Ugandan

interlocutors, who possess a very clear understanding and critical analysis of their colonial subjugation.

Her political identifications coupled with her firsthand experiences led Robeson to resist some of anthropology's claims. First, she flat out rejected popular notions, alive and prevalent among her teachers and peers at LSE, that fixed African peoples as outside history and tied to an eternal premodern past. Her own experiences within the rich black diasporic community of London, where she and Paul regularly hosted African students and expatriates at their home and were active in the West African Students' Union, a political, social and cultural organization, gave her firsthand knowledge to the contrary. Essie's formal and informal meetings with natives in their homelands reveal a critical understanding of the ways colonial ideology has fixed them as "primitives" unfit for self-governance. For example, in Kabarole, Uganda, a gathering of "young, eager, and intelligent" schoolteachers ask Essie a range of questions about educational policy and opportunities for black people in England and America, and they are excited to hear about successful integration efforts of nomad tribes in the Soviet Union. In the course of the conversation, the group challenges the label of "backwardness" levied against them by the colonial government. "'What do they mean by this 'backward'? Before I could answer, or try to answer, a fellow teacher said: 'They mean people they have kept back, and continue to keep back.'"[19] "Backwardness" is a condition imposed by white colonizers rather than an organic state; "primitive" is a fiction Europeans tell themselves to assuage and justify hierarchy and inequity. Similarly, when meeting with a group of chiefs in Mbarara, the capital of the Nkole province of Uganda, Essie was "surprised and impressed" by their inquiries into the conditions of Native Americans alongside more expected questions about Negro life and politics in the United States. Such conversations reveal Robeson's interlocutors as actively seeking information on antiracist struggles against settler colonialism globally, as well as challenging the racial logics of such systems.

On a lighter note, *African Journey* highlights the "here and now" of her subjects by consistently noting their engagements with technology and the vitality of their cities. Essie gushes over host Dr. Alfred B. Xuma's "gorgeous new 1935 Buick, complete with balloon tires, shock absorbers, special springs, etc" that brought her and Paul Jr. from Sofiatown, Johannesburg to Bloemfontein.[20] The lights of Johannesburg were "like Detroit"; Kampala, Uganda is a "colorful town with good roads, shops, smart African police, markets, and handsome African women."[21] Orderly cities, flashy amenities, and up-to-date technologies offer evidence of

modernity, especially when peopled (and patrolled) by Africans. And even if black Africans are segregated and sequestered into certain parts of the city or country, they still traverse these spaces, working in homes and mines that constitute them as a modern proletariat.

Further, rather than taking the anthropological tack that the non-European Other was different from the ("Western") researcher yet still worthy of scholarly interest, Robeson deemphasized difference and distance, highlighting instead similarity. Textually, she found commonality in the similar experiences of black peoples under global white domination, the analogous ways that, for example, colonialism and Jim Crow segregation defined the textures of black life in South Africa and the southern United States. Essie notes that the network of safe houses developed by black travelers on the roads of southern Africa echoes the informal systems throughout the Deep South: "You are passed from friend to friend, from car to car, from home to home, often covering thousands of miles without enduring the inconveniences and humiliations of the incredibly bad Jim Crow train accommodations and lack of hotel facilities for Negroes."[22] Likewise, she is able to identify the vibrancy of black townships, segregated spaces cast off as dangerous slums but made into communities by their residents. Friedasdoorp, also known as Ferreirascamp, was the oldest township in Johannesburg, developed from a mining camp, and was considered "to be the roughest section." For Essie, "It reminded me very much of Lenox Avenue in Harlem on a summer Sunday afternoon," full of people enjoying themselves and each other.[23] The promotion of likeness over difference also emerges in the form of *African Journey* as travelogue rather than formal anthropological study: where the latter purports the objectivity of the social scientist, the former situates the writer/traveler at the center of the narrative.[24] Through attention to African modernity by highlighting Africans' engagement with colonial politics as well as emergent technology, *African Journey* makes a claim to Africa and Africans' *presentness*, over and against anthropology's tendency to place the continent and its peoples outside of history.

Photography

Visually, Robeson's photographs augment such a political project by refusing exoticism and racial hierarchization, hallmarks of visual anthropology of the time.[25] This was also characteristic of film of the period, and Essie was acutely aware of the ways such images circulated globally.

"I blush with shame," Robeson reflected after the Bloemfontein confer-
ence, "for the mental picture my fellow Negroes in America have of our
African brothers: wild black savages in leopard skins, waving spears and
eating raw meat. And we, with films like *Sanders of the River*, unwittingly
helping to perpetuate this misconception. Well, there will be no sequel
to *Sanders*!"[26] Essie was of course referring to the 1935 film that starred
Paul Robeson as a leopard-print clad African chief who loyally serves the
British colonial regime. Essie had negotiated a handsome contract for
this film but could not secure rights to approve of the final cut. The film's
degrading images and procolonial sentiment pained and embarrassed
the Robesons (as well as opened them up to critique from black leaders),
making them both sensitive to their roles in future depictions of African
and African-descended peoples.[27]

This overlap between Hollywood film and scientific photography also
alerts us to the ways in which the photography and visualization of "racial
and cultural 'otherness'" across genres could be "absorbed into scientific
anthropology itself."[28] That is, while formally trained anthropologists may
not have made touristic, erotic, or caricatured images of African peoples,
such images were "informed and legitimated" by scientific anthropology.
Likewise, anthropological collectors enlisted quotidian photographs of
this sort to expand their archives. Thus, as Elizabeth Edwards avers, "pho-
tographs *became* anthropological through patterns of consumption."[29]

Essie's cultural politics become evident in the photographic work
and practices of *African Journey*. Though new to photography and film-
making as a practitioner at the time of the trip, Essie took hundreds of
photographs and made some twenty reels of film.[30] She took great pains
in putting the book together to choose the most evocative images for
final publication. The images cross genres: portraiture, ethnographic evi-
dence, landscape, casual snapshot, family portrait. The trajectory of the
photographs—not only from the beginning of the book to the end, but
across the span of her stay within each location—suggests that Essie was
learning her equipment and developing her eye as the trip progressed.
The opening folios of *African Journey* (there are seven in all) feature many
photographs taken from a distance and devoid of people. For example,
photographs like "Typical Basuto village" or "Palace of Mukama of Toro at
Kabarole" make an effort to take in as much of the scene as possible. Pan-
oramas such as "Basutos and Basuto house at Matsieng, typical of Basu-
toland" aim to present "a context of situation," as her teacher Malinowski
endeavored to do in his own anthropological photography.[31]

As *African Journey* progresses, and as Essie settles into a particular

place and establishes a rapport with the people she's met, her camera gets closer and closer to her subjects. Some of these photographs reflect the parameters of her fieldwork, a study of "cattle culture in Uganda," and present careful visual categorizations that aim to catalogue, at indexicality, but also reflect her very real enthusiasm for the beauty of everyday objects. A series of photographs detailing "the making of banana wine [in] Kabarole," for example, ends with a carefully framed image of a "wooden vessel for finished wine." Similarly, Robeson's images of people also start out in an ethnographic vein (e.g., "A Pondo miner having his hair 'wrapped' in the compound at Robinson Deep [South Africa]") but often produce insightful portraits in which her subjects smile back comfortably.

Robeson chose to photograph the majority of her African subjects in a manner that directly countered the visions of empire, which sought the primitive and the iconic, the authentic and the timeless.[32] In contrast, Robeson's photographs feature weddings, schools, people in combinations of Western and traditional/local dress. In these images, especially through the affirming genre of portraiture, Africans emerge as modern *individuals*, navigating both precolonial histories and colonial exigencies.

Through her camera, Essie also practices a modest gaze. Women almost always appear clothed in her photos, in contrast to the majority of photographs, postcards, films, and other visual ephemera that constructed native African women as savage and sexually available through visually equating nudity with primitivism (figures 7.2 and 7.3). Such framing might suggest a "politics of respectability," in which Essie imagines that a key way of elevating African women subjects in the eyes of American and European audiences is by visualizing them as modestly and chastely as possible. Indeed, an important goal of Robeson's trip was to seek out African women specifically. This was not always easy as Robeson's privilege placed her in a kind of liminal space as an honored guest under the protection of men and not relegated to designated "women's spaces." Her photographs, however, image women as often as she can: in marketplaces, in schools, in front of their homes. In Toro, Robeson spent the majority of her time with the herdswomen who handle the *bisahi*, the dairy. She describes this work as "women's business" and the women who conduct it as "delightful, intelligent, companionable."[33] She writes, "We enjoyed a lot of gossip while we worked, became very good friends, examined each other's hair, skin, clothes. We each found out how the other managed her husband, home, and children."[34] Thus we might also understand these photographs, like many others ("The schoolteachers of the district come to see us at our home in Kabarole"; "Some members

of the Nkole family who visited us at Kabarole to persuade us to come and see their country") as reflecting relationality and exchange, the encounters that were at the heart of this trip.[35]

Robeson does not take camera work lightly. Throughout the text, she reveals that she is highly sensitive to the ways in which the camera as an anthropological tool can lay bare the unevenness in the relationship between the anthropologist and her subjects, as well as, more importantly for the political commitments of the project, between black American and black African. Robeson repeatedly asks permission to pull out her camera and make photographs—whether of people, of objects, or of workspaces—and waits until she has established a rapport: "I never bring [my camera] out unless I am sure no one will mind."[36] She often offers something in return, whether photographs staged by the sitters themselves, as at the behest of the house staff in Kabarole; or money, as in the case of the Maseru, Basutoland, in South Africa where Robeson paid the hospital fees of those folks she photographed outside of the dispensary (clinic).[37]

In each of these ways, Robeson describes and practices photography as a kind of diasporic civil contract, photography as a tool that emphasizes mutual recognition between African diasporic subjects. Here, I borrow from Ariella Azoulay's compelling concept of "the civil contract of photography," in which Azoulay encourages us to envision the role of photographic spectatorship as one of "civic duty," specifically in the case of images of the abused, the violated, the dispossessed:[38] "The nation-state (re)territorializes citizenship. . . . Photography, on the other hand, deterritorializes citizenship, reaching beyond its conventional borders and plotting out a political space in which the plurality of speech and action . . . is actualized permanently by the eventual participation of all the governed. These governed are *equally* not governed within this space of photography where no sovereign power exists."[39] In Azoulay's formulation, the civil contract of photography reinvigorates the radical political and liberatory potential of the medium of photography.

One aspect of this political relation is to recall that the photograph is not merely the product of a technology but also evidence of a set of relations. In the case of Robeson's African images, the photographs record an encounter between two (differently) marginalized people, the photographer and the photographed, who have shared a space and a time. In the making of the image, the "partner-participants" enter a contract with one another and also with the users (later viewers) of the photograph, one in which we agree to speak to, of, and on behalf of the image and

Basutos at Maseru, Basutoland.

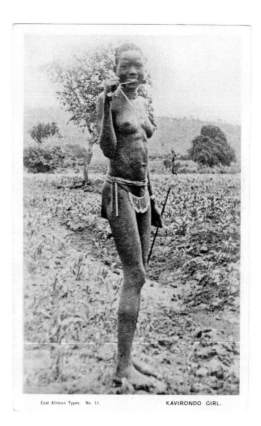

East African Types. No. 11.　　　　　KAVIRONDO GIRL.

7.2.

"Basutos at Maseru, Basutoland,"

photo by Eslanda Robeson, from *African Journey*. Courtesy of Robeson Family Trust.

7.3.

Postcard of African woman, collected by Eslanda Robeson, circa 1936. Courtesy of Robeson Family Trust.

its subjects. The photograph then is never simply a record of the past, but in its ability to travel physical and temporal distances is persistently extending viewing communities and reminding us that the "effect" and "meaning" of any photograph is never "sealed off" or determined in the final analysis. Photography's work is always in the present, in the here and now.[40]

Diaspora

We might understand Robeson's commitment to photography as announcing her as a "citizen in the citizenry of photography [which] entails seeking, by means of photography, to rehabilitate one's citizenship or that of someone else who has been stripped of it."[41] Put another way, photography reterritorializes belonging. This disposition is underscored by the presence throughout the photographs of Paul Jr., her young son whom, like Africa, she wants the world to see on his own terms. Robeson's photographs in *African Journey* draw on, and blur the line between, ethnographic photography and family snapshots; a desire to note the familiar

unknowingly slips into recording the familial. If anthropological photography finds pleasure in difference, family snapshots locate joy in sameness, in the filial and the familiar. In her dedication to "the brothers and sisters," Robeson is clearly hailing Africans as family, and locating her Pan-Africanist political vision in the space of kinship. Paul Jr.'s presence, in both text and image, brings this conjuncture into sharp relief.

It is the presence of Paul Jr., as traveling companion, interlocutor, photographic subject, and ward, that brings the genre-crossing or antidisciplinary work of *African Journey* into focus. Paul Jr. was born in Brooklyn in 1927, and for the first decade of his life lived primarily in England and Moscow, attending elite schools, and was largely isolated from other black children. For much of his life up to the moment of this trip, Paul Jr. was looked after primarily by Essie's mother, Ma Goode, while Essie traveled with Paul and managed her husband's business affairs. Essie often expressed enormous guilt about her extended absences as a mother. She did, however, have very clear ideas about how she wanted Paul Jr. to be raised and what kind of person she hoped he would become. She committed these ideas to paper in lengthy letters of instruction to her mother. In one letter, composed a little over a year before the Africa trip, Essie wrote that she wanted Paul Jr. to view himself the way Essie understood herself: "to feel perfectly at home and at ease in any company . . . to consider myself a pretty swell human being, and to look for human beings everywhere, in any walk of life . . . to open up my mind and to think with it . . . to do impossible things . . . to be as good as I could . . . never to think I am being looked down upon. I unconsciously feel I'm top dog. That's the reason I am at home in any society. I want Paul to have that."[42] Though originally not in the plan, it would seem that taking Paul Jr. along on this journey fit neatly into Essie's broader vision for her son: "If some Africans on a film set open up a new world to the child, a trip to the heart of Africa itself will be a revelation. He will see millions of other brown and black people, he will see a black world, he will see a black continent."[43] By intertwining her narrative of Africa with the experiences of her son, a dark male child, Essie alerts us to the fierce urgency of her vision for the African continent now and in the future.

Take for example the first image in which Paul Jr. appears, a group photograph of Zach Matthews, his wife Frieda, and their four children (figure 7.4). The Robesons visited with the Matthews at their home on the campus of the Fort Hare Missionary College in Alice, South Africa, almost 150 miles northeast of Port Elizabeth. Zach was a teacher there of "Bantu Studies." In the photograph, Paul Jr. (at extreme left), stands in line with

the three oldest children. He wears a button-down, short-sleeved, white shirt and khaki shorts just like the two other boys. At the same height, Paul Jr. and the Matthews's older daughter stand side by side, with matching smiles and each with a half of a piece of fruit in their left hand. Their bodies squarely framed by Zach's shoulders, Paul Jr. and the girl twin each other. Similarly, Paul Jr.'s facial angle echoes that of Frieda's as they both smile for Essie's camera. Zach's right hand rests on Paul Jr.'s shoulder, his left hand appears on Frieda's shoulder. Frieda's hands rest on the shoulders of two of her children. Through a series of circles, of visual rhyming patterns, Paul Jr. is successfully enfolded into the Matthews family.

Photography scholar Marianne Hirsch asserts that the camera functions as "the family's primary instrument of self-knowledge and self-representation . . . the primary means by which the family story is told."[44] In the photograph described above, as well as in the three other family portraits in which Paul Jr. is featured, we might consider Essie Robeson as attempt-

ing to tell a new "family story," of "Africa, 'my old country,' my background, my people, and thus about myself."[45] Paul Jr. serves as the link between Africa as anthropological research site and ancestral homeland. Paul Jr.'s presence also works to diminish the "intrinsic distance" between the Western observer occupying modernity and the "authentic African," fixed in a "backward" past. In doing so, Robeson asserts the "here" and "now" of African peoples, the urgency and exigency of African struggles in real time, and a new "truth" and "authenticity" of African subjects.

But familial looking can be deceptive and divisive. The identifications such imagery engenders, as Hirsch reminds us, "can be too easy . . . and can also draw . . . lines of exclusion and disidentification." These problematics become clear in Essie's photos of Paul Jr. in Ngite, a "Pygmy" village and popular tourist site in the Ituri forest of the Belgian Congo (figure 7.5). (The term *Pygmy* refers to any group whose members are "unusually short," generally under five feet tall. The specific group visited was likely the Twa.) In this image, Paul Jr. stands to the far right side of the group of village elders. They consider each other with curiosity. Paul Jr. and the village elders are all about the same height, probably around four feet, seven inches, and they occupy the same visual plane. This positioning certainly stands in contrast to popular safari photographs of full-grown white men and women who also visited Ngite, in which towering whiteness emphasized dissimilarity and worked to disparage and ridicule the Pygmies. However, it is Paul Jr.'s pith helmet, a hat commonly worn by British officials in the tropics, and his hands thrust into his khaki pants that mark him as foreign and highlight difference and distance. In the photograph with the Matthews family, Paul Jr.'s inclusion draws fictive though still heartfelt bonds of kinship between the African American Robesons and the Bantu Matthews, visually reconnecting the black family broken by and scattered in diaspora. As one woman proclaims of Paul Jr. on their trip, "That boy belongs to us—see his mouth, eyes, nose, and the shape of head—pure African. Oh yes, that boy belongs to Africa, to us."[46]

But as Essie stresses, the Pygmies are from another time and another place. She quotes author Grace Flandrau's description of the Pygmies as "not Negro" and Essie describes them as having "an oriental cast." In the Ngite village photograph, Paul Jr.'s Western clothing and his place at the edge of the frame alert us to the challenges of a project that visualizes race, to quote Tina Campt, as "the link that presupposes diasporic membership and is simultaneously the site of its questioning."[47] The juxtaposition of these two images of Paul Jr. in Africa underscores that the attempt to forge a politically viable diasporic relationship in the present is

not uncomplicated or without challenge. For example, throughout *African Journey* Robeson identifies her kinship and connection to the people she encounters and articulates a privileged access to the hidden transcripts of African colonial subjects. What aided her in gaining this access: her blackness? That she traveled alone with a child? That she was wife to the famous Paul Robeson? Indeed, was Essie flattering herself by imagining a belonging that she didn't actually possess, a brutal revelation that Saidiya Hartman discovered she must make peace with when she was hailed as *"obruni"* or foreigner by Ghanaians in her own African journey, as she described in *Lose Your Mother* a half century later? In terms of Essie's camera work, did her fierce desire to counter Hollywood and other dominant misrepresentations of Africans lead her to own misrecognitions?

We might consider Robeson's photographic practice the projection of a "Pan-African gaze." On one hand, this gaze aims to produce a visual counternarrative that will reframe global blackness against dominant visual narratives of primitivity and abjection. Yet on the other hand, such a gaze highlights relations of power in looking that speak to the unevenness of relations between differently positioned diasporic subjects. In addition to offering a vital political intervention, *African Journey*, in text and in image, also reveals moments of *décalage* and disavowal.

Notes

Epigraphs: Letter from Eslanda Goode Robeson to Harold Jackman, Monday, October 6, 1936, Robeson Correspondence, James Weldon Johnson Collection, Beinecke Library, New Haven, CT. Eslanda Robeson, *African Journey* (New York: John Day, 1945), 84.

1 Robeson, *African Journey*, 18.

2 Barbara Ransby, *Eslanda: The Large and Unconventional Life of Mrs. Paul Robeson* (New Haven, CT: Yale University Press, 2013).

3 *The Literary Guild Review*, August 1945, 14–15. In Eslanda G. Robeson Papers, Series B: Personal Papers, Box 11: *African Journey* Book Reviews, Moorland-Spingarn Center, Howard University, Washington, DC.

4 Roland Barthes, *Camera Lucida: Reflections on Photography* (New York: Hill and Wang, 1982).

5 Elizabeth Edwards, "Anthropology and Photography (1910–1940)," in *The Image of the Black in Western Art: The Twentieth Century: The Impact of Africa,* vol. V, part 1, eds. David Bindman and Henry Louis Gates Jr. (Cambridge, MA: Harvard University Press, 2014). See also Christopher Pinney, *Photography and Anthropology* (London: Reaktion Books, 2011); Stuart Ewen and Elizabeth Ewen, *Typecasting: On the Arts and Sciences of Human Inequality* (New York: Seven Stories Press, 2009); Deborah Poole, *Vision, Race and Modernity: A Visual Economy of the Andean World* (Princeton, NJ: Princeton University Press, 1997).

6 Kenneth W. Warren, "Appeals for (Mis)Recognition: Theorizing the Diaspora" in *Cultures of United States Imperialism,* eds. Amy Kaplan and Donald E. Pease (Durham, NC: Duke University Press, 1993), 394.

7 Warren, "Appeals," 394.

8 Letter from Eslanda Goode Robeson to Carl and Fania Van Vechten, September 9, 1945, Robeson Correspondence, James Weldon Johnson Collection, Beinecke Library, New Haven, CT.

9 Robeson, *African Journey*, 89.

10 Robeson, *African Journey*, 152.

11 Ransby, *Eslanda*, 121.

12 Robeson, *African Journey*, 119.

13 Robeson, *African Journey*, 119.

14 Lee D. Baker, *From Savage to Negro: Anthropology and the Construction of Race, 1896–1954* (Berkeley: University of California Press, 1998), 143.

15 On Malinowski, see James Clifford, *The Predicament of Culture: Twentieth Century Ethnography, Literature, and Art* (Cambridge, MA: Harvard University Press, 1988); Maureen McMahon, "Eslanda Goode Robeson's *African Journey*"; and Henricka Kulick, *The Savage Within: The Social History of British Anthropology, 1885–1945* (Cambridge: Cambridge University Press, 1991). See also Malinowski's introduction to his student (and Essie's classmate) Jomo Kenyatta's important ethnographic work, *Facing Mount Kenya: The Tribal Life of the Gikuyu* (New York: Vintage Books, 1965 [1938]).

16 Eslanda Goode Robeson, *What Do the People of Africa Want?* (New York: Council on African Affairs, 1945), 15, quoted in McMahon, "Eslanda Goode Robeson's *African Journey*," 126.

17 Robeson, *African Journey*, 136–37.

18 "Handmaiden of colonialism" is a phrase taken up and popularized by Talal Asad in his edited collection *Anthropology and the Colonial Encounter* (Ithaca, NY: Ithaca Press, 1973). See also Kamari M. Clarke, "Toward a Critically Engaged Ethnographic Practice," *Current Anthropology* 51, no. S2 (Oct. 2010): S301–12.

19 Robeson, *African Journey*, 107.

20 Robeson, *African Journey*, 65. Dr. Alfred Bitini Xuma, one of Essie and Paul Jr.'s hosts in South Africa, would go on to be president of the African National Congress (ANC) from 1940 to 1949. See Ransby, *Eslanda*.

21 Robeson, *African Journey*, 128.

22 Robeson, *African Journey*, 65.

23 Robeson, *African Journey*, 73.

24 James Clifford, *Routes: Travel and Translation in the Late Twentieth Century* (Cambridge, MA: Harvard University Press, 1997); Farah J. Griffin and Cheryl J. Fish, eds., *A Stranger in the Village: Two Centuries of African-American Travel Writing* (Boston: Beacon Press, 1998). Indeed, *African Journey* is based on and hews closely to the handwritten diary that Robeson kept during the trip. "Essie African Diary 1936," Eslanda G. Robeson Papers, Box 17: Diaries (1934–63), Moorland-Spingarn Center, Howard University, Washington, DC.

25 See Ann McClintock, *Imperial Leather: Race, Gender and Sexuality in the Colonial Contest* (New York: Routledge, 1995).

26 Robeson, *African Journey*, 48.

27 Ransby, *Eslanda*, 97-98.

28 Edwards, "Anthropology," 48.

29 Edwards, "Anthropology," 49.

30 These reels are held in the Eslanda G. Robeson Papers at the Moorland-Spingarn Center, Howard University, Washington, DC, but are currently unavailable for viewing.

31 Michael Young, discussing Malinowski's photographic practice, quoted in Pinney, *Photography and Anthropology*, 55.

32 See Paul S. Landau, "Empires of the Visual: Photography and Colonial Administration in Africa" in *Images and Empires*, eds. Paul S. Landau and Deborah D. Kaspin (Berkeley: University of California Press, 2002), 141–71.

33 Robeson, *African Journey*, 108.

34 Robeson, *African Journey*, 109.

35 See Charles Musser, "Presenting 'A True Idea of the African Today': Two Documentary Forays by Paul and Eslanda Robeson," *Film History* 18 (2006): 412–39.

36 Robeson, *African Journey*, 96.

37 Robeson, *African Journey*, 134, 60–61.

38 Ariella Azoulay, *The Civil Contract of Photography* (Brooklyn: Zone Books, 2008), 125.

39 Azoulay, *Civil Contract*, 25.

40 Azoulay, *Civil Contract*, 23. This "ontological-political understanding of photography" stands in opposition to colonial uses of photography; see Landau, "Empires of the Visual," 141–71.

41 Azoulay, *Civil Contract*, 117.

42 Letter from Eslanda Goode Robeson to Ma Goode (Eslanda Elbert Cardozo Goode), March 29, 1935. Quoted in Martin Duberman, *Paul Robeson: A Biography* (New York: New Press, 1989), 194.

43 Robeson, *African Journey*, 17.

44 Marianne Hirsch, "Introduction: Familial Looking," in *The Familial Gaze*, ed. Marianne Hirsch (Hanover, PA: University Press of New England, 1999), xvi.

45 Robeson, *African Journey*, 14.

46 Robeson, *African Journey*, 133.

47 See Tina M. Campt, *Image Matters: Archive, Photography and the African Diaspora in Europe* (Durham, NC: Duke University Press, 2012), 68.

8

Black and Cuba

An Interview with Filmmaker Robin J. Hayes

ROBIN J. HAYES AND JULIA ROTH

Black and Cuba, directed by Robin J. Hayes, a New York-based documentary filmmaker and scholar, follows a diverse group of Ivy League students who feel like outcasts at their elite university because of their concern about social justice, band together, and, in 2002, journey to the Caribbean island of Cuba—whose population is 60 percent Black. The students are drawn to Cuba because it is the only country in the African diaspora that claims to have an ongoing revolution. According to one of the travelers in the film, a trip to Cuba provides the opportunity to see "how Black resistance is lived."[1]

While filming their poignant encounters with Afro-Cuban rappers, students, and tourism workers, the American travelers discover connections between the continuing struggles for racial equality in the United States and Cuba. In the documentary, their experiences in Havana and Santiago are placed in historical context, with rarely seen archival footage featuring activists Fred Hampton, Kathleen Cleaver, and Malcolm X as well as hip-hop-style narration by a trio billed as the Harlem Chorus. Black and Cuba directly challenges assertions that either the United States or Cuba is postracial or colorblind while it illuminates how racial discrimination continues to be an international human rights issue. Prior to the 2014 symposium this volume is based upon, Black and Cuba was chosen to screen at a number of highly competitive film festivals—including the Pan-African Film Festival in Los Angeles and the BlackStar Film Festival in Philadelphia—and named "Best Film by a Black Director" at the Berlin Black International Cinema Festival. The following interview of Robin J. Hayes by Julia Roth and the discussion among the symposium participants took place after a screening of the film at the symposium in Hannover, Germany in September 2014.

As a visual text, *Black and Cuba* addresses three scholarly themes that relate directly to the study of race and politics. First, the documentary examines the significance of transnational engagement in the African diaspora. By illuminating how the students found commonality with their Afro-Cuban peers through sharing experiences of White supremacy and desires for progressive social change, the film shows how diasporic practice reflects what scholar Brent Hayes Edwards describes as the *décalage* (or gap) created by the dispersal of communities of African descent during the trans-Atlantic slave trade.[2] Second, the film demonstrates the impact of antiracist activism in the United States and abroad. The students' travel to Cuba is motivated by their exploration of the larger Black Radical Tradition through the work of authors such as C. L. R. James, Assata Shakur, and Frantz Fanon.[3] According to interdisciplinary scholars Cedric Robinson, Robin D. G. Kelley, and Besenia Rodriguez (among others), the Black Radical Tradition has consistently involved relatively nonviolent collective action by communities throughout the African diaspora who challenge "racial regimes" while reaching across borders to enhance knowledge and build networks in a manner that improves social movement efficacy.[4] The significance of the Black Radical Tradition is underscored by *Black and Cuba*'s juxtaposed imaging of the connections between the students' contemporary struggles with racial inequality and broader historical African American and Afro-Cuban struggles to overcome slavery, imperialism, and corruption. Third, this documentary indicates that certain policies and practices, such as racial profiling and police misconduct, continue to make racial discrimination a human rights issue for both African Americans and Afro-Cubans. *Black and Cuba*'s consideration of human-rights-oriented (rather than civil-rights-oriented) solutions to the violence, marginalization, and other forms of oppression caused by racial inequality builds on the Black Radical Tradition and anticipates the present-day work of movement organizations such as the Dream Defenders and Ferguson Action.[5]

Roth's interview of Hayes, and the lively discussion among the symposium's participants that follows, show how *Black and Cuba* can serve as a knowledge-producing resource for educators, students, artists, and activists alike. Roth, Hayes, and their colleagues discuss how the film articulates the often empowering process of the cultural and ideational exchanges and encounters that characterize transnational practice in the Black Radical Tradition. In addition, the group deliberates the film's ambiguities in regards to the impact of the Cuban revolution and the "colorblindness" policy of the Castro regime.

The Interview

Julia Roth: Thank you so much for sharing this wonderful documentary with us. I think it's a great project you realized. What did you and the other students discover during your trip?

Robin Hayes: Thank you, Julia. I only feel comfortable speaking for myself. Honestly, the trip to Cuba was the beginning of a long journey of self-discovery that paralleled the making of this film. During the trip, I began to understand how my experience of racial inequality in the United States as an African American linked to Afro-Cuban struggles. I also became more aware of how the extensive social safety net in Cuba has created certain conditions for Afro-Cubans, such as universal education and health care access, a lack of racial discrepancy in life expectancies, as well as smaller scales of violence and police brutality that we in the United States long for. Through making the film and showing it as a work in progress to community groups throughout the United States and internationally, I learned that I wanted to use film and interactive media to build a bridge between the antiracist knowledge we are building in the academy and the antiracist activism that is happening on the ground. Part of the process of developing as a filmmaker is that it's been helpful for me to get away from words. *Black and Cuba* is an expanded version of a documentary short I made about this journey called *Beautiful Me(s)*, which is based mainly on interviews with the people who were on the trip. In showing that piece at film festivals and community organizations, the feedback that I received was that people wanted to see more of Cuba, they wanted to feel like they were on the trip, basically. And that's why I expanded the project into a feature film—that was about forty minutes, and this is eighty-two.

The process for me has been about learning how to get away from words, after spending so many years in graduate school being absolutely drowned, drunk in words—to paraphrase Beyoncé—and feeling that words could solve everything and represent everything. They can't. Especially if your goal is to reach different kinds of audiences and advance knowledge for people at a number of different levels in a number of different contexts, you have to be willing to use all the tools that are at our disposal. The process for me has really been about allowing for image, allowing for abstraction, and allowing for people to take away their own meaning.

In my academic writing—I am in the social sciences so this is especially true—there's this pressure to be right, to predict, and to have

everything absolutely crystal clear and unambiguous. This is incredibly limiting in terms of what you can express. Therefore, for me this process of allowing people to really see my work for themselves and then allowing for the ambiguity that is going to evolve from that—because everyone has different eyes, different soul eyes and different historical eyes—and you have to just allow for that. That has been probably the thing I learned the most, and it has been extremely helpful also for my research now and my academic writing. A little bit of letting go, of having your say, and then letting go without letting go of responsibility.

Roth: Tying the discussion back to this symposium, "Migrating the Black Body," migration is a huge issue concerning Cuba in many ways, and by now Cubans are officially allowed by the Cuban state to travel to many more countries. Did you reflect on the fact that most countries on this planet won't let Cubans in or have great restrictions on them entering? Is it maybe a privilege that—for African Americans—Cuba is one of the few places in the world they cannot travel very easily to?

Hayes: I think it is fair to say everyone in the group was aware that having the blue passport of the United States of America (or in Theresa's case, the blue passport of Canada) is a privilege. Even though there's a blockade, the restrictions are coming from our government, not Cuba. Even though there have been these Cold War tensions, Americans are still able to go there from the Cuban side. It's not something that the group really discussed, but it was something that we were very clear about. We were able to engage with Cuba in a way that Afro-Cubans are not free to do. They are not free to come to the United States.

Roth: Have you considered a project that would invite Afro-Cuban students to come to the United States?

Hayes: Something that I have thought about in terms of moving forward with the project is how we can think about funding to see the reverse, which would be to have Afro-Cubans from the University of Havana, for example, come to the United States and do a tour and see what they think about African American life. What would be their impressions? How would their preconceived notions be tested and confronted if they came?

Roth: What is the intended audience of the film?

Hayes: The film's intended audience is people who are concerned about racial inequality and want to learn more. Because the reality is most people have not been exposed to these concepts. We are not teaching students in a lot of places in the world about the impact of U.S. imperialism

in the Caribbean or the full truth about the brutality of slavery and how people of African descent resisted this brutality. There is little in film or in scholarship that teaches history from the perspectives of those who have been colonized and/or enslaved or their descendants.

Roth: You mention in the film how complicated it was to explain to authorities and institutions the importance of a field trip to Cuba. Further, you were forced to work with this state organization for tourism in Cuba. Can you explain this context a little bit? What other obstacles did you encounter?

Hayes: Well, in terms of obstacles, honestly, the money *was* the biggest obstacle. Because we had been working together for such a long time and we also had been learning together prior to being in the Black Resistance Reading Group, we had a lot of confidence in one another and in our ability to keep working on it.[6] We found the Center for Cuban Studies in New York City—a nonprofit organization that organizes educational travel to Cuba—with which we designed our itinerary. The Cuban Institute for Friendship amongst the Peoples, also called ICAP, was very responsive to the fact that we wanted to do something specifically about race. So, planning the trip wasn't particularly difficult.

What really was difficult was getting the money to do it. As Erin, one of the students, mentions in the film, funding for our work—especially at the graduate student level—really focuses on thinking of yourself as an individual, competing with other people, competing with your peers to get a small sum of money and learning alone, developing your own expertise alone. As we all know from our studies of the African Diaspora, it is actually collective action that tends to help us most to advance work against racism.

In terms of being in Cuba, we spent a lot of time on our own. The supervision that we had was Alex [who worked for Havanatur, Cuba's national tourist agency]. In the film, he is very open about his frustrations as a young, well-educated Afro-Cuban man who wanted to use his skillset to help his family. He was critical of how Cuban police had racially profiled him and how the current economic structure in Cuba incentivized professionals like him to leave public service, where they earn Cuban pesos, and work in the tourist sector, where they can earn U.S. dollars. Alex's personal experiences echo Mark Sawyer's arguments in *Racial Politics in Post-revolutionary Cuba*, which state that Cuba's increased dependence on tourism and a privatized economy is exacerbating racial tensions, thus having a disproportionate negative impact on Afro-Cubans.[7]

Roth: . . . but he was working for the Cuban state.

Hayes: Yes, while Alex was working for the Cuban state, he felt very comfortable being on camera talking with us about his experiences of racial profiling in Cuba and his hope that educating the police could help solve the problem. When we were making the documentary, there was no hidden camera. We were with an official tourist organization. Alex was our guide. When we weren't with Alex, which was basically for a lot of time, from six P.M. to nine A.M., because he was off work, we were alone, except for the time when we were at the block party [in Santiago]. A lot of footage you see in the film of candid conversations between us and Cubans comes from our just walking around talking to people. The Cubans we spoke with knew they were being recorded, that we were making this documentary and still, they were open with us and sometimes critical of their government. For example, the young Afro-Cuban rappers we met were very open about their desire to go to the United States because they thought they could have a more lucrative music career there.

There's this impression of Cuba—because Cuba does have a state-owned press and there is censorship—that people don't ever speak their mind, that there's no on-the-street conversation that is free. And that was just not the case in our experience. It is also important to note that in the United States we, too, know something about censorship of the press, and a lack of freedom of expression by everyday people in the most powerful media outlets.

Roth: You shared with me that you personally know activists in Cuba that are much more critical towards the government. Was it more out of respect for those people not to film them? Or was this the overall aim of the film—to work more towards solidarity and also to point out conditions in the United States? Which I totally see, considering the U.S.-Cuban relations framework.

Hayes: The criticism of the Cuban government is loud and clear from Cubans in the film. In the United States our understanding of dissent in Cuba centers exclusively around the free speech issue and now more around freedom of speech as it has to do with the Internet. And the majority of the dissent community in Cuba is White, and they haven't had a lot to say (about) race.

We didn't meet with [free speech] dissenters, because it really wasn't what we were trying to find out about, which is these connections between African Americans and Afro-Cubans. We were asking: How does race and revolution work when you are really trying to live it, not just theorize about it?

Roth: One scene that struck me in the film was the one when one of the students says, "We're doing a 'field trip' to Cuba." This is telling because I think that Cuba remains pretty much the object of knowledge in the film, rather the foil, on which you discuss very important transnational issues. What I'm missing a bit are especially these voices of people who address these issues. Critical race thinking in Cuba is very vivid. I think here of the volume *Afrocubanas* on Afro-feminist thinking, for example.[8] There seems to be not enough dialogue in this regard—from both sides.

Hayes: Well, with the next phase of this project, which is going to be the audience engagement phase, we certainly plan to highlight even more Cuban voices. A lot of resources are already available. The website Afro-CubaWeb, for example, has a lot of Roberto Zurbano's work.[9] It has a lot of work by Esteban Morales. Both Zurbano and Morales are Afro-Cuban scholars who have been translated into English and who offer critiques about race that parallel what's seen in the film.[10]

Roth: Did you discuss what I call "global inequalities" in the sense that coming from any Western country—besides our passports, our currencies, our money—creates hierarchies?[11] Cuba has a double economy, and the tourism sector works completely in CUC, the convertible peso, which is close to the dollar, whereas Cubans that are not working in the tourism industry live on something like twenty dollars a month. And I think this is something that many people, even when traveling to Cuba, don't really get, because the Cuban state is not very interested in communicating it.

Your tour guide mentioned it in the film, but not how harsh it is according to my experience. The Cuban education system is impressive in my view. But nevertheless, the situation makes many young people drop out of the education system in order to make money in the tourism industry, and this is a big problem we are all involved in. When traveling to Cuba, we're catering to that very system in a way and their dependence on foreign currency.

Hayes: The Cuban experience of educational pursuits not necessarily leading to financial security was something that really hit home to me as an American because wages are essentially stagnant in my country.[12] So for my family, a Black working-class family, to get a PhD was everything. My grandparents, who are from the Jim Crow South, would tell me, "You want to get that education, that's the ticket to mobility," but the reality in the United States, as it is in Cuba, is that this is not really the case. Although I am fortunate enough to have a tenure track position as a professor, in Brooklyn where I live the average home price is over $600,000,

requiring a down payment of $120,000.[13] Meanwhile, the average amount of student loan debt an American PhD carries in the social sciences, humanities, or education is about $20,000.[14] An academic salary can no longer guarantee the kind of financial security it once did.

Obviously, there's a difference between being in a developing Caribbean country and being in the United States. There are different material conditions. But we are getting to a point in America where, because there's so little funding for public education and the arts and any kind of cultural production, young people are checking out of liberal arts/humanities education, because it literally doesn't pay. So I think it's a struggle Americans definitely have in common with Cubans. In both countries, for many people there is a big difference between what you can do to get enough dollars to live and have some semblance of financial security versus what you really might want to do with your life, to be fulfilled, to make a contribution to society. And those things are often not aligned, you know.

Roth: I know, and I'm really with you. It was just my impression that the students in the film seem to have a nostalgic impression of what Cuban everyday life is like. [This nostalgic impression] might not hold true once you move to Cuba and try to be part of the revolution. Nevertheless, it's a great project. And I'm sure people in the audience want to jump in and join the discussion.

Discussion

Courtney Baker: I'm glad Julia did bring up this question of Cuba as an object of knowledge. I want to ask about disentangling Cuba as an object of knowledge, which is really kind of problematic and complicated, and the film as an instructional tool and the way it frames this journey as an educational project. The film itself is a kind of exposé. I'm one of two people who are leading the initiative at my institution to reinvigorate Africana studies. I was watching the film in part thinking about the efficient work it did in articulating the simultaneous political and educational investments of Africana studies and where the Cuban experience fits in. My question, because I'm thinking about how to screen this, is what have been your experiences showing it? I am thinking here of a term you engage with in the film, which is "propaganda." Have you encountered people who have said, "This is just propaganda"?

Hayes: No one has said distinctly, "This is propaganda." There have

ROBIN J. HAYES AND JULIA ROTH

been a series of work-in-progress screenings to get feedback from the communities I hope to serve with this piece. At those screenings, audiences consistently told us [Hayes and the film's distributor, Progressive Pupil] that they want more information, more in-depth, glossary-like scenes that contextualize the students' experiences. If anything, audiences at places like La Casa Azul bookstore in East Harlem and the California African American Museum wanted more so-called propaganda, not less.

There has been only one work-in-progress screening for a majority White audience, which took place at the Institute for Retired Professionals at the New School. Interestingly, two-thirds of the audience was one hundred percent with it. A White woman actually came up to me after the screening and said, "I was in Cuba in 1952, and that revolution had to happen, it was deplorable! The conditions were terrible!" But then there were people who walked out during the scenes that discussed slavery in Cuba.[15] They walked out. And there was another gentleman who was very disturbed. I really tried to understand what was so disturbing to him about the film and he literally didn't have the words. He just didn't like it. I think that's okay—it's okay if people have really strong reactions because it's time to talk about these things. Who knows, maybe I'm priming the pump, and the next time someone mentions slavery, that person won't have to leave the room.

The propaganda charge—having done work on Cuba for a long time—is always something that infuriates me, because we're bombarded with propaganda all the time, and it's never named as such. CNN is considered by some to be twenty-four-hour capitalist neoliberal propaganda. I wouldn't necessarily use those terms, but I wouldn't necessarily argue with someone who did. I think one might make a convincing case. The accusation of "propaganda" shuts conversations down. It's a weapon against work that is for people who are trying to advance human rights and a weapon against work that reflects the perspective of people who are marginalized. People still say that Howard Zinn's *A People's History of the United States* is propaganda, but it simply tells truths rarely told even today in American textbooks.[16] So, it doesn't bother me, the charge of propaganda. I think that it is okay to tell a story from a certain point of view. And then I also say: What's the counter-argument? Do you really need me to explain the White supremacist side? I don't feel compelled to defend White supremacy in order to present a fair and balanced argument.

Charles Nero: I'm always asking, "Where is the Queer perspective"?

And I know that it was difficult to find, but I was grateful that there was LGBT in the credits, that it was addressed. And maybe you would want to talk about what were the challenges that you faced with that. . . . [There are] a couple of questions I have about omissions . . . one is that we haven't any discussions at all about imprisonment especially of Gay men by Castro—

Roth: —but this has changed.

Nero: I was a little bit curious about why we didn't have any discussion about the massacre of 1912, the race massacre of 1912.

Alanna Lockward: There is a great film by Gloria Rolando.[17]

Hayes: The historical information in the film links more or less directly to the students' experiences in the United States and Cuba. The massacre of Afro-Cuban activists who were part of the Independence Party of Color, many of whom were veterans of Cuba's independence war, is a very important part of Afro-Cuban history, but it did not quite fit with the film's narrative arc. The auxiliary and second-screen elements of *Black and Cuba,* which include curriculum guides for professors and high school teachers (tied to the Common Core), a website, and a social media education campaign, will broaden the information provided by this project beyond the film itself.

The audience engagement plan is to make the film a starting point, so there is room for the other resources that are available about the issues that are raised. We want to empower people to customize the film according to their local needs by, for example, discussing diversity on campus, Black Lives Matter, and violence in communities of color in the United States.

Nana Adusei-Poku: You show people of color in search for their identities, I was just wondering if you can elaborate a little bit about [how the Afro-Cuban perspective relates to] what happens in South Africa [with the categorization of indigenous and mixed race people as "colored" as shown in the photography exhibition *Coloured: A Profile of Two Million South Africans* by Rushay Booysen] and how are these categories still playing out?

Hayes: There is quite a tension within Cuba between Afro-Cubans who identify as Black and Afro-Cubans who identify primarily as Cuban. From what we learned and everything I've researched in the making of the film, it is clear that although older forms of exclusion and discourses of White supremacy never completely disappeared after the Cuban revolution, the reintroduction of capitalist competition is exacerbating these

ROBIN J. HAYES AND JULIA ROTH

issues. The introduction of dollars has literally fanned the flames of racial difference. The public sector was such a vehicle of economic mobility, of social mobility, for Afro-Cubans (as it has been for African Americans). Now, as that diminishes, and more and more dollars are coming from the Cuban American community, which is something like 97 percent White, the inequality that was already there is deepening.[18]

And the cultural discourse, from what I understand, is lying on top of those intersections between race and class to explain and justify these differences. It is complicated in that sense.

Also, there is this postrevolutionary national discourse of what it means to be Afro-Cuban and what needs to happen in Cuba to fully empower that identity and to fully address these problems. There's not necessarily a consensus. But there is pressure to present to the outside world this sense that the Cuban state has made progress around racial issues and is working on it. So, it is important for us—and when I say us, I mean people who are concerned about racism and people concerned about Cuba—to encourage a conversation that respects Cuba's autonomy, but also respects Afro-Cuban autonomy to have these conversations. It is important to find a way to engage across borders without necessarily imposing one's own understanding of race, which is always difficult.

Adusei-Poku: From the aesthetic point of view, as I was watching the film there are so many different strands that came together in this historical narrative. I was just wondering why you haven't chosen other aesthetics rather than pointing the camera at the dancing bodies [at Casa de Cultura in Santiago de Cuba]. I don't know if you're familiar with Isaac Julien's film about Frantz Fanon. Can you imagine something like that for your upcoming project?

Hayes: I love Isaac Julien's film *Frantz Fanon: Black Skin, White Masks*. In *Black and Cuba*, my intention with the dancing was to balance this very difficult conversation about the violence and the subjection of slavery with a discussion about how Afro-Cubans have then and now recovered their subjectivity and humanity. It's not meant to be dancing for dancing's sake.

Something that I have learned from this process is that it's okay to allow things to be fun. So part of what the dancing does from an entertainment standpoint is that it takes the edge off. And maybe it adds the edge for some people. But these are the kinds of things that you think about when you're making a film and that you don't necessarily have to think about when you're writing an academic monograph in which you can never take the edge off because people can just close the book.

Cheryl Finley: I read it as something that's very documentary of your experience with the graduate students—being in this reading group, going on this quest together. Something that's very different from Isaac's work—it's wonderful, but it's also different. And I don't think one could actually do the type of really important activist educational work and art that you are doing in that format. And I'm not saying that Isaac's work doesn't do that, but it's a different thing. It's a different moment in time and a different quest.

Roth: While I was in Cuba recently I was shocked by the racist vocabulary White Cubans used in our conversations with them, but also by some non-White Cubans, by describing their children and themselves because they were using terms I do not want to repeat here. The vocabulary was different from what we were used to in our German (understanding of) political correctness. This was constantly troubling our students. My experience is that the dancing is, of course, a tradition Afro-Cubans are proud of, but it also is an image that the Cuban state wants to reduce them to.

Leigh Raiford: You are trying to think through some of the questions that I have myself in regard to Eslanda Robeson, about her journey and your journey as differently routed heritage tourism, but still journeys of desire and homecoming. What are the geographic points of an early twenty-first-century diasporic imaginary for African Americans, particularly versus what they were in the early twentieth century? Does Cuba become that place in this film?

Hayes: In terms of different kinds of heritage tours, it's interesting to me because at least since I ran away and joined the radical circus when I was twenty-one, I have thought about this political heritage as my family. So for me all the travel I've done has been about trying to discover roots. But the roots that were mine were these radical roots.

I've been involved in this kind of heritage tourism for a long time, and it has actually similar problems, as Julia and Nana have pointed out, that you can oversimplify and glamorize the struggle that has come before and its implications. You can ignore the complexities and dynamics of power that are happening right now in your interest of holding on to what came before. A great example of that was the commemoration of the March on Washington for Jobs and Freedom, in August 2013. It was a kind of heritage tourism where people went to recreate this great moment in antiracist history. There were all these people who were there who wanted to talk about Trayvon Martin and mass incarceration, and [instead] they got

Obama talking about personal responsibility. It's important to obviously understand the history, but the tourism can slip into obscuring the present. Articulating the relationship between the past and the present is hard work, but there is really great understanding that can come out of that. It's important not to just throw the heritage out with the complicated bathwater. We have to try to figure out how to make a nuanced connection.

Karen Salt: I wanted to thank you, not only for showing it, but for your graciousness to talk about this. One of the things I found probably the most interesting but yet unresolved in the film is this search for an interracial or Black imaginary that is then localized in a natural space. But what I found really interesting is the affective charge being in that place. The students walking around [Moncada Barracks], seeing the gunshots and having this emotional response . . . It's like a physical response to being in these places where others have been. Actually, it's a visceral response. I'm fascinated about how that plays out in the film, but then simultaneously, it's undercut and doesn't play out with the scenic breaks between these historical scenes.

What do you do with all of that affect? Because I can imagine that you were having these experiences, but then you sit in your room at night and you're trying to talk about the day, how did it all feel, and people cry and people feel this and that . . . Why didn't you put that in? Do you feel like talking about [these emotional responses] with the audience, or do you feel like that would lead to a whole different set of conversations?

Hayes: As graduate students we didn't feel very comfortable with our feelings in the sense that our feelings would be something legitimate to explore and discuss, something that could help produce knowledge. In the academy, especially as people of color in the academy, when we start talking about our feelings, we often get into a lot of trouble. We're not free to cry, right.

(From the audience): Yeah, well, but we do it.

Robeson Taj Frazier: I enjoyed the film. I've been waiting to see it for some time. I have two questions for you. The first is: What kind of multimedia presence do you have, if you have one, or do you have other kinds of pedagogical tools, because clearly the film is a pedagogical tool in of itself, but are there other forms of media, texts, or film that you can bring in alongside with it?

The other question I have is, where do you see your film alongside other recent films in the last ten years that deal with a certain kind of contemporary Black radical imaginary in Cuba? Like *Inventos,* which is

talking about hip-hop in Cuba or the film *Black August Hip Hop Project* by Dream Hampton?

Amna Malik: I have an observation that has to do with the form. It seems to resonate with when Nana mentioned Julien's film and Cheryl insisted that it's a documentary, and it's different. I think it might be interesting to mention Getino and Solanas's *The Hour of Furnaces*, which is a really inspiring documentary. It's pedagogical, it's about liberation, yet very long. The Black Audio Collective took that novel *Signs of Empire* and created something to raise awareness about colonialism in the UK in 1980.[19]

This raises the question of creating a project that extends what you were doing, which I think is fantastic, but deliberately moving away from a form of professionalism and it demands a lot more discussion around it. To a point where the question of the ethnographic gaze or the question of a sort of an imaginary that you're seeking, but that you are not able to find is left critically unresolved but in a quite productive way. And there is a lot of really fantastic material here. I am thinking about how this could be pushed in other ways. So that's another observation.

Lockward: Have you seen the exposition "*Queloides*: Racism and Race in Cuban Contemporary Art" by Alejandro de la Fuente?[20] When this finally took place, I thought "fantastic" because this is a taboo so far in the art world, racism against Black people in Cuba. This is the first major exhibition that thematizes the subject. So I think for my own therapeutic state of mind, I have to say this: I see your film, and I see a totally different Cuba.

Hayes: Thank you all for your comments. I wanted to speak quickly to the comment on form. The form of eighty minutes, for me as an educator, seemed like it could fit into a three-hour, once-a-week seminar and you can have discussions; or you could also break it into two forty-minute installments if you have 120-minute classes two or three times a week. Also with an eighty-minute film, you could have a two-hour community program that leaves time for discussion and introduction. My thinking about form and how it could be used for community activism, as it was for [Argentinian filmmakers Octavio] Getino and [Fernando] Solanas, who helped us understand the concept of third cinema with their manifesto and how filmmaking could be used to help communities of color envision social change.[21] However, we're in a different time from the late 1960s, where it's tough to show a seven-hour piece like [Getino and Solanas's classic work] *Hour of the Furnaces*.

Alanna, I also want to address your comment. I respect completely that you have seen a different Cuba than what is represented in the film. I would never assert that this documentary tells every story that needs to be told about the Afro-Cuban or the African American experience. My hope is the film will begin a vibrant conversation between those of us who have had the chance to see Cuba for ourselves and those of us who are interested in Cuba because of its historical, symbolic, and cultural location in the African diaspora. I hope this conversation will illuminate—despite all our different viewpoints—how those of us who are concerned about racial equality can work together across borders and see ourselves as agents of change.

Notes

1 Robin J. Hayes, dir., *Black and Cuba,* Progressive Pupil, 2014.
2 Brent Hayes Edwards, *The Practice of Diaspora: Literature, Translation, and the Rise of Black Internationalism* (Cambridge, MA: Harvard University Press, 2009), 1–15.
3 Cyril Lionel Robert James, *The Black Jacobins: Toussaint L'Ouverture and the San Domingo Revolution* (London: Penguin UK, 2001); Assata Shakur, *Assata: An Autobiography* (London: Zed Books, 1987); Frantz Fanon, *The Wretched of the Earth* (New York: Grove Press, 2007).
4 On the Black Radical Tradition, see Cedric J. Robinson, *Black Marxism: The Making of the Black Radical Tradition* (Chapel Hill: University of North Carolina Press, 1983); Sidney J. Lemelle and Robin D. G. Kelley, "Imagining Home: Pan-Africanism Revisited" in *Imagining Home: Class, Culture, and Nationalism in the African Diaspora,* eds. Sidney J. Lemelle and Robin D. G. Kelley, 1–16 (London and New York: Verso, 1994); and Besenia Rodriguez, "'De la Esclavitud Yanquí a la Libertad Cubana': U.S. Black Radicals, the Cuban Revolution, and the Formation of a Tricontinental Ideology," *Radical History Review* 9, no. 2 (2005): 62–87. On enhancing the effectiveness of social movements, see Doug McAdam, *Political Process and the Development of Black Insurgency, 1930–1970* (Chicago: University of Chicago Press, 2010); and Robin J. Hayes, "'A Free Black Mind Is a Concealed Weapon': Institutions and Social Movements in the African Diaspora," *Souls* 9, no. 3 (2007): 223–34.
5 Iris Marion Young, *Justice and the Politics of Difference* (Princeton, NJ: Princeton University Press, 2011); Penny Marie von Eschen, *Race against Empire: Black Americans and Anticolonialism 1937–1957* (Ithaca: Cornell University Press, 1997); "Dream Defenders Team Up with NAACP to Fight 'Stand Your Ground' Laws," *Huffington Post,* September 13, 2013; Lindsey Bever, "Michael Brown's Parents Take Their Case to the United Nations," *Washington Post*, November 12, 2014.
6 The Black Resistance Reading Group was a collective of graduate students at Yale primarily based in the African American Studies Department who met monthly to read works about the Black Radical Tradition between approximately January 2001 and June 2002; Hayes, *Black and Cuba*.
7 Mark Q. Sawyer, *Racial Politics in Post-revolutionary Cuba* (Cambridge: Cambridge University Press, 2005).
8 Daysi Rubiera Castillo and Ines Martiatu Terry, *Afrocubanas: Historias, Pensamiento y Prácticas Culturale* (Havana: Editorial De Ciencias Sociales, 2011).
9 "The African Cultures in Cuba," AfroCubaWeb, accessed April 1, 2015, afrocubaweb.com.
10 Roberto Zurbano, "El Rap Cubano: Can't Stop, Won't Stop the Movement!" *Cuba in the Special Period: Culture and Ideology in the 1990s* (New York: Palgrave Macmillan, 2009), 143–58; Esteban Morales Dominguez, *Race in Cuba: Essays on the Revolution and Racial Inequality* (New York: New York University Press, 2012).
11 Julia Roth, "Translocating the Caribbean, Positioning Im/Mobilities: The Sonic Politics of Las Krudas from Cuba," in *Mobile and Entangled Americas*, eds. Maryemma Graham and Wilfried Raussert (Farnham: Ashgate, 2016); and Manuela Boatcă, "Unequal and Gendered: Notes on the Coloniality of

Citizenship Rights," in *Dynamics of Inequalities in a Global Perspective*, ed. Manuela Boatcă and Vilna Bashi Treitler, special issue, *Current Sociology* (January 2016): 191–212.

12 Data from the U.S. Bureau of Labor confirms that in purchasing power, wages have increased only approximately $1.50 per hour between 1964 and 2014; see Drew Silver, "For Most Workers, Real Wages Have Barely Budged for Decades," *FactTank: News by the Numbers*, October 9, 2014, accessed April 1, 2015. On the economic impact of wage stagnation in the United States, see Jon D. Wisman, "Wage Stagnation, Rising Inequality and the Financial Crisis of 2008," *Cambridge Journal of Economics* 37, no. 4 (2013): 921–45.

13 Zillow, accessed April 1, 2015, www.zillow.com.

14 Jordan Weismann, "Ph.D. Programs Have a Dirty Secret: Student Debt," *The Atlantic,* January 6, 2014, accessed April 1, 2015.

15 To offer viewers historical context about the practice of slavery in Cuba, *Black and Cuba* utilizes graphic illustrations from the nineteenth century to discuss the use of *barracones*, or prison-like structures to house Cuban slaves, torture techniques employed to discipline slaves such as the "four poster" treatment and whippings, as well as how Afro-Cubans used drumming, dance, and other forms of African culture to build community and affirm their humanity.

16 Howard Zinn, *A People's History of the United States: 1492–Present* (London: Pearson Education, 2003).

17 Gloria Rolando, *1912: Voces para un silencio* (Havana: Imagenes de Caribe, 2010).

18 Sawyer, *Racial Politics in Post-revolutionary Cuba.*

19 *The Hour of the Furnaces*, dir. Octavio Getino and Fernando E. Solanas, 1968; *Expeditions: Signs of Empire*, dir. Black Audio Collective, 1983–1984.

20 Alejandro de la Fuente, ed., *Queloides: Racism and Race in Cuban Contemporary Art* (Pittsburgh: University of Pittsburgh Press, 2011).

21 Fernando Solanas and Octavio Getino, "Toward a Third Cinema," *Cineaste* 4, no. 3 (1970): 1–10. Getino and Solanas's manifesto argued for an approach to filmmaking distinct from the escapism common in Hollywood films (which they called first cinema) and from the individualism of the *auteur*-driven independent film (second cinema) in order to create films that would authentically reflect the experiences of communities in the developing world, as well as empower those communities to action.

9

Return to Which Roots?

Interracial Documemoirs by Macky Alston,
Eliaichi Kimaro, and Mo Asumang

CEDRIC ESSI

he last two decades have seen the emergence of numerous
American autobiographical works that thematize heterosexual
kinship across the color line, ranging from James McBride's *The
Color of Water* (1995), Barack Obama's *Dreams from My Father* (1995), and
Bliss Broyard's *One Drop* (2007) to Danzy Senna's *Where Did You Sleep
Last Night?* (2009). Part of this phenomenon has been the production
of filmic versions that will be here addressed as "interracial documem-
oirs." Across medial specificity these works frequently formulate claims
to multiracial kinship through quest narratives in which the protagonist
returns to familial roots in the American South or homelands abroad to
seek out racial and cultural coordinates of origin. This essay contours the
rise of interracial (docu)memoirs, interrogates their narrative formula, and
zooms in on the motif of the return as "diaspora poetics."[1] By way of three
case studies, I carve out three distinctive modes of return and examine
how representations of the black-identified body are functionalized to
project and claim specific forms of roots. I will first turn to *Family Name,*
in which the white New Yorker Macky Alston travels to North Carolina to
uncover his slaveholder lineage but gradually shifts his focus in a search
for familial connections to black America. In *A Lot Like You,* I follow the
self-identified mixed-race protagonist Eliaichi Kimaro in her journey from
Seattle to her father's birthplace on Mount Kilimanjaro and interrogate
how the multiracial-diasporic subject seemingly "comes home" to the
ancestral hut. Lastly, this essay broadens the discussion of the return
motif through an analysis of the documemoir *Roots Germania,* which
revises the Africa-centered homecoming script to lay claim to Germany
as a homeland for the marginalized Afro-German filmmaker Mo Asumang.

The critical readings thus follow different routes by turning from a U.S.-specific paradigm to an American transnational one, before finally exploring the phenomenon of interracial documemoirs and the politics of return in the German context.

Interracial (Docu)Memoirs

The extensive contemporary production and circulation of autobiographical narratives about interracial kinship in the U.S. context can be read as an intervention in a longstanding racial discourse that tabooed, denied, and criminalized sexual and familial relations across the color line.[2] Interracial memoirs at the turn of the twenty-first century constitute counterdiscourses to this cultural-historic legacy. Almost obsessively, interraciality is retrieved from a script of tragedy and reframed into stories of familial cohesion, personal closure, and upward mobility that follow a formulaic narrative structure of thematizing, reconstructing, and reconciling "competing ethno-racial . . . inheritances."[3] First, the narrator addresses the tensions that arise out of a multiracial heritage. Second, the attempt to level these conflicting affiliations leads to a physical as well as internal journey to the American South or origins abroad to claim familial and/or cultural roots. Third, the success of the quest is communicated through invocations of closure and the image of a reconciled interracial family that is, in turn, frequently projected as a national allegory.

I understand the formulaic quality of these memoirs as, on the one hand, linked to the specificity of the autobiographical genre, and as, on the other hand, symptomatic of and participating in a pervasive postracial aspiration that Tavia Nyong'o describes as the "inarticulate desire to see the color line subside along with the twentieth century."[4] The paradigm of the family, with its emphasis on progress and reconciliation, closure, cohesion, and coherence at century's end, usually obscures ongoing structural racism and reduces racial politics to the cultural legitimization of interracial kinship constellations that adhere to otherwise conservative, heteronormative, middle-class ideals of "family."

It is significant that autobiographical narrative is the primary mode through which interracial kinship has been articulated since the 1990s. The truth claim that is inscribed into this nonfiction genre through the "autobiographical pact" is employed as an empowerment discourse on interraciality that serves as a self-authored corrective to external, pathologizing projections of the past.[5] These visibility politics tie in with

a specific form of narrative construction that I frame as "interracial memoir." Unlike conventional autobiography, which focuses instead on the writer's own individual timeline, the narratives in question are designed as quests that revolve around immediate, distant, or absent kin in order to claim specific forms of familial-racial affiliations. This structure is not limited to written texts but also applies to filmic versions. Documemoirs such as Macky Alston's *Family Name* do not center on the reconstruction of an individual life but present relational narratives that address competing racial-familial affiliations, organize themselves around a quest for roots, and end in the supposed reconciliation of interracial genealogies.

The fusion of autobiographical storytelling with the medium of documentary that proliferated in the United States in the 1990s emerged, in part, as a critical response to observational documentary that was no longer considered as objective but rather as complicit with oppressive, hegemonic discourses.[6] In the words of film scholar Bill Nichols, autobiographical aesthetics in documentary enabled a paradigm shift from "I speak to you about them" to "I speak about myself to you." Along these lines, documentary in the autobiographical mode has often been framed as a form of democratized storytelling and dovetails with the visibility politics of interracial memoirs generally.[7] Scholarship has referred to such audiovisual narratives through terms like "first-person documentary," "auto-documentary" or "autobiographical documentary."[8] However, these labels do not account for the narrative's relational design, which is why I employ Thomas Couser's terminology of "documemoir" to mark the intersection of the visual and the relational framework of memoir narrative.[9]

Narratives of Return as Diaspora Poetics

Marianne Hirsch and Nancy K. Miller argue that since "diaspora" relies on an originary space as a point of reference, it usually implies "a fantasy of return," which they position as a defining "diaspora poetics." According to them and other scholars like Alondra Nelson, the bestseller *Roots* by Alex Haley established an "ur-text" of "the performance of roots seeking" for black as well as white Americans, a narrative template of return for the identification and recovery of "personal and cultural beginnings."[10] The quest for roots in many interracial (docu)memoirs can be seen as another variation of Haley's foundational story. Time and again, interracial memoirs present a return to the American South or homelands in Africa or Europe in order to anchor the self in an empowering genealogy and

tie the return to diasporic familial reunion and reconciliation as well as to epiphany, catharsis, and closure.

Following Tina Campt's considerations on family photography, I read interracial (docu)memoirs not as factual representations of cross-racial familial relations and genealogies, but as an "active production of (af)filiation."[11] In the context of the return motif, this entails Hirsch's and Miller's premise of diaspora poetics, arguing that the return does not discover or recover roots, but that these are "constructed in the process of the search."[12] The return narrative actively constructs what it claims to uncover, or in Alondra Nelson's words, "Root-seekers . . . become root-makers."[13] But which roots are to be followed and claimed when dealing with interracial genealogies? What is the root seeker's specific investment? Who is (and who is not) claimed as kin and ancestor figure in the quest for origins? Which racial, cultural, geographic, and ideological coordinates have been set as the destination of the return while other potential points of origin are discarded and repressed?

Returning to the Plantation:
The Black Body as Redemptive Figure

In the documemoir *Family Name*, the New Yorker Macky Alston returns to his Southern origins in North Carolina to lay bare his family's slaveholder past and simultaneously embarks on a quest for black kin in order to initiate a "conversation" on slavery through the prism of kinship: "I wanna find someone who through slavery somehow might actually be my cousin. If I can find out that we are, in fact, related, I wonder what kind of conversation then we would have with that knowledge."[14] That conversation, however, never comes to pass and the quest narrative accomplishes redemptive rather than challenging work and joins the ranks of memoirs such as Edward Ball's *Slaves in the Family* (1998) or Bliss Broyard's *One Drop* (2007) by articulating claims of interracial kinship in a sensationalist, confessional register. While these narratives have been frequently understood as subversive acts that reveal hidden legacies of race and slavery in America, my argument holds that the subversive potential of these stories is usually contained, even neutralized, as critical engagement with the past is gradually displaced by the prioritizing of cross-racial kinship recognition. Macky Alston, for instance, begins his narrative by posing as a rebellious, queer heir to the South willing to address a repressed slaveholder legacy. Over the course of the narrative, however, the *famil-*

ial secret of slavery becomes reformulated as *slavery's secret of family* as Alston eclipses rape under slavery as the root of his interracial family tree and never explores the afterlife of slavery beyond the disavowal of interracial kinship.

Throughout the narrative, shame around a slaveholder legacy is furthermore deflected from the autobiographical subject to his black surroundings. While the documentary starts out by announcing its goal to critically revisit white family history, it predominantly engages in interviews with black Alstons who are, time and again, pressed to elaborate on their sense of self in regard to being the descendants of slaves owned by white Alstons. Instead of directing the camera at Macky Alston himself in order to interrogate his own relation to the familial legacy and how that legacy positions him as a white subject in terms of economic, cultural, and social capital, *Family Name* inverts the shame around ancestry and displaces it onto black bodies that are forced to respond and negotiate their relation to black abjection. While *Family Name* is marked and marketed as a liberal endeavor of racial reconciliation, it actually performs the work of a white redemptive project that unwillingly reproduces slavery's forms of abjection on a symbolic level. *Family Name* becomes another instance of what Christina Sharpe describes as "slavery's inherited and reproduced spaces of shame, confinement, intimacy, desire, violence, and terror," as we see, time and again, the privileged descendent of slave owners pressing black Alstons to confront their origin in the social death of the slave.[15]

This dynamic becomes most salient during an interview at the site of a former Alston plantation. The protagonist meets with Reverend Dolores Alston, who does not seem to be interested in reuniting white and black Alstons, but rather comes in the hope of recuperating genealogical knowledge that the institution of slavery has erased for the vast majority of the black diaspora in North America. As Macky and Dolores Alston revisit the "spaces of shame . . . violence, and terror" of slavery, the protagonist again displaces questions of shame onto the black body as he relentlessly screens his interlocutor for anger towards him as the descendent of slave owners. Towering over Dolores Alston, his potential feelings of guilt in the confrontation of a "common" legacy of slavery become reduced to being an issue of black anger. When Dolores Alston declares in a semi-annoyed (and semi-upset) manner, "No, I don't feel any anger!" we hear Macky Alston's voice-over conclude with relief: "I guess I expected black Alstons to be angry and white Alstons to feel guilty." In putatively attesting the absence of black anger, the film seems to conclude that accountability

and ongoing structural racism as slavery's legacy do not have to be inter-rogated either.

The last part of the documemoir thus not only deflects shame by skip-ping the initially announced conversation on slavery altogether and by jumping ahead to celebrations of reconciliation. In fact, the end of the doc-umemoir even seems to suggest, retrospectively, that a (self-)critical inter-rogation of the history of enslavement is obstructive to reconciliation. Like many interracial memoirs, the quest narrative *Family Name* culminates in what is staged as an extended family "reunion" that is encoded in terms of reconciliation and closure. Here, the camera again turns away from Macky Alston in order to zoom in on black bodies through whom redemp-tion is ventriloquized for the white subject.[16] During the reunion itself, the documemoir focuses on Fred Alston, who performs a poem entitled "A Prayer for Healing." Subsequently, the protagonist is absolved from his ancestor's deeds through the positioning of a black savior figure. We meet Vincent Alston, a young African American descendent of an Alston plan-tation who is introduced as having been "on a similar search for Alston history, but from the black side" ever since he contracted HIV. Once again, the camera and narrative divert attention away from a potential self-crit-ical engagement on the part of the autobiographical subject by turning the often-announced conversation on the legacy of slavery into a black monologue—this time literally, because the editing has omitted the inter-viewer's questions so that Vincent's words are actually decontextualized for the viewer. Macky Alston's voice-over and choice of supplementary video footage, however, (re-)frame Vincent's presence and words within a redemptive line of argument. His words are thus implicitly extended from a personal stance on his illness to a testimony on the legacy of slavery that seemingly allows *Family Name* to formulate a postracial epiphany. We listen to Vincent as he recalls his diagnosis: "They were telling me that I would only probably live six months to a year. After dealing with that, real-izing how fragile life is and how unimportant it is to hold on to things that prevent me from growing . . . that has helped me today with everything in my life, because I wanna grow, everyday wake up *move forward* and grow, not let anything hold me back."[17]

The testimony of the terminally ill Vincent Alston is utilized to shut down the initially announced conversation for good. The way this mono-logue is placed at the end of a white autobiographical engagement with a familial legacy of slavery is conspicuous. Implicitly, as in a range of pre-vious interviews, it does not relate the crux of the racial divide to white supremacy but to black people (angrily) "hold[ing] on to" the past as "hold-

ing [themselves] back," and thus secures the protagonist with a black messenger who relieves him from the task of having to critically reflect on his own heritage: "Not let anything hold me back." In the accompanying scenes to Vincent's monologue, we see the black savior figure literally "move forward" a self-conscious white Macky Alston, helping him up from the ground. This closing gesture catapults the narrative from a legacy of slavery across the Civil Rights era towards the promise of collective redemption at the dawn of the twenty-first century. We now see the phenotypically indistinguishable silhouettes of Macky Alston and Vincent Alston against the backdrop of the glistening light of a golden sunset which marks the horizon of a postracial era, supposedly already within view as an accompanying gospel soundtrack promises that "the Gospel train is coming ... coming around the bend ... Jesus said he was coming."

Family Name's paradigm of confession and redemption comes full circle in a post-production segment. As the screen blacks out, we are rather briefly confronted with the information that Macky Alston eventually discovered that he is not related to his slaveholder ancestors "by blood." The puzzling insertion of this "epilogue" seems to be the last piece of the puzzle that is Macky Alston's white redemption project, as it dovetails with its overall logic of a distanciation from the familial legacy of slavery. Alston's quest for roots across race and space, ultimately, hinges on the thematization and eventual neutralization of the legacy of U.S. slavery. The following section of this essay will explore what happens to claims of interracial origins that largely figure outside this specific framework of national trauma.

Returning to Homelands:
Housing the Racially Ambiguous Body within the Ancestral Hut

A Lot Like You presents first-generation American Eliaichi Kimaro, who articulates a dilemma of cultural and racial placelessness as the daughter of a Tanzanian father and a South Korean mother. Her narrative belongs to a subgroup of interracial (docu)memoirs in which the autobiographical subject seeks to suspend the tension of conflicting racial and cultural affiliations through a quest that anchors roots on the African continent. Barack Obama's *Dreams from My Father* figures as the most prominent example of this type of memoir, which ties in with a whole tradition of African American return narratives, from Richard Wright's *Black Power* (1954) to Saidiya Hartman's *Lose Your Mother* (2008). The journey in

contemporary interracial memoirs, however, differs from most African American "pilgrimages" to the "motherland" as the quest usually does not reconstruct a history of enslavement but often follows a direct paternal lineage that links the protagonist to a specific country, ethnic community, and family network. These transnational-interracial memoirs often form a trajectory in which the narrator initially articulates strong skepticism about the possibility of a homecoming, but, over the course of the narrative, gradually falls back on the trope of "return" and projects moments of catharsis, closure, and epiphany onto African soil. In the specific instance of *A Lot Like You*, African origins are claimed by repeatedly framing the racially ambiguous body—via image and narrative—within and in relation to the ancestral hut, which is presented as a symbolic space of enveloping, transcendent black roots.

A Lot Like You opens and ends with the image of interweaving branches to reconstruct a traditional Chagga hut on Mount Kilimanjaro, which serves as a metatextual reference for the narrative recuperation of diasporic origins. The audiovisual narrative is set in motion through the display of a child who is framed by an interplay of darkness and light within the ancestral hut. From inside, the camera is filming the young child, who approaches the hut's door. While remaining phenotypically unidentifiable through the employment of lighting and camera perspective, the child will eventually turn around during the closing scene of *A Lot Like You* in order to be framed as a child of the black diaspora. As we watch the child struggle with the door in the opening segment of the documentary, Kimaro employs a voice-over to position herself as a biracial, bicultural subject in an interracial marriage, and she reflects on the potential task of having to racially identify her children: "If they would ever ask me, 'What am I, Mama?' what would I say?" Extending the image of interweaving branches as a metaphor for narrative construction, the protagonist's genealogies are first presented as unintelligible: the child as inheritor of that history is struggling with the architectural design while heading for the "light." The hypothetical question of racial identification then launches the transnational quest for roots. We now see the child crossing the threshold of an open doorway, the figurative entrance into a family narrative towards self-knowledge and epiphany that is signaled through the enveloping sunlight that is flooding the screen, thereby forming a caesura to begin the main narrative.

This narrative first revolves around the father figure. Sequences of computer animations portray Kimaro's father's childhood around the hut in a schematic, mythical agrarian idyll that bespeaks a desire to locate the

fragmented, multiracial, diasporic self in the coherence of an imagined Edenic African past. Her research into the female side of her father's background, however, eventually also brings to light stories of familial abandonment, arranged marriages, and experiences of sexual abuse. These insights dispel romanticized notions, instate a critical perception of her father's ethnic group as a heavily male-dominated society, and shift the focus of the documentary to the women in her Tanzanian family.

In the last quarter of the documemoir, Kimaro is thus interviewing her female relatives inside the hut where each of these women eventually discloses experiences of sexual violence as a significant aspect of Chagga society. This disclosure is mirrored by the narrator's sharing her own experience of abuse with the viewer through a voice-over. While first articulating shock over the previously repressed legacy of sexual violence in the family, Kimaro a little later appropriates that past to envision a transcendent bond to her ancestral home. The intimate exchange in the hut becomes reciprocally interpreted as a preordained, cathartic moment. Her aunt concludes, "I feel a great burden has been lifted off my heart. . . . It was God who did his work here today. God wanted us to meet," and reaches across the camera to embrace the documentarist's hands. Her aunts' legacy of sexual violence is then constructed as coming full circle to Kimaro's own experience of abuse. Overcoming her childhood trauma had led Kimaro to become a trained counselor for victims of sexual abuse and, so the narrative claims, had prepared her in a form of providential guidance to eventually record her aunt's testimonies. Even more than that, the roots seeker's epiphany implies that her whole life has been fundamentally shaped by a tacit knowledge about this repressed legacy; she muses, "Maybe I did know, because it's like all the seemingly random choices I made since I was seven, were paving the way for me to sit down with my aunts twenty years later, right up to the decision to interview almost all the women in the hut." Accompanied by an accelerating juxtaposition of images that chronicle her life from childhood to her standing at the foot of Mount Kilimanjaro, this moment subtly, but powerfully, effectuates a representational shift. The return narrative is transposed from the diasporic subject seeking to claim African roots to African roots inevitably claiming the diasporic subject. This moment of "arrival" and closure is underlined by the narrative's return to the opening image of constructing the traditional Chagga hut. We now see it being finished as an ancestral home in analogy to the quest narrative that is about to end. In closing, a sense of having successfully recuperated Chagga roots is stretched across generations. First her father declares in an interview snippet that

"Life around me is complete. . . . I think the hut, it's like saying where my life has originated." Her father then invokes "singing" as a metaphor for the transmission of Chagga roots that have to be hybridized in the process: "I think there's a responsibility to adapt . . . to not only think in terms of 'I'm going to do a thing the way my grandfather did it' or 'I'm going to sing the way my grandmother sang' but also knowing there is this person I have to sing to." "This person" is finally projected as the protagonist's child, who in the final scene will literally respond to "singing."

The child, whose silhouette appeared against the backdrop of a Chagga hut at the beginning, reappears at the close of the narrative in a modern home whose wooden shutters against bright daylight echo the hut imagery of the documentary's opening. Kimaro repeats this motif as well as the documentary's opening thesis, and concludes: "If she asks me, 'What am I, Mama?' . . . this film is a good place to start." While the narrative voice does not explicitly name the racial or cultural identity of the child, the visual frame of the final scene nevertheless suggests continuity between Chagga roots and the body of the racially ambiguous child. The daughter is shown in a low-angle shot through which a television screen appears in the top background. The screen displays footage from the documentary project *A Lot Like You*, significantly at a moment when Kimaro women are "singing" in celebration of the finished reconstruction of the ancestral home. With this citation and revision of the opening image, the child is constructed as an inheritor of Chagga lineage through her position below and at a remove from Kimaro elders on screen. As the child turns around to exclaim, "They are singing, they are singing," the narrator and her child are seemingly brought into the fold of the black diaspora.

While Kimaro's documemoir, in general, can be said to operate on an Afrocentric paradigm, my last case study inverts the Africa-centered quest for origins by positioning Germany as the vanishing point of rootedness for the diasporic subject.

Returning from Homeland to *Heimat:*
The Black Body in Perpetual Motion

Roots Germania can be regarded as a German version of the interracial documemoir as it addresses the tensions of an interracial heritage within the specificity of the German cultural and historical landscape. Similar to much of Afro-German autobiographical expression, *Roots Germania* draws attention to the ways in which the black body in these surroundings

is often understood as being out of place and conventionally constructed in opposition to Germanness. Mo Asumang's quest seeks to revise this paradigmatic condition of placelessness by claiming Germany as *Heimat*, as homeland for the black diasporic subject.

The documemoir's title constructs a relation to Alex Haley's foundational narrative on the recuperation of diasporic origins but redirects its course. Roots are not claimed in an imaginary homeland on the African continent, but in Germanic mythology. Significantly, the protagonist never utters the English word "roots" in the original version of the documentary, but speaks of *Heimat*. The term's concept of a specifically German form of cultural belonging is lost in translation.[18] I retain the German word *Heimat* in my analysis not only to signal the quest's *telos* of German cultural affiliation but also in order to build an opposition to "Africa" as the putative homeland that she is assigned to by a predominantly white German society.

Racist rejection is posited as the very impetus behind *Roots Germania*. In the documemoir we learn that the Nazi band Aryan Rebels had released a song that called for the murder of a number of public figures including Asumang. Coming to terms with this threat eventually developed into the project of *Roots Germania,* in which the diasporic subject affirms German belonging as a form of resistance, as an intervention in "the hegemonic discourse of German identity . . . that often conflates Germanness with Whiteness as a form of racial identity."[19] The following discussion traces Asumang's construction of German roots in a tension between movement (quest) and repose (roots/ rootedness) that is only seemingly dissolved at the film's end.

The main narrative is framed through the image of Mo Asumang embarking on and returning from her quest on a motorcycle. Like the film poster, this image encodes the Afro-German experience as a state of being neither here nor there by highlighting an interstitial subject position through a detachment from the ground. In fact, the whole narrative is pervaded by images that characterize her life as an interstice. Recurrently, the protagonist negotiates her belonging in liminal spaces such as bridges and, most notably, her simultaneous status within as well as outside Germanness is captured by her self-representation through German folklore in a sequence where we see her rushing through the woods dressed up as *Rotkäppchen*, an Afro-German Little Red Riding Hood constantly on the run from the wolf of racism.

Asumang's quest does not try to anchor her roots in the "heterosexual, masculinist and patrilineal" concepts of family that structure most dia-

sporic return narratives, but instead turns to origins in form of cultural legacies.[20] When she travels to the paternal homeland of Ghana, this does not represent an attempt to reconnect with her father, but rather constitutes an ironic response to a Nazi interviewee who revoked the relevance of Asumang's white mother and demanded that she "return" to her father's home country. Arriving in Ghana (for the first time), Asumang articulates not euphoric aspirations of African homecoming but persistent skepticism. While multiple scenes display her father and grandmother acknowledging her place within the family, we also become witness to how the protagonist is generally perceived as a *white* foreigner in Ghana.

The protagonist is again contoured as inhabiting an interstitial status that is underlined by the liminal spaces in which introspection and familial dialogue occurs, for instance, when she asks her father at the border between the Ghanaian coastline and the Atlantic Ocean: "What do you think? Am I a child of Ghana or am I a child of Germany?" Interestingly, her question is filtered through the rhetoric of family but nevertheless posits nationhood as a parent instead of her Ghanaian father or German mother. Asumang's answer lies in ambivalent attempts to retrieve a form of knowledge from her journey that will help her transcend the black-German binary. For instance, we see her engaging in spiritual practices with Ghanaian priests to "bring . . . her white and black side[s] together," in a sequence that is inscribed with affective quality through slow-motion rendition as well as an accompanying soundtrack of drums. What are the insights drawn from this experience? *Roots Germania*, in fact, constructs a form of serial epiphany. Through image, voice-over, and musical soundtrack, the documentary draws a host of universalist and essentialist analogies between what Asumang identifies as "Africanness" and "Germanness." Most notably, Asumang builds an equation of Ghanaian spirituality with Germanic mythology before its appropriation by the Nazi regime in the 1930s and its continued use in neo-Nazi symbolism.

Back in Germany, she seeks to reclaim a Germanic heritage from the grip of Nazi ideology. Visiting right-wing civil-religious sites such as the Externsteine, Asumang states that the Third Reich legacy has robbed Germans, including her, of an empowering identification with their history. In connection with these declarations she starts to follow and interview esoteric subcultural groups that celebrate a Germanic heritage in explicit opposition to right-wing beliefs. At one point she participates in their spiritual practices. The framing of this scene builds the most significant analogy to her experience in Ghana as the images are underscored by the same soundtrack of drumming that were being played during the

slow-motion sequence of her encounter with the Ghanaian priest. Again and again, *Roots Germania* draws universalist connections between Ghanaian and Germanic cultural traditions to assert sameness and shared origins.

The positioning of these "insights" always implicitly works to erase the dilemma of her quest by leveling and overwriting the complexity of her racialized subject position in modern-day Germany through simplifying universalisms. In the penultimate sequence of the documemoir, the protagonist thus positions herself as an inheritor and descendent of two cultures, allegedly indistinguishable. We see her in a line of ancient Germanic sculptures that decline in height down to Mo Asumang who faces the camera to announce an overall conclusion by way of a rhetorical question: "Don't they look a bit African?!"

The final sequence communicates closure through another blending of Germanic and West African heritage in a desperate attempt to declare sameness. In this final image the trinity of Germanic matrons (a trio that stands for balance and unity in Germanic folklore) is represented by three women of different racial backgrounds: Mo Asumang of African descent on the right, a white woman in the middle, and a woman of Asian descent on the left. If the frame narrative emphasized placelessness through the image of the black body in motion and in detachment from the ground, the closing scene shows a barefooted protagonist firmly connected to a soil that is unequivocally marked in terms of German nationhood. The updated Germanic matron constellation is situated in the surroundings of the Reichstagsgebäude, the building that houses the German Parliament and is dedicated to the German people according to its famous inscription on its front: *"dem deutschen Volke,"* to the German people.

Asumang is now positioned as representative of this people. In contrast to the beginning, we now see the protagonist motionless and with eyes closed in the supposed moment of arrival in Germany's midst. Her "arrival" is underscored by a waving German flag and an Afro-gospelized soundtrack of the German national anthem: "Einigkeit und Recht und Freiheit für das deutsche Vaterland, danach lasst uns alle streben" (Unity, law, and freedom for the German Fatherland, let us all strive for that). Within the logic of *Roots Germania* the black body, perpetually on the move, has finally come home to stay, while glistening light is flooding the screen to mark a cathartic end of the quest narrative. One could also read the closing image less optimistically. While the overall visual-acoustic frame suggests closure, I read Asumang's shut eyes as still indexing *Heimat* as a mere yearning for recognition. Perhaps *Heimat* for the Afro-German

diasporic subject can only be an individual state of mind that might turn out to be as imaginary and inaccessible as conventional visions of African homelands.

Conclusion

This essay used the term "interracial documemoir" to frame autobiographical documentaries by Macky Alston, Eliaichi Kimaro, and Mo Asumang within a recent wave of autobiographical narratives that thematize interracial origins. The documemoirs' motif of return was framed within a diaspora poetics that allowed readings of three diverse modes of quests for roots, from the U.S.-specific paradigm via the transnational one to the German-diasporic context. Along these routes I charted the terms on which representations of the "black" body in these audio-visual narratives construct and reconfigure the autobiographical subject's origins. In his road trip to the plantation ground of his slaveholder ancestors, Macky Alston installs a number of African American figures along the audio-visual narrative trajectory, assigning them the redemptive function of deflecting and ultimately canceling out his white slaveholder heritage in a call for a postracial tomorrow. Eliaichi Kimaro's return narrative attempts to claim Tanzanian roots for the "mixed-race" subject by repeatedly framing the racially ambiguous body in an unequivocal genealogical relation to the symbolic location of the ancestral hut that not only outshines alternative originary coordinates of the United States or Korea, but also the experience of sexual violence across which that space is claimed. Mo Asumang's quest for origins begins to "queer" the genre by relegating questions of biological lineage to the background. However, heteronormative concepts of kinship and diaspora are only revoked to be replaced by the equally conservative construction of the nation as well as by universalisms in which the black body, only seemingly, can be recast from Germany's national-racial Other into its very representative.

Notes

1 Marianne Hirsch and Nancy K. Miller, "Introduction," in *Rights of Return: Diasporic Poetics and the Politics of Memory*, eds. Marianne Hirsch and Nancy K. Miller (New York: Columbia University Press, 2011), 5.

2 See Werner Sollors, *Neither Black nor White yet Both: Thematic Explorations of Interracial Literature* (Cambridge, MA: Harvard University Press, 1997).

3 Michele Elam, *The Souls of Mixed Folk: Race, Politics, and Aesthetics in the New Millennium* (Stanford, CA: Stanford University Press, 2011), 19.

4 Tavia Nyong'o, *The Amalgamation Waltz: Race, Performance, and the Ruses of Memory* (Minneapolis: University of Minnesota Press, 2009), 1.

5 Philipp Lejeune, "The Autobiographical Pact," in *On Autobiography*, ed. Paul John Eakin (Minneapolis: University of Minnesota Press, 1980), 119–37.

6 Alisa Lebow, "Introduction," in *The Cinema of Me: The Self and Subjectivity in First Person Documentary*, ed. Alisa Lebow (London: Wallflower Press, 2012), 6. Jim Lane, *The Autobiographical Documentary in America* (Madison: University of Wisconsin Press, 2002), 14.

7 Bill Nichols, *Introduction to Documentary* (Bloomington: Indiana University Press, 2010), 204–29.

8 Lebow, "Introduction," 2–3. Lane, *Autobiographical Documentary*, 3–4.

9 G. Thomas Couser, *Memoir: An Introduction* (New York: Oxford University Press, 2012), 15–32.

10 Alondra Nelson, "The Factness of Diaspora: The Social Sources of Genetic Genealogy," in *Rights of Return: Diasporic Poetics and the Politics of Memory*, eds. Marianne Hirsch and Nancy K. Miller (New York: Columbia University Press, 2011), 23. Hirsch and Miller, "Introduction," 2.

11 Tina Campt, *Image Matters: Archive, Photography, and the African Diaspora in Europe* (Durham, NC: Duke University Press, 2012), 54.

12 Hirsch and Miller, "Introduction," 3.

13 Nelson, "Factness," 35.

14 Macky Alston, *Family Name*, dir. Macky Alston (Los Angeles: Docurama, 2008), DVD.

15 Christina Sharpe, *Monstrous Intimacies: Making Post-Slavery Subjects* (Durham, NC: Duke University Press, 2009), 4.

16 My phrasing here is inspired by Mita Banerjee's book *Ethnic Ventriloquism: Literary Minstrelsy in Nineteenth-Century American Literature* (Heidelberg: Winter Verlag, 2008).

17 My emphasis.

18 Imke Brust, "Transnational and Gendered Dimensions of Heimat in Mo Asumang's *Roots Germania*," in *Heimat Goes Mobile: Hybrid Forms of Home in Literature and Film*, ed. Gabriele Eichmanns and Yvonne Franke (Newcastle upon Tyne: Cambridge Scholars Publishing, 2013), 172.

19 Tina Campt, "The Crowded Space of Diaspora: Intercultural Address and the Tensions of Diasporic Relation," *Radical History Review* 83 (Spring 2002): 109.

20 Jarrod Hayes, "Queering Roots, Queering Diaspora," in *Rights of Return: Diasporic Poetics and the Politics of Memory*, eds. Marianne Hirsch and Nancy K. Miller (New York: Columbia University Press, 2011), 75.

10

Dreaming Diasporas

CHERYL FINLEY

> There is no place you or I can go, to think about or not think about,
> to summon the presences of, or recollect the absences of slaves. . . .
> And because such a place doesn't exist . . . the book *[Beloved]* had to.
>
> —Toni Morrison, 1988

Dream

In 2007, at the twelfth installment of Documenta, the international con-
temporary art exhibition held every five years in Kassel, Germany, an artist
from Benin, Romuald Hazoumè, was awarded the coveted Arnold Bode
Prize for his installation *Dream*.[1] This was the first time the top honor had
been bestowed upon an African artist. Dominating the Orangerie's Aue
Pavilion, a greenhouse-like structure built to protect artworks from the
rain, *Dream* resembles a large, angular pirogue, of the type often seen
in picturesque West African fishing villages (figure 10.1, plate 13). But
Hazoumè's boat is constructed of 421 painted petroleum canisters, each
one representing an economic and political refugee, who has paid dearly
for her place on the boat, but whose safe passage from Africa to Europe
is not at all guaranteed. Fused together to form one makeshift vessel, the
dark plastic canisters are further individuated by painted white crosses,
words, and colors. Hanging on either side of the boat, bulbous glass fend-
ers contain corks, photographs, and letters, the kinds of mementos that
refugees might carry as they travel far away from home in search of their
dreams. The plastic petroleum canisters, used to transport smuggled
fuel from oil-rich Nigeria to Benin, are emblems in perpetual motion that
permeate everyday Beninese life, as objects of survival, ritual, and even
death. In Hazoumè's installation, they form a vessel, some tagged in fluo-
rescent orange spray paint with the word "Dream," before a seductive,

mural-sized panoramic photograph of paradisiacal golden sands, palm trees, and crowds of eager children—who are, as the artist's inscription reads, "damned if they leave and damned if they stay: better, at least, to have gone, and be doomed in the boat of their dreams." Hazoumè's installation possesses subversive buoyancy that reverberates between the shores of Africa and Europe, kept afloat by the dreams of an ever-aspiring, frequently migrating African diaspora.

Characteristic of Hazoumè's mnemonic aesthetic—a process of ritualized remembering, underlying contemporary presentations of the art of slavery—the plastic petroleum canisters also were the building blocks of his sophisticated conceptual installation *La Bouche du Roi* (The Mouth of the King), conceived between 1997 and 2005, purchased by the British Museum in 2007, and the centerpiece of a controversial British national commemoration of the bicentenary of the abolition of the slave trade. In this work, arranged in the shape of the familiar late eighteenth-century slave ship icon circulated by proponents of abolition, the canisters are transformed into masks representing African captives taken as slaves from the mouth of the River Porto Novo as well as their African and European captors. In Hazoumè's accompanying photographs of young Beninese gasoline smugglers, the plastic containers hang from their necks or envelop their torsos, eclipsing their bodies while transforming them into potentially lethal, larger-than-life Michelin men. As key elements of the artist's mnemonic aesthetic, the plastic containers assume symbolic shapes and forms, as in the outdoor sculpture *Serpent*, commissioned for the Victoria and Albert Museum's Uncomfortable Truths exhibition, part of the national public exhibition program marking the bicentenary of abolition of the slave trade in 2007.

Roger Buergel, artistic director of Documenta 12, posed three leitmotifs for the artists to consider: "Is modernity our antiquity? What is bare life? What is to be done?"[2] Hazoumè responded with the installation *Dream*, which also featured a selection of his individual sculpted heads. Taking playful inspiration from the five-thousand-year-old classical African culture of mask making, Hazoumè's single sculptures made from the discarded plastic canisters—urban detritus that industrious gasoline smugglers and city inhabitants like Hazoumè reuse and repurpose—appear as contemporary puns on the mask-making tradition. Using a blowtorch to transform the plastic containers of commerce and grief into comic sculpted heads (*Sénégauloise*, 2005), the artist converts watering spouts into necks (*Citoyenne*, 2005) and adds hair extensions to lend character and attitude (*Dogone*, 2005).[3] Yet these satirical works are also weapons

10.1.

Romuald Hazoumè, *Dream*, installation (photograph mounted on wood; boat made from plastic canisters, glass bottles, corks, cords, letters, photographs), 2007. Collection Neue Gallery, Kassel. Photograph courtesy of October Gallery, London. © Artist Rights Society, New York / ADAGP Paris, 2015.

that Hazoumè uses to challenge the canon of Western art history, and more. More than a century ago, African masks enticed Pablo Picasso, Georges Braque, and Henri Matisse to trailblaze new forms in painting for European modernism, figuring blackness and concepts of race and sexual contamination through the depiction of white bodies that took on Africanized, if not mask-like, forms. By shattering concepts of both modernism and antiquity into shards, then sharpening the pieces to create new aesthetic forms, Hazoumè reveals how these ideas circulate in perpetual motion and in conversation with one another. Asserting that dreaming is part of the human condition, he moreover claims, "This story is not over yet."[4] Hazoumè's elegant installation presents a dreaming diaspora awash in the ongoing global economic, social, and political effects of slavery and colonialism by imagining, quite literally, migrating black bodies from Africa to Europe.

Touring the African Diaspora

Romuald Hazoumè is among a group of artists engaged in a sustained aesthetic debate about the nature of global capitalism and its psychic, social, and economic effects on contemporary traveling cultures, particularly the

African diaspora. As active participants in a system of art tourism both *they* and the works they produce are imbricated in a crisscrossing web of pleasure-seeking, destination-based exhibitionary commerce that values authenticity, identity, history, and cultural specificity. My essay charts key nodal points along this web of exchange through the movement of the artists themselves through residencies, fieldwork, and international art events while recognizing, too, that their artworks reveal the faulty wiring of globalization. Its frequent short circuits empower black artists to travel along unintended paths to uncover new modes of expression that redirect dominant currents of understanding. In so doing, these artists and their works destabilize the outposts of Western art history and remap the traditional grand tour (taken by young aristocratic European men from the mid-seventeenth century through the mid-nineteenth century to places of classical antiquity, notably Italy and Greece, to complete their classical training) to incorporate the activism and innovation of twenty-first-century African diasporic traveling cultures.[5] Their works reveal the unreported and underreported incidences of loss of life, risky migration tactics, lives led under the radar, and contemporary survival strategies while simultaneously exposing the historical causes and routes of the need to get away *and* keep moving. To be sure, diaspora cultures are always shifting, morphing, renewing, and reinventing themselves. Through a series of case studies, I present five artists—Romuald Hazoumè, Isaac Julien, Terry Adkins, Yinka Shonibare, and Joy Gregory—who are engaged with the constant invention of ideas and practices as well as flows of information and technology that reveal links to slavery, history, activism, economics, and aesthetics. I argue that *touring* is not about destiny, nor is it a destination. Rather, it is the recognition and understanding of *perpetual motion*, of being in flux, that is the symbolic destination here—and a condition of the African diaspora in the early decades of the twenty-first century.

Also in 2007, Isaac Julien, a black British installation artist/filmmaker, presented *Western Union: Small Boats,* the third in a series of works titled *Cast No Shadow* to consider exploration travel, art and cultural tourism, and political migration.[6] Composed of photographic light boxes that feature striking images of the journey taken by African migrants leaving the shores of North Africa for Italy, as well as moving images suggesting drowning and capsizing boats and the choreography of Russell Maliphant, the installation-performance piece seeks to give the viewer-participant an affective sense of movement and uneasiness, if not perpetual motion, in and out of different spaces of contestation. Ideas of desire, beauty, and the dream, all part of the Western notion of tourism and travel, are put

off-kilter in Julien's sublime yet haunting images of longing and fate—a graveyard of colorful capsized boats, a passenger in detention longs for home, the stark whitewashed landscape seems unwelcoming. According to the artist,

> I think *Western Union: Small Boats* is also a project about location and dislocation. It is not only about bodies, but also about spaces and who has the right to be in certain spaces. In that sense it is an exploration of space and the politics of space. And the way I am using choreography and dance explores that, it is just in a different language. I think it is not only about the postcolonial discourse but also other discourses that have been developing around space: I think about the writing of Doreen Massey, among others, and how she formulates the questions of space and globalisation.[7]

My essay is a response to the recent transformations in diaspora cultures as a result of the ever-increasing movement and flow of people, information, art, and ideas globally. Certainly, technology plays a large role in these transformative shifts, creating virtual communities and pioneering evanescent yet ever-popular forms of communication, exchange, and aesthetic practice. Hazoumè's example of reusing a discarded yet potent vessel to bring to the fore questions about power, energy consumption, risk, and migration is just one example of a longstanding African diaspora art-making practice that also shares links with the current discourse on sustainability.[8] El Anatsui, an artist from Ghana, is also noted for his use of discarded liquor bottle caps and wires, urban waste that refers to both the use of liquor to trade for slaves and the more pressing contemporary social ill of alcohol abuse, to form three-dimensional sculptural tapestries that often resemble kente and other traditional weaving forms in Akan culture.[9] Yet the unprecedented metamorphoses in global cultures have changed how we think of community, how we relate to one another, and how we define ourselves, often producing a sense of loss and disconnectedness. For these reasons, questions and practices that tend towards centeredness, towards belonging, and towards suture, become more urgent.

I invite you to join me as I chart these points of translation and transformation in the global art economy, geographically, conceptually, and historically. Romuald Hazoumè's dreamboat provides an able vessel in which to cast off on our journey. For the metaphor of the dream, its unattainability and fantasy-like nature, is what makes dreaming possible, makes it possible for artists to imagine new spaces of creation and new ideas. Touring

also suggests a certain kind of aspiration and the possibility of movement into these spaces, of reclaiming, if not claiming spaces that were hitherto off limits, of charting and walking new paths.

But before we embark, we have to set some provisions in place to determine how much can be achieved on our journey. Let's be clear: this cannot be the grand tour of old. Rather, we are journeying through the artwork and experiences of Romuald Hazoumè, Isaac Julien, Terry Adkins, Yinka Shonibare, and Joy Gregory—the artists whose ideas and images helped to build the mnemonic model that I am suggesting here.[10]

John Brown, in Rome?

On a 2010 visit to Rome, I interviewed the late sculptor/musician/performance artist Terry Adkins about the most recent installment of his critically acclaimed *John Brown Recital,* on view at the American Academy in Rome in 2009–10. Called *Meteor Stream*, the multimedia installation marks the next stop on our journey, one that reveals how one contemporary African American artist translates a significant moment in American history into an imagined history relevant to our times and to Rome in the second decade of the twenty-first century. To be sure, the radical, white abolitionist John Brown never traveled to Rome. But his actions on October 16, 1859 resonated around the black Atlantic to such a degree that he was a familiar figure to many of the visitors gathered at the exhibition's opening, scheduled to coincide with the 150th anniversary of John Brown's historic raid on Harpers Ferry, West Virginia—enough so that they could all join in singing "John Brown's Body" from memory, a song that is taught in secondary schools in Italy, according to the artist. Indeed, they were well aware of the events that John Brown's historic raid on Harpers Ferry set in motion in 1859. What might we gather from this exhibition and why is its locale an important stopping-off point, even if momentarily, on our journey?

In 1998, Adkins began a series of installations or "sculpture recitals," serial performance-based art installations that studied the figure and impact of John Brown, some sited for places with significance to the historical figure or his actions and others that place John Brown and his revolutionary actions in unlikely but soon to be revealed locales of potential historic significance. Through Adkins's work, history is recovered, examined, and reinterpreted to open up new possibilities for understanding how certain marginalized histories still resonate, often in unforeseen

CHERYL FINLEY

places and ways. A kind of dream work, Adkins's notion of "imagined history" sets him apart from other artists and implies a different relationship to the past altogether. His courage to go beyond the scripted historical record—to dream of a different outcome (as in his John Brown recital at the Harn Museum of Art in Gainesville, Florida in 2001, called *Deeper Still*, which imagined John Brown's raid on Harpers Ferry as successful)— has the power to conjure up a changed vision of the world. Celebrating radical imagination, *Meteor Stream* charted John Brown's October 16, 1859, raid on a U.S. armory and the events that led to his execution by hanging on December 2 at Charlestown, West Virginia. Adkins dutifully explored biblical aspects of Brown as a shepherd, soldier, martyr, and prophet through a communion of sound, text, video, sculpture, drawing, and ritual actions. He also included new research for the installation that reveals incredibly far-reaching ties, binding the legend of this enigmatic American figure to parallel histories of Rome, the Janiculum Hill, and the American Academy in Rome, where Adkins was a 2009 Rome Prize fellow in the Visual Arts.

Adkins's work in Rome points to the long history of the grand tour and its significance to artists, but also to the unfolding of European modernity. In a familiar trope in art history, men of aristocratic classes in Europe took the grand tour to places of antiquity like Rome and Greece or to foreign lands that were deemed exotic, untamed, and other. These places were used to educate by emphasizing difference, classical art, and antiquities. But, as contemporary British-Nigerian artist Yinka Shonibare has revealed, the grand tour was about much more. The education that these aristocratic young men were to glean was not just of ancient and classical cultures or of foreign and strikingly different individuals. Rather it was also a sexual education and one of domination, that by enabling these "gentlemen" to engage in exploits abroad that they would never dream of doing at home, combined proto-forms of both art tourism and sex tourism. In the installation *Gallantry and Criminal Conversation* (2002), commissioned by Okwui Enwezor for Documenta 11, Shonibare uses his now-familiar headless mannequins dressed in Dutch wax cloth styled in eighteenth-century high fashion to reveal the unsavory and less talked about side of the grand tour (figure 10.2, plate 14). Set amid steamer trunks and wooden crates strewn about a raised platform, three couples and one threesome engage in a variety of illicit sex acts. The carriage used to transport them looms overhead as a reminder of home, while discreetly placed props, a parasol and a hatbox, emphasize the extreme bodily gestures of their sexual exploits. Power, privilege, and pleasure reign over this unabashed scene

of debauchery that solicits viewers as voyeurs and references practices of looking and new forms of technology that were ushered in during the era of the grand tour and intensifying European colonial expansion.

Shonibare's cunning use of a culturally confounding fabric—Dutch wax prints styled after Indonesian batiks, produced in the Netherlands and England, and sold in West Africa and Brixton—demonstrates his desire to unsettle assumed notions of origin, specificity, and authenticity. "The textile is neither Dutch nor African," Enwezor has observed, "therefore the itinerary of ideas it circulates are never quite stable in their authority or meaning."[11] This dual sense of layered history and possible futurity is a feature of other of his works that imagine new realms and territories for colonial subjects, other African diasporas, such as in *Space Walk* (2002), in which a pair of astronauts wearing helmets and backpacks floats next to a model of Apollo 13, or *Dysfunctional Family* (1999), in which a miniature family of Hollywood-styled space aliens sewn of his familiar prints pokes fun at prejudice, stereotype, and belonging. Works such as these bring us back to Adkins's powerful notion of imagined history in *Meteor Stream*.

Self-consciously inserting himself in one of the birthplaces of European classical antiquity, Rome, Adkins's presence reframes the grand tour, while hinting at the radical possibilities for African diasporic artists in Europe. He chose the figure of John Brown for his longest-running sculpture recital (from 1998 to 2010) to illuminate the ongoing struggles over history and belonging for black people not only in the United States, but also globally.[12] With the figure of John Brown, Adkins also brings the radical imagination to Rome, as the capital of Italy, reimagined now a symbolic center of black suffering in Europe in the wake of thousands of deaths annually of refugees and migrants attempting to enter Italy from Africa's shores.[13] The hotly debated migration policies coming from the nation's capital, including Operation Mare Nostrum (Our Sea), an intercept and rescue operation that has produced further humanitarian suffering at detention centers, emphasize the physical suffering and lack of regard for black lives. The widely publicized, unforgettably tragic images of overloaded, makeshift boats traveling from Libya and other North African nations—and the horrific rows and rows of covered corpses lining Italian shores in body bags after a boat has capsized—recall images of overcrowding on slave ships, publicized by the eighteenth-century slave-ship icon used by abolitionists to expose the inhumanity of the slave trade as well as mid-nineteenth-century photographs of captured illegal slave ships showing hundreds of captives on deck. The visual similarity

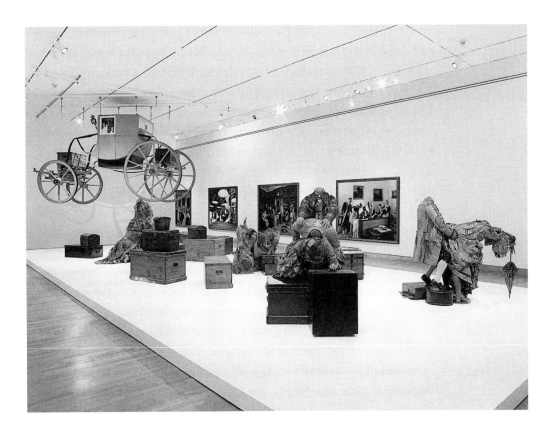

between these contemporary and historical images cannot be empha-sized enough. The hypervisibility of black bodies contrasts with their invis-ibility as chaotically crowded ships are tragically emptied of their human cargo when body bags are lined up neatly on Italy's shores. To be sure, their incessant reverberations, recycled in perpetual motion, were not lost on Adkins, Julien, or Hazoumè as inspiration for works that treat migration, access to land, uneven distribution of resources, the aftermath of slavery and colonialism, and desire for a better life.

A few notable historical facts that connect John Brown to the Ameri-can Academy inspired Terry Adkins and influenced his approach to this last installment of the *John Brown Cycle*. Charles McKim, architect of the American Academy in Rome, was born to noted abolitionists Reverend James Miller McKim and his Quaker wife, Sarah Speakman McKim, in Pennsylvania. The McKims both attended John Brown's hanging and afterwards aided his wife, Mary Brown, in claiming his body. Reverend McKim accompanied Mary Brown on the trip home to North Elba, New York, where he delivered a speech at the burial. Hugh Forbes was an English mercenary and John Brown's treacherous military advisor, who exposed his Harpers Ferry plans because of lack of payment for his

services. He fought with Garibaldi on Janiculum Hill, where the American Academy in Rome is sited. William Styron won the Rome Prize in 1953 and in 1968 won the Pulitzer Prize for fiction with the controversial *Confessions of Nat Turner*. Nat Turner's rebellion inspired John Brown, who often spoke of striking fear being necessary for his plan to work and compared his efforts to the Nat Turner rebellion and its aftermath. Robert Penn Warren was an American Academy resident in 1956. His first book was *John Brown: The Making of a Martyr*, published in 1929. The abolitionist Frederick Douglass's relationship to Brown is widely known, but his attitude towards Rome less so. The sculptor Edmonia Lewis, whom Douglass visited while on an 1887 tour to Rome, got the funds to travel to Italy, in part, from the sales of a medallion of John Brown that she cast. In a May 2010 review of *Meteor Stream*, Adkins told Cathryn Drake, "The connections to John Brown here are getting to the point where I myself feel part of the continuum of these ongoing connections."[14]

Situated in a two-room gallery connected by a small passageway, *Meteor Stream* included twenty-two iron pikes that the artist had forged to represent the twenty-two men who accompanied John Brown on his raid; a wolf hide, referring to the legend of Romulus and Remus, who are nursed by the wolf-goddess Lupa in the founding of Rome; portraits of John Brown; statements taken from newspaper accounts of his trial; and layered cartographic drawings of Harpers Ferry made by the artist, who was trained by noted African American artist Aaron Douglas at Fisk University in printmaking (figure 10.3, plate 15). Perhaps most boldly visible in the installation are the two banners Adkins had fabricated to mark Du Bois's historic antilynching campaign of 1935. As documentary photographs reveal, black and white banners with bold type reading, "Another Man Was Lynched Today," were hung outside the window of the NAACP's offices on Fifth Avenue in New York City after the incidence of a lynching.

Another salient work in the installation is projected on two video monitors: two-dimensional stereoview cards, which I call Adkins's "flickers," have been digitally manipulated to resemble early films, but also seduce with the depth of 3-D vision. These images show how the legacy of John Brown became embedded in American memory by the advent of stereograph cards depicting his legend, trial, and execution. Produced in the 1890s, sets of stereograph cards by H. T. Anthony and others sold views of West Virginia, the Potomac and Shenandoah Rivers, and Maryland as important sites of memory relating to John Brown's historic raid, as well as images of the armory, Brown himself, the bridge at Harpers Ferry, and

Brown's grave. It is important to reiterate that these images were sold as sets, distributed widely in the United States and abroad. Stereograph technology, with its offer of 3-D vision, also suggested a way that the eye had power over its subject. But Adkins also interspersed with these images of site specificity other jarring stereographic images of cotton, black Civil War soldiers, enslaved rice plantation workers, and the meteor stream after which the show was titled, suggesting historical connections to slavery, Brown's own legacy as a prophet and soothsayer, and the dream of the future as forecast by the stars. Like Hazoumè and Julien, Adkins's insistence on the use of photography (and twenty-first-century digitally rendered moving stereoviews) emphasizes the importance of the landscape and its ties to place and displacement, ownership and disenfranchisement, literally, life and death.

Cinderella Tours Europe

Joy Gregory's series *Cinderella Tours Europe* (2001) provides yet another pivotal point on our journey, one that brings us back full circle to Hazoumè's notion of the dream. Gregory was inspired by numerous interviews she conducted during a four-month research trip around the Caribbean in the late 1990s. For many of that region, Europe is a place of unattainable dreams, due to stringent visa restrictions and high costs of travel and transportation. In Gregory's work, the dreamer is wrapped in the narrative of Cinderella, transformed into a pair of golden shoes and transported around the major sites of Europe. On this grand tour of desire,

the shoes are photographed in front of familiar landmarks in the style of posing for a tourist photograph.

The impetus for *Cinderella Tours Europe* grew out of research that Gregory conducted in Europe and its former colonies in the Caribbean for two critically acclaimed projects, *Lost Histories* (1997) and *Memory and Skin* (1998). Over five months, Gregory traveled extensively in Belgium, Holland, France, Spain, Portugal, Cuba, Jamaica, Panama, Trinidad, Guyana, Suriname, and Haiti. Probing for evidence of the contemporary and colonial relationship between Europe and the Caribbean, she conducted interviews with people while also collecting artifacts, recording sound, and photographing important sites of memory.

One of the paradoxes Gregory noticed about the people she met in the Caribbean was their strong connection to and affinity for Europe as a motherland, despite the fact that some were the descendants of enslaved Africans who had been brought by Europeans against their will to the so-called New World to work the sugar cane, rice, and tobacco plantations. The fruits of their labors helped to build Europe while stripping the Caribbean and Africa of valuable natural and human resources. Today, many of the world's poorest nations are located in these regions, including Haiti and Sierra Leone, to name just two.

Noting the continuing effects of the transatlantic slave trade and the subsequent ravages of colonial rule, it should come as no surprise that the familial bond between Europe and the Caribbean is complicated, to say the least. On the one hand, Europe represents the evil stepmother of the Cinderella fairy tale, and on the other it represents the free, happily-ever-after lifestyle that the handsome prince offers. Many Caribbean residents were lured to Mother Europe in the period following the Second World War to reach for the promise of employment, better education, and the benefits of being a part of the empire. Gregory's parents emigrated from Jamaica to England in the late 1940s. They represent the West Indian emigrants that Caryl Phillips speaks of in his novel *The Atlantic Sound*, who "traveled [to Europe] with the hope that both worlds might belong to them, the old and the new. They traveled in the hope that the mother country would remain true to her promise that she would protect the children of her empire."[15]

For those who stayed behind in the Caribbean, Europe still represents a mythical, faraway place, a fantasy land, and an unattainable dream, according to many of the people that Gregory interviewed. She asked them, "Where would you go, if you could?"[16] Many responded with the name of a European country or city: England, France, Spain, and Portu-

gal were the popular countries, while London, Paris, Venice, and Lisbon were favored cities. The people that Gregory spoke to were knowledgeable about Europe from the colonial ties that bound them as well as from articles in the press, grade school history classes, and their relatives who emigrated there some fifty years earlier or more recently. One person explained her dream of going to Europe, "My mother left us here and went to England in 1962; she never came home."[17] But today's residents of most Caribbean nations rarely have the means to travel overseas to visit family, let alone for a vacation. Not to mention the fact that even if they did book a holiday, access is now restricted: they are required by some mother countries to have a visa. For example, the United Kingdom now requires residents of Jamaica to carry a visa.

As a first-generation Jamaican English woman, Gregory has a special understanding of the complicated relationship between Europe and the Caribbean. She still has familial ties in Jamaica and is acutely aware of how freely she can travel there with her British passport and of how difficult it is for her Jamaican relatives to visit her in the United Kingdom and elsewhere in Europe (and around the world). The artist also noted how painfully ironic it is that the people whose ancestors labored to build Europe are increasingly shut out by its borders and unacknowledged. But their fate seems to be part of a larger trend, indeed a backlash that is born out of fears stemming from the globalization of labor, commodities, and tourism, on the one hand, and the formalization of the European Union, on the other. It is both telling and timely that *Cinderella Tours Europe* was completed at the close of 2001, just months before the European Union introduced the euro in January 2002, setting off significant discussions about the consequences of a global economy in the major news media and in artistic and academic circles.[18] For example, the exhibition *Unpacking Europe*, which questioned the historical and contemporary meaning of Europe in light of the introduction of the euro, stricter immigration policies, increasing xenophobia, and the program of globalization, opened in 2001 at the Museum Boijmans Van Beuningen in Rotterdam, curated by Salah Hassan and Iftikhar Dadi.[19]

Today, the European Union continues to make it more difficult for refugees, asylum seekers, and migrants to enter irregularly, especially from the south and by sea, where the largest percentage of African migrants attempt to cross. According to a 2014 report by Amnesty International, "The Human Cost of Fortress Europe: Human Rights Violations against Migrants and Refugees at Europe's Borders," at least twenty-three thousand people are estimated to have died trying to reach Europe

since 2000.[20] Moreover, the security, access to amnesty, and livelihood of those migrants who do make it to Europe is questionable, due to increased surveillance, rising xenophobia, and poor treatment at detention centers. For example, the *Guardian* reported in June 2014 that French riot police had bulldozed three refugee camps at Calais, while in Melilla, a Spanish region in northern Morocco, one thousand refugees stormed a barbed wire fence, attempting to reach European territory.[21] According to the Amnesty International report, an estimated four billion euros was spent by member states on Fortress Europe between 2007 and 2013, with nearly half going to infrastructure reinforcement and technological surveillance of its external borders, and approximately 16 to 21 percent each going to asylum, integration, and the return of migrants.[22] The public outcry of conservative politicians and hate groups in the last two years has boldly broadcast Europe's xenophobia, forcefully seeking to prevent black migrants and asylum seekers who dream of entering Europe from arriving on its shores.

Cinderella Wore Prada

The shoes that have a starring role in Gregory's *Cinderella Tours Europe* caught the artist's eye in a shop window in Panama City, Panama. Hardly the design of Prada, Manolo Blahnik, or Pedro Garcia, they are flashy, gaudy, and sexy nevertheless. An obvious allusion to wealth, the shimmering faux-snakeskin shoes reference the contemporary yet age-old style of many Caribbean people who proudly don showy gold jewelry and ornamentation as a status symbol.[23] This fashion stems from pre-Columbian times when gold was abundant and worn in elaborate designs as part of headdresses and clothing accessories as well as body adornment. Indeed, it was this overstated opulence that attracted early European explorers such as Christopher Columbus and Sir John Hawkins, who made profitable voyages to the Caribbean after finding vast resources of gold there in the fifteenth and sixteen centuries. The exploitation of native Indian and later imported African labor made it possible for countries like Spain, Portugal, and England to reap vast amounts of wealth while stimulating a demand for enslaved African labor.

In *Cinderella Tours Europe*, the fantasy, the dream goes ahead, even when the traveler cannot go to the place of his or her dreams and desires. Gregory's is a perpetual tour, a disembodied haunting, represented only by a pair of golden shoes firmly planted at the sites of memory that have

10.4.
Joy Gregory, "Bridge of Miracles, Venice," from *Cinderella Tours Europe*, 1997–2001, Fuji crystal archive print. Courtesy of the artist.

significance to colonial and black Atlantic history. Posed at the Bridge of Miracles in Venice, on the shores of Cadiz in Spain, or at the July 25 Bridge in Lisbon, Gregory's golden slippers take on added meaning in today's climate of Fortress Europe (figure 10.4, plate 16).

The Invisibility of Hypervisibility

Coinciding with the introduction of the euro, the phenomenon of the art superstar has forged a novel form of art tourism in which internationally acclaimed artists create celebrity brands and markets. Strategically jet-setting around the globe between biennials, art fairs, conferences, high-profile auctions, designer museums, and blockbuster exhibitions, the new generation of art superstars—including Hazoumè, Adkins, Julien, Shonibare, and Gregory—has mapped hitherto uncharted routes for contemporary African diaspora art against the exclusionary practices of the art world and the barriers of Fortress Europe. Along the way, the constellation of art world personalities—dealers, collectors, curators, scholars,

critics, and, notably, paparazzi—got on board to praise the artists and their works, and an unexpected presence emerged in the global art economy: the hypervisibility of the black body in contemporary art. Revamping the seventeenth-century grand tour, this perhaps unforeseen and indeed unprecedented black presence in the global art economy highlights both the actual artists and the works they produce as objects of desire. Take note that the 56th International Art Exhibition of the Venice Biennale was directed for the first time in its more than one hundred years of history by an African-born curator, Okwui Enwezor, who is originally from Nigeria and now directs the Haus der Kunst in Munich. An unprecedented thirty-five black artists (of the 136 artists and collectives selected) from Africa, Europe, and the Americas were chosen for the international exhibition, *All the World's Futures,* curated by Enwezor. Architect David Adjaye designed the Arena, a dynamic live space within the exhibition's Central Pavilion, which featured performances by Isaac Julien and Jason Moran, among others. Kara Walker designed the set and costumes for a new production of Vincenzo Bellini's opera *Norma.* The Golden Lion, the top prize, was awarded to conceptual and performance artist Adrian Piper, whose stand-out works in the biennale were characteristically nonfigurative.

Moreover, while the artists' works signal the hypervisibility of the black body in these spaces not usually welcome to African diasporic people and arriving migrants, they do so by presenting works that hide, obscure, or make invisible the black body, only revealing an allusion to it, suggesting the dream of belonging or acceptance, or the need to hide or remain unseen. In the case of Hazoumè, it's gasoline cans standing in for people who clamor for political and economic stability in a faulty boat. For Adkins, it's his own presence in Rome revamping the grand tour, pikes representing revolutionary fighters, and stereographic flickers as jarring historical flashbacks. For Gregory, a simple pair of shoes literally "stands in" for people who cannot travel today due to immigration and visa restrictions based on national belonging. Yet they also reference the dreams and aspirations of today's irregular migrants, whose perilous voyages from the shores of Africa often end in misery, rejection, and at worse, death. These purposeful apparitions thus circle back to the idea of the dream as well as to the hypervisibility of the black body, suggesting that in its ubiquity it becomes invisible.

Notes

Epigraph: "A Bench by the Road: *Beloved* by Toni Morrison," in *Toni Morrison: Conversations*, ed. Carolyn C. Denard (Jackson: University Press of Mississippi, 2008), 44–50.

1 The ten thousand euro Arnold Bode Prize is named in honor of the late founder of Documenta and has been awarded to a distinguished contemporary artist since 1980.

2 Roger Buergel, "Documenta 12: Leitmotifs," December 2005, www.documenta12.de/index.php?id=leitmotive&L=1, accessed September 15, 2007.

3 With names riffing off nations and ethnic identities, such as Senegal (*Sénégauloise,* 2005), Dogon (*Dogone*, 2005), and citizen (*Citoyenne*), the titles of these works further reinforce how Hazoumè's *Dream* seeks to lay claim for African migrants in Europe and crash through the barriers of Fortress Europe. Each sculpture is made from plastic gasoline canisters and mixed-media embellishments (beads, braided synthetic hair, feathers, etc.).

4 Romuald Hazoumè, interview with Cheryl Finley, October Gallery, London, March 24, 2007.

5 The Grand Tour was meant to serve as a cultural awakening, in which these aristocratic travelers took note of the art, architecture, classical ruins, clothing, and foodways of foreign lands. Many took along artists to document their travels, and also brought back examples of painting and sculpture, which were reproduced and emulated in their home countries.

6 The *Expedition Trilogy* began with *True North* (2004), which traced Matthew Henson's journey to the North Pole in sublime images projected in a three-channel video installation. It was followed by *Fantome Afrique* (2005), which again used video installation, this time to chart the cultural and artistic wanderings of figures like André Gide and Michel Leiris to West Africa. *Western Union* (2007) is the title given to the photographic light boxes, whose images offer deceptively sublime views of the North African and Italian coastline in an homage to Italian filmmaker Visconti. *Small Boats* (2007) is the theatrical projection. *Western Union: Small Boats* has been exhibited together with choreography and separately.

7 Isaac Julien, "I Am Putting the Fire underneath People: Isaac Julien in conversation with Katarzyna Bojarska," *Obieg*, June 18, 2009, www.obieg.pl/english/12332, accessed April 10, 2015.

8 My use of the word "vessel" in this sentence seeks to evoke the multivalent meanings of the word in Hazoumè's work—as a container for smuggled fuel, as a container for stolen lives, and as a container for a self-determined people.

9 The African American artist David Hammons is also known for reusing discarded objects in his works—chicken bones and hair, for example—often imbuing them with ritual significance in the process of making the work. Similarly, the late African American artist Terry Adkins, considered later in this chapter, employs found objects in his sculpture recitals and likens his reassembly of them to an aesthetic ritual.

10 The aesthetic practices, works, and biographies of other artists, including Maria Magdalena Campos-Pons and Lois Mailou Jones, also aided in the construction of this theoretical model.

11 Okwui Enwezor, "Tricking the Mind: The Work of Yinka Shonibare," in *Yinka*

Shonibare: Dressing Down, exhibition catalogue, (Birmingham: Ikon Gallery, 1998), 10.

12 Adkins is not alone in taking on John Brown as a subject. Rather, beginning with the earliest known image of John Brown, taken by the African American daguerreotypist Augustus Washington at Harford, Connecticut, in 1847, John Brown's image has long captured the imagination of black artists. The celebrated intellectual W. E. B. Du Bois devoted an entire biographical volume, *The Quest of the Silver Fleece*, to John Brown in 1911, to mark the fiftieth anniversary of his death. In the mid-twentieth century, the painters Charles White, Horace Pippin, and Jacob Lawrence memorialized the life of John Brown. The legacy of John Brown provided the inspiration for poems by Robert Hayden and Michael S. Harper written in the 1970s. The historian Benjamin Quarles made a thoughtful examination of the historical trajectory of the political allegiance between blacks and John Brown in 1972. See Benjamin Quarles, *Blacks on John Brown,* (Champaign: University of Illinois Press, 1972).

13 In 2014, more than 170,000 refugees and migrants traveled to Europe from Libya; the following year, more than 150,000 people traveled the same route fleeing political, economic, and sexual oppression in countries such as Eritrea, Somalia, Mali, Gambia, Ethiopia, Nigeria, and Guinea. As the African migrant and refugee crisis mushroomed, it was marked by significant loss of life for thousands attempting to reach Europe by making the perilous voyage from North Africa in overcrowded, unseaworthy vessels to the shores of Italy via the Mediterranean Sea. Of note was the tragic April 19, 2015 shipwreck off the coast of the Italian island of Lampedusa in which more than eight hundred people lost their lives, according to the United Nations; Alessandra Bonomolo and Stephanie Kirchgaessner, "UN Says 800 Migrants Dead in Boat Disaster as Italy Launches Rescue of Two More Vessels," *Guardian*, April 20, 2015, https://www.theguardian.com/world/2015/apr/20/italy-pm-matteo-renzi-migrant-shipwreck-crisis-srebrenica-massacre. Exactly one year later to the day, a repurposed fishing boat foundered off the coast of Eastern Libya, leaving five hundred people to drown in its wake; Patrick Kingsley and Ruth Michaelson, "Hundreds Feared Dead in Migrant Shipwreck," *Guardian*, April 20, 2016, https://www.theguardian.com/world/2016/apr/20/hundreds-feared-dead-in-migrant-shipwreck-off-libya.

14 Cathryn Drake, "Terry Adkins: American Academy in Rome," *ArtForum International* 48, no. 9 (May 2010).

15 Caryl Phillips, *The Atlantic Sound* (New York: Vintage, 2001), 20–21.

16 Author interview with Joy Gregory, London, June 9, 2003.

17 Interview with Gregory.

18 *Cinderella Tours Europe* was commissioned by the Organization of Visual Arts, London, in 2001 and first exhibited as *Cinderella Stories* at the Pitshanger Manor Gallery in London the same year. In 2003, *Cinderella Tours Europe* was exhibited at Archivo del Territoria Histórico de Álava, Vitoria-Gasteiz, Spain.

19 Salah Hassan and Iftikhar Dadi, eds., *Unpacking Europe* (Rotterdam: Museum Boijmans Van Beuningen and NAi Publishers, 2001).

20 Amnesty International, *The Human Cost of Fortress Europe: Human Rights Violations against Migrants and Refugees at Europe's Borders*, www.amnesty.eu/content/assets/Reports/EUR_050012014__Fortress_Europe_complete_web_EN.pdf.

21 Harriet Sherwood, Helena Smith, Lizzy Davies, and Harriet Grant, "Europe Faces 'Colossal Humanitarian Catastrophe' of Refugees Dying at Sea," *Guardian*, June 2, 2014, www.theguardian.com/world/2014/jun/02/europe-refugee-crisis-un-africa-processing-centres.

22 Amnesty International, *Human Cost*.

23 This fashion is not exclusive to Caribbean people: it is also highly prevalent in hip-hop culture and urbanized global culture as well as in parts of Africa, such as Ghana, where gold production is still a primary economic industry. In some poorer parts of the world, including the Caribbean, many people wear imitation gold, gold plate, and hollow gold jewelry, an indication that the resources that their lands once had have been all but depleted.

Part 3

Differently Black

11

Differently Black

The Fourth Great Migration and
Black Catholic Saints in Ramin Bahrani's
Goodbye Solo and Jim Sheridan's *In America*

CHARLES I. NERO

In this chapter I examine two films from the independent cinema movement that draw attention to West African migrations to the United States and their diaspora in the late twentieth and early twenty-first centuries. Ramin Bahrani's *Goodbye Solo* (2009), set in Winston-Salem, North Carolina, tells the story of an unlikely friendship between a Senegalese taxi cab driver named Solo and a possibly suicidal, older white male passenger. Jim Sheridan's *In America* (2002), set in the lower Manhattan of the 1980s, tells the story of an Irish illegal migrant family trying to succeed in the United States. The family forms a friendship with a neighbor, Mateo, a West African immigrant who is an artist and is dying from an unspecified disease that resembles AIDS.[1] I consider these films together because they refer to multiple diasporas and migrations. Bahraini is a first-generation American, of Iranian descent.[2] Sheridan is Irish and resides in the United States.[3]

Bahrani's and Sheridan's West African characters are members of what has been called the Fourth Great Migration, which began in the latter part of the twentieth century when the Immigration Act of 1965 repealed national quotas that had effectively excluded sub-Saharan Africans from entering the United States. Since then migration from Africa has steadily increased, so that between 2000 and 2010 more than one million legal immigrants from sub-Saharan Africa have arrived in the United States. Putting that into perspective, the *New York Times* noted in 2014 that during the first decade of the twenty-first century "more black Africans arrived in this country on their own than were imported directly to North America during the more than three centuries of the slave trade."[4]

This Fourth Great Migration has significance for how we understand black identity. Notably, this generation of migrants may not connect to the protest traditions that have characterized and shaped the lives of native-born African Americans. "Selma doesn't cut it for them," stated Khalil Gibran Muhammad, director of New York Public Library's Schomburg Center for Research in Black Culture, referring to one of the touchstone events of the Civil Rights Movement.[5] Indeed, we need new models to address the changing demographic of blackness for a population without the baggage of slavery or the history of Jim Crow segregation.

In this essay, I examine West African characters from the Fourth Great Migration who are what I call "differently black." They come from the geographical areas of the historic transatlantic slave trade, but they are not American descendants of that commerce. I examine these characters because of the need for scholars to be attentive to the way that artists, and in this particular case, two filmmakers from diasporas themselves theorize and represent race in the United States.

Christina Greer's work *Black Ethnics: Race, Immigration, and the Pursuit of the American Dream* is central to my thinking in this essay. Greer astutely asks the question, "What does racial identity and ethnic distinction mean for blacks living in America?"[6] In her search for an answer to this query, Greer follows a path laid down by critical race theorists, who argue that racial difference and white supremacy are fundamental features of American life. Greer contends that for migrants, both origin and phenotype matter for success in American life. For immigrants from Africa and the Caribbean, Greer states, "the dissolution of their black status is not possible. It is impossible to remove the black phenotype that serves as the fundamental distinction between black immigrants from Africa or the Caribbean and the assimilation narratives of Irish, Italian, and Jewish immigrants, or even current immigrants [from] Latin America or Asia."[7] Greer argues that black immigrants receive an "elevated minority status," a position that denies them the potential for assimilation afforded to a "model minority group," but that is an "elevation above their black American counterparts, the widely accepted 'last place' racial group."[8] Afro-Caribbean and African immigrants are perceived as "good blacks" who are "different, that is, harder working, smarter, and/or 'better' than native-born blacks."[9] This idea of the "differently black" immigrant reinforces views that non-native blacks are industrious, family-oriented, and have cultural values that mirror the ones prized by white middle-class Americans. Notably, the view of black immigrants as an elevated group

has influenced social science-driven public policy and has had an impact upon college admissions at elite universities.[10] As an elevated minority, immigrant blacks are potentially "good blacks," defined by their difference from native-born blacks, not in relationship to other immigrants or whites.[11] Thus "the new problem facing the twenty-first century is not just of the color line," Greer states, "but how the stratification of this line creates more complex tensions for groups struggling against the notion of 'last place' in American democracy."[12]

In crafting their "differently black" characters in America, I argue that the filmmakers Bahrani and Sheridan re-create the racial hierarchies and stratification that define immigrant blacks in relationship to "last-place" native-born blacks. Their characters allude to the memory of blackness associated with transatlantic slavery. Although not direct descendants of transatlantic slavery, the "differently black" West African immigrants in these two films are ascribed a social and/or cultural status that is elevated over native-born blacks. Elevation occurs when filmmakers draw upon a Catholic tradition of saintly imagery to craft ultra-decent but differently black characters whose sole purpose is to help white characters navigate and resolve crises. In crafting such explicitly religious characters, the film-makers from their respective diasporas—Iran and Ireland—reveal a nos-talgic yearning for the iconic images of blacks as caretakers—usually as maids, butlers, and other kindly servants—of white people that emerged in classical Hollywood cinema. To this day, black characters appear in films as servants and often as "magical Negroes."

The elevated status of these differently black characters obscures the nostalgic yearning for these stereotypes from old Hollywood. Nostalgia is always already a problem in American cinema. A yearning for the past brings with it an unavoidable re-creation of the racial stereotypes that were cornerstones for white supremacy. For instance, the classic cin-ematic work *Who Framed Roger Rabbit?* (1988) yearns for a time when seemingly innocent cartoons entertained America and the world. How-ever, it is unavoidable to compare the comic, always willing to please, animated "toons" with the black coons of yore. Likewise, we get the image of the tragic mulatto when the film evokes the historical practice of pass-ing: the character that wants to destroy the toons is revealed to be a self-loathing toon "passing" for a human.[13] When *In America* and *Goodbye Solo* represent a nostalgic yearning for the fantastic stories of saints that animated the church before Vatican II, the filmmakers wittingly or unwit-tingly recreate the stereotypes that are typical of Hollywood film.

A Black Magus in Hell's Kitchen

In Sheridan's *In America*, Djimon Hounsou plays Mateo, whose Portuguese name is actually the name of the biblical writer, Matthew, through whom we know the story of the magi whose appearance heralds the Christ child, foretelling the Christian era. Hounsou's Mateo is the exemplar of the iconic black magus in Jim Sheridan's story of an Irish Catholic family's spiritual crisis following the death of its male child. At the beginning of the film Mateo is part of the terror associated with the family's new apartment in Hell's Kitchen, populated with junkies and prostitutes. As the family ascends the stairwell to an upper floor apartment, they see a door with "Go Away" and "Do not enter" painted on it in red. Then they hear a man screaming from inside the apartment. When the family finally sees Mateo, they recoil in fear from this screaming man. He is shirtless, very dark, and muscular—all elements that matter for the role he will assume as saintly savior for the family.

The film uses Mateo's body in a way that recalls the Christian narrative of the black magus. Traditionally in Western art, the black magus is notable for the wealth he brings to the newborn Christ. However, his wealth is not only material, but potentially erotic. Medieval and Renaissance artists mark the black king as different from the two white kings by his youth and his opulent attire. Richard Trexler points out in *The Journey of the Magi* that the black magus's youth, blackness, and opulence suggest a "darker," erotic force that contrasts with that of the other two kings and ultimately "stands for the biological reproduction of the races," by contrast with "the impotent first and second kings, who merely want to maintain, or culturally reproduce, the existing patriarchy of their societies through a stale and authoritarian ceremonialism."[14] Hieronymous Bosch's 1510 *Adoration of the Magi* is a canonical painting of this scene of adoration among the thousands produced in the Middle Ages and Renaissance. One can see that the black king is clearly the most youthful of the three. He wears bright white attire and stands tall and erect, unlike the two older kings who kneel and appear more like supplicants.

Mateo's sculpted, beautiful body as the black king who is a synecdoche for reproduction is made apparent in two pivotal scenes that ultimately restore the white couple, Sarah and Johnny, to the faith. Both scenes use crosscutting, alternating shots of Mateo and the white Catholic couple to build suspense and to imply causality. The first is the scene of Sarah's miraculous conception. Sarah and Johnny, like their biblical antecedents Sarah and Abraham, struggle to conceive another child. When they at

CHARLES I. NERO

last conceive, a thunderstorm takes place. Shots of the two in bed are crosscut with shots of Mateo in the lower apartment. Mateo is screaming, cutting himself, and letting his blood spill out onto the canvas. The couple reaches a climax as Mateo's screams blend with the thunder. After the stresses of bloodletting and lovemaking, Mateo and the couple collapse in their separate apartments, the storm subsides, and the voice-over narrator announces that this is the night that Sarah and Johnny's child was conceived. This scene is Christian theology at its most elemental: Mateo's blood has been given for this child to come into the world.

More than Mateo's blood will be demanded in the second scene of reproduction. The child is born prematurely and lies in a semiconscious state. In alternating crosscut shots, Sarah and Johnny watch the premature child, who lies in an uncertain state in an incubator, while Mateo, draped in an opulent golden brocade robe, lies in an equally uncertain state in a hospital bed and begins to speak "in an African language" according to the subtitles. His words are not translated into English. As Mateo dies, the baby miraculously comes to life, squeezing its parents' fingers and screaming, clearly an allusion to Mateo's nickname, "the Screaming Man." The baby is given Mateo as its middle name, which also establishes the connection between its life and Mateo's death. In Christian ideology, Mateo died so that the baby might live.

Mateo's built body is also a symbol of the wealth that the magi brought to the newborn Christ. In *White*, Richard Dyer writes that the "built body is a wealthy body. It is well fed and enormous amounts of leisure time have been devoted to it."[15] Mateo's built body—his huge chest muscles and biceps, his tapered waistline, the six-pack on his stomach—allude to this wealth. Eventually, Mateo's wealth will become a cornerstone for the Irish Catholic family's successful passage into becoming Americans.

When Mateo dies, Sarah and Johnny, who are in debt to the hospital, find that Mateo has paid their enormous medical bill. This scenario is probable—rather I should say believable—only because Mateo is "differently black," a state that allows an audience to unquestionably accept that he is without kith and kin, that is, other black people, so that he can provide wealth to a literally "alien" white family who crossed the Canadian border illegally.[16] Mateo's wealth, used for the white family, recalls the memory of blacks in transatlantic slavery. Like the enslaved Africans whose ties with kin and community were severed in the Middle Passage, Mateo has neither family nor community who will benefit from his wealth—all of which will go to whites.

Mateo's role as gift giver to the white family is believable, but not

probable. The economies of many nations on the African continent are kept afloat by remittances from their relatives in America and in Europe. But Mateo has no one except the struggling, desperate Irish to whom he bestows his wealth. When the film repeats this motif of the black servant morally obligated to care for the white family, rather than to care for his own family in Africa, it practices what Snead calls "omission," the most pernicious and persistent form of racial stereotyping in classical Hollywood cinema.[17] When Sheridan omits the reality of black immigrants and their remittances to their kin back home, he continues a practice that allows audiences in an indie film to accept the traditions established in classical Hollywood cinema to defend white supremacy. The film must ignore the reality of migration in the black diaspora in order to create what the American Film Institute called, when it awarded *In America* the honor of "Movie of the Year," "a spellbinding fable that captures the modern day immigrant experience and retells it through the eyes of a child."[18] Does this sound like a yearning for Shirley Temple and Bill "Bojangles" Robinson? A story like *In America* could only be told from the supposed innocence of a child.

A Black Fool

The story of *Goodbye Solo* is a narrative of the Fourth Great Migration too, but not like Jim Sheridan's *In America*. In this film the Senegalese protagonist Solo is clearly at home in America. The fact that he has a pregnant Mexican wife and a step-daughter points to an America that has been created by new migrants from Latin America and Africa. However, I want to argue that this new America is once again a story about a needed but excluded blackness that "the differently black" character fulfills. More specifically, Solo offers a blackness that is necessary for American identity, but does not come with the baggage or memory that descendants of the transatlantic slave trade possess. *Goodbye Solo* is a return to an Africa with no memory of a Middle Passage and no legacy of white supremacy.

Filmmaker Bahrani stated in an interview that Roberto Rossellini's film about St. Francis of Assisi was an inspiration for *Goodbye Solo*.[19] Rossellini's film is most commonly known in the United States by its English title, *The Flowers of St. Francis*. However, its original title in Italian is *Francesco, giullare di Dio,* which translates as *Francis, God's Fool* or *Francis, God's Jester.* I do not want the Italian title to be lost because

using a black male to depict God's fool or jester is not without historical baggage.

Peter Brunette, in his study of the films of Roberto Rossellini, makes an argument that is quite relevant for this essay. Brunette contends that in creating *Francesco, giullare di Dio*, Rossellini had a didactic purpose for making such an overtly religious film. According to Brunette, in *Francesco*, Rossellini was "concerned with the despair and cynicism facing postwar Europe and unashamedly offers St. Francis and his philosophy as answers, as a way back to an essential wholeness."[20] Rossellini's St. Francis was a historical Italian figure amidst other Italians, yet Rossellini removed many of the historical facts about St. Francis—for instance, his aristocratic background—to craft his vision of "divine madness" and "a crazy world of faith."[21] Like Rossellini, Bahrani needs to alter reality for his saint. While Rossellini removed the facts of class in his cinematic society, Bahrani removes or alters the facts of race and racism. However, Bahrani's *Goodbye Solo* exists in a world where racial difference exists and matters. When Bahrani removes history to craft a "crazy world of faith," to use Brunnette's phrase, the memory of white supremacy is, in fact, evoked. In the U.S. entertainment and film culture especially, African Americans have played the role of the religious fool, usually as the character type we call Uncle Tom.

In *Goodbye Solo,* Souleymane Sy Savane (Solo) and William meet as taxi driver and passenger. William, an old and bitter white man, offers the much younger Solo a thousand dollars to pick him up in ten days, drive him to Blowing Rock, leave him there, no questions asked. Solo recognizes that William wants to commit suicide, so he decides to intervene. The choice of Blowing Rock as the site of William's planned suicide folds into the Christian image of death and resurrection. Blowing Rock is a place where the wind is so strong that snow blows up. Sometimes the wind at Blowing Rock is strong enough to blow a body upwards. William is planning his Ascension.

It is difficult not to see Solo's foolish behavior in the film through a lens of the stereotype of Uncle Tom. In Harriet Beecher Stowe's 1852 novel, Uncle Tom continually suffers and endures punishment at the hands of whites and of black drivers, in order to uphold his Christian principles. While Stowe's Uncle Tom is certainly an emblem of Christian heroism, he is also part and parcel of white supremacy. As James Baldwin famously commented in "Everybody's Protest Novel," since Uncle Tom is "black, born without the light, it is only through humility, the incessant mortification of the flesh, that he can enter into communion with God or man."[22]

Like Uncle Tom, Solo suffers mightily for his loyalty to William. Solo brings William to his home against his wife's wishes, and, of course, she and her male kin put both men out. Solo is reduced to sleeping on a couch in William's seedy hotel room. Not only is Solo homeless now, but he is unable to see his newborn son and has only limited access to a stepdaughter whom he clearly loves. In addition, Solo has to figure out how to study for an exam to become a flight attendant. Of course, he fails the exam. Things get worse. Solo is repeatedly beaten while trying to defend and help William. First, William beats Solo, then a fellow cabbie beats him. Nevertheless, Solo is the loyal sidekick to William.

One reviewer writing about the film from a Christian perspective summed up the narrative: "Solo wants to know William, and to help him, even if he must endure rejection and insult along the way."[23] What is remarkable about this statement is that it would smack of a racist stereotype were Solo a native-born African American. Solo would be dismissed simply as the iconic Uncle Tom that Donald Bogle calls the "socially acceptable Good Negro . . . chased, harassed, hounded, flogged, enslaved, and insulted," who nevertheless "keep[s] the faith, n'er turn[s] against [the] white massas, and remain[s] hearty, submissive, stoic, generous, selfless, and oh-so-very kind."[24] However, turning Solo into a Senegalese man resolves the problem of the Uncle Tom stereotype because it allows the audience to witness a tale seemingly without a white supremacist agenda but clearly with a racial agenda. As in Jim Sheridan's *In America*, Bahrani's *Goodbye Solo* requires a "differently black" male character that can evoke, yet evade, the harsh memory of the transatlantic trade. The filmmaker does this delicate balancing act when Solo explains that his desire to help William is because where he comes from in Senegal, old people are revered. Referring to what he says is a Senegalese proverb, Solo tells William, "An elder who dies is like a library that burns." As a Senegalese who does not come from the descendants of the Middle Passage, Solo says this proverb to an old white cantankerous southern man—read, a "redneck"—without rancor or irony.

An important reason that Solo appears as a comic foil to William is that the film takes its form from the quintessentially American interracial buddy film. This genre has its origins in American literature as what Leslie Fiedler identified as the chaste "sacred marriage" that allowed white males to confront the terror of their past by imagining that a "dark-skinned brethren will take us in . . . when we have been cut off, or have cut ourselves off, from all others, without rancor or the insult of forgiveness."[25] This growing interracial intimacy allows white males to meditate on

CHARLES I. NERO

friendship and desire across boundaries of difference and hate. Benjamin DeMott writes that these depictions of interracial intimacy in popular culture divert our attention away from structural and institutional inequity by repeatedly telling audiences that "racism is nothing but personal hatred, that when hatred ends, racism ends."[26] I agree with DeMott's observation. The interracial buddy film emerged during the post–World War II period as a vehicle for Hollywood liberals to affirmatively engage the social changes being brought about by the Civil Rights Movement. In films such as *Bright Victory* (1951) and *The Defiant Ones* (1959), black and white men were placed in situations that allowed them to forge friendships across boundaries enforced by the law. *Bright Victory* addressed the issue of racial integration of the military: in it, a racist white veteran learns the value of being colorblind after losing his eyesight in an explosion and developing an intimate relationship with a black veteran who is also blind. In *The Defiant Ones,* a black and a white criminal, each chained to the other, learn that in order to be free they must cooperate. In a slew of films beginning in the post-Civil Rights era 1980s, black and white men—usually law enforcement officers, athletes, or soldiers—forge enduring friendships across barriers of racial difference to become a coordinated team that can rescue innocent civilians, win contests, or solve crimes.[27] The friendships in these films demonstrate over and over a belief that intimacy between racially different males is the basis for social equality.

As an interracial buddy film, *Goodbye Solo* explores the growing bond between a crusty old southern white male and a recent immigrant from Senegal. It is notable that the black character is an immigrant and that the setting is in North Carolina, a former slaveholding state and a location that was the epicenter of the modern Civil Rights Movement. As a black, but a recent immigrant, Solo does not possess a memory of slavery, white supremacist practices, or the Civil Rights Movement. The deepening friendship between William and the "differently black" Solo is not a story about overcoming racism and bigotry after centuries of tensions between descendants of owners and the owned. Instead, *Goodbye Solo* is an interracial love story without the baggage of the American past of white supremacy.

Solo's foolishness resembles the roles that Sidney Poitier played in the 1950s and 1960s. For instance, in *Lilies of the Field* (1963) Poitier comes to the aid of a group of nuns in the American Southwest who have fled communist persecution in Eastern Europe. As Homer Smith, Poitier not only secures a job to feed the impoverished nuns, but he uses his carpentry skills to build a chapel free of charge for them. Poitier received an

Academy Award as best actor for portraying the saintly Homer Smith. In *The Defiant Ones*, Poitier's foolishness led him to give up his freedom to join his white convict pal in jail. Ed Guerrero appropriately called Poitier an "ebony saint."[28]

But there is another element here in which Bahrani crafts Solo as "differently black" by elevating him above native-born blacks. When Solo speaks in an African American vernacular or when hip-hop appears on the soundtrack the film evokes the memory of transatlantic slavery. At the very beginning of the film, the audience is made aware that Solo can code switch between African American vernacular and a more conventional standard American speech. Solo speaks a more standard variety of English to William: "But last time I was talking shit because I thought you were talking shit. I'm sorry, sir. I apologize for my language. Sorry about that." Solo then code switches to more African American variety of speech when he receives a call on his mobile phone. "Yo, what up, player? Yeah, I'm just chillin' here, man. North side in an hour. I got you. Yo, big dawg, let me call you back, all right? I'll call you right back. Peace." Solo's performance reveals that African American vernacular is not his native speech. Solo can speak "black" when his job requires him to do so, but it is not his natural code. Solo's code switching ability matters for his difference, especially to audiences for indie films. These audiences tend to be white, educated, and liberal. For these audiences, Solo's skin color allows his performance to escape the embarrassing label of minstrelsy or "wiggery" associated with white characters that act black. However, Solo's performance of African American vernacular sounds foreign and different and affirms his status as "differently black," thus allowing audiences a license to experience his performance as humorous rather than embarrassing.[29]

Solo's humorous performance also underscores the film's need for blackness, but its disapproval of native-born blacks. The film associates native blackness with violence and the illicit. Solo picks up an African American man who seems to be "the real thing." This passenger's speech is African American vernacular and it does not evoke humor. Solo drops the passenger off at an apartment complex, and on the soundtrack we hear loud, unsettling rap music that uses "nigger" a lot, and refers to doing time in the penitentiary. When Solo's passenger runs back to the car, black men stream out of the apartment with guns and rocks. We get the impression that something illicit has happened, perhaps, a bad drug deal. Notably, after this scene, native-born U.S. blacks and their culture disappear. We never hear rap again or encounter other U.S. blacks. However, black-

ness remains, especially on the soundtrack, as music from the African diaspora outside the United States because reggae and salsa appear on the soundtrack. Here, the film relies upon a contradiction about immigrant blacks. It forgets that Caribbean and Afro-Latin peoples were products of transatlantic slavery, too.

The image of native-born blacks as criminal is in line with Rossellini's view, in *Francis, God's Fool,* that the modern world is cynical. Native-born blacks have no potential to redeem the nation. This is ironic in light of the fact that since the late eighteenth century, African Americans have argued that the elimination of white supremacy is fundamental to America's redemption.[30] Bahrani does not reject the idea that blacks have a role to play in the redemption of America; rather, he argues that the blacks that assume this role must be "different" and without a memory of the Middle Passage, slavery, and the legacy of white supremacy and resistance to them.

Eventually, the "differently black" Solo completes his role as William's caretaker when he brings him to Blowing Rock. William disappears. When Solo goes to look for him, William is gone. We are not told whether he jumped. There is no evidence of a body or of blood from a fall. So perhaps William ascended upwards into heaven after all. If this is a parable about a new America, it is one that gets rid of both old whiteness (William) and old blackness. Yet, this new America needs blackness, just a blackness without the memory of transatlantic slavery.

Conclusion

As stories about the United States, *In America* and *Goodbye Solo* are not innocent parables. Both films rely upon nostalgia, with its attendant racial hierarchies. *In America* is the more blatantly offensive of the films because it reveals an intense yearning for the faithful, docile black servants of classic Hollywood. Sheridan uses the saintly, differently black Mateo to deflect attention away from how stereotypical the character Mateo is. Bahraini's film is more innovative, given its inspiration by Italian neorealism.

Unfortunately, Bahraini's differently black Solo in an American context conforms to racial stereotypes solidified in another Hollywood genre, the interracial buddy film. Bahraini, more than Sheridan, relies upon a discourse of an elevated black contrasted with degraded native-born blacks. Although both films were created by nonblack, though diasporic, film-

makers, they suggest how strong the need is in the present for films to reproduce the fantasies of whiteness presented in Hollywood cinema. In these fantasies, blacks—regardless of ethnicity or origin—are once again caregivers for white characters in crisis.

Notes

1 In 2014, news reports announced that Jim Sheridan planned to make a television series based upon *In America* and was in communication with HBO about the project; Kirsty Blake Knox, "Jim Sheridan's *In America* Set for the Small Screen," *Irish Independent*, July 16, 2014, www.independent.ie/entertainment/movies/movie-news/jim-sheridans-in-america-set-for-the-small-screen-30434821.html.

2 Bahraini was born March 20, 1975 in Winston-Salem, North Carolina; his parents are Persian from Iran. His first two feature films were *Man Push Cart* (2005) and *Chop Shop* (2007); both received wide and universal praise, including a nomination for director in the Independent Spirit Award, and an Official Selection for the Director's Fortnight at the Cannes Film Festival. Bahraini received a Guggenheim Fellowship in 2009 and currently is a professor of film at Columbia University. I am uncertain about Bahraini's religious upbringing or affiliation. However, there has been a concerted effort to Christianize Persians living in America.

3 Jim Sheridan was born February 6, 1949 in Wicklow, Ireland. He emigrated to Canada and later, in 1981, to New York City. He is renowned as both a writer and a director, having been nominated for Academy Awards six times: for original screenplay of *In America*; for director, adapted screenplay, and coproducer of *In the Name of the Father*; and for adapted screenplay and director of *My Left Foot*. He has played a significant role shepherding actors to acclaimed careers, notably Daniel Day-Lewis, Emma Thompson, Brenda Fricker, and Samantha Morton.

4 Sam Roberts, "Influx of African Immigrants Shifting National and New York Demographics," *New York Times*, September, 1, 2014, www.nytimes.com/2014/09/02/nyregion/influx-of-african-immigrants-shifting-national-and-new-york-demographics.html?_r=0.

5 Roberts, "Influx of African Immigrants."

6 Christina Greer, *Black Ethnics: Race, Immigration, and the Pursuit of the American Dream* (Oxford: Oxford University Press, 2013), Kindle edition, loc. 316.

7 Greer, *Black Ethnics*, loc. 705.

8 Greer, *Black Ethnics,* loc. 333.

9 Greer, *Black Ethnics*, loc. 521.

10 Prominent African American scholars Henry Louis Gates Jr. and Lani Guinier have criticized elite American universities for their preferences for recruiting immigrant blacks over native-born blacks. According to one study, immigrant blacks make up 13 percent of the black college-age population but constitute more than 25 percent of the students enrolled at Ivy League and other selective colleges and universities. The same study noted that low-income blacks

tend to be the descendants of American slaves who suffered from generations of racial discrimination during the Jim Crow era. For the most part, they are not the students benefiting from today's race-sensitive admissions programs at America's most selective colleges; see Darryl Fears, "In Diversity Push, Top Universities Enrolling More Black Immigrants," *Washington Post,* March 6, 2007, www.washingtonpost.com/wp-dyn/content/article/2007/03/05/AR2007030501296.html. See also "University Race-Sensitive Admissions Programs Are Not Helping Black Students Who Most Need Assistance," *Journal of Blacks in Higher Education*, accessed March 6, 2015, www.jbhe.com/news_views/56_race_sensitive_not_helping.html.

11 These are purely anecdotal pieces of evidence from my own biography that led me to empathize with Greer's findings about the idea that some blacks belong to an "elevated minority group" whose elevation depends upon their relationship to a permanently subordinated native-born blacks. The first anecdote happened at my elite liberal arts college, which named an endowed chair in economics after the economist Thomas Sowell, who has argued that native-born and immigrant blacks have different cultural values that have led to failure for the former and mainstream success for the latter. In a conversation, the professor who holds the chair adamantly agreed with Sowell's position that native-born blacks do not have the drive for success that Caribbean and African blacks have. The second anecdote occurred at my elite liberal arts college during a symposium about Haiti. A white female visitor told me that she had adopted Haitian children because they were so different from U.S. blacks. The Haitians are proud—"you can see it in the way they walk," she said and I wrote in my diary—"unlike the black Americans." I deliberately point to the fact that these anecdotes happened at the institution in which I work because it is located in one of the whitest states in the United States. It amazes me that people who have minimal contact with blacks—native-born or immigrant—hold beliefs that so closely mirror the dominant discourse about race and ethnicity.

12 Greer, *Black Ethnics*, loc. 512.

13 Mark Winokur, "Black Is White/White Is Black: 'Passing' as a Strategy of Racial Compatibility in Contemporary Hollywood Comedy," in *Unspeakable Images: Ethnicity and the American Cinema*, ed. Lester D. Friedman (Urbana: University of Illinois Press, 1991), 190–214.

14 Richard C. Trexler, *The Journey of the Magi: Meanings in History of a Christian Story* (Princeton, NJ: Princeton University Press, 1997), 123.

15 Richard Dyer, *White: Essays on Race and Culture* (New York: Routledge, 2002), 155.

16 When the Irish family crossed the Canadian border into America, they lied to border agents, claiming to be on holiday, thus concealing their plans to reside permanently in the United States so that the father could find work as an actor. That few critics noted the illegal status of the family is incredible, considering the anti-immigrant hysteria in the United States at the time of the film's commercial release.

17 James Snead, *White Screens/Black Images: Hollywood from the Dark Side* (New York: Routledge, 1994), 6.

18 "AFI Awards 2003," accessed March 16, 2015, www.afi.com/afiawards/AFI-Awards03.aspx.

19 *Charlie Rose Show*, PBS, May 15, 2009.

20 Peter Brunette, *Roberto Rossellini* (Berkeley: University of California Press, 1996), 131.

21 Brunette, *Roberto Rossellini*, 135.

22 James Baldwin, "Everybody's Protest Novel," in *Notes of a Native Son* (Boston: Beacon Press, 1955), 17.

23 John Sizemore, "Love Doesn't Give Up in *Goodbye Solo*," *Crosswalk*, accessed March 6, 2015, www.crosswalk.com/culture/movies/love-doesnt-give-up-in-goodbye-solo-11604876.html.

24 Donald Bogle, *Toms, Coons, Mammies, Mulattoes, and Bucks: An Interpretive History of Blacks in American Films,* 4th ed. (New York: Continuum, 1973), 6.

25 Leslie Fiedler, "Come Back to the Raft Ag'in, Huck Honey," in *The Leslie Fiedler Reader* (New York: Prometheus Books, 1999), 11.

26 Benjamin DeMott, *The Trouble with Friendship: Why Americans Can't Think Straight about Race* (New York: Atlantic Monthly Press, 1995), 23.

27 Ed Guerrero, *Framing Blackness: The African American Image in Film* (Philadelphia: Temple University Press, 1993), 78–80.

28 Guerrero, *Framing Blackness*, 72. It is worth noting that Sidney Poitier was a differently black actor. Born in the Bahamas, Poitier immigrated to the United States as a teen.

29 A mostly white audience laughed at Solo's performance of African American vernacular when I saw the film because I think that they felt comfortable and could enjoy Solo's difference. The audience's reaction might have been different if Solo had been a white man, an Eastern European immigrant, for instance, speaking African American vernacular.

30 See Wilson Jeremiah Moses, *Black Messiahs and Uncle Toms: Social and Literary Manipulations of a Religious Myth* (University Park: Pennsylvania State University Press, 1982), especially chapter 4, "The Myth of Uncle Tom and the Messianic Mission of the Black Race."

12

Coloured in South Africa

An Interview with Filmmaker Kiersten Dunbar Chace
and Photojournalist Rushay Booysen

SONJA GEORGI AND PIA WIEGMINK

How does a change of locality from the Americas to South Africa
alter the concept of African diaspora and the idea of migrating
the black body? What are the potential benefits of this shift of
perspective? What is at stake for both the concept of the African diaspora
and the idea of migrating black bodies when we include the Coloured
population of South Africa, when we make comparisons and point out dif-
ferences between African American history and the history of, for exam-
ple, the Cape Coloured community? How does this shift in perspective
unsettle parameters and experiences, such as the centrality of the experi-
ence of race-based slavery, the Middle Passage, and the emergence as
well as legacy of Jim Crow and anti-miscegenation laws, that are all too
often considered paradigmatic for the African diaspora?

Rushay Booysen's photo project *Coloured: A Collage of a Hybrid
Society* and Kiersten Dunbar Chace's film *I'm Not Black, I'm Coloured*
destabilize and decenter the primacy of the transatlantic slave trade and
the American-centric experience of diaspora. Their works thus perform
a shift in view that not only establishes a more critical perspective on the
rootedness of the diaspora in the African American experience but like-
wise allows for a much more transnational and thus comparative frame
of reference. Such a perspective, this interview shows, not only sheds
light on similarities in U.S. American and South African systems of racial
segregation and their legacies but also could help to reflect upon African
American conceptualizations of the African homeland, Pan-Africanism,
and South Africa's struggle for racial equality.

The interview with filmmaker Kiersten Dunbar Chace and photojour-
nalist Rushay Booysen was conducted over a two-month period before,

during, and after the symposium "Migrating the Black Body: The African Diaspora and Visual Culture" in Hannover, Germany. Chace's documentary *I'm Not Black I'm Coloured: Identity Crisis at the Cape of Good Hope* (2009) was screened during the symposium. The film is a feature-length documentary about the history of the Cape Coloured people of South Africa, one of several cultural groups classified as Coloured by the Apartheid government. Booysen exhibited *Coloured: A Collage of a Hybrid Society* (2010), a photo collection of the Coloured community in Port Elizabeth, at the conference venue. The interview also includes comments and questions from conference participants.

Sonja Georgi: Rushay, how did the portraits in your photo series *Coloured: A Collage of a Hybrid Society* come into being?

Rushay Booysen: First of all, the title of the project alludes to a book by Al J. Venter called *Coloured: A Profile of Two Million South Africans* (1974), which was banned back then by the South African government.[1] Venter's book is about the accomplishments and contributions of Coloured people in the struggle of South Africa. It was a book that did not have any visuals, which I felt was important to include. The book itself was very progressive at the time as we know race relations were a very sensitive topic in South Africa, and they actually still are. In Southern Africa the label "Coloured" is used to denote people of mixed racial heritage/ancestry. I've come to see it more as a label that brought people from various backgrounds under one umbrella. Our family histories expand pretty far and wide—a racial category would actually not be a true reflection of my community. What is really important for my work is to be able to create a dialogue, because the topic itself, migrating the black body, is so controversial if only viewed from the point of the diaspora. I've found urgency in seeking a conversation and a better comprehension in the discussion between the African root and the diaspora that's located in various places across this world. I also feel that we, the people on the continent of Africa, fail to understand the impact of forced enslavement on people from Africa who were taken to places like North or South America, so it's difficult at times to place ourselves in the conversation. You will often find the framing of Black Americans, as in the context of music, sports, and film entertainers, and it's particularly this headline that drives our understanding. Within this context, there is this big racial divide that is happening between the "black" world and the "white" world, there is this binary that is being created—people only see black and white, everything in between is not recognized. Especially when I travel to the United States discussing

this issue, people tell me, "You should not say that!" or they compare the situation of the Coloured community in South Africa to American history. I find that the members of the Coloured community find themselves in this in-between space that doesn't offer them a concrete place. This is a particular community that came into being by the slave trade. They hardly speak their mother tongue because they were either raised with Afrikaans or English as their mother tongue and that largely leaves them out of the mother tongue spectrum. This also plays out in the job sector where a requirement is to speak an African language, which they don't speak.

Georgi: When and where did you take this series of photographs? Who are the people portrayed?

Booysen: I started taking the images about five years ago and it's been a gradual process of capturing and archiving. Due to the sensitivity of asking someone to contribute a piece of their life for a photo project I saw the need not to rush the process but gather it gradually over time. Most of the photographs are taken in Port Elizabeth where I am from, but I'm hoping to get a more extensive archive that covers the whole region as each part of the country has such a unique history and blend. Most of the people in the images are family and close friends around my community that I asked to be photographed. Part of my idea in choosing the subjects seeks to explore the broad spectrum of features that you could find in the Coloured community and in a particular family group. It was a play around the idea of a phenotype community, which you could see is not displayed in these portraits. This is also the stereotype that I commonly came across when people made statements like "You don't look African" (figure 12.1, plate 17; figure 12.2, plate 18; figure 12.3, plate 19).

Krista Thompson: Rushay, with regard to a community like the Cape Coloured community, a community who's [characterized by] nonidentity, that is, their not knowing who their ancestors are, do you think photography allows us to understand or grasp a better understanding of the nature of their identity?

Booysen: From my travels I got to witness how race is viewed outside of the paradigm of South Africa. My community, in particular, extracts its history from various nationalities and ethnic groups within the makeup of South Africa/Southern Africa. As you can imagine, a kaleidoscope of various groups would create all sorts of features. At times you don't find any connection in physical appearance but you find people are blood relatives. I wanted to capture firstly people that are closest to me, my family and friends, people whom I could track through a common family tree. I firstly found out how the subjects saw themselves. There were

12.1.
Jonathan Booysen,
twenty-five years
old. Photograph by
Rushay Booysen,
from *Coloured: A
Collage of a Hybrid
Society,* 2010.
Reprinted with
permission of the
artist.

12.2.
Alka Myburgh,
twenty-three years
old. Photograph by
Rushay Booysen,
from *Coloured: A
Collage of a Hybrid
Society,* 2010.
Reprinted with
permission of the
artist.

12.3.
Sean Plaatjies,
nine years old.
Photograph by
Rushay Booysen,
from *Coloured: A
Collage of a Hybrid
Society,* 2010.
Reprinted with
permission of the
artist.

various answers but the most common response was "I'm brown," "I'm Coloured." Oftentimes it was too complicated for them to answer where they were from or where their ancestors came from or what ethnic group they belong to. I felt it was important to have these discussions with our young kids. It was easy to start the discussion around a photo as most were eager to be snapped. To answer Krista's question, I definitely think a photo project can start the discussion because it first needs to start with the community in understanding the complexity of its history. You would oftentimes hear racist slurs directed at individuals depending on what side of their family tree they extract their features mostly from. I want the image to be the starting point because that's how we see each other.

Pia Wiegmink: Kiersten, how did you become interested in South African race relations, how did your film come into being?

Kiersten Dunbar Chace: In 1995, approximately one year after the abolishment of Apartheid, I helped produce a concert tour for one of South Africa's top gospel choirs. Approximately two weeks into that concert tour, a young woman from the choir by the name of Suzanne, who was staying with me, said, "Kiersten, I have something important to share with you when we get home. We can fix tea and we will sit down and talk." It just sounded so serious. That evening Suzanne said to me, "Kiersten, I have a secret. Please, you cannot tell anybody. Especially do not tell the rest of the group." I obviously agreed and was very anxious to hear what she had to say. "Kiersten, I just want you to understand that in my country, I am not a black South African. I am considered a Coloured South African." This comment would later become the basis for the title of my first film, *I'm Not Black, I'm Coloured*. My first reaction was, this is not a word we use anymore in the United States. The term "Coloured," or "colored," is derogative [in the United States]. But I kept an open mind, tried not to be judgmental and became even more curious about South African history. I asked a lot of questions. It was from that moment on, twenty years ago, that I began my research and became actively involved in Coloured communities across South Africa, which eventually led me to producing the film. Because of my long-time involvement in the community, it was important to create a film or story solely about the South African experience—no one else. This community deserved to have their own unique story and place in history so I gave them their own safe space to tell their stories, and from their own perspective.

Wiegmink: One aspect that we think is particularly prominent in both your works is the relation between the photographic images and attempts to ascertain racial identity. In *I'm not Black, I'm Coloured* there is this

scene in which one of the older men, Roger, says that during Apartheid, the government had to identify everybody and one of the ways they identified people was by looking at their passbooks and their photographs. He told an incredible story about his own family—two children were considered white and the other two were considered Coloured. They were not allowed to visit each other. The government determined their race by looking at their pictures! Rushay, did you choose the genre of the portrait as a comment on this Apartheid practice of putting people into racial categories?

Booysen: Yes, another important reference is the South African ID document with a photograph, which used to specify what group you belong to (figure 12.4).[2] The ID document had many forms. Black South Africans were forced to carry a pass. Besides just being Coloured at that time you had various subcategories for Coloureds in those documents. I would always remember as a kid seeing my grandmother's little portrait; it was this green little identity card that said "Cape Coloured" and it had a picture and her ID number with the last few digits denoting the individual's race. These documents became the crux of identification for the country's nonwhite citizens. I'm not sure if the separation of documentation was symbolic to the separation of the community. These ID cards would often also stipulate the type of Coloured category one was placed in. I could vividly recall the photographic details, but about the other parts of the detail, I only learned later when I was grown and did some research. My portrait series was basically a reenactment of the identity document, which clearly defined the group you belonged to. I wanted to display the features and the broad range that you can find within my community. It could be somebody from here [in Germany], somebody you won't expect being from Africa. So that for me was the inspiration for choosing portrait and also being able to have something, almost like a carry-on exhibit, something that I could easily—because you might travel and meet someone and start an interesting conversation—take with me, and the portrait was for me the most obvious form of display, something with which I could start a discussion or debate with somebody that has a potential interest in the topic.

Chace: There are other layers to that, too. For example, if government officials could not determine a person's race, they could look at the last two numbers of a person's ID—and that would identify them as either black, white, Indian, or the various groupings of Coloured people such as Cape Coloured, Other Coloured, Cape Griqua, Cape Malay, et cetera. Surnames were also another indication of one's identity or ethnicity. If

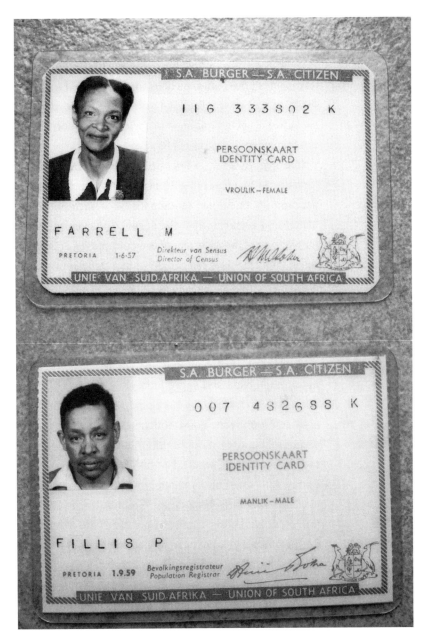

S.A. BURGER — S.A. CITIZEN

I I 6 3 3 3 8 0 2 K

PERSOONSKAART
IDENTITY CARD

VROULIK — FEMALE

FARRELL M

PRETORIA 1-6-57 Direkteur van Sensus
Director of Census

UNIE VAN SUID-AFRIKA — UNION OF SOUTH AFRICA

S.A. BURGER — S.A. CITIZEN

0 0 7 4 8 2 6 8 8 K

PERSOONSKAART
IDENTITY CARD

MANLIK — MALE

FILLIS P

PRETORIA 1.9.59 Bevolkingsregistrateur
Population Registrar

UNIE VAN SUID-AFRIKA — UNION OF SOUTH AFRICA

12.4.
Sample ID card
used for basic
(racial) identification
in South Africa.
Photograph by
Rushay Booysen.

they weren't sure, they would certainly look into surnames. They used the "pencil test" in the hair; they measured the width of one's nose and compared skin tone to brown paper bags.

Booysen: There were a lot of people that could pass. Venter gives many examples in *Coloured: A Profile of Two Million South Africans.* I remember one example in which he reports about a kid that went to a white school, but none of his friends ever went to his home. Somebody would pick him up after school; therefore, the other students never knew

until one day they found out that he was not actually white but Coloured. Some people chose to hide their real identity or be disconnected from their family. The identity card played an important role in clarifying identity as the lines could often be blurred, so by the time one reached high school there was a clear racial picture drawn, as these identity documents would provide a clear indication what group the person belonged to if one could not tell by facial feature.

Georgi: Rushay, at first sight, Venter's book can easily be mistaken for a study which depicts South Africans from a colonial perspective and accordingly, one could assume that your portraits were meant as a means of "writing back" to that discourse. However, it actually is a really good early study of the diversity of the community of South Africans. Your pictures thus translate his project into a contemporary timeframe and use a different medium. So when you spoke about the ID cards as a legal and official form of categorizing and racializing people during Apartheid, then maybe your portraits could nonetheless be read as a form of "writing back" to Apartheid practices?

Booysen: Yes, the images and the discussion is definitely a counter for me on the boxes and segregation that the Apartheid laws placed on us, but most importantly for me it's also a counter for this idea that has been created around race and identity. Al J. Venter was an Afrikaner.[3] But he had an interest in the Coloured community and showed the contribution and the history of the Coloured community. That is why the book was banned during Apartheid because the government saw his work as a threat.

Chace: When I first went to South Africa in 1995, I had a difficult time finding publications about the history of the Coloured people, not just in South Africa but anywhere. Libraries in the United States carried one of two books, either John Western's *Outcast Cape Town* (1981), which is a U.S. publication by the University of California Press or Allister Spark's *The Mind of South Africa* (1991). And so, when Rushay had told me that Venter's book was banned, it made sense to me because I've searched high and low for books and I never came across Venter's publication in South Africa or the United States. Unfortunately, very little has changed since Venter wrote his book. That is also one of the reasons why I produced *I'm Not Black, I'm Coloured*. There is very little academic discourse about the Coloured population in South Africa, very few courses being taught on the subject in universities. We did many screenings at U.S. colleges and universities, among them were several prominent liberal arts colleges. After the screenings the audience often stated things like, "We never knew! I thought I knew everything about South Africa." I remember

the reaction of some postgraduates at a top law school in Chicago who said, "We've been researching for a year on South Africa and we never heard or read anything about the Coloured people." My main motivation for the film was teaching Americans or Europeans, or whoever would want to learn about the Coloured community. There was and still is this ignorance, especially in academia. Half of the participants at the *Migrating the Black Body* symposium came up to me afterward to tell me they were unaware of the Coloured people or surprised at the current state of affairs in terms of race relations in South Africa.

Wiegmink: That is a very important issue, the lack of discourse. When I first watched *I'm Not Black*, it struck me that the film added an important frame of reference to the perspective of U.S. race relations. It enables viewers to get a much more global, comparative perspective on race. It helped me to realize once more that what I considered "the black experience," is actually a very specific U.S. experience, one experience among a broad variety of black experiences.

Booysen: Yes, that is right. For me, the thing is that for people in America, the history that they portray is mostly connected to the history of slavery. People are mostly embedded within the idea of slavery. But even with regard to slavery, Kiersten's documentary is important, because it brings in another perspective or group: the slaves that didn't cross the Atlantic but came across the Indian Ocean to Africa/South Africa. In South Africa, there were other slaves brought from elsewhere, Malaysia, Indonesia, even other parts of Africa. This is also important with regard to understanding the dynamics of race or more importantly, the ethnic makeup in Africa.

Wiegmink: Kiersten, your film shows how Coloured members of the film's cast and crew received the test results of their genetic DNA tests, which were donated by the commercial genetic testing company Family Tree DNA and which listed their genetic ancestral backgrounds. What is your position on DNA testing in this context?

Chace: I never intended to do the DNA testing; this was never built into the business plan or the project. When the idea came up from Family Tree DNA, I was unfamiliar with the science and was very hesitant about going to South Africa and testing people. After learning more about genetic genealogy, and seeing similar African and African American DNA projects commence by black scholars, I decided to pursue this idea for the film. I contacted the cast and crew and discussed the benefits and the limitations of the DNA testing and they knew the tests were not mandated of them. Aside from one cast member, they all wanted to partici-

pate in the DNA testing. Over the years, however, I have recognized that the DNA testing could be a dangerous thing to do in an already divided Coloured community, in particular. Here is one example of how DNA testing concerns me: KhoiSan tribal leaders [First Nation people of South Africa] are asking for land reparations due to colonization. There was a situation many years ago when an ANC party representative stood up before a large audience of prominent Coloured/KhoiSan leaders and asked them to prove their "indigenous" identity. The entire room became quiet because there was, of course, no way to prove it. This was the point when I recognized that the DNA testing could lead to blood politics—that concerned me greatly. That is also part of the reason why I stopped promoting the DNA testing. The project is still open at Family Tree DNA (and to my surprise a growing number of white South Africans are joining the Cape Coloured DNA project and are testing), but we don't maintain a separate website any longer.

Sylvester Ogbechie: I am very much bothered by this DNA analysis. It gives the wrong idea about race; the whole point about the Coloured community is that they don't come from one particular race, they come from everybody. DNA testing completely negates the cultural process. I think it is a very dangerous thing to do. You are contributing to the further marginalization of the Coloured community because you are giving people who are already prejudiced against you even more ammunition. There needs to be a much more sophisticated interpretation and understanding of "self" and why I am saying that is my own ethnic group in Nigeria doesn't belong to the larger Igbo ethnicity under which it is classed. In my hometown six different languages are spoken. I think it's dangerous; I'm not saying that DNA testing doesn't work. But for the kind of things we are interested in—the right to belong to a particular place regardless of racial or ethnic origins—DNA testing may not be the best solution. Nobody can prove their ancestry to a particular race.

Krista Thompson: I noticed how a lot of people were talking about a nonidentity and it struck me that the nonidentity was part of the identity. So to me, the nonidentity was actually disrupted by this kind of [DNA] testing, and we all know that years from now the science [of it] will all change.

Tina Campt: There is something about the way we are talking about this that is troubling to me, which is the way we're imposing a number of different frameworks on the very sincere testimony that those individuals were giving. Yes, it is troubling how science serves a particular function in the absence of something else. But I think we have to note that absence. We need to think about the work science is made to do, in other words,

why does science appeal to certain groups and why does it have certain kinds of explanatory power. It's also important to emphasize the fact that we're speaking from the perspective of African American communities, Creole communities, and other communities that can trace their very specific history to a history that we know, like plantation slavery, a knowable history. But one of the things that was most profound to me was that they were saying: "I just needed something." We [as scholars] need to accept this desire for knowledge while at the same time critiquing what is done with that knowledge. We have to historicize the fact that we are actually speaking from a position after the fact—after these different moments of historical recovery have occurred.

What is important about this film to me is that it is documenting a particular historical moment of inquiring—a moment of desire in the absence of knowledge. We can't critique their desire for knowledge, their desire to latch onto a technology that we have already critiqued. They are saying "I've never known anything, just give me something" and that could be a lot of different things, but I don't think it's my place to say that you need to stop grasping or creating absence as a place of struggle in the absence of anything else. My argument has always been that diasporic or any form of multiple identity is always based on having something that we can distance ourselves from. We can say that we don't want to be a part of something in the sense of a disidentification, in order to be something more than it. But what these individuals were talking about is not having anything. Not having blackness, not having race, not having nation, not having region, not having anything to be able to position themselves in relation to as a position of strength. I'm troubled by our willingness to not accept the radical absence that they are speaking from. We need to historicize the moment that we are seeing. That moment is the moment when they get those results. We don't know what happened two weeks after that or a year after that. We need to embrace the moment that this film so brilliantly captures of both these individuals and "when" that is happening.

Wiegmink: What I found particularly striking is that both your works do not primarily address the issue of migrating the U.S. American black body, they do not focus on a/the black American experience, an experience characterized and to a major extent determined by the history and legacy of slavery and the slave trade. Instead, in both your works it becomes evident that the parameters we use to think about race in the United States are not the same employed in South Africa.

Booysen: Yes. The parameters are totally not the same but this is often not understood in this manner. Here is an example. Friends of mine, a

famous American musician and his wife, are currently living in South Africa. When you get into Cape Town, there is a hill [Devil's Peak] overlooking the city and there are baboons all over the place. There is a sign up there that says, "Please do not feed the baboons." She took a picture of this sign and put it on Instagram with the title "This sounds very racist to me." I told my friend, "Hey, you are looking for racism everywhere!" It should be very obvious that you are in a country where there are actually baboons and they are really dangerous.

Wiegmink: In which respect does your work then encourage a dialogue and at times also debates across continents? Who are "migrating black bodies" for you? Where do they travel? Why do they travel? Where do they come from?

Booysen: People in my society take on the role or views of prominent American figures, because that's what they are exposed to through media. Popular media, I should say. I find we oftentimes negate our own stories. We have to look at this balance or slanted shift in power obtained through media channels that ultimately influences our opinion but has a limited aspect when it comes to us broadcasting our stories, our music, et cetera. A music artist coming from abroad will still be paid fifteen times more than the local artist. We do not share equal value. These were some of the issues we faced, and it is also mostly the fact that this version has become the mouthpiece for Africa. The African diaspora becomes the voice of Africa and not really the Africans on the continent themselves. It's important for us to create mutual spaces of discussion. But the views of African people hardly get out elsewhere. For example, during my trip to the United States two years ago with twenty people from different African nations—it was a music tour—we had a lot of conversations with people in mostly black American communities. But we found that we are so different in many ways culturally. The discussion that's been going on for years has been very superficial. It's mostly the idealized idea of Africa I hear it so often, but it becomes tiring to always try and counter it. Pan-Africanism is also driven from the West. We take a bite from it and we make it our own but it is still not an African perspective. I wanted to counter that. Of course, it won't just take one symposium or five talks, it's gonna take a while.

Another issue is that people tend to turn the discussion into a mixed-race issue. We are not first-generation descendants, we are multiple generations, which is similar to the African American, the Brazilian, or Caribbean experience—or any other place where you find the diaspora.

We share commonalities as far as time frames, and we are not a first generation of black and white mixing but multiple generations down the line. Coming from a community that is first generation mixed presently is a whole other dynamic on its own. There are crossroads where we have similar questions and outcomes because of our disconnection from our root source. I am pretty sure if asked what tribe we come from, most of us would have a blank response as this is lost on most of us.

Georgi: With regard to the topic of the conference, migrating the black body, this would suggest that we are usually focusing on the moment of the migration and the "arrival" in one place but we're not, then, taking into account the spaces where the migration process might have "originated." That is to say we need to look at both ends of the process more closely.

Booysen: Yes, and I think that was for me powerful in a sense that if at least one or two people can recognize that, this will start opening up the conversation. But there is always denial or people don't want to know. They want us to identify according to their standards. It is a continuous struggle that we have to stop looking at race. We have to start looking at the influence of culture and how we identify, you know, our cultural identity. Because where does a Western culture or cultural identity fit into Africa? So we'll have to start looking at this. Even with the DNA test, when Erykah Badu did it, I thought, okay, she knows she comes from Cameroon, does it mean she can move back and claim land?[4] It's almost like there's a sense of ownership, the sense of ownership, which we still are fighting for in the land of my ancestors.

Karen Salt: I'm going to return to the DNA testing for a quick moment. I find the ambivalence in it quite interesting, and Tina, your point was valid in how people within the film experienced that moment and what goal it ultimately served for them. I want to return to all the things we were talking about because one of the things I found most interesting about both the reluctance to want to deal with the DNA by the participants and its affective charge in their lives was our inability as a larger group to talk about ink, and skin, and paper and bodies and screens—the things that have been consuming us for the last few days. We have been talking about presence and visibility and writing selves into existence. And ironically, the DNA tests are doing that same work and doing it on very different screens both biological and unlike the bioluminesence. There is something to encourage us here—to use this moment to think about this and what this actually means. We are talking about migrating bodies and should not reject it or push it aside if it disturbs our emotions or

simultaneously makes us feel like we are being marked. This is a compelling instance in which large groups try to mark or unmark themselves in an interesting and complicated racialized space.

Booysen: If you look at the historical context of South Africa, the indigenous people are hardly mentioned, right? The indigenous people of South Africa are the Khoi and the San and a lot of Coloureds trace their African ethnic identity to this group. They are largely discriminated against in the new dispensation by not being awarded the same rights as the major black ethnic groups. So in understanding the Coloured groups' place in South Africa one needs to understand their fight against colonization, slavery, and tribalism. What I'm also alluding to is the fact that this group (Coloured South Africans) extract from the First Nation people yet we are not good enough to receive the same opportunities as other black groups in post-Apartheid South Africa. If nobody contests why they are not in, why we are not featured within the historical context, then eventually all this information will be lost and wiped out. And generations will come and grow up with a new identity. This is just for me the importance of my particular work and how I see it playing out in the field. Some of the institutions I've come across that offer African studies, I found their studies never reflected the story and the contribution of my community. So students would come on exchanges and my community gets bypassed altogether because we are the unspoken people of South Africa, whether it's in the historical story or the political landscape where our contributions are negated to the back of the line. A lot of studies do not give one the full scope. After 1994 South Africa was seen as this hope for humanity because we were one of the last countries where race and race problems had occurred and we gained freedom, but since then, what has occurred in South Africa? The international community does not know, they still see the pictures of Nelson Mandela being freed and all the later images that showed a happy society. But this is not reflective of our community nowadays. We have to also tell the world what is happening within our country. We have to tell the world that the idea of a rainbow nation that encompasses everybody and is inclusive of everybody is not really the case. It's not inclusive. So how, as humans, will we work together to ultimately dissolve the issue not of race, but of our differences, thus accepting our differences? I think this is for me the importance in what I do.

SONJA GEORGI AND PIA WIEGMINK

Notes

1 Al J. Venter is a white South African writer, journalist, and film producer. *Coloured: A Profile of Two Million South Africans* (1974) is a comprehensive study about the history and culture of the Coloured community in South Africa and their struggle against Apartheid.

2 Introduced with the 1950 Registration Act, the South African Apartheid-era identity numbers were used to indicate a person's race in legal documents. Eventually, South Africans were classified into numerous racial groups: Black, White, Indian, and Coloured. Within the category Coloured there were eight subcategories.

3 *Afrikaner* is the term for White South Africans of Dutch descent.

4 Erykah Badu is an African American musician and actor who participated in Okayafrica's *The Roots Of . . .* series, testing her DNA in order to find out more about her African ancestry.

13

When Home Meets Diaspora at the Door of No Return

Cinematic Encounters in *Sankofa* and *Little Senegal*

HEIKE RAPHAEL-HERNANDEZ

Concepts of diasporas are complex theoretical constructs that have developed over time to describe, and at times prescribe, the deterritorialization of historically geopolitically descended people and their supposed identities. Growing interest in the theoretical potential of the notion of diaspora during recent decades has generated an ever-widening set of applications of the term—ranging from region-specific applications (e.g. "South Asian Diaspora") to "queer diasporas" to "digital diasporas." The expansion has caused both fascinating debates about the term's potential, but also serious doubts about its very meaning and its analytical utility. Khachig Tölölyan, founder and senior editor of *Diaspora*, one of the first journals focusing exclusively on diaspora studies, for example, voices his concern that today's claims to diasporic belonging are often just conflated with dispersion and migration. He sees that when the new residences of "exiles, expatriates, refugees, asylum seekers, labor migrants, . . . domestic service workers, executives of transnational corporations, and transnational sex workers are all labeled diasporas," the distinction between diaspora and dispersion increasingly collapses.[1] According to him, "a diaspora that is born of catastrophe inflicted on the collective suffers trauma and usually becomes a community to which the work of memory, commemoration, and mourning is central, shaping much of its cultural production and political commitment. . . . A dispersion is the consequence of individual and chain migration, motivated by economic reasons; in such communities, nostalgia can be strong, but commemoration and collective mourning are less prominent."[2]

When focusing on the African Diaspora, one encounters several conflicts in regard to Tölölyan's insistence on differentiation. Does, for

instance, the concept of diaspora apply only to communities who can claim a connection to the transatlantic slave trade past because they are the only ones who, in Tölölyan's words, suffer as a collective from a trauma to which the work of memory, commemoration, and mourning is central? Or does the concept also include the very recent African (im)migrants who have been arriving in steady and ever-increasing numbers since the 1990s in Europe and North America alike? If they are indeed included, does the concept need geographical restrictions? For example, should the African Diaspora as a concept for political empowerment and solidarity embrace only sub-Saharan Africans? Or does the African Diaspora accommodate also North African migrants who, although considered white by colonial geography as well as by U.S. immigration laws, have nevertheless been part of the historical experience of colonial racism? Often, the members of these different groups seem to be in conflict with each other when meeting in their respective diasporic places. Does a theory of the African Diaspora offer an opportunity for reconciliation and unity? Or is the theory purely an illusionary attempt at neo-Pan-Africanism?

The discourse gets even more complicated when one turns to the different migratory communities that have never left the African continent. Does the concept extend to Africans who migrated inside Africa? Is it possible to locate a unifying identity via a symbolic construct of an African Diaspora that was created by the trauma of transatlantic slavery, colonialism, racial capitalism, and imperialism?

Indeed, one has to ask what such a globalizing notion of an African Diaspora with roots in a historical colonial Africa and its accompanying claims to a mutually experienced trauma hopes to accomplish, as it might also conceal or obscure problems between the different groups that actually need to be exposed. The question is particularly important when understood in terms of granted or denied solidarity and unity among people of African descent. Acts of denied unity point to some pressing concerns that, unfortunately, need to be dealt with in many twenty-first-century societies. Yet, despite these aspects, the claim to a mutually experienced trauma still makes sense. It allows one to locate what Susan Arndt, scholar of African history, calls "ideological interrelatedness"; Arndt suggests that any discussion of concepts of migration and diaspora related to Africa needs "not to be simply read additively, but rather in terms of historical continuity and ideological interrelatedness."[3] During recent years, the call for such a quest for ideological interrelatedness has gained in importance among scholars of African Diaspora studies.

My essay picks up the challenge of such an epistemological reori-

entation. While the Old African Diaspora, New African Diasporas (sub-Saharan as well as North African), African nondiasporic, and intra-African migratory communities often prefer to disengage from each other—in worst-case scenarios, the ideological conflicts lead to physical confrontations—they are connected by the experiences caused by colonial and postcolonial capitalism and racism. Therefore, it is important that both aspects are jointly addressed in critical discourse.

While all fields of the humanities and social sciences are tasked to engage in the interrelated critical discourse, art occupies a privileged position. Not only is art able and even allowed to criticize entrenched thought patterns with rather provocative means, art also functions as a test laboratory in which new concepts can be tried out. Concerning the ideological interrelatedness of Africa's past and present with its different diasporas, literature and life writings have already begun dealing with this intertwinement, thus testing several critical ideas in their texts.[4] Films have rather been hesitant in their approaches to these complex trans-diasporic encounters for the transatlantic context. So far, only *Sankofa* (1993), by the Ethiopian American filmmaker Haile Gerima, and *Little Senegal* (2001), by the French Algerian filmmaker Rachid Bouchareb, consider the ideological interrelatedness of the Old and New African Diasporas and Africa itself.[5] To do so, both filmmakers have chosen the narrative of the return, employing the Door of No Return (the door of slave castles in West Africa through which captured Africans were forcefully moved onto slave trading ships) as their symbolic marker. While *Sankofa* limits its focus to Africans and African Diasporians who have a connection to the transatlantic slave trade, *Little Senegal* deals not only with these groups, but includes also the New African Diaspora that has resulted from the migration waves of the late twentieth and twenty-first centuries. Using the image of the Door of No Return as a marker for the past, present, and future, both films provoke a critical discourse about victimhood and agency while simultaneously conceptualizing the ideological interrelatedness caused by colonial racism, thus hoping to raise a sense of a unifying political commitment.[6]

African Diasporas, Home, and Linkages

During the last decade, scholars of both the Old and the New Diasporas have begun to point to the necessity of focusing on unifying rather than dividing experiences brought about by transatlantic slavery and by colo-

HEIKE RAPHAEL-HERNANDEZ

nialism. What might, at first glance, look like a critique of earlier adamant positions is rather an invitation to broaden the spectrum for critical possibilities. For these scholars, opening up the discourse about the divide between the Old and the New African Diasporas has become of utmost necessity because any form of disinterest or any competition for victimhood, be it symbolic or literal, carries the danger of weakening their political struggles in Western white-majority societies. Paul Gilroy, for example, points to the danger of a divide when he cautions Old and New Diasporians to understand that "what was racial politics becomes policy or therapy and then simply ceases to be political. At best, the enhancement of racial equality and the battle against racial injustice become technical problems to be managed and administered."[7]

For a respectful dialogue, racial capitalism, New World slavery, colonialism, and imperialism serve as entry points. One can start with Gilroy's often-cited but still fundamental work, *The Black Atlantic*; in it Gilroy suggests that black communities across the Atlantic are linked not only by the historical experience of colonial racism but also by their mutual perceptions of shared racialized conditions in their respective communities. He argues that African consciousnesses informed by this awareness, although coming from different localities, are able to transcend national boundaries because the history of the black Atlantic, "continually crisscrossed by the movements of black people—not only as commodities but engaged in various struggles towards emancipation, autonomy, and citizenship—provides a means to reexamine the problems of nationality, location, identity, and historical memory."[8] He offers these thoughts as an invitation to rethink certain antagonistic positions he observes among slavery-descendent as well as recent diasporic communities; for him, several of their ideological constructs carry the danger of turning into "volkish popular cultural nationalism."[9]

New African Diasporians are often aware of the refusal by slavery-descendent diasporic communities to include them in discourses on ongoing racial discriminatory practices; therefore, they counter with arguments about their own specific trauma. Isidore Okpewho, for example, coeditor of the collection *The New African Diaspora*, argues that for the people of the New African Diaspora, the decision to leave their home countries, even if this was voluntary expatriation, came also with "huge social and psychological costs that are not so easy to appreciate."[10] Along these lines, Toyin Falola and Niyi Afolabi also argue that recent migratory departures from different African countries cannot be easily dismissed as having no common diasporic theoretical connotations; Falola and Afo-

labi maintain that "the migrant is placed in a subtle but equally problematic quagmire—that of a permanent exile and the blues of being stuck in that discomforting middle—wanting to go and having to stay, wanting to stay and having to go. In essence, the migrant becomes an entity permanently in transit both physically and psychologically."[11] Because of these divides, scholars have called for a new discourse on the Black Atlantic. Paul Tiyambe Zeleza, for example, sees the danger that a competition over diasporic trauma "inscribes an epistemic division between two approaches that are otherwise deeply implicated with each other."[12] Mamadou Diouf, Senegalese American scholar and professor of African history, supports this epistemic argument when he reminds one that "the 'Other' was invented by [European] Enlightenment philosophy. 'Africa' was part of the invention of Europe as the 'Other.'"[13]

But why have scholars begun to insist on new readings of the Black Atlantic? What is the urgent necessity? One can turn again to Gilroy who in his 2005 publication, *Postcolonial Melancholia*, refers to the political rhetoric in North American and European societies concerning debates on the migration waves of the twenty-first century. Here Gilroy argues: "Contemporary discussions of immigration, asylum, nationalism, and other areas of government where race is strongly resonant have been enriched not only by the capacity to reflect clearly on the history of decolonization but also by consideration of the conceptions of political power that resulted from detours through the bloody history of colonial societies and the planetary ambitions of race-driven imperialism. Disturbing views of government in action can be derived from close historical studies of colonial domination, to which the idea of 'race' and the machinations of racial hierarchy were always integral."[14] Gilroy's thoughts about the current mindset point to the fact that most Western societies have not even begun to face up to their historical participation in the creation of racism that is lingering in their societies' contemporary realities. A rereading of the history of the Black Atlantic, Toyin Falola argues, would facilitate an understanding that "the three issues of slavery, migration, and contacts are united in terms of how they were instigated by the expanding and extensive power of Europe (and also the Americas) in creating dynamic global forces of interactions, and of how Africans have had to respond to many circumstances."[15]

One of the scholars who has most radically demanded a rereading of the Black Atlantic has been Saidiya Hartman.[16] In her discourse about trauma, return, and healing, she offers the "historical continuity and ideological interrelatedness" that Susan Arndt is calling for when she vehe-

HEIKE RAPHAEL-HERNANDEZ

mently criticizes current critical cultural works and their nexus of the past with memory. Hartman argues:

> In the workings of memory, there is an endless reiteration and enactment of th[e] condition of loss and displacement. The past is untranslatable in the current frame of meaning because of the radical disassociations of historical process and the discontinuity introduced into the being of the captive . . . memory is not in the service of continuity but incessantly reiterates and enacts the contradictions and antagonisms of enslavement, the ruptures of history, and the disassociated and dispersed networks of affiliation. It is by way of this reiteration or differential invocation of the past and by way of this memory of difference that everyday practices are redolent with the history of captivity and enslavement.[17]

Instead, Hartman suggests a new approach, one where "memory confronts head-on the issues of dislocation, rupture, shock, and forgetting and the texture of its fragmented existence."[18] For her, the logical consequence is not "to recover the past but to underscore the loss inscribed in the social body and embedded in forms of practice."[19] Toyin Falola, too, sees the need to reread history, but he takes Africa to task; according to him, African history, "tends to end at the departure points It is rare to find in African history the insertion of the experiences of slaves and exiles into national or local histories, suggesting that those who have left have been disconnected from those who remain behind."[20] Hartman's and Falola's thoughts serve as invitations to reread the past in order to locate a present that would equip all Black Atlantic communities in their diversity with a chance for collective mourning and subsequently for a joint political commitment.

Cinematic Approaches

As I argue above, art is a privileged medium because not only can it criticize entrenched thought patterns with rather provocative means, but also it can function as a test laboratory in which new concepts can be tried out. Two films that bring these aspects together for the African Diaspora and for Africa as the home, are *Sankofa* by Haile Gerima and *Little Senegal* by Rachid Bouchareb. Both filmmakers choose the Door of No Return as their methodological frame.[21] In her *A Map to the Door of No Return: Notes to*

Belonging, Dionne Brand explains the symbolic importance of the door for the African Diaspora; according to her, "this door is not mere physicality. It is a spiritual location. It is perhaps a psychic destination. Since leaving was never voluntary, return was, and still may be, an intention, however deeply buried."[22] Brent Edwards, theorist of African Diaspora studies, calls these thoughts the "ideology of return." He maintains that "if black New World populations have their origins in the fragmentation, racialized oppression, and systematic dispossession of the slave trade," then healing can only happen by confronting "that legacy through racial organization itself: through ideologies of a real or symbolic return to Africa."[23]

In *Sankofa*, the legacy of transatlantic slavery is investigated as an event that is inseparably connected to Africa. *Sankofa*, an Akan word, suggests "return to the past in order to go forward." The choice of the title points already to the focus of the film—the importance of returning home, to Africa, and using Africa as the starting point when confronting the legacy of slavery. Locating the nexus of the past with the present in colonial power hegemonies, Gerima offers his cinematic discourse on intertwined pasts and presents as part of his "imperfect cinema"—an aesthetic concept that asks viewers to perceive the film experience as personal journey. It is the idea that "in contrast to 'perfect cinema' . . . 'imperfect cinema' sees the revolutionary potential in anti-illusionist elements of film narrative and form that 'shows the process of a problem.'"[24] To accomplish this, he uses the Door of No Return and a former slave castle at an African shore as aesthetic means to frame his invitation of combining the present with the past.

The film opens with Mona, a black American model, who is using the slave fortress as the backdrop for her fashion shooting. Neither she nor her photographer takes any interest as to what the castle actually represents for her own history. During the shooting sessions, an African man, Sankofa, is so outraged about her disrespect for her own past that he repeatedly yells at her, "Back to your past. Return to your source." Turning to the white photographer, he yells that he should not be there because this is sacred ground for black people. Turning again to Mona, he keeps yelling at her, but this time it sounds more like an angry history lesson not only for Mona but also for the African American audience; as the African screams the following words at Mona, the viewer understands that Gerima is yelling at African Diasporic people: "Return to your past! This ground is holy ground. Blood has spilled here before. It was from here that we were bought and sold. To America, to Trinidad, to Jamaica. The white man forcefully snatched away our people. It was genocide. They treated

us with contempt. They disgraced us, put us to shame. Go back. It is special ground. If you must be here, be aware. Blood has been spilled here." Because of a cinematical out-of-body experience, Mona indeed returns to her past where she is confronted with the atrocities of the slave trade in Africa and in the Americas. Transported back in time, she is now Shona, a house slave on a plantation in the Caribbean who is abused physically and sexually. In addition, she observes many mental and physical crimes committed against enslaved Africans. Mona's conscious development happens now through her alter ego, Shona. The film ends with the historical Shona returning to the twentieth century and the slave castle. While the Mona of the beginning had no respect and simply no knowledge of her own past, the new Mona participates now in a spiritual session at the castle grounds where she honors her ancestors who were taken into captivity. This spiritual conversion is possible only because of Mona's travel to Africa. In her discussion of *Sankofa*, Ruth Mayer emphasizes the importance of Gerima's approach: "In view of the twentieth-century frame, the warning against slavery gives way to an excavation of its still valid underside, its recoverable codes of solidarity and resistance. Gerima's very emphasis on the diasporic condition—the interaction of Africans, African-American, and Caribbean slaves, and his virtual exclusion of white protagonists—points to a shift of interest, leading from social critique and political protest to a historical and anthropological probing into the possibility of diasporic self-fashioning against the diatribes of racism."[25] *Sankofa*, in dealing with the African Diaspora and its intertwined connection to Africa, the home, deserves scholarly praise. The film's novelty is offered in its insistence in connecting the past with the present, the diaspora with its home, so that healing and reconciliation can begin.

Little Senegal is even more radical in its approach to the interrelatedness of Africa with its diasporas. The film tries out a concept that Saidiya Hartman considers necessary when dealing with memory and Africa as the mythical home: "The discussion of memory in black cultural practice has been interpreted most often through continuist narratives of tradition grounded in the foundational status of Africa. However, it is absolutely necessary to demystify, displace, and weaken the concept of Africa in order to address the discontinuities of history and the complexity of culture practice."[26] This is the strength of *Little Senegal*. In contrast to *Sankofa*, the film not only makes the descendants of slaves return to their original home, to Africa, but also invites Africans who have never left the continent to rethink their own past and ask what the legacy of transatlantic slavery might also imply for them two hundred years later. As we

have seen, Toyin Falola criticizes that, in general, African history tends to stop at the Door of No Return.[27] This film, however, sends its protagonist, Alloune, a sixty-five-year-old Senegalese, to the United States to search for information about his ancestors who were sold into slavery. Alloune's cinematic departure and search for his ancestors is an artistic endeavor to remind Africans that transatlantic slavery is part of their own national histories, too.

Yet, the film would be one-sided if this were its sole intention. In addition, the film hopes to point out that New World slavery as epistemological foundational force is still the underlying power for many relationships between different Black communities and between all Black communities in their combined relationships versus white society. Like Gerima, Bouchareb uses the iconic power of the Door of No Return for the theoretical framing of his film; however, in distinction from Gerima, Bouchareb deals with the symbolism of this image throughout the entire film in artistically unique and often unusual cinematic interpretations.

Little Senegal includes representatives for many different groups of the Black Atlantic. On African shores, one meets Senegalese who work as tour guides in former slave fortresses, and African American tourists who have come to Senegal as part of their slavery heritage travel. On the other side of the Atlantic, in the United States, one meets slavery-descendant African Americans and recent African immigrants who have come from sub-Saharan as well as North African countries. From the very start, the film depicts the groups in the United States as being in very disrespectful and even violent conflicts with each other. For example, when the film introduces Hassan, the recent immigrant from Senegal who works now in a car repair shop in New York City, one finds him in an aggressive encounter with an African American customer. One listens to disrespectful statements uttered by the African American, such as "Don't touch my car with your dirty African hands," or "You can only dream about a car like this." Hassan nonverbally answers by physically attacking the customer.

To understand what the filmmaker is trying to accomplish with his film, one has to first look at the plot. The film opens in Africa; the viewer meets the protagonist, Alloune, who works as one of the guides at the slave fortress on Gorée Island in Senegal. Since he meets many Black Americans who visit the slave fortress as part of their return-home-to-Africa journey, he decides to turn around the idea: he will travel to the United States to look for the descendants of his ancestors who were once enslaved in Africa and brought to the Americas. Through his research in museums and public libraries in South Carolina, where he goes through plantation

records, announcements of slave auctions, and notes of fugitive slaves, he is eventually able to find a relative, Ida, who lives in Harlem, New York City. At first, Alloune is excited about the discovery of Ida because it implies that the extended family that was separated two hundred years ago is now reunited again. However, what Alloune finds with Ida and other African Americans he encounters in New York City is rather disappointing to him: they have no sense of community or family anymore and do not care about such notions at all. He gets the impression that for them, individual, often very egocentric desires are more important than any community spirit. Ida's granddaughter Eileen can serve as example here: Eileen is pregnant at the age of fifteen and runs away from her grandmother's home before her grandmother has the chance to throw her out anyway; Eileen's father has never cared about his own daughter, but lives in a relationship with a girl who is Eileen's age; when Eileen has the baby, she refuses to keep the child because her boyfriend does not want to have a girlfriend with such a burden; Eileen's boyfriend actually does not care for her at all, but uses her only for petty crime jobs. When Alloune voices his concerns about all these attitudes, Ida, while laughing about his old-fashioned African backwardness, explains that in America, only green counts, referring to the dollar notes. When Hassan, who is also Alloune's nephew, is murdered by several young African American men, Alloune leaves Ida and the United States to take Hassan's body home to Senegal. Alloune's act should not just be read as a statement about a proper resting place for the dead Hassan. It serves also as a symbolic gesture towards the homelessness of the North American African Diaspora.

One can get the impression that the film is simply trashing the contemporary image of African Americans. Indeed, among African Americans, *Little Senegal* has often been discussed as being too critical of their community; the film seems to imply that home and diaspora cannot come together again except in nostalgic wishful thinking. Home and diaspora seem to be mutually exclusive. Therefore, at first, one could assume that the film's intended focus is to criticize Pan-Africanism's fundamental assumption of (if not obsession with) Black unity and cultural essentialism.

However, I argue that this is the impression one gets if one views the film on a superficial level only. If one allows an interpretation of the film according to its excellent iconic use of the Door of No Return, one sees a different picture. The film establishes this theoretical framing with its very first shot (figure 13.1). Through the Door of No Return, one is able to see a ship and read the caption "1788, North Carolina." In the context of the door and the ship, the caption is deliberately misleading because the

13.1.
Opening shot of
Little Senegal, dir.
Rachid Bouchareb,
2001. Screenshot
by Heike Raphael-
Hernandez,
courtesy of Rachid
Bouchareb.

1788, North Carolina

viewer immediately assumes that this is a cinematic device for a flashback that will take the scene back to the historical times of the slave trade. Yet when the ship approaches the door, one sees that it is a modern ocean liner. The following shots crosscut the twenty-first-century ship arriving with Black American tourists returning to Africa in hopes of finding their long-lost African home with shots of Alloune reading from a slave ship's logbook from 1788. With these establishing shots, one is able to locate Saidiya Hartman's insistence on framing all contemporary debates about Black Atlantic communities with the issue of slavery as an epistemological foundation.

In subsequent shots, one sees Alloune standing at the Door of No Return, but now sharing the space of the door with two Black American women. All three look at each other, but no words are spoken. The viewer senses in these nonverbal exchanges the longing of the two women for home, for belonging, for reconnecting with family members that they lost a long time ago. In this shared space, Alloune does not turn away from them, thus granting them the assuring certainty of family and connectedness. However, these are also the encounters that provide Alloune with the illusion that he would be able to find the same connectedness with family on the other side of the Atlantic, in America. Yet, as already discussed earlier, Alloune is not able to find this sense of community in America.

Again, one could get the impression that the film is anti–African American. Yet, this is not the case because *Little Senegal* is equally critical of the African side. After Alloune returns to Senegal to take home the body of his murdered nephew Hassan, the film offers a shot of several Senegalese tour guides telling African American tourists about the slave trade

13.2.
Senegalese tour guides at Gorée Island, explaining the transatlantic slave trade to visitors of the slave castle, in *Little Senegal*. Screenshot by Heike Raphael-Hernandez, courtesy of Rachid Bouchareb.

(figure 13.2). The cinematic play with the image of the Door of No Return is rather provocative because, while the door is normally shown from the perspective of someone who is looking from the fortress to the ocean, in this shot the perspective is turned around and the viewer is looking from the ocean through Alloune's eyes into the fortress. It is important that this scene happens after Alloune's return from the United States; now he is able to see something he might not have been aware of before. Looking through the Door of No Return from the ocean side, the side of the captives and sold family members, Alloune watches the African tour guides selling the slaves one more time—this time as part of a growing heritage tourism industry for slavery-descendent Americans who are in a spiritual need of home and belonging, yet commerce grants them only an illusory version. The film seems to argue that the "color green" that Ida saw as the sole driving force for the African Diaspora in the United States does not differ at all from the driving force for Africa, the home.

While these cinematic usages of the Door of No Return might appear as separating more than unifying the different African and African Diasporic groups, the film offers also a scene that, at first glance, is as dividing in its brutality as the other ones. However, it can be regarded as the most important scene of the entire film because it offers unity. It is the scene of Hassan's murder. The film uses again the technique of crosscutting: while Hassan is being beaten to death by several African American men, the film is crosscutting to Alloune who is watching TV in Ida's home. To understand the centrality of this crosscutting scene for the entire film, one has to actually see what the filmmaker makes Alloune watch: it is the trial of the murderers of James Byrd, an African American man in Texas who was chained to a pickup truck by three white supremacists

13.3.
TV coverage of
James Byrd murder
trial being watched
by the Senegalese
Alloune while
staying in Harlem,
in *Little Senegal*.
Screenshot by Heike
Raphael-Hernandez,
courtesy of Rachid
Bouchareb.

in 1998 and then dragged to death. The way the film positions the TV in these shots allows one to claim the framing of the TV set as a possible image of the Door of No Return (figure 13.3); the African man watches through the TV Door of No Return the brutal hatred that white society still holds for Black people. Even two hundred years after the slave trade, American white society's racism has not stopped murdering them. Here, in this scene, the film makes its most important statement: while the different Black communities are destroying each other, they do not even realize how much white majority society, which is still based on racism and hatred of Black people and still murders them, does not have to do all the work itself because black men destroy each other, too. White racist society openly confesses its supremacist ideas, but black men do not even realize how much they have become victims of this racist ideology when they hate each other in murderous ways.

While the film criticizes Black hetero-masculinity as a dividing force, it equips its young women, the slavery-descendent African American Eileen and the African immigrant from Senegal, Biram, with the ability to envision these divided communities overcoming such divisions. Through its cinematic representation of the two women, the film eventually allows home and diaspora to come together. Biram, Hassan's fiancé, would love to learn English and then attend school. Yet, Hassan is utterly against such ideas; instead, he forces her to work as an illegal street peddler. Repeatedly, one watches Hassan silencing her objections by brutally beating her.[28] When Biram and Eileen meet for the first time, they instantly share an understanding of each other because they both know about misery caused by their so-called loved ones. After Hassan's murder, Eileen is taken to the police station too, as she was present at the beating. At the police

248 HEIKE RAPHAEL-HERNANDEZ

Young African
American Eileen
at police station
in Harlem, after
the murder of the
Senegalese Hassan,
as seen from the
perspective of the
Senegalese Alloune,
in *Little Senegal*.
Screenshot by Heike
Raphael-Hernandez,
courtesy of Rachid
Bouchareb.

station, Alloune is looking at Eileen through a little door window (figure
13.4). The camera takes such a close shot of the door that one does not
see any other details of the waiting room except for the window's frame
with Eileen's face in the frame; the rest of the shot is filled by the dark
door. The viewer recognizes the film's symbolism: these young women
were taken into "slavery" by their own men. Only through Hassan's death
and Eileen's boyfriend's imprisonment do both women receive a chance
of a new beginning. At the end of the film, one watches the women sup-
porting each other—Biram helps Eileen take care of her baby, and Eileen
helps Biram study English. Their respect and support for each other sug-
gests future possibilities for Old and New African Diasporic members'
empowerment.

The film concludes by using one more time the image of the Door of
No Return. In the final shot, Alloune, back in Senegal, is looking through
the door toward the ship with the Black American tourists, but this time
the ship is leaving. The camera waits until the ship is not visible anymore
and then lingers for the final shot on the empty space (figure 13.5). One
could read this final shot as emptiness or the void that does not enable
diaspora and home come together again. Yet, in her scholarship, Tina
Campt advocates that we not perceive the African Diaspora as static and
closed, but rather realize how much transnational black communities
could gain by directing the discourse "toward the less comfortable, and
more problematic elements of this discourse, as well as their implications
for our attempts to make sense of the histories, cultural formations, and
expressions of black communities elsewhere."[29] Campt's ideas applied to
Little Senegal and the film's final shot allow seeing the empty space not as
capitulation, but as opportunity. The door without any ships, with just the

13.5.

Closing shot of *Little Senegal*, as seen by the Senegalese Alloune through the Door of No Return at the slave castle on Gorée Island. Screenshot by Heike Raphael-Hernandez, courtesy of Rachid Bouchareb.

wide and open space of the ocean could serve as *tabula rasa*, the clean slate that allows new beginnings. May the slate be used wisely.

Notes

1 Khachig Tölölyan, "The Contemporary Discourse of Diaspora Studies," *Comparative Studies of South Asia, Africa and the Middle East* 27, no. 3 (2007): 648.
2 Tölölyan, "Contemporary Discourse," 649.
3 Susan Arndt, "Rereading (Post)colonialism: Whiteness, Wandering, and Writing," in *Africa, Europe and (Post)Colonialism: Racism, Migration and Diaspora*, eds. Susan Arndt and Marek Spitczok von Brisinski (Bayreuth: Breitinger, 2006), 14.
4 See, for example, Caryl Phillips's *Crossing the River* (1995) and *The Atlantic Sound* (2000); Ekow Eshun's *Black Gold of the Sun: Searching for Home in Africa and Beyond* (2006); and Chimamanda Ngozi Adichie's *Americanah* (2013). More texts exist, yet the majority of these belong to travel writing connected to heritage tourism; therefore, they are rather one-dimensional in their interest, not dealing with the above-raised questions in critical ways.
5 In Europe, Rachid Bouchareb is a well-known and celebrated French-Algerian filmmaker who is part of the Maghrebi French *(Beur)* cinema tradition; with his films, he attempts to confront Western societies with their colonial and postcolonial pasts by dealing with topics he considers unfinished in public discourse. Two of his films received nominations for the Oscar for Best Foreign Language Film: *Dust of Life* (1995) and *Days of Glory* (2006). In the United States, he is mostly known for *Dust of Life* because of the film's focus on Eurasian children who were fathered by American GIs and left behind in Vietnam.
6 Maghrebi French filmmakers have offered a variety of films that address sites of memory in order to challenge France's neocolonial epic self-perception. French official rhetoric still propagates that France brought positive aspects to Africa via French colonialism.
7 Paul Gilroy, *Postcolonial Melancholia* (New York: Columbia University Press, 2005), 17.

8 Paul Gilroy, *The Black Atlantic: Modernity and Double Consciousness* (Cambridge, MA: Harvard University Press, 1993), 16.

9 Gilroy, *Black Atlantic*, 16.

10 Isidore Okpewho, "Can We 'Go Home Again'?" in *The New African Diaspora*, eds. Isidore Okpewho and Nkiru Nzegwu (Bloomington: Indiana University Press, 2009), 9.

11 Toyin Falola and Niyi Afolabi, "The Moral Ambiguity of Trans-Atlantic Migration," in *Trans-Atlantic Migration: The Paradoxes of Exile*, eds. Toyin Falola and Niyi Afolabi (New York: Routledge, 2007), 275.

12 Paul Tiyambe Zeleza, "Diaspora Dialogues: Engagements between Africa and Its Diasporas," in *The New African Diaspora*, eds. Isidore Okpewho and Nkiru Nzekwu (Bloomington and Indianapolis: Indiana University Press, 2009), 34.

13 Peter Bloom, "Theorizing Senegalese Migrant Identities in the Era of Globalization: An Interview with Mamadou Diouf," *Emergences* 13, nos. 1–2 (2003): 56.

14 Gilroy, *Melancholia*, 17.

15 Toyin Falola, *The African Diaspora: Slavery, Modernity, and Globalization* (Rochester: University of Rochester Press, 2013), 2.

16 Saidiya Y. Hartman offers her ideas in her fundamental works *Lose Your Mother: A Journey along the Atlantic Slave Route* (New York: Farrar, Straus and Giroux, 2008) and *Scenes of Subjection: Terror, Slavery, and Self-Making in Nineteenth-Century America* (New York: Oxford University Press, 1997).

17 Hartman, *Lose Your Mother*, 74.

18 Hartman, *Lose Your Mother*, 74.

19 Hartman, *Lose Your Mother*, 75.

20 Falola, *African Diaspora*, 239.

21 For an excellent discussion of literature that deals with this complex issue, see Alan Rice, *Creating Memorials, Building Identities: The Politics of Memory in the Black Atlantic* (Liverpool: Liverpool University Press, 2010).

22 Dionne Brand, *A Map to the Door of No Return: Notes to Belonging* (Toronto: Doubleday, 2001), 1.

23 Brent Hayes Edwards, *The Practice of Diaspora: Literature, Translation, and the Rise of Black Internationalism* (Cambridge, MA: Harvard University Press, 2003), 46.

24 Quoted in Allyson Nadia Field, "To Journey Imperfectly: Black Cinema Aesthetics and the Filmic Language of *Sankofa*," *Framework* 55, no. 2 (Fall 2014): 172.

25 Ruth Mayer, *Artificial Africas: Colonial Images in the Times of Globalization* (Hanover, CT: University Press of New England, 2002), 237–38.

26 Hartman, *Subjections*, 74.

27 One finds in literature as well as in film the African character who departs for Europe or the Americas. However, the reasons for their journeys are part of the push-and-pull factors of the migration waves of the twentieth and twenty-first centuries. So far, the protagonist Alloune of *Little Senegal* is the only one who travels to the United States with the sole purpose of doing research on New World slavery and its legacy.

28 In an interview, Mamadou Diouf even refers to *Little Senegal*; according to him, the film captures a problem that is more common among African immigrant families than one would like to admit. It illustrates a crisis between the young male migrant and his wife because for many African women the arrival in the United States "is simultaneously opening more space for them and

creating new contradictions in the household. African couples outside Africa are experiencing an increase in domestic violence. Women are acquiring more economic power in their capacity as outside actors. In this scenario, the patriarchal structure is compelled to control these women and reassert its domination. Nonetheless, they (i.e., the patriarchs) need the (economic) resources that women bring into the household but, at the same time, they want to maintain a controlling grip on their wives"; Bloom, "Theorizing Senegalese Migrant Identities," 69.

29 Tina Campt, "The Crowded Space of Diaspora: Intercultural Address and the Tensions of Diasporic Relation," *Radical History Review* 83 (Spring 2002): 95.

14

Of Plastic Ducks and Cockle Pickers

African Atlantic Artists and Critiques of
Bonded Labor across Chronologies

ALAN RICE

To them who knew to break free from dark hold of ships

who trusted their unsqueezed bodies instead to the Atlantic . . .

. . . to those bright yellow dots that crest the waves

—Kei Miller

The tongue-in-cheek celebration of the possibilities of migration and commemoration of the traumas of the Middle Passage by the 2014 Forward Prize–winning, London-based Jamaican poet Kei Miller in his poem "When Considering the Long, Long Journey of 28,000 Rubber Ducks" is only the latest artistic salvo in works by African Atlantic writers and visual artists who seek to make links between the forced historical movements of people through slavery and contemporary bonded labor. The opening lines, quoted above, seem to presage the familiar images of the Middle Passage, but the "unsqueezed" bodies that break free are, as the poem reveals, actually yellow rubber ducks and the ship a container vessel rather than a slave ship. The visual image of the "bright yellow dots" spread across the world's oceans and beaches goes beyond what might be captured in a visual field, allowing the full implications of this dispersal to be pictured in the imagination. Miller's poem conjures dimensions that traditional artistic frames would find hard to encompass, and it is the hypervisuality of the poem that I think lends it its power and makes it an ideal comparator to African Atlantic visual artists' response to slavery and bonded labor. This essay will explore the poem, together with installations by the black British artist Isaac Julien, to show how each makes links between past and present oppressions to create works that

are both effective critiques of the excesses of contemporary capitalism and memorials to the victims of the historical transatlantic slave trade.

In looking at these two works I want to posit African Atlantic writers and artists as uniquely positioned to comment on the operation of global capitalism then and now, because of the systematic exploitation of Africans through the slave trade and slavery, which interpellated them as pure commodities, or, as Ian Baucom, in his magisterial volume *Specters of the Atlantic*, has described in relation specifically to their Middle Passage journey, as a kind of liquid money in motion:

> The slaves were thus treated not only as a type of commodity but as a type of interest-bearing money. They functioned in this system simultaneously as commodities for sale and as the reserve deposits of a loosely organized, decentered, but vast trans-Atlantic banking system: deposits made at the moment of sale and instantly reconverted into short-term bonds. This is at once obscene and vital to understanding the full capital logic of the slave trade, to coming to terms with what it meant for this trade to have found a way to treat human beings not only as if they were a type of commodity but as a flexible, negotiable, transactable form of money.[1]

The extreme degradation and commoditization of African people in the operational workings of slavery has come to stand for a horrendous inhuman modernity and has become a powerful symbol for the description of subsequent labor exploitation. Paul Gilroy has written about how black thinkers and artists have used their history in slavery to make distinct and powerful critiques of the social and political structures that underpin modernity; he argues that "[African Atlantic] artistic practice . . . can be examined in relation to modern forms, themes and ideas but carries its own distinct critique of modernity, a critique forged out of the particular experiences involved in being a racial slave in a legitimate and avowedly rational system of unfree labour."[2]

It is this "distinct critique of modernity" that links these two works despite their different forms and contexts. Working across chronologies and geographies, they both function as critiques of bonded labor that utilize a shared memory of chattel slavery to provide a critique of the heinous conditions experienced by bonded labor in contemporary global capitalism.

ALAN RICE

Migration and Ducks: Kei Miller's Poetics of the Ordinary

Miller's poem takes its inspiration from the sinking of the *Ever Laurel* in the Pacific Ocean in 1992. This year is significant as it marks the quincentenary of Columbus's voyage to, and "discovery" of, the Americas, which initiated the transatlantic slave trade and the global modern world order that the poem critiques. As the ship sank, it disgorged from one of its containers twenty-eight thousand Friendly Floatee plastic bath toys, including a plethora of plastic ducks. This consignment of mass-produced goods made by Third World labor for First World consumers is typical of contemporary capital's flow of commodities in large ocean-going container ships. The making of these goods in sweatshops on the Asian subcontinent elides from the view of Anglo-American consumers the exploitative labor practices that are essential to their production. Miller uses the serendipitous escape of the ducks as a *deus ex machina* that reveals origins and traces with both contemporary and historical resonances. In terms of the contemporary, these throwaway goods made by exploited labor in the East come to stand for the dispersal of that labor through the forces of globalization in search of better futures. The ocean currents spread these ducks far and wide to all four corners of the earth so that their dispersal has been key evidence for oceanographers trying to understand the workings of currents. Miller riffs on the "ocean's sense of humour" on setting these ducks free to roam, and makes analogies in historical terms to the diasporic travels of Africans in the wake of the enslavement of millions of them from the fifteenth to the nineteenth century.[3] As the ducks "break free from the dark hold of ships," so did some enslaved Africans who rebelled to escape their fate as commodities in the mercantile economy in onboard ship revolts that occurred, according to the research of David Eltis and David Richardson in their comprehensive Slave Trade Database, on up to 10 percent of slave voyages.[4] Miller, though, uses the analogy of ocean-floating ducks to commemorate creative survival as much as rebellion. The "unsqueezed bodies" "trusted" to the Atlantic make an important analogy with the Middle Passage journeys undertaken by Africans, which were always ones where their bodies were squeezed into confined spaces to maximize the profits of the enslavers. By escaping, they ensured their bodies were "unsqueezed." The ducks "scorned the limits of bathtubs, / refused to join a chorus of rub-a-dub," and many Africans, despite the oppressive practices of enslavement, managed to make lives that refused geographical limits and resisted European cultural domination and the demand to sing its tunes.

Miller goes further than showing this resistance, indicating that enslaved Africans "hitched rides on the manacled backs of the blues," that is, that from their oppressive and chained condition they made their own cultural life, one which helped them to survive. Miller's brilliant, economic use of language here combines the idea of movement, music, and oppression as central to African Atlantic cultural survival. Miller has his ducks "pass in squeakless silence over the Titanic," a heralded and over-celebrated voyage and wreck.[5] The "squeakless" ducks refuse to join in the chorus of commentary on the ship, an emblem of riches and Anglo-American power that has been heralded enough. In Miller's "signifyin'" transformation the ducks commemorate the thousands of more everyday and unheralded ocean voyages that have created African diasporic cultures across the world. Like the ducks, African Atlantic people now "grace the shores of hot and frozen countries" due to the operation of slave and post-slave capitalist economies that have moved in involuntary and voluntary migrations tens of millions of African diasporic people around the globe. Many of these Africans are marginalized both historically and in the present and Miller is keen to use the analogy of the "bright yellow dots that crest the waves like spots of praise" to "hail" their survival and achievements.

Foreign Bodies Washed Up on British Shores:
Isaac Julien's *Ten Thousand Waves*

An unlikely winter sight: hundreds of people on the beach at Morecambe, in Lancashire in the northwest of England, on a cold February evening in 2014, a time when it would normally be deserted. They gather round a pile of old furniture in the shape of a boat, a sculptural bonfire which they soon set light to, and then make paper lanterns which, at the appointed hour, they step forward and release into the sea, to the accompaniment of a polyglot community orchestra playing Chinese instruments. The *Sigh of the Sea* commemoration brings together most of the Chinese community of the Lancaster and Morecambe area, but there are also hundreds of Lancastrians and "Sand Grown 'Uns" (the vernacular name for someone born and bred in Morecambe) drawn to the ceremony by their need to commemorate the shared horror of what had happened on these shores exactly a decade ago. In the deep dark before dawn on February 5, 2004 many of them had, like me, been awakened by the unreal sounds of police and rescue helicopters which invaded the usual quiet of the winter night

so that at times it sounded like the opening frames of *Apocalypse Now*. And when we woke from our disturbed sleep it really felt like an apocalypse: the riptide had drowned twenty-three Chinese immigrant cockle pickers who had been harvesting, despite a danger that had already caused all the local cockle pickers to leave the scene earlier in the night. The group of Chinese cockle pickers had been left prey to the fast-incoming tide as they worked in the dark and cold, thousands of miles from their homes in the southern province of Fujian, from where they had been trafficked as bonded laborers to be controlled by gangmasters in conditions akin to slavery.

Sigh of the Sea also featured a remarkable installation made by Cumbrian ceramic artist Victoria Eden: "This piece, called 'On the Night of February 5th,' consists of 23 ceramic forms each constructed from red earthenware clay moulded on to individual plaster casts taken from the ripples and depressions in the sands of Morecambe Bay. Each piece represents one of the lost Chinese cockle pickers and uses screen-printed quotations from press reports to highlight the issues of migration, loss and modern slavery. Taiwanese artist and calligrapher Chun-Chao Chiu added the individual names of the victims."[6] Eden's use of the very hollows and depressions of the bay to construct the memorial is a wonderful environmental artistic response to traumatic loss. The memorial marks on the landscape are made integral to the narrative memory of the event and symbolise the retention of the inscription of trauma in the shifting sands. *Sigh of the Sea* was the culmination of a decade of local memorialization, much of it led by the local Chinese community in cooperation with the community music organisation More Music in Morecambe. One of the most effective responses was a large-scale multimedia performance piece, *The Long Walk,* composed by Pete Moser with lyrics by the black British poet Lemn Sissay. It was completed in 2007 and there were performances in Morecambe, Liverpool, and Gateshead over the next two years. Sissay describes it: "This is a story of a journey. A story of a journey of people I didn't know. A story of the journey of the Chinese people who came to Morecambe Bay. And it's a story that may open up our own stories. Their journey is a metaphor for all of ours."[7]

Sissay himself was born in the northwest, so that his acknowledgment of the shared human story of the Chinese cockle pickers refers in part to this. However, there are deeper resonances to do with the murky past of Morecambe Bay which impact his background as a black Briton: the history of the transatlantic slave trade and Lancaster's status as the fourth-largest British slave port. Engaged through the local Lancaster

Slave Trade Arts Memorial Project in erecting the first quayside memorial to the victims of the transatlantic slave trade in a British port (completed in October 2005), the people of Lancaster were suddenly presented with a contemporary tragedy with resonances to the Middle Passage journeys that had been initiated by Lancaster merchants over two hundred years before. Only now the victims were not drowning in the Atlantic or working on plantations in the Americas, but toiling in a traditional industry on these shores, only an oystercatcher's brief flight from the slave boy Sambo's famous 1736 grave at Sunderland Point at the mouth of the River Lune, which feeds into Morecambe Bay.[8] Sissay's elegiac poem surely reflects on both these contemporary and historical resonances:

> The moon laughs the clouds cry
> And a seagull screams at the night's sky
> And the sad sea sighs—goodbye.[9]

Sissay's lament describes these very human tragedies of chattel slavery and contemporary human bondage as occurring in the same mourning landscape. Isaac Julien, whose epic nine-screen installation *Ten Thousand Waves* (2010) responds to the tragedy and incorporates grainy police satellite footage of the attempted rescue, makes the link to the wider slave trade (though avoiding specific mention of, or any image link to the historical Lancaster slave trade). He describes how the long history of slavery in the northwest connects these contemporary tragedies to past tragedies and says: "What resonates for me was that they drowned in the sea and that connects with the slaves' passage across the Atlantic, in which so many were lost in the ocean."[10] In talking of these highly exploitative and murderous labor arrangements as "new slaveries," Pietro Deandrea describes how such "undocumented migrants can be described as modern ghosts haunting the complacent conscience of British spaces."[11]

In writing about slavery, modernity, and subject formation in her provocative and paradigm-shifting essays, Sabine Broeck is careful to differentiate between the historical transatlantic slave trade and such modern instances of slave-like conditions.[12] However, incidents like this and the continual drownings of African refugees in the Mediterranean mean that historical European elision of the importance of slavery and the slave trade to the construction of European free subjects still have significant and specific resonances in today's globalized, digital world. Cultural contributions like *Ten Thousand Waves* enable a politically astute and historically informed response to contemporary prob-

lems that mean "foreign" bodies continue to wash ashore on European beaches.

It is the very multidirectionality of memory that contemporary African Atlantic artists are able to engender through the eclectic juxtapositions of their imaginations, showing the connections that capitalist ideology seeks to occlude by its concentration on the anonymous movement of goods, services, and money alone. As Michael Rothberg elucidates: "Memories are not owned by groups—nor are groups "owned" by memories. Rather, the borders of memory and identity are jagged: what looks at first like my own property often turns out to be a borrowing or adaptation from a history that initially might seem foreign or distant. Memory's anachronistic quality—its bringing together of now and then, here and there—is actually the source of its powerful creativity, its abilities to build new worlds out of the materials of older ones."[13] Rothberg's discussion here is very pertinent. During the nineteenth-century imperium, the colonizing British government encouraged opium dependency before fomenting deeply destabilising, but profitable, opium wars through the East India Company; its rapacious activities used the financial might of the London markets to access capital in the same way that slave merchants and planters had previously used capital to develop slaving oligopolies throughout the new world. Such shared colonial pasts are awakened and envisioned as histories collide in the wide reaches of Morecambe Bay. The "foreign [and] distant" colonial histories of the Far East and the Americas now exist multidimensionally and seemingly anachronistically thousands of miles away and generations later in the sands of Morecambe Bay, simultaneously in the person of slave children traded to big houses in Britain as signifiers of conspicuous consumption in the eighteenth century, and as Chinese laborers trafficked to a life of drudgery by global capitalism in the twenty-first century.

Accessing and envisioning such multidirectional memory, as Miller does in his disarmingly simple poem, Julien combines critiques of contemporary capitalism, and the memory of British colonialism in China, with awareness of the historical legacies of slavery and the African diaspora. *Ten Thousand Waves* uses multiple screens to orchestrate several narratives that vision the histories of global capitalism, transnationalism, and exploitation that "make the distance from the factories of Southern China to the aisles of Tesco or Walmart appear a wholly fractionless space" (figure 14.1).[14] A key thread in Julien's multiple narratives is the tragedy that unfolded on Morecambe Bay in 2004: it gives the installation a bleak backdrop that imagines oceans as tragic spaces. In the catalogue of the

installation, Christopher Connery contends that historical merchants ("world conquerors") like those who had left slave ports in the northwest in the eighteenth century, had made of the water they controlled "a sea of sublimity, of power, of mastery, a smooth sea of world space where they sailed freely."[15] According to Connery, Julien sees the oceans where the powerless—pawns of mercantile and then later commodity transnational capitalism—are set adrift as: "material oceans, drowning oceans, fearsome passages, spaces of death delivering to the shore, besides those in search of a better life, dead bodies and broken or empty boats . . . the sea is a dark matte fringed with the white of waves and foam, a barely discernible entity in which the heat-seeking camera searches for signs of life or death. The CGI waves that fill entire screens—dark, rolling, and animate—convey a violent dynamic of abstract and masterful space."[16] The terror-inducing sea is related directly to the ocean's history as producer of bonded labor wherever its exploitative sojourners have alighted. Julien had already explored this phenomenon in his *Western Union: Small Boats* installation of 2007. He describes how: "there are some very tough things happening along the Mediterranean coast that have instigated the making of *Western Union: Small Boats*. Dead bodies washing up on the coast, interrupting holiday suntanning on the beach . . . it's the clash of the two activities that forms a disturbing geography of the space."[17]

In this installation, Julien uses as significant images African figures at the Door of No Return on Gorée Island (the final embarkation point for numerous enslaved Africans and now a significant tourist destination) to show how the long history of enslaved labor provides a poignant backdrop to modern-day migration. He does this by juxtaposing these iconic scenes with those in Lampedusa, Italy of the boats, now abandoned and broken

up, which modern-day African migrants, after having already traversed the Sahara, had used to cross the Mediterranean. The boats bear witness to many failed attempts, and to the fragility of those crafts that made it, but then were not fit for use again. The detritus of these migrant lives stands cheek-by-jowl with vacationing Europeans, and Julien makes clear through his film the links between Middle Passage histories and contemporary migration, which both lead to dead bodies, albeit now more extensively on European beaches, rather than mid-Atlantic. The three-screen installation juxtaposes scenes from Gorée, broken boats with bodies and body bags on the beaches, and the grand baroque European buildings that were enabled by cheap slave and colonial labor.

Although *Ten Thousand Waves* does not make such explicit visual links, the European setting in Morecambe Bay, from which over two hundred slave voyages left from the 1730s to 1806, and the churning sea make their own connections to this tortured history. Julien is clear that the two installations are linked through their stories of migration and connections to earlier forced and voluntary migration. He comments: "*Ten Thousand Waves* and *Western Union: Small Boats* are kind of sister projects because they are both about people searching for the so-called 'better life,' which of course, is why my parents came to England from the Caribbean in the first place."[18]

Both installations talk to a history of migration geographically and chronologically much wider than Julien's own autobiographical story. *Ten Thousand Waves* does this visually and aurally. The soundtrack of the installation is composed in part of the poems "The Great Summons" and "Small Boat" by the Chinese writer Wang Ping, which Julien commissioned for the installation. These poems poignantly evoke the loss of the cockle pickers thousands of miles from their homes in Fujian:

> On the night of riddles and lights
> The moon if full behind with clouds
> We cockle, cockling
> In the sands, the distant North Wales Sea
> . . . How empty is desire foaming
> On the cold North Wales Sea.
> . . . (Oh home, a foam on the wild, wild sea).[19]

Laboring deep into the night, long after local cocklers had left, warning the Fujian laborers' gangmasters of the imminence of the incoming riptide, the Fujians are envisaged as helpless in the sea's wake, which

eventually becomes their tomb (home). In Julien's installation, Ping's elegy accompanies the shots of the dark, swirling, CGI-enhanced sea and other shots taken of the sands where the cocklers had worked, striving to make some kind of sense of the waste of such merely laboring lives miles from home, in a place where the only home they are able to make is in the foam of the wild sea. As Laura Mulvey describes, the waves Julien evokes through image and sound have multiple resonances:

> On an immediate level, this vividly evokes the fearful nature of the sea; on another level, it establishes visually the highly metaphoric significance of "waves." Both levels of significance lead to two contrasting kinds of "movement" that lie at the heart of *Ten Thousand Waves,* connecting its intertwined layers, the migration of impoverished peoples under globalized capitalism and the circulation of capital itself, through both manufacturing and finance, and particularly, in this context, as it flows into the new China While it was real waves that engulfed [those] searching for a "better life," the word has yet another metaphoric significance in the racist concept of migrant "waves" threatening fragile indigenous economies and communities.[20]

The movement of capital is shown through multiple shots of the new Pudong sector of Shanghai, which Julien films from a bedroom of the Hyatt Hotel "to underscore the internationalism of the new China . . . so that the exotic high rise buildings represent the sudden arrival and rapid growth of Chinese capitalism."[21] These scenes, juxtaposed with the fatal drowning of Chinese workers for whom capitalism has not provided wondrous multistory backdrops, but rather backbreaking toil estranged from home shores, illustrate the failures of capitalism to sustain fulfilling lives across geographies. Julien's multiscreen installation enhances the connections between these differing worlds by providing a sensory overload, eschewing the linear approach of a traditional documentary approach. The multiple problematics caused by global capitalism's obscene workings, which stretch from skyscraper temples of glass and steel in China to workers' bodies from that very country exiled and abandoned to their fate on a cold winter's night in Morecambe Bay, can be fully envisaged only by multiple screens that mirror the contemporary postmodern experience. As Gao Shinning argues: "What is most important to note is that this kind of multi-screen, chaotic visual scenario is the typical sensory condition of our daily lives, while it is the fixed viewpoint of the cinema that is highly

abnormal and institutionalized. Our visual and sensory experiences have been domesticated by the entire visual approach of exhibitions, cinemas and so on, which makes Isaac's installation method of non-linear, multi-screen film, a form of visual liberation, even if the liberation is only temporary."[22]

Such visual liberation is a method that ironically enables the viewing of the bonded nature of life across many geographies and peoples that has been created by global capitalism in the unequal twenty-first century world, which Julien shows has parallels to earlier capitalist modes of production and exchange. It is through the glitz and glamour of a multiscreen installation in a modern art temple that capitalism is ironically critiqued. Julien is aware of such paradoxes, explaining how:

> Even in feeling pride at the success of *Ten Thousand Waves*, I am
> well aware of how closely the currents that have taken the work
> from city to city and from continent to continent, and that we attri-
> bute to a modern international art world, resemble the currents of
> globalization that displace the cockle pickers from Fujian to north-
> west England. I still feel so saddened by the fact that so many peo-
> ple came so far to meet a tragic end. Every time I go to Morecambe
> Bay, I look out into its empty landscape and it is as if I can still see
> them.[23]

The currents of globalization imaged by Miller's poem and symbolized by the dispersal of thousands of plastic ducks are mirrored here by the fore-grounding in the installation of the "displaced cockle pickers." The empty landscape which the ghosts of the victims still seem to haunt has become even more desolate with the emergence from the sands of the vehicle to which many of them clung, which now exists as a permanent memorial of that ill-fated night. The abandoned decaying minibus, its own rusting memorial to lives wasted, posits a mechanical modernity that chimes both with Miller's poem and Julien's installation and their critiques of contemporary and historical globalized capitalist systems that scatter Global South workers far and wide and at times wash their dead bodies onto European shores. These people, transported halfway across the world by slave merchants, or more recently by people traffickers, and then set to work by plantation owners or gangmasters as slave laborers or for a pittance, had different other lives before their place in the bottom rung of global economies forced them into their deadly work. As the Black British artist Lubaina Himid and I discussed in talking about her work, such lives,

spanning the centuries, are "human beings to be bartered and used like checkers on a checkerboard."[24] Likewise, Julien's installation and Miller's poem work to commemorate the "throwaway people" of the Middle Passage and of subsequent exploitative postmodern economic geographies, to show, "what it meant to be a people who were neither one thing nor the other, however horrendous being either of those things was, either slaves or colonised trying to find a way, as an artist, in a world of art to talk about this. How do you talk about something that can be seen and be thought of as not being there? Inside the invisible, if you like."[25]

Miller and Julien find novel ways to make art get "inside the invisible," to conjure fully realized lives out of the millions that have been, and are, marginalized and forgotten. They understand that in order to do this effectively and empathetically, they cannot isolate African Atlantic lives, but must place them alongside other victims of exploitation, being open to the multidirectional nature of memory. As Rothberg elucidates: "Even if it were desirable—as it sometimes seems to be—to maintain a wall, or *cordon sanitaire* between different histories, it is not possible to do so. Memories are mobile, histories are implicated in each other. Thus, finally, understanding political conflict entails understanding the interlacing of memories in the force field of public space. The only way forward is through their entanglements."[26] It is testament to the artistic power of Julien and Miller that they create wonderful "force field(s) of public space" which foreground the "entanglements" among people across chronologies and geographies, to create works that bring together echoes from history whose powerful messages help break down the barriers that inhibit the understanding of systemic exploitation that continues to this day.

Notes

Epigraph: Kei Miller, "When Considering the Long, Long Journey of 28,000 Rubber Ducks," *The Cartographer Tries to Map a Way to Zion* (Manchester: Carcanet Press, 2014), 53.

1 Ian Baucom, *Specters of the Atlantic: Finance Capital, Slavery, and the Philosophy of History* (Durham, NC: Duke University Press, 2005), 61–62.
2 Paul Gilroy, *The Black Atlantic* (London: Verso, 1993), 58.
3 Kei Miller, poetry reading at the Wordsworth Trust, Grasmere, Cumbria, September 23, 2014.
4 David Eltis, Stephen Behrendt, David Richardson, and Herbert S. Klein, eds., *The Transatlantic Slave Trade: A Database on CD-Rom* (Cambridge: Cambridge University Press, 1999).

5 For a more comprehensive perspective on the varied nature of African American cultural commentary on the Titanic disaster, see my *Radical Narratives of the Black Atlantic* (London: Continuum, 2003), 25–47.

6 Victoria Eden, "Sigh of the Sea," accessed December 15, 2014, www.moremusic.org.uk/events/118/sighofthesea.

7 Lemn Sissay, *The Long Walk,* site-specific performance, Liverpool, March 14, 2008.

8 I talk about gravesite and its cultural history in both of my publications; see Rice, *Radical Narratives of the Black Atlantic*, 213-217, and Alan Rice, *Creating Memorials, Building Identities: The Politics of Memory in the Black Atlantic* (Liverpool: Liverpool University Press, 2010), 32-43.

9 "Sigh of the Sea," Lemn Sissay, accessed December 15, 2014, http://www.moremusic.org.uk/events/118/sighofthesea.

10 Quoted in Laura Mulvey, "Ten Thousand Waves," in *Isaac Julien: Riot* (New York: Museum of Modern Art, 2013), 200–11.

11 Pietro Deandrea, *New Slaveries in Contemporary British Literature and Visual Arts: The Ghost and the Camp* (Manchester: Manchester University Press, 2015), 102.

12 For more details for her argument, see Sabine Broeck, "The Legacy of Slavery: White Humanities and its Subject," in *Human Rights from a Third World Perspective: Critique, History and International La*w, ed. Jose Barreto (Cambridge: Cambridge Scholars Publishing, 2013), 103–16.

13 Michael Rothberg, *Multidirectional Memory: Remembering the Holocaust in the Age of Decolonization* (Stanford, CA: Stanford University Press, 2009), 5.

14 Chris Connery, untitled essay, in *Ten Thousand Waves*: *Isaac Julien* (London: Victoria Miro Gallery, 2010), n.p.

15 Connery, *Ten Thousand Waves*, n.p.

16 Connery, *Ten Thousand Waves*, n.p.

17 Martina Kudlacek, "Interview with Isaac Julien," in *WESTERN UNION: small boats* (Warsaw: Centre for Contemporary Arts, 2007), 100–5.

18 Andrew Maerkle, untitled essay, in *Ten Thousand Waves*: *Isaac Julien* (London: Victoria Miro Gallery, 2010), n.p.

19 Isaac Julien, untitled essay, in *Ten Thousand Waves* (London: Victoria Miro Gallery, 2010), n.p.

20 Mulvey, "Ten Thousand Waves," 204.

21 Mulvey, "Ten Thousand Waves," 204.

22 Gao Shinning, untitled essay, in *Ten Thousand Waves*: *Isaac Julien* (London: Victoria Miro Gallery, 2019), n.p.

23 Isaac Julien, "Screen," *Isaac Julien: Riot* (New York: Museum of Modern Art, 2013), 198.

24 Alan Rice, "Exploring Inside the Invisible: An Interview with Lubaina Himid," *Wasafiri* 40 (Winter 2003): 26.

25 Rice, "Exploring Inside the Invisible," 24.

26 Rothberg, *Multidirectional Memory*, 313.

15

At Home, Online

Affective Exchange and the
Diasporic Body in Ghanaian Internet Video

REGINOLD A. ROYSTON

In the YouTube series *An African City*, the main protagonist, Nana Yaa, narrates her transition from life as a publicist in New York City to her homeland Ghana, in voice-overs reminiscent of Sarah Jessica Parker's character Carrie in the HBO series *Sex and the City*. In an episode titled "He Facebooked Me," Nana gives an exposition on Africa's contemporary "rise," against the backdrop of chaotic street scenes and fervent construction projects in the capital city Accra: "According to *The Economist,* Africa is the next frontier in ICT [information and communications technology]. According to *The Financial Times*, technology is driving Africa's transformation. According to the publication *African Renewal*, Africans are coupling their already extensive use of cell phones with a massive interest in social media. According to the experience of five African women, this may not be such a good thing."[1] Consisting of ten-minute "webisodes," the short-format dramedy chronicles the rocky homecoming and romantic follies of a group of globe-trotting "returnees"—Africans who were born or schooled in the West and are now seizing opportunities back on the continent. Nana Yaa has left the corporate world to make things anew in Ghana, where her parents enjoy comfortable lives as business and government elites. At the outset of this particular episode, the homeland migrant has just received a Facebook message from her UK-bred ex-boyfriend, stating that he is now engaged to a "local" Ghanaian woman, whom we find out later speaks perfect Ashanti/Twi, unlike Nana, who grew up in the United States.

Many of the lives depicted in *An African City* reflect the real world experiences of the show's actors and producers. Nicole Amarteifio, the writer and director, attended Brandeis and Georgetown universities in

the United States and worked as a social media coordinator at the World Bank. Maame Yaa Boafo, the actress who plays Nana Yaa, is a Ghanaian American who has never lived in Ghana.[2] Both a reflection and a product of what online is often hashtagged as #TINA (This Is the New Africa), *An African City* revels in the newfound chic discourse about Africa in media broadly, stoked in part by foreign wonder over a cell phone "explosion" in this part of the developing world, as well as economic, and arguably some political, success stories that came out of Ghana, Nigeria, Côte D'Ivoire, Kenya, and South Africa in the first decade of the new millennium.

This narrative of success abroad, triumphant return, and cultural solidarity among a millennial generation of African transnationals has coalesced around the term *Afropolitanism*, introduced by writer Taiye Selasi, philosopher Achille Mbembe, and others.[3] Competing views on this African modernity and its entanglement with globalization have simultaneously embraced and excoriated the Afropolitan concept. I deploy the notion here in order to mark its encroachment into popular discourse and to highlight the multivalent lifestyles that the "experience" conjures up, some which have often been ignored in critique.[4] Emerging digital media such as *An African City* embrace a reading of African cosmopolitanism that is wrapped in glamour and fashion. In contrast, another web series I discuss below, *Azonto in Real Life*, invokes a populist experience of this transnationalism, as it is ensconced in mass-cultural phenomena such as *hiplife* music. This digitally-enabled cultural flow finds analogous expression via film, international beauty contests, and evangelical ministry among Africans abroad. These practices, not solely enraptured with a discourse of glamour, could be described as *Afropolitanism from below*, though the audience for these media often cut across class divisions. Beyond the overlapping claims of identity, nationalism, and class that are embedded in this emerging cyberculture, I seek to highlight the ways the Black body is deployed as an indispensable tool in this contemporary politics of representation, especially in the facilitation of a global political imaginary around the nation-state, in this case Ghana. Internet video, though a privilege of networked geography and "early adopters," allows producers and participants to engage in what I term *affective exchange* that is, at its most robust experience, an embodied diasporic practice that produces "real-time" sociality.

The Afropolitan Mediascape

The YouTube homepage for "Africa's first web series" states: "*An African City* tells the story of five successful women who confide in one another about their love-lives and find new ways to deal with being a 21st-century woman in Africa."[5] This confluence around techno-utopianism and Afro-optimism is not simply born out of frustration with Africa's marginalization in the *longue durée* of technological and economic development.[6] The continent has been experiencing an upsurge of commercial and political interest in the past fifteen years. Ghana's gross domestic product, which grew by 14 percent in 2011, up from 7.9 percent in 2010, was described as the world's fastest growing economy in those years, with Nigeria also a top-ten growth country in the same period.[7] The World Bank has reclassified nations such as Kenya and Ethiopia from "developing" to "middle-income" economies since 2013, signaling an emerging African "middle class."[8] China and India have partnered to build dams and ICT centers in Ghana; Arab states have invested in agricultural projects in Eastern Africa, with Qatar lending millions to build a port in Kenya.

An African City's introductory narrative suggests that technology is also key to this discourse of an "Africa rising." Africa has been the fastest growing market for mobile phones since the mid-2000s, and currently boasts more than 650 million mobile subscriptions, up from 250 million in 2008.[9] Vernacular tech practices also abound, such as Kenya's M-Pesa application, an immensely successful text-message money transfer service.[10] In the rhetoric of the "rise," African nationals who have returned home to set up businesses and reestablish roots are especially significant, in part due to African transnationals gaining more visibility in Western popular culture, academia, and business. This phenomenon magnifies an exceptionalist narrative, beginning, perhaps most dramatically, with the election of U.S. President Barack Obama, son of a Kenyan émigré — a fact often cited by online bloggers who herald a new Afro-cosmopolitanism. The discourse conflates the growing popularity of global Black celebrities such as actors Lupita Nyong'o and David Oyelowo, soccer players Asamoah Gyan and Kevin-Prince Boateng, and designer Ozwald Boateng, among many others, with economic and political stabilization in Africa itself. In *An African City*, this is played out as a drama of the "arrived," with Nigerians, Tanzanians, Angolans, Sierra Leoneans, Black Americans, and Brits dropping into the series with similar backstories of professional success in the West and a desire to return home. Since 2013, however, rising inflation and an energy crisis in Ghana, and torrential elections and violence

from militants in Nigeria and Kenya have cooled this discourse, with the *Guardian,* among others, now disputing the efficacy of a yet another "African Renaissance."[11]

What follows is an examination of a cyberculture that can be properly classified as Afropolitan, though the label can also be applied to the emerging heterogeneous media of digital practices, organizations, and tech policies taking shape on the continent. Anthropologist Arjun Appaduari has described the intersecting institutions and consumptive practices of media as not simply constitutive of one kind of public sphere, but rather as a *mediascape* of sociocultural flow. According to Appaduari, this space is inherently multivalent, uneven, and particularistic given the asymmetry of global capital and distribution of technology. He states that in such an information environment, "many audiences throughout the world experience the media themselves as a complicated and interconnected repertoire of print, celluloid, electronic screens and billboards."[12] Media scholar Okoth Fred Mudhai has described Africa-based media organizations as central to this particular mediascape, especially in broadcast and web forums on the continent, given the geographic disjunctiveness of the audiences, languages, and borders.[13] His notion of an African mediascape speaks to the enduring sociopolitical imaginations of Pan-Africanism. This serves as an important departure for what can now be experienced as a global continuum of African media practices that, like the Afropolitans, are "global in focus" and "rooted in Africa."[14] In the transnational productions I discuss below, the Afropolitan adage can also be flipped, with the media sources themselves "focused" on Africa, though their production headquarters may be based anywhere, particularly in the diaspora.

Ghanaian radio stations CitiFM and JoyFM are but a few examples of the former: they broadcast multiple feeds online, and repost morning shows to YouTube. At a different scale, media firms such as South Africa's Multichoice cable network provide television feeds to viewers throughout the continent, including channels and movies in local languages such as Hausa, Twi, and Yoruba.[15] Internet service providers such as MTN (South Africa) and GLO (Nigeria), with network service in multiple African markets, configure a digital infrastructure that bridges both fiber-optic and cellular networked publics. These same firms are now also providing YouTube programming and sponsorship of live events, extending their brands and linking their users. GhanaWeb, a popular news site and online exchange for diasporans, is based in the Netherlands and reports that most traffic originates from the United States or Europe.[16] In Accra, radio

stations and television VJs group music from South Africa, Cote D'Ivoire, Senegal, Kenya, Liberia, as well as the United States and the United Kingdom in the same programming. As such, this contemporary media flow is reflective more broadly of what I would term an Afropolitan mediascape—a global media ecosystem and set of practices with a collectivizing discourse on Africa.

While variously neoliberal and Pan-African in character, online filmic interventions such as *An African City* and *Azonto in Real Life* do more than work at the representational level. These productions also provide what feminist scholar bell hooks describes as an "oppositional gaze," in this case, directed against the common portrayal of Africa as historically backward.[17] That legacy includes "White savior" flicks such as *Blood Diamond* (2006) and *The Constant Gardener* (2005). As visual narratives, these epics find affinity with British colonial cinema in Nigeria and India during the 1930s. Media scholar Brian Larkin describes the practices of publicly showing of imperial news reels as an effort to produce "a particular sort of modern colonial subject. Technologically adept, forward thinking, mutable, this subject was formed by the criss-crossing of new communication networks."[18] Against this history, these web shorts inject an oppositional practice of representation, via small-scale, user-generated content, deploying networking and high-definition cameras to recognize and produce new exemplars of African modernity.

It would be easy to analyze diverse media forms from across the continent (including hybrid technologies such as global television channels, transnational blogs, and online radio) as objects that make information flow "horizontal."[19] However, the multivalent and unequal distribution of these technologies reflects enduring urban-rural, religious, linguistic, political, infrastructural, and economic divides in Africa that produce fragmented experiences rather than seamless webs of connection. Only 20 percent of the African continent has consistent access to the web.[20] While mobile penetration is officially at 100 percent in some countries as of 2015, only 20 to 40 percent of these users have smartphones with robust interactive and streaming apps that enable video-based cyberculture.[21] If the continent's digitization has transformed only elite and professional usage, Africa's communities in the West have had access to a different Internet. Country-wide average download speeds in the United States and Europe typically figure at fifty or more megabytes per second.[22] Cost for landline Internet (as a percentage of annual income), is also much cheaper in Europe and the United States. Broadband for mobile devices (at download speeds faster than three megabytes per

second), while pricier, is nearly ubiquitous in the West. Africa's "new" diasporas of the late twentieth and early twenty-first centuries, living in Europe and the United States, have benefited tremendously in the Internet age, eliding the disjunctive global flows that marked diaspora engagement prior to the 1990s. In many ways, the "real-time" sociality of the Internet age, where it is available, has overcome the boundaries of "life abroad," specifically the time lag that Léopold Senghor and later Brent Hayes Edwards describe as a condition of *décalage*, a fragmented chronoscape among migrants, the homeland, and the broader African diaspora.[23] According to the International Telecommunications Union and the Internet sea-cable mapping service Telegeography, the majority of global Internet bandwidth and traffic is facilitated by underwater fiber-optic cables linking Europe and North America.[24] In the case of Africa's digital diasporas, this West-facing structure provides a benefit not only for banks and dominant conglomerates such as Verizon and Airtel but also for Africa's digital diasporas, social networks of expatriates, and children of immigrants living abroad.[25] As narratives of the twenty-first-century African, projects such as *An African City* and *Azonto in Real Life* are in the minority of digital practices emanating from the continent and its diaspora, but they also represent a rising tide of early adopters, advancing digital cultural production for the Global South.[26]

The Diasporic Body and the Returnee's Gaze

What is striking, however, is that while shows like *An African City* and *Azonto in Real Life* reaffirm the imagined community of Ghana's national identity, the projects are not framed as diasporic or as being about the diasporic experience. Instead, these cosmopolitans in their content, presentation, and subject matter reflect a desire to be seen as participating in a national discussion about belonging, rather than foregrounding life abroad. In both series, the use of terms such as "African," "Ghanaian," "Nigerian," and "West African" in many ways stands in for discourse that is diasporic in nature, forgoing serious discussion of ethnicity ("tribalism"), region, religion, and party politics that are key to shared identities in the homeland. These digital actors are participating in what seems like a national discourse on the surface. However, given their geographic position, modes of exchange, and access via the West, their concerns and discourse can reasonably critiqued as pertaining instead to the diaspora. In these digital spaces, the global connection and social imaginary of Ghana,

Nigeria, and Africa in general can often be routed through diaspora rather than nation-based networks.

In the analysis and theorizing below, I examine different approaches towards these two recent exemplars of diasporic Internet video from Ghana, with their claims of cosmopolitan agency and connection with the homeland. *An African City* and *Azonto in Real Life* share approaches towards digital embodiment that go beyond visual representations. In these ventures, the Black body can be seen as a tool of representation for diaspora-homeland connections, a signifier of the unity of diasporic and homeland media publics, and through reenactments and performances (especially via dance), a physical site of cultural production and identity construction. New media—the digital technologies of the Internet age, with their affordances of user-generated, broad- and narrow-streaming of information, and of linked tools for sociality, creativity, and surveillance— seem an undisputable enabler of these reflexive transnational ties. For political theorist Benedict Anderson, the "imagined community," central to a nation's identity, is the product of the media apparatus of the state and the narratives of belonging it facilitates within its polity.[27] These visual projects go beyond the discourse of diaspora-homeland media, conjoin- ing the dispersed and grounded notions of a national imaginary that is also global.

In May 2014, *An African City* premiered on YouTube, primarily promoted through viral marketing, and later through a strong media push. Print and blog reviews appeared in outlets such as the *Guardian*, *Ebony* magazine, and a host of influential Africana-centered sites such as *Shadow and Act* and *Bella Naija*. As a returnee-centered drama, the series is striking in its stylization: the kind of African women portrayed are not just full-bodied "strong Black women," but independent, sexually confident, and vocal in attempting to untether themselves from the deep cultural obligations and contemporary social mores of religion, graft, patronage, and respectabil- ity that are part of the social terrain of urban Accra.[28] The dialog renders an undeniably African transnational life, with complaints about genera- tors, importing cars (and vibrators), relations with the "house help" (read, servants), trips to sparkling new malls, the shabbiness of the international airport, traffic on one of the many dusty roundabouts, finding a job, going on dates just to get an apartment, abstinence versus indulgence, sex with- out condoms, and boyfriends with questionable hygiene.

The setting of the series is significant in that Accra is not simply the capital of Ghana, but one of the first such Pan-African hubs for entertain- ment, labor, and most importantly, political ferment. In the years immedi-

ately following independence in 1957, the country's first president, Kwame Nkrumah, hosted African, Caribbean, and Black American political luminaries such as George Padmore, Malcolm X, and Richard Wright. W. E. B. Du Bois was buried there in 1963. His wife, Shirley Graham Du Bois, would help establish the nation's first public broadcasting service.[29]

An African City is framed as an antidote to the typical images of children with distended bellies, violence over coltan and oil, and perennial corruption. Instead, Nana Yaa and her cadre of Afropolitan professionals are adorned in boutique trends from diaspora and homeland designers. In Accra, they share laughs and cocktails and spend lazy afternoons in the over-white gleam of a striving urbanite's marble-tiled condominium. A document in contemporary African visual splendor, *An African City* shows the protagonists on dates at miniature golf courses and at all-girl pool sessions at exclusive hotels. Describing the show in an interview, its director, Nicole Amarteifio, specifically identified a gendered intervention in the enterprise: "This could be a moment to change the narrative of the African woman. The African woman does not always have to be the face of an antipoverty campaign. Rather, she can be the face of everything beautiful, trendy and modern."[30]

The style of the show attempts to powerfully encode a new visual realism in African cinema. Ghana and Nigeria's local film industries, called "Ghallywood" and "Nollywood," respectively, are typically strong on story nuance, interpersonal drama, and cultural reference. With key exceptions such as Leila Afua Djansi's *Sinking Sands*, these films suffer in cinematography and other aspects of production, in part due to their quick turn-around times.[31] While not always precise, *An African City*'s videography is consistently produced with warm, golden lighting, rendering the subjects in great detail and building emotional richness with close-up shots. This is a vital innovation in the cinema-photographic canon, given the film industry's long history of configuring dark skin as a problem. Richard Dyer's historical work on photography and racism, most notably "Lighting for Whiteness" (1997), describes an ideologically driven technological quest on the part of film developers and mass-market firms such as Kodak to prioritize the perfection and reproduction of Whiteness, often making White skin appear to be lighter than the actual White models. Instruction manuals and training techniques expressly described ways to calibrate film and cameras using such terms as "normal," "preferred," and "pleasing" in the discussion of White flesh.[32] *An African City*'s visual fidelity is in part due to what seems the extensive use of high-definition cameras, technology which has become more ubiquitous and affordable, as well

as a budding film aesthetic pursued by filmmakers such as Biyi Bandele (director of the film version of *Half of a Yellow Sun*) and Andrew Dosunmu (*Mother of George*).

The body, as a narrative tool, figures in other ways as well, in makeup and fashion for instance. While the materialist dimensions of the fashion industry chiefly consists of styling around makeup, jewelry, and fabrics, the central tool in the fashion designers' kit is the model herself—here, the bodies of the actresses serve as a canvas for the art. Amarteifio takes care across all ten episodes to portray Nana Yaa as an ordinary and yet naturally beautiful subject, filming her in mundane shots walking across broken pavement, stopping to adjust, then abandoning high-heeled shoes stuck in a rut. Group mid-shots capture her young crew from head-to-toe in crisp, iridescent dresses and sculpted hair. They sparkle in the warm light of an exclusive restaurant. Even the less-glamourized scenes, for instance shots of the protagonist's sweat-patched armpits as she navigates local bureaucracy, attempt to humanize Nana Yaa without making her base or transgressive.

Amarteifio's vision then is in many ways the outcome of an Afropolitan gaze, producing iconography and cinematic signs that read beauty, humanism, and glamour onto subjects typically rendered as diseased, abject, and dangerous, especially in comparison to what the anticolonial philosopher and activist Frantz Fanon would describe as the "epidermis" of Western civilization.[33] This Afropolitan gaze is hardly an even-handed practice, however. In *An African City,* a chief source of comic relief is the dullness of the homeland population. In one episode, a gateman's stunted English and out-classed desire for one of the young women is the butt of a joke. Slimy real estate agents and government officials are poorly lit. Their parochial fashion sense and lack of charm is the basis of revulsion, and cinematic flatness. A scruffy-faced postman is duped into believing a dildo is a backscratcher. While there are other more equal encounters, the inequities between the educated, cultured traveler and the "locals" of the homeland are on main display: the stars of the show receive the best visual treatment, pathos, and sympathy, while everyday Ghanaians are portrayed less than favorably at times, and certainly less glamorously. In the "Facebook" episode discussed earlier, the camera shoots back and forth between energetic close-ups of the returnees engaged in debate. The camera eventually pans out to a mid-shot to reveal a dour waitress, restlessly standing next to the table awaiting orders. Her russet brown flesh is without makeup, and she remains unremarkable during her brief moment on screen.

Comedy as a source of identity politics is perhaps one of the most engaging and also particularistic forms of discourse within any shared media public. Humor requires a shared set of codes, understood at a vernacular level. This ability to read linguistic and gestural cues quickly, practices that lie at the heart of cultural boundary-marking, delineates insiders and outsiders. But embodied techniques can also disrupt familiarity around humor. Slapstick, for instance, deploys the body as an epistemic tool, a kind of special effect that in cinema often marks a significant interruption of the spoken and written narrative with kinetic gesture or liveness.[34] The confluence of the two is part of what makes the other web series I will discuss, *Azonto in Real Life*, a very different narrative project, and very compelling for questions of diasporic identity construction on matters of the Black body.

The series, filmed in New Jersey by Ghanaian director Alexi Ju Nior, consists of two- to fifteen-minute episodes, primarily distributed on YouTube and the Vine video app. The video shorts pair jokes, dancing, and the dating drama of young Africans using dramatic musical vignettes. The series' first episode—filmed and uploaded to YouTube in October 2012—was shot via an iPhone in a Target parking lot with ubiquitous Garden State license plates, unsettling the otherwise Western-embeddedness of the scenes.[35] *Azonto in Real Life*'s actors are typically comedians, and not the acting school and art school grads who make up the cast of *An African City.* As such, the costume, sets, and attention to detail betray amateurishness. Black-and-white cut scenes, stutter-frame sequences, and inconsistent subtitling demonstrate a reliance on the stock visual effects of home video editing software, and less formal cinema training. In later episodes, footage is shot in HD, and this effectively elevates the project's quality: The especially dark skin of the two main protagonists (Uncle Boga and Apush) are lit with proper calibrations for their tone in these episodes. *Azonto in Real Life* shares with *An African City* a realist, filmic portrayal of African bodies, with close-ups and tight head-shots. Fashion also plays a central role in this series, albeit the fashion of the young, urban male. Here, boutique East Coast sportswear signifies hip-hop and street-culture masculinity, as opposed to high-fashion dandyism. Ultimately, comedy and dancing drive the visuals in this production, given the nature of the shorts and their obviously smaller filming budgets.[36]

Azonto is the term for a style of Ghanaian pop dance, akin to American hip-hop "battle dance" styles, in which the dancers pantomime humorous body movements for dramatic effect. Along with hiplife, and the Nigerian genre Afropop, azonto represents a distinctly West African form of global

electronic dance music trends that incorporate, hybridize, and speak to the *glocal* in club culture.[37] As Ghanaian pop music researcher Jesse Weaver Shipley describes, "azonto, in content and form, is the embodiment of circulation, though the meanings attributed to its mobility vary. Azonto is identified with Ghanaian indigeneity by those abroad and with cosmopolitanism by those at home."[38]

On the surface, the interestingly named series *Azonto in Real Life* presents itself as a vehicle for humor, music, and entertainment for both diaspora and homeland publics. The particularity of *Azonto in Real Life* as a diasporic media production is that it is shot entirely in Twi with some Ghanaian English, pidgin, and slang. The sketches and music are multimodal, as the songs originate from Ghana or Nigeria, are in multiple languages (mostly Twi, with some Ga, Yoruba, and Hausa), and slip between dialects of English, pidgin, and street slang. In doing so, the embodied performances reproduce a diverse set of cultural codes that co-construct a digital and transnational audience, even if it is largely accessible from diaspora. To know, chant, and dance azonto songs, ostensibly first circulated in the explicitly national market of Ghana, presents a series of gestures of epistemic unity with the homeland by diasporans. *Azonto in Real Life* elides the distinction between at-home and abroad in interesting ways. Unlike in *An African City,* in which the Accra landscape occupies a major dialogic and visual anchor, in most *Azonto in Real Life* videos there is a striking lack of recognition that the action is taking place in diaspora. Scenes are set rather unself-consciously in the New York Tri-State area, including shots on parking garage roofs with skyscrapers in the background, the Jersey boardwalk, and what is obviously, due to street signage and traffic, downtown Manhattan—again with little spoken reference to place. Save for intermittent subtitles, there is no attempt to signal the foreignness of the physical set for the actors, nor the actors' own alienation as foreigners. In many ways, the absence of these signals may mark the unity with which Ju Nior and his actors perceive their social positioning as Ghanaian cultural producers.

In later episodes of *Azonto in Real Life*, Ghallywood film star Kojo "Lil Win" Nkansah makes several cameos. Nkansah, a popular dancer and comedian, performs entirely in Twi and pidgin in Ghana, and is often seen in widely released hiplife and azonto videos, as well as in his own films. His appearances on *Azonto in Real Life* ultimately resulted in a full-feature collaboration with Ju Nior, *Lil Win in America* (2014), a film which satirizes the comedian's own background. He plays a street-performer/rube who is attempting to find fame by connecting with his namesake, the American

rapper Lil Wayne. With the series' name, the enduring controversy between what is "virtual" and what is "actual" or "real" takes on special significance. Internet denizens in the early era of virtual communities often spoke of what life was like online versus experiences in "IRL" (in real life). Scholarly debate continues over what in the digital world is real versus what is virtual, life online versus life on land, the physical versus the digital; all these trouble the categories, making the boundaries within the growth of new media increasingly uncertain.[39] In the case of azonto or hiplife, music is ephemeral; digital music is intangible and its corporate organization is deterritorialized. The comedy of *Azonto in Real Life* emerges from the idea that impromptu azonto dancing is not something that is just inserted into everyday "real life." Thus, the spoof videos are themselves rematerialized fantasies of a fandom, that is in essence a fully mediated culture. The reference to physical African bodies, however, remains crucial to the production of azonto for those living abroad.

Affective Exchange and the Reflexivity of Video Cyberculture

New media as a conceptual category includes not simply digital techniques of connection and networking, but also the affordances of manipulability, customization, and localization primarily from the viewpoint of the consumer, now writ as producer-consumers or *prosumer*.[40] Beyond the representative ability of *Azonto in Real Life* and *An African City* to render the variable and contemporary bodies and lives of African agents in modernity, I believe the interactive nature of these projects bears further exploration.

Azonto in Real Life's chief gags are participatory dance reenactments of popular music tracks inserted as cut scenes during the action of their comedy shorts. These reenacted dances are often emblematic of both the song being played and the song's official artist-released accompanying dance, a key convention of African pop music. In keeping with the conventions of a YouTube or online video "short," the action is choppy, and music segments repeat footage to emphasize a lyric or embodied translation of a song, similar to the ways a stuttering phrase is repeated in hip-hop music. For example, when one of the main actors in a skit steals a computer and is beaten up in the process, he points to his bloody head, singing "Eshi Shi, Ewo Wo," a song by rapper Criss Waddle, which translates from Ashanti/ Twi to mean roughly, "you'll get poked, you'll get burned."[41] His friend replies that he would have never let anyone attack him in such a way, and

begins to pantomime singing "Over" by Bisa Kdei, a boastful song about emcee skills, which takes over the audio soundtrack. The actors mimic the dance moves from Bisa Kdei's official video, in a seven-second dance cut that includes them flexing their arms, as the song chants "*flex,*" meaning, in Ghanaian slang, to boast and be confrontational.

But far and away Ju Nior's most popular videos (with five hundred thousand to one million and more views on YouTube) are not the comedic shorts *Azonto in Real Life,* but a series of videos in which U.S.-based West African dancers perform to Afropop tracks, reenacting the club moves and video-choreography of the song's official artist-released videos. As the troops of dancers in New Jersey imitate and perform new azonto dances in response to the official music videos, the circuit of global dance is activated, and thus embodied forms of cultural citizenship become synchronous via the Internet's capabilities for real-time response. Diasporic consciousness and the national imaginary are coproduced through practices of embodied knowledge, which while not a new phenomena of African diasporic life, are novel as this is mediated by the Internet with responses that transverse time, distance, and linearity.[42]

These videos are emerging forms of cyberculture which use the body to produce what I term *affective exchange*—the transfer of physicality and emotional sentiments through, in this case, digital media forms. Video cyberculture (including video blogs and video chats) has the potential to have more impact than other forms of online representative prosumer discourse (blogs, email, podcasts, etc.) precisely because of its visual, aural, and interactive nature. Video cyberculture, especially via videos produced by niche artists, disrupts passive cinematic consumption with what *An African City*'s director has described in interviews as "realistic" images and life-worlds. But this is accomplished not simply with strong imagery and "authentic" personal narratives, but also through the televisual performance of African bodies and the interpersonal dialogue with producers and consumers, which include forms of embodied participation, particularly via nonverbal gestures and dance.

I use *affect* here to describe more than emotion or the quality of being emotive—rather, it indicates the lingering impact of external stimuli that attempt to appeal to an emotion and the senses. In a similar exploration of the digitally mediated sensorium, video gaming theorists Ian Graham, Ronald Shaw, and Barney Warf define affect as "the precognitive, unconscious, and embodied reactions to on-screen representations."[43] Balance takes up this notion further to describe how Asian diasporans in the United States transform experiences of racism into music and comedy,

calling this "affective labor."[44] These approaches to affect draw on social theorist Brian Massumi's notion of affects as "virtual synesthetic perspectives anchored in (functionally limited by) the actually existing, particular things that embody them."[45] These ideas, including my own, reflect a bias towards the notion of the body as the chief medium against which all other representational techniques are gauged: gesture, tangibility and the physical are in their rawest forms *mediums* which signify the highest measures of *fidelity*—the accuracy and quality of a message as its transits from its sender to its receiver. This is attested to in the many ways that the audience for these shorts, the participant-viewers, respond to the projects. Message board comments and YouTube comments laud the directors for "Finally, [producing] a Web series I can totally relate to," with statements such as "It's so nice to watch women who are like ME and my friends, thinking the same things I thought when I was there, and wearing African-print styles like we do [sic]." These responses include hundreds of both celebratory and critical posts: "As a Cameroonian girl living in Amsterdam I am LOVING this!!!!"; "I can live vicariously through these characters. I've always wanted to try out living somewhere in Africa"; "I experienced this when I returned home and I know lots of people who go through the same things."[46] Just as popular, are comments reproaching *An African City* for its gestures of sexual liberalism. One popularly upvoted comment led with "For a show that depicts successful, educated black women, the emphasis on sexual relations (with numerous men) leaves a lot to be desired."[47] These message-board-style posts, in terms of content, are not much different than what one might expect in typical reactions to any form of media. However, given their ability to live online indefinitely, they arguably maintain a discursive resonance that outlives ephemeral, nonwritten forms of discourse. Online, the comments themselves serve as points of reference that one can return to: they can be nodes in a network, or locations from which many points of discourse can depart, separate from the video that seemingly anchors the discussion.

The most evocative of embodied responses sparked by the exchange between the digital series' producers and the participant-viewers comes in the form of video blogging by fans providing their thoughts and reviews on the show. In one particularly poignant clip, Caroline, a Ghanaian living abroad who blogs videos about everyday fashion and natural hairstyling, delivers a post affirming Amarteifio's portrayal of diasporans and the resonance it has with her own desires for connection with her home. In her video-recorded post, the Londoner states: "I was really excited at the prospect of seeing African women on screen who were like me.

Because I've also thought about returning to Ghana, and that's something I would like to make happen sometime in the very near future. . . . As I was watching this series, I was thinking, 'Wow these girls have really taken advantage of the opportunity to create their own narrative about Africa and about Ghana in particular and to show a different side of Africa from the starving, wars and corrupt officials.'"[48] Filming from within her car, this video rendered through YouTube reinforces a reflexive and performative relationship with the original video texts, which are intended to be products of a lived reality. I argue that such network-based affective events reproduce physical affect via performances and participation that combine the narrative fidelity of West African experiences "in real life" and the cinematic reference to this same culture. The media suggests embodiment and demands participation in the form of physical reproduction, via reblogging in the case of *An African City* and reenactment in the case of azonto dance videos. Thus the experience within the diaspora space is deterritorialized both technologically and physically, but also reterritorialized in the same ways through this mediation of affect.[49]

Shorts like *An African City* and *Azonto in Real Life* project a realism for the signified which "stands for" and "stands in place of" live bodies. But it is the interactive affect exchange, via conversation, commenting, video responses, blogging, and especially dance reenactments of music videos, that marries what in literary studies is called "narrative transport" to dialogic and socially mediated forms of sensory immersion. Hence, among these Afropolitan producers, there is rarely simply the desire for consumption in the making of Internet videos—rather there is an attempt to elicit an exchange between the producer and the participant-viewer. It is ultimately in the confluence of music, dance, and narrative that these shorts produce their most engaging embodied experiences for participants, especially azonto music reenactors. Azonto videos, their mimicked home-videos, and their parodied viral responses in this sense are pedagogical for their participants, enculturating the audiences in the how-tos of embodying Ghanaian and West African contemporary culture.

In both transnational filmic gestures, one might argue, it is diasporic bodies, as opposed to homeland bodies, that are privileged: their physical proximity in the West not only foregrounds a narrative of distance and longing, but enables the concentration of capital, and access to technology, including robust Internet bandwidth. Yet, the occupation of Western space seems to work out for both publics: Afropolitans in Accra have their own version of *Sex in the City* that humanizes a formerly invisible public and maligned homeland; both Ju Nior and his actors are now seen as

emerging entertainers among Ghanaians worldwide, while Kojo Nkansah is broadening his appeal outside Ghana. Yet this robust online product and its distribution, though only indicative of a nascent Ghanaian cyber-culture, serve as an identity project allowing Africans to seize a moment of openness in the newly configured "network society," in which the social ills of body elitism and race are said not to exist because of the virtuality of digital life.[50] The reflexivity between homeland and diasporic bodies and their mediation, however, energizes a broader imaginary for Ghana and Africa writ-large, ultimately enabling social and physical connections that are tangible and real.

Notes

1 These are quasi-fictional reports, based upon real news stories such as the cover story, "Africa Rising," *The Economist,* December 3, 2011. The quote is taken from "He Facebooked Me," *An African City*, dir. N. Amarteifio, April 6, 2014, www.youtube.com/watch?v=3yKSTT-VhVM.

2 Akilah Walker, "Interview: 'An African City' Star Maame Yaa Boafo," *Okayafrica*, May 9, 2014, www.okayafrica.com/film/an-african-city-maameyaa-boafo-interview.

3 Taiye Selasi, "Bye-Bye Babar," *The LIP*, March 3, 2005, http://thelip.robertsharp.co.uk/?p=76; Achille Mbembe, "Afropolitanism," in *Africa Remix: Contemporary Art of a Continent*, eds. Njami Simon and Lucy Durán (Johannesburg: Jacana Media, 2007); *Afropolitan* as a term has also been embraced by transnational Ghanaian artists such as Blitz the Ambassador and Derrick N. Ashong, whom the author has interviewed about this subject; Derrick Ashong in discussion with the author via phone, April 23, 2013.

4 See discussion and references in Emma Dabiri, "Why I'm Not An Afropolitan," *Africa Is a Country* [blog], January 21, 2014, accessed May 1, 2014, http://africasacountry.com/2014/01/why-im-not-an-afropolitan.

5 "An African City," dir. N. Amarteifio, n.d., https://www.youtube.com/user/AnAfricanCity/about.

6 Ebere Onwudiwe and Minabere Ibelema, *Afro-Optimism: Perspectives on Africa's Advances* (Westport, CT: Praeger, 2003).

7 World Bank, *Ghana: World Development Indicators: 2014* (Washington, D.C.: World Bank Publishers, 2014); United States Department of State, Bureau of African Affairs, "U.S. Relations with Ghana," www.state.gov/r/pa/ei/bgn/2860.htm#history, accessed June 23, 2016; "Africa Rising," *The Economist*.

8 World Bank, *Ghana*.

9 Groupe Spéciale Mobile Association, *Sub-Saharan Africa Mobile Economy 2013* (n.p.: Groupe Spéciale Mobile, 2014); Madanmohan Rao, *Mobile Africa Report 2011: Regional Hubs of Excellence*, www.mobilemonday.net/reports/MobileAfrica_2011.pdf.

10 Erik Hersman, "Mobilizing Tech Entrepreneurs in Africa (Innovations Case Narrative: iHub)," *Innovations: Technology, Governance, Globalization* 7, no. 4 (October 1, 2012): 59–67, DOI:10.1162/INOV_a_00152.

11 Bruce Gilley, "The End of the African Renaissance," *The Washington Quarterly*, October 2010, DOI: 10.1080/0163660X.2010.516612; Jostein Hauge, "Africa's Economic 'Rise' Does Not Reflect Reality," *Guardian*, September 3, 2014, www.theguardian.com/global-development/poverty-matters/2014/sep/03/africa-economic-rise-does-not-reflect-reality.

12 Arjun Appadurai, *Modernity at Large: Cultural Dimensions of Globalization* (Minneapolis: University of Minnesota Press, 1996), 35.

13 Okoth Fred Mudhai, Wisdom Tettey, and Fackson Banda, *African Media and the Digital Public Sphere* (New York: Palgrave Macmillan, 2009).

14 Selasi, "Bye-Bye Babar."

15 Sean Jacobs, "Shifting African Digital Landscapes," London School of Economics Africa Talks public lecture, March 17, 2015, www.lse.ac.uk/publicEvents/events/2015/03/20150317t1830vNT.aspx.

16 Roberto Bezzicheri, CEO of GhanaWeb, personal interview, October 2013.

17 bell hooks, *Black Looks: Race and Representation* (Boston: South End Press, 1992).

18 Brian Larkin, *Signal and Noise: Media, Infrastructure, and Urban Culture in Nigeria* (Durham, NC: Duke University Press, 2008).

19 Dalberg Research, *Impact of the Internet in Africa*, 2013, accessed April 17, 2013, available at www.dalberg.com/insights/impact-internet-africa/; International Telecommunications Union (ITU), *Measuring the Information Society* (Geneva: International Telecommunications Union, 2014), www.itu.int/en/ITU-D/Statistics/Documents/publications/mis2014/MIS2014_without_Annex_4.pdf.

20 ITU, *Measuring the Information Society*, 2014.

21 Official numbers regarding Africa's mobile phone penetration are often troubled due to local practices such as the use of multiple subscriptions by one user. The Ghanaian regulatory agency, NCA, often halves its projections of mobile ownership to 50 percent penetration among adults.

22 ITU, *Measuring the Information Society*, 2014.

23 Brent Hayes Edwards, *The Practice of Diaspora: Literature, Translation, and the Rise of Black Internationalism* (Cambridge, MA: Harvard University Press, 2003).

24 Barney Warf, *Global Geographies of the Internet* (Dordrecht: Springer, 2013), http://dx.doi.org/10.1007/978-94-007-1245-4; ITU, *Measuring the Information Society*.

25 Jennifer M. Brinkerhoff, *Digital Diasporas: Identity and Transnational Engagement* (Cambridge: Cambridge University Press, 2009); Anna Everett, *Digital Diaspora: A Race for Cyberspace* (Albany, NY: SUNY Press, 2009).

26 Other popular African transnational videos that have gained notoriety at this time include the "African Dad" series on Vine, https://vine.co/u/1033613008334917632. Also see Houston rap-parody group the Naija Boyz, who are discussed in Krystal Strong and Shaun Ossei-Owusu, "Naija Boy Remix: Afroexploitation and the New Media Creative Economies of Cosmopolitan African Youth," *Journal of African Cultural Studies,* 26, no. 2 (2014): 189–205.

27 Benedict Anderson, *Imagined Communities: Reflections on the Origin and Spread of Nationalism* (London: Verso, 1991).

28 The characters' personalities are explored in multiple dimensions throughout

the show, including via the long-troubled trope of "strong black women." See Michele Wallace, *Black Macho and the Myth of the Superwoman* (New York: Dial Press, 1979). Selasi, "Bye-Bye Barbar"; Ato Quayson, *Oxford Street, Accra: City Life and the Itineraries of Transnationalism* (Durham, NC: Duke University Press, 2014).

29 Kevin Gaines, *American Africans in Ghana: Black Expatriates and the Civil Rights Era* (Chapel Hill: University of North Carolina Press, 2006).

30 Yolanda Sangweni, "Ghanaian Writer Nicole Amarteifio on Creating the Hit Web Series, 'An African City,'" *AfriPOP!*, April 27, 2014, available at https://web.archive.org/web/20140414232158/http://afripopmag.com/2014/04/ghanaian-writer-nicole-amarteifio-on-creating-the-hit-web-series-an-african-city/, accessed June 23, 2016; Takyiwaa Manuh, ed., *At Home in the World?: International Migration and Development in Contemporary Ghana and West Africa* (Accra: Sub-Saharan Publishers, 2005); the title of this essay was inspired by this volume.

31 Babson Ajibade and Ben Williams, "Producing Cheaply, Selling Quickly: The Un-Hollywood Production Paradigm of Nollywood Video Films," *International Journal of Humanities and Social Science* 2, no. 5 (2012): 203–9; Sylvester Ogbechie, "Enhancing Film and Production Design: Looking at the Big Picture," panel presentation, Nollywood Foundation Convention, Los Angeles, June 20, 2008.

32 Richard Dyer, *White* (London: Routledge, 1997); see also chapter 6 in this volume, Lyneise Williams, "The Glamorous One-Two Punch," and chapter 17, Krista Thompson, "The Black Body as Photographic Image."

33 Frantz Fanon, *Black Skin, White Masks* (1952; repr. New York: Grove Press, 2008).

34 Henry Jenkins, *What Made Pistachio Nuts? Early Sound Comedy and the Vaudeville Aesthetic* (New York: Columbia University Press, 1992); Tom Paulus and Rob King, *Slapstick Comedy* (New York: Routledge, 2010).

35 Alexi Ju Nior, "Azonto in Real Life," January 16, 2012, www.youtube.com/watch?v=tNfzN8Ly21c, accessed June 23, 2016.

36 The last official short of *Azonto in Real Life* was recorded in 2014 and included English-language translations and song subtitles with links to artist information—perhaps in a nod to a wider English-only speaking audience. This episode, the most-watched in the series with 618,147 views as of June 2016, included subtitles, HD camera work, and five actors, and was shot in Jersey City.

37 Halifu Osumare, *The Africanist Aesthetic in Global Hip-Hop: Power Moves* (New York: Palgrave Macmillan, 2007).

38 Jesse Weaver Shipley, "Transnational Circulation and Digital Fatigue in Ghana's Azonto Dance Craze," *American Ethnologist* 40, no. 2 (2013): 363.

39 Howard Rheingold, *The Virtual Community: Homesteading on the Electronic Frontier* (Reading, MA: Addison-Wesley, 1993); Sherry Turkle, *Life on the Screen: Identity in the Age of the Internet* (New York: Simon and Schuster, 1995); Tom Boellstorff, *Coming of Age in Second Life: An Anthropologist Explores the Virtually Human* (Princeton, NJ: Princeton University Press, 2008).

40 Henry Jenkins, *Convergence Culture: Where Old and New Media Collide* (New York: New York University Press, 2006).

41 Many thanks to DJ Ras Nii Ardayfio for assistance with translation of hiplife and azonto songs.

42 For more on embodied knowledge practices, see Osumare, *The Africanist Aesthetic*; Yvonne Daniel, *Dancing Wisdom: Embodied Knowledge in Haitian Vodou, Cuban Yoruba, and Bahian Candomblé* (Urbana: University of Illinois Press, 2005); Christey Carwile, "From Salsa to Salzonto: Rhythmic Identities and Inventive Dance Traditions in Ghana," in *The Oxford Handbook of Dance and Ethnicity*, eds. Anthony Shay and Barbara Sellers-Young (New York: Oxford University Press, 2014), DOI: 10.1093/oxfordhb/9780199754281.013.026. For more on Internet-mediated diasporic practices, see chapter 17 in this volume.

43 Ian Graham, Ronald Shaw, and Barney Warf, "Worlds of Affect: Virtual Geographies of Video Games," *Environment and Planning A* 41, no. 6 (2009): 1332–43, DOI: 10.1068/a41284.

44 Christine Bacareza Balance, "How It Feels to Be Viral Me: Affective Labor and Asian American YouTube Performance," *Women's Studies Quarterly* 40, no. 1 (2012): 138–52.

45 Brian Massumi, *Parables for the Virtual: Movement, Affect, Sensation* (Durham, NC: Duke University Press, 2002).

46 "The Return," Episode 1, *An African City,* dir. Nicole Amarteifio, March 2, 2014, www.youtube.com/watch?v=kg7hUuWKe2U, accessed April 20, 2014.

47 "A Big Decision," Episode 10 (Season Finale), *An African City*, dir. Nicole Amarteifio, April 27, 2014, www.youtube.com/watch?v=MGq3UZksx3s, accessed April 30, 2014.

48 Carolineonline, "Review of the Webseries *An African City*," May 4, 2014, www.youtube.com/watch?v=e4HkI2xowLY, accessed May 10, 2015.

49 For these perspectives on deterritorialization, see Jonathan Xavier Inda and Renato Rosaldo, *The Anthropology of Globalization: A Reader* (Malden, MA: Blackwell Publishers, 2002); Gilles Deleuze and Félix Guattari, *Anti-Oedipus: Capitalism and Schizophrenia* (Minneapolis: University of Minnesota Press, 1983); García Canclini, *Hybrid Cultures: Strategies for Entering and Leaving Modernity* (Minneapolis: University of Minnesota Press, 1989).

50 Alexander R. Galloway, "Networks," in *Critical Terms for Media Studies*. eds. W. J. T. Mitchell and Mark B. N. Hansen (Chicago: University of Chicago Press, 2010), 280.

Part 4

Afrofabulation

16

Habeas Ficta

Fictive Ethnicity,
Affecting Representations,
and Slaves on Screen

TAVIA NYONG'O

Can slavery be represented on screen? The question may sound rhetorical. Ever since D. W. Griffith's *Birth of a Nation* revolutionized the medium in 1915, slavery—and the repression of the afterlife of slavery—has been constitutive of cinematic representation. Indeed, one way to chart the history of Hollywood melodrama has been through its ever-shifting strategies for holding a distorting mirror to the spectacle of slavery and the lived experience of the slave. Linda Williams, for example, has carefully reconstructed the historical interplay between sentimental and melodramatic spectacles of black suffering in U.S. cinema.[1] Without attempting to review the history of slave representation on screen comprehensively, this chapter does propose to describe four strategies that have crystalized recently: the *sentimental*, the *antisentimental*, the *pornotropic*, and the *counter-pornotropic*.[2] Through this admittedly schematic rendering of the affective genres through which the slave is brought to impossible presence on screen, I aim to forward a second claim: I argue that the emergence of ethnic and national difference within screen representations of chattel slavery is not a recent phenomena, but a problem built into the im/possibility of representing the slave as such.

In what way can slave representation be said to be im/possible, that is to say, both possible and impossible, without recourse to any "final analysis" that decides between the two? Film and performance theorist Frank Wilderson has influentially argued that the slave represents a constitutive *antagonism* in the U.S. social order, an antagonism that is hidden by the social *conflicts* that racial melodrama wrestle with and seek to narratively

resolve.³ Drawing on traditions of political theory that construe the social as riven by antagonisms (and the quixotic attempt to suture them), Wilderson has innovated a distinctive brand of criticism that assigns to the slave a position of structural lack, a "nothingness" from which no affirmative or resistant representation can emerge. If such a critique stops short of prohibiting cinematic depictions of slavery as such, it does at least point to the need to reformulate the question with which I opened: can *slaves* be represented on screen? Or is cinema always already an apparatus for slave capture?

What does it mean to approach cinema as an apparatus of capture? My own response to the scenario of structural antagonism and ontological capture Wilderson presents is guided by Fred Moten's provocative work on blackness, criminality, and cinema. In particular, in this chapter, I follow Moten's argument that the blackness *interpolated* in between cinema's vaunted "twenty-four frames a second" can be read contrapuntally against the blackness *interpellated* within the narrative the cinema sets in motion. Of cinema, Moten notes: "Motion within the frame is stilled so that motion between frames can be activated. Here's where fidelity and capture converge. Seriality makes a motion out of stillness, a one out of a many: so that the essence of cinema is a field wherein the most fundamental questions are enacted formally and at the level of film's submission to the structure of narrative. At the same time, *blackness—in its relation to a certain fundamental criminality that accompanies being-sent—is the background against which these issues emerge.*"⁴

In the above passage, Moten reads the cinematic apparatus as containing a break between the visible and invisible; one that animates and is animated by blackness. The structural antagonism that *forecloses* blackness from affirmative representation thus *depends* upon blackness to produce its affecting images. In this chapter, I employ the shorthand *in/visibility* to refer to this interplay of blacknesses, which provides a context for thinking through the im/possibility of slave representation. Absence and presence, lack and excess, blackness and nothingness: these terms all find new significance in the theory of screen memory that Moten's account of black fugitivity ushers in. I take this distinction between formal questions of narrative or generic strategy, on the one hand, and the ontology of screen capture, on the other, as axiomatic for any subsequent detailing of genres that, in their disjunctive synthesis, risk contravening the assertion of a general antagonism underlying representation (not just filmic representation, but politico-aesthetic representation as such within societies structured in racial dominance).

Can the varieties of slave experience on screen be approached with the tools of critical ethnic studies and affect theory, as well as black studies? This question returns us to classic accounts by Frantz Fanon, Hortense Spillers, Stuart Hall, and Étienne Balibar, by way of more recent formulations by Kara Keeling and Alexander Weheliye.[5] My aim in retrieving the concepts of "new ethnicity" and "fictive ethnicity" from those earlier debates is to redirect a nascent polemic—waged in particular over Steve McQueen's *Twelve Years a Slave,* but also, more generally, the casting of non-U.S. black actors in African American roles—over who has the "right" to represent U.S. slavery and its afterlives cinematically.[6] While I cannot address this polemic in any substantial way, I point to a necessary prolegomena to any such discussion: How do black ethnicity and nationality figure in relationship to slave affectivity on screen? Is ethnicity accurately understood as that which the U.S. slave is natally alienated from, and must reclaim via a diasporic trajectory? Or has a certain troping of black ethnicity always been constitutive to how blackness emerges into in/visibility on screen? As contemporary cinema continues to "migrate the black body" across its planet-dominating apparatus, at speeds that sometimes cause national distinctions to blur; as black writers, actors, directors, and producers increasingly tackle stories of slavery shipped from and to various parts of the globe at disparate points in history; as all this continues to happen I believe we now need to attune ourselves to a blackness that is *internally differentiated and differentiating*, agonistic and aleatory as well as antagonistic and structured in lack. Beyond the choice between an optimistic or pessimistic orientation towards the truth of our case, can we better comprehend the dark and divergent powers of the false?

It could be argued that the in/visibility of black affectivity is precisely what cinema, as an apparatus of slave capture, sets out to repress. Frantz Fanon's account of the "racial epidermal schema" might corroborate this account of cinematic indifference to black diversity. But to leave matters there would be to rest superficially at the visible skin of blackness.[7] The work of Leigh Raiford and Maurice Wallace has, on the contrary, shown how formalist readings of the technical limitations of photographs miss their power to performatively intervene within crucial episodes of black struggle.[8] Their work leads me to agree with visual theorist David Marriott when he concludes, in the midst of a recent reconsideration of Fanon's account of the colonial gaze, that "we can no longer consider black film as merely contingent to the problem of time or the Other's gaze."[9] Marriott draws our attention to how Fanon's black filmgoer, in moving from colony

to metropole, experiences a shift in "racial historical schema" (Fanon's term for how histories of slavery and colonialism congeal in black affectivity) and is disoriented by the sudden foreclosure of the prior possibility of identifying with the white hero.[10]

"In the Antilles," Fanon writes, "the young black man identifies himself de facto with Tarzan versus the Blacks"; it is only upon re-viewing the film in Paris, among whites, that the migrant sees himself on screen *as black*, as if for the first time.[11] Marriott makes the case here for what we might call, after Jean Copjec, the "di-phasic onset of time" in black spectatorship.[12] The African blacks (white actors in blackface in the 1932 *Tarzan*) that the young Antillean sees on screen are in/visible at home: the shock of their presence comes when that first impression is overlaid and retrospectively crystallized by an experience of metropolitan racism. The twin movements of diasporic migration and the cinematographic animation of the black body on screen are herein articulated.

Tarzan belongs to a historical moment before the varieties of slave affect we are now interested in here were projected in cinema. Then, the "Negro" was little more than a natural slave, whether in the United States or Africa, whether under colonial rule or Jim Crow. Marriott, therefore, rightly makes Fanon's account of *Tarzan* key to what he terms "a racism tied to an experience of rupture and crisis and corresponding with the breakdown in the narratives of colonialism, and the emergence of neo-liberalism, in modern cinema."[13] This is also therefore the period in which we can undertake a consideration of the "new ethnicities" that emerge in the wake of the scientific-racist image of the Negro.[14] What happens in Fanon's account when diasporic blacks encounter themselves, in the screen travesty of the tribal African, as a certain kind of ethnic "as if for the first time"? Can the diphasic onset of such ersatz recognition proceed otherwise than through political closure and ontological lack? Or can we think about other varieties of slave affectivity, legends and myths that may travesty historical truth but, in so doing, open out the virtual past for another mode of becoming?

Habeas Ficta: Rethinking Fictive Ethnicity

Is ethnicity, however, the right keyword for such a thought? The concept has enjoyed a recent revival under the rubric of *critical ethnic studies*. This revival has, unfortunately, led to the pitting of "ethnicity" against "race" within contemporary academic interdisciplinary knowledge for-

mations. Skeptical as I am that a full or final vocabulary adequate to the critique of our present can be found, I will sidestep this particular dispute and deploy both as incommensurate terms. In this regard, it may be useful to return to Stuart Hall's influential essay, "New Ethnicities," for a reminder of how ethnicity has in the past forwarded a "politics of criticism in black culture."[15] While the concept of ethnicity proposed in Hall's 1989 essay may no longer be tenable, the "end of the essential black subject" that his essay announced did presciently usher in the study of aesthetics as a site of black agonism:[16]

> Once you enter the politics of the end of the essential black subject you are plunged headlong into *the maelstrom of a continuously contingent, unguaranteed, political argument and debate*: a critical politics, a politics of criticism. You can no longer conduct black politics through the strategy of a simple set of reversals, putting in the place of the bad old essential white subject, the new essentially good black subject. Now, that formulation may seem *to threaten the collapse of an entire political world*. Alternatively, it may be greeted with extraordinary relief at the passing away of what at one time seemed to be a necessary fiction.[17]

Although neither ethnicity nor aesthetics are directly mentioned in this passage, the fundamentally *agonistic* conception of politics Hall evokes in his image of "the maelstrom" is one precipitated by his account of the passing away of certain "necessary fictions" regarding the identity of interests. Yet if "race" operates, within the anti-essentialist politics of this essay, as the necessary fiction, then the "new ethnicity" it proposes is not yet a stable truth. I will return to this ambiguity later in this chapter. Here I only suggest that, in this image of agonistic argument and debate, Hall opens up his concept of ethnicity to an aesthetics in which it is also possible to imagine another set of reversals, not the "simple" reversal Hall bemoans, but a more complex passage through the sentimental and antisentimental, the pornotropic and counter-pornotropic I sketch here.

The reversals I seek here for the concept of ethnicity are founded on its vexed relation to the "real" (in particular the vexing, empiricist belief, which I reject outright, that ethnicity is somehow "closer" to the truth than race as a social construct). The contrary possibility, of a dialogic reversal between "real" and "fictive" ethnicity, is corroborated and deepened in Étienne Balibar's influential definition of nationalism as "fictive ethnicity." For Balibar, as for Hall, fictive does not mean illusory or inefficacious,

but is offered "by analogy with the *persona ficta* of the juridical tradition in the sense of an institutional effect, a 'fabrication.'"[18] As Balibar noted in 1991: "No nation, that is, no national state, has an ethnic basis, which means that nationalism cannot be defined as an ethnocentrism except precisely in the sense of the product of a *fictive* ethnicity. To reason any other way would be to forget that 'peoples' do not exist naturally any more than 'races' do, either by virtue of their ancestry, a community of culture or pre-existing interests. But they do have to institute in real (and therefore in historical) time their imaginary unity *against* other possible unities."[19]

In this formulation, historical time intervenes to convert ethnic, racial, and national fictions into real unities. Here we must return to Wilderson's haunting reminder that such a passage of civic time is always conducted over and against the figure of the slave, held outside historical time. At the same time, we might retrieve from Moten's dialogue with Wilderson another vision of politics, one that is subtended by the *im/possible unities of blackness* that disrupt any sense of historical time that cinema or any other apparatus of ethno-national capture may secure.

In contemporary black cinema studies, the work of Kara Keeling stands signally for generating an affective politics of such im/possible unities of blackness. Keeling mobilizes the "witch," a figure who scuttles between "a sustained analysis of contemporary processes" and "a critical interrogation into the enslavement of Africans"; the witch is key to my argument insofar as I follow Keeling's call to account for what she calls the *black femme function:* "a portal to a reality that does not operate according to the dictates of the visible and the epistemological, ethical, and political logics of visibility."[20] In the interstices of blackness out of which the illusion of cinematic motion leaps, we try to follow the flight of the witch who guides us towards "undecidable, unlocatable, nonchronological pasts, presents, and futures."[21] Keeling's work invites us to think the inside/outside of cinematic production through a queered concept of affectivity that will be essential to my concluding sketch of the counter-pornotropic.

How might such an attention to cinema as affective production address the "migration of the black body"? I have already suggested, following Moten, that the technology of motion capture is also a technology of fugitive slave capture. The black radical aesthetic he extolls is an aesthetic of fugitivity, and the debate between him and Wilderson is conducted on the basis of the im/possibility of escape from the slave ship's hold. For Wilderson, the negation of blackness is the basis out of which civil society and its ethno-national cinematic life is animated; for Moten, blackness is the negation of civil society, on the basis of which social life

can flourish.[22] For myself, I hew closer to Moten's version of negativity than Wilderson's. I also draw on the negativity in José Esteban Muñoz's concept of disidentification.[23] Disidentifying with fictive ethnicity, I will suggest, is not so much a fantasy of escape as it is a mode of working on and through the *persona ficta* of the screen slave. To anticipate my subsequent discussion of Alexander Weheliye's provocative call for *habeas viscus* (produce the flesh), perhaps the move here is towards *habeas ficta* (produce the fiction).

Returning to the diphasic onset of black diasporic affectivity, we begin to see how the screen affectivity Keeling tracks must take shape within *duration*. The Bergsonian-Deleuzean concept of duration Keeling draws upon, as film theorist Thomas Kelso explains, does not refer to simply a period of measurable time, but "itself implies the real but virtual coexistence of the present and the entirety of the past"—a coexistence, film theorist Peter Gaffney further notes, articulated as the distinction between ordinary memory, adapted to presentist concerns, and recollection, or "true memory," a memory that "remains 'suspended' above the contingencies of the present moment, 'truly moving in the past and not, like the first, in the ever renewed present.'"[24] I offer this brief exegesis of the concept of duration within the theoretical paradigm that Keeling moves in, in order to forestall a literalist misapprehension of her argument that would see in specific elements of cinematic technique—such as the montage or dream sequence—a visible "portal" to nonchronological time. Her argument, to the contrary, is ontological, and bears upon blackness as the invisible ground out of which such visibility springs. Sensing the cinematic apparatus from the point of view of the black audience that waits "in the interval" for the appearance of black images on screen (images that induce "tense muscles" as the living past is contracted into the violent subordination and ordinary expropriation of the present), Keeling posits an intensive space of the virtual wherein black cinematic duration can exceed the representational aporia.[25]

The power of Keeling's approach, in my estimation, is the balance her readings achieve; construing lack and antagonism within a theoretical field that sustains black desiring-production. Black emotivity following the witch's flight diagrams an alternative mode of existence that is indicated nowhere in the fixed and reified images of race, gender, and sexuality of narrative cinema. Escape and confinement are not an either/or proposition in Keeling's view of duration; they immediately imply and are entangled with each other. Cinema as an apparatus of capture would appear to leave the black body nowhere to go, and to deny any sense in which, as

Moten claims, objects resist.[26] But the witch's flight induces a different sense of black becoming than one enframed by lack.

In my larger project, I am concerned with where the rhetoric of constitutive lack and its *aporetics of loss* may be leading black criticism. However useful, lack can be both overdrawn and oversimplified. Furthermore, as Nathan Widder shows, political ontologies of lack can, with only a minimal gesture, tip over into ontologies of excess.[27] The enigmatic difference of a blackness that never emerges into the agonistic play of representational opposites is, from this vantage, both a lack and an excess of representation, much as the black space between frames of cinema, on Moten's account, provides the unseen background to the illusion of visible movement. It is within this zone of indistinction between lack and excess, between negation and affirmation, that I engage the titular problematic of this book: migrating the black body. Consider this problematic grammatically: "migrating the black body" is a sentence fragment, a gerund and predicate without a subject. The black body does not migrate; it is *migrated.* In Harney and Moten's terms, we can say that the black body is *shipped.* By what agency is this (violent) movement accomplished? Shall we align this movement with the racial-colonial genealogy of the cinematic apparatus? And what would it take to render this apparatus inoperative?

The Double Rotation of Sentimentality and the Pornotropic

Although I opened this chapter by suggesting there are at least four contemporary modes through which slave affectivity is represented on screen—the sentimental, the antisentimental, the pornotropic, and the counter-pornotropic—time and space permit me to make my case through a discussion of just two films about slavery—*Mandingo* (1975) and *Manderlay* (2005)—and one postcinematic case of screen memory I will briefly discuss in my conclusion.[28] I have deliberately selected two films which foreground the fictive construction of black ethnicity. In neither case does the film appeal to ethnic realism or authenticity (in contrast to, say, a film like *Roots*). Although one is a mainstream exploitation movie from the 1970s and the other recent art-house cinema (whose existence was brought to my attention through the critical reading of it provided by Wilderson), both derive their power from a frank depiction of the depraved craving for black flesh, as Weheliye describes it, a craving that violently fragments the black body into something both films, in different ways,

mark as "ethnicity." In harnessing slave ethnicity to the work of black degradation and white depravity, these films set into motion an "ever-so-slight vacillation" that, for Weheliye, indicates "a conceptual galaxy" beyond Western humanism: our affective pursuit of the witch's flight may lead us toward the "differently signified flesh" of *habeas viscus*.[29] My concern here will be the agonistic black diasporic productivity of ethnic fictions, *habeas ficta*, as a provocative supplement to this "ever-so-slight" space of *habeas viscus* that Weheliye convincingly outlines.

The popular novel *Mandingo* (1957) by white American author Kyle Onstott was the source of both the 1975 film and prime culprit for the widely circulated myth that slaves in the American south were "bred" for gladiatorial fights to the death. Its Mandingo slave protagonist, Mede (portrayed by Ken Norton), must navigate a cascade of depravations as he is bought and sold, competes in death matches, is forcibly bred with other slaves, coerced into sex with his white mistress, and finally, boiled alive by his jealous and despotic white master. In associating this myth with a particular West African ethnicity, the Mandinka, Onstott lent his pulp fiction historical verisimilitude (much as deriving Mede's name from the Greek myth of Ganymede lent his sadistic homoeroticism a knowing air of camp classicism).[30] The "Mandingo" slave, that is to say, was *both* an ostensive retention of African ethnicity and a *persona ficta* of U.S. slaveholding. *Mandingo*, appearing just as the wave of the civil rights and decolonization movements was cresting, is an astonishing effort to capture and destroy, within the cinematic apparatus, the homoerotic, hypersexualized image of the rebellious black slave. It is an ur-text of cinematic *pornotroping*, to use Hortense Spiller's useful term.[31]

Today, the film's lurid representation of rape, torture, and murder in the plantation South may appear over the top. While there appears to be no historical evidence for "Mandingo fighting" on American plantations, the Mandingo myth concatenates several repressed realities of chattel slavery: slaveholder awareness, in some contexts, of black ethnicity; slaveholder attempts to bring principles of animal husbandry to bear on human chattel; and the sheer sadistic pleasure to be taken in enslavement, over and above its legal and religious routinization and economic rationalization. The myth of the Mandingo slave fighter condenses and diffracts for popular enjoyment these complex and contradictory histories, which had their postslavery sequel in such diverging genres as pornography, eugenics, and folklore. As the film *Mandingo* circulated globally as a Hollywood major studio production, it was clear that the language of "fictive ethnicity" it disseminated was read out of an "American grammar book."[32] By evok-

ing Hortense Spiller's influential framework, I mean to follow Weheliye in pointing out how, through the novel and film, "Mandinka" ethnicity is captured and restaged as an American "born and bred" eugenic pornotropic fantasy of "Mandingo" black masculine strength, savagery, and sexual virility. This reading depends upon our holding in tension two senses of "fictive ethnicity": the violent construction of national civic identity around racial and ethnic exclusion, and, concomitantly, the construction of "real" ethnic types within the crucible of cinemas of national fantasy.

The use of fictive ethnicity (in this double sense) to produce Americanness on screen is even more vividly on display in Lars von Trier's *Manderlay* (2005). Shot on a bare Danish sound stage with no attempt at period verisimilitude, *Manderlay* tells the story of the people of the Manderlay plantation who are still held in slavery seventy years after the emancipation proclamation. Grace (played by Bryce Dallas Howard), an idealistic young white woman, arrives at the plantation and tries to set things right by imposing freedom and democracy by force. Stumbling upon a secret book of laws left by Mam, the former slave mistress, Grace realizes the slave community has been divided into eight invidious categories of "Nigger." The strong and handsome Timothy (Isaach de Bankolé) presents himself as proud African warrior but is exposed, over the course of events, as a "pleasin' Nigger," able to put on whatever face his mistress would like to see. In a final mise en abyme, Mam's secret book of law is revealed to have been written by one of the slaves themselves, Wilhelm (Danny Glover), in an attempt to preserve the status quo of the plantation in isolation from meddling "liberators" like Grace.

Because it explicitly counters the expected conventions of period drama and cinematic identification, I would term *Manderlay* an antisentimental representation of slave affect on screen. The "anti" is probably not controversial: *Manderlay* has been described as an "anti-American" film, both because of its director Lars von Trier's vaunted hostility to the United States (a country he has famously never visited), and because it has been taken, quite plausibly, as an allegory of the U.S. invasion, occupation, and attempted "freeing" of Iraq. Such allegorical abuse of slave memory is certainly to be criticized: founding a critique of the Iraq war on a historical allegory of Northern "carpetbaggers" in the post–Civil War U.S. South is the height of ideological arrogance. My interest, however, lies neither in attacking nor defending von Trier's politics but in locating his avant-garde directorial tactics of audience estrangement within a speculative typology of fictive slave affect. If *Mandingo* stokes the pornotropic fantasy of the virile African warrior born and bred into slavery (one incited again in

Quentin Tarantino's *Django Unchained,* a pastiche of blaxploitation por-
notroping), Wilderson points out how *Manderlay* disillusions the viewer
of even this cold comfort. The "proud" virility of Timothy is revealed to be
just "pleasing" dissimulation, and the mastermind of this plantation night-
mare turns out to be neither white oppression (Mam) nor white liberation
(Grace), but the secret wizard Wilhelm who has decided, in a grotesque
inversion of Rousseau, that his people must be forced to be unfree. It is a
powerfully antisentimental film, in contrast to Steve McQueen's *Twelve
Years a Slave* (which seems by contrast, in its verisimilitude, method act-
ing, and immersive spectacle, to bring screen sentimentalism to a certain
apotheosis). The offensive typology of blackness offered up in Mam's law
seems to set up an impassable barrier to anything like an originary African
ethnicity: any proud reclaiming of African origins is always already antici-
pated by a voracious pornotroping.

I discuss these two films in particular because they have been entered
into the recent critical debate within black studies about slavery and its
cinematic afterlives. In *Habeas Viscus*, Weheliye offers a detailed and per-
suasive reading of *Mandingo.* Wilderson has been the critic to convinc-
ingly bring *Manderlay* to attention in black studies circles. Both critics
employ these films to launch powerfully indictments of the social con-
tract. Weheliye, however, resists readings of the afterlife of slavery as
social death, and directs *Habeas Viscus* to show how the state of "bare
life" exception famously theorized by Agamben is insufficient to slave
experience and postslave memory. Part of his argument proceeds by way
of offering up Spillers's concept of pornotroping as a dangerous supple-
ment to "bare life."

As Weheliye notes, dwelling on the nuance of Spillers's concept: "In
pornotroping, the double rotation [Hayden] White identifies at the heart
of the trope figures the remainder of law and violence linguistically, stag-
ing the simultaneous sexualization and brutalization of the (female) slave,
yet—and this marks its complexity—it remains unclear whether the turn
or deviation is toward violence or sexuality."[33]

The pornotrope, Weheliye here argues, is radically unstable: at its limit
it can be said to generate, through this "double rotation," the counter-
pornotrope as well (much as the fierce antisentimentality of a Baldwin,
say, is established only on the basis of the writer's powerful affinities for
the sentimental mode himself). This ambivalence remains at the heart of
the representational dilemma Weheliye wrestles with. Rather than human-
ize the slave, the general desire for the pornographic production of her
image in states of intensity throws the humanity of the slave into abyssal

doubt. This can be seen plainly in an early scene in *Mandingo* that imme-
diately belies the myth of racial equivalence and gender complementarity
suggested by the movie poster. In this scene, the slaveholder Hammond
is introduced to the pleasures of sex with black female slaves by a friend
who assures him that black women prefer white men to be violent with
them. When Hammond asks Ellen and is informed that, to the contrary,
she prefers rape not to include blows and bruises, he proceeds in his
rape of her without them. The scene reveals how pornotroping throws
Ellen's humanity into radical incoherence. Only more dehumanizing than
the slave who agrees that rape is violent—and insists it be enacted as
such—is the slave who agrees to participate in a fantasy of consensual
seduction.[34] Pornotroping in *Mandingo* thus stages what Christina Sharpe
has aptly termed a "monstrous intimacy," an inhuman relation that is pro-
duced out of acts of intimacy, care, and passion.[35]

Is there ever any exit from the double rotation of the pornotrope?
Weheliye suggests that there is. His reading of *Mandingo* shows that
the pornotroping, in its rendering violence and sexuality indistinguish-
able, indifferently captures both male and female flesh alike in its zones
of depravity. Slaveholders in *Mandingo* crave male and female slave
flesh equally, if not in the same way. *Manderlay*, by comparison, works
the reversal of the pornotrope through "Mam's law," a law whose cold-
ness and cruelty ungenders black flesh by assigning black subjects to a
typology of (un)natural kinds that are more aligned to the *persona ficta*
of the law of ethnicity than to any law of sexual difference. Pornotropes
likes "Mandingo fighter" or "pleasin' Nigger" thus present a question that
this chapter is also preoccupied with: "How does the historical question
of violent political domination activate a surplus and excess of sexuality
that simultaneously sustains and disfigures said brutality?"[36] Can fictive
ethnicity be conceptualized as part of that surplus and excess, not the
"real" or authentic original identity of the slave before her violent deracina-
tion, but something like its unexpected remainder? This remainder would
come not in spite of, but *through* the radical ungendering of flesh Spillers
point to.

For Weheliye, "racial assemblage" is a theoretical concept that helps
pry open this question. His attention to the assemblage, *agencement*, or
fabrication of race in and through the cinematic apparatus, returns us
again to the theory of fictive ethnicity mobilized by Hall and Balibar, but
with a critical difference I aim to mark through the idea of *habeas ficta,*
desiring production as another subversion of the law.

In "New Ethnicities," Hall writes: "What is involved is *the splitting of the*

notion of ethnicity between, on the one hand, the dominant notion which connects it to nation and "race," and on the other hand what I think is the beginning of *a positive conception of the ethnicity of the margins, of the periphery*. That is to say, a recognition that we all speak from a particular place, out of a particular history, out of a particular experience, a particular culture, without being contained by that position as 'ethnic artists' or film-makers."[37] I want to linger briefly in this split notion of ethnicity that Hall produces, rather than rushing, as he does, to fill it in with a "positive conception" from the margins. Between the fictive ethnicity of nationalism and xenophobia and the "recognition that we all speak from a particular place," I am suggesting, Hall points to an originary split in the concept of ethnicity that renders it constitutively *ambivalent*. Both positive *and* negative, ethnicity cannot be recuperated for an affirmative politics of recognition (which Hall himself appears to confirm when, after gesturing towards an ethnicity of the margins, he redoubles upon his guiding assertion that such a positionality cannot possibly contain the artist qua ethnic). Ambivalence, however, also opens out the agonistic space of reversal that this chapter has been insisting upon, against the theoretical overdetermination of blackness as lack.

The split of ambivalence within the concept of ethnicity *before* it gets mobilized in representation is crucial to my account, and it is here that Weheliye's racial assemblage theory helps us forward. Weheliye's analytic prevents us from falling back upon any common sense image of "real ethnicities" as providing the basis for thinking the multiplicity of Africa and its diaspora ("real" ethnicity presenting, among other hazards, the lethal hazard of "ethnic conflict" when it finds political instrumentalization in various locations in contemporary Africa).[38] Speaking indirectly to the question of who has the "right to represent" slavery and its afterlives, Weheliye registers an important caution against reifying ethnicity: "Given that peoplehood represents the foremost mode of imagining, (re)producing, and legislating community, and this managing inequality in the intertwined histories of capitalism and the nation-state, *peoplehood sneaks in as the de facto actualization of diasporas in the national context, especially when we avoid specifying how black collectivity might be codified in the absence of this category.* Thus, in the parlance of comparison, diasporic populations appear as real objects instead of objects of knowledge."[39] In this quote Weheliye underscores how his concept of racial assemblage is emphatically *not* the grouping together of a series of discrete, empirical nationalities and ethnicities into a collectivity known as "Africa and its diaspora." No matter how far into the margins of representation one goes,

no matter how deep into the history and prehistory of racial capitalism, one never arrives at any retrievable "positive conception" of ethnicity from which to posit a pure lineage, freed of ambivalence. And yet, African ethnicity as an "object of knowledge" is perfectly attainable: it is retrieved, I have sought to show in this essay, through the diphasic onset of diasporic memory. The emergence of new ethnicities, insofar as such fictions continue to operate within Weheliye's formulation, cannot be as empirical phenomena: they must instead arise out of an agonistic and "particular mode of knowledge production."

Weheliye's own reading of slaves on screen, principally of *Mandingo* and *Sankofa* (1993, dir. Haile Gerima), proceeds along this protocol. Building upon Spillers's theorization of a split between the body and the flesh in the Middle Passage into slavery, Weheliye presents a contrast between a cinema of restored bodily plenitude *(Sankofa)* and a cinema of depraved violation of the flesh *(Mandingo)*. *Mandingo* makes plain what *Sankofa* cannot: that the figure of bodily integrity is itself an ideology of Western humanism. In pursuit of a model of fleshly living otherwise, Weheliye instead takes black feminist theorist Sylvia Wynter as his guide through the abyss of racial pornotroping and "beyond the word of Man."[40] As I have tried to show, however cursorily, *Manderlay* is a quite different film from either *Mandingo* or *Sankofa*. In *Manderlay*, any empiricist conception of ethno-racialized knowledge is thrown into chaos by the impossibility of exiting the law of slavery, even in conditions of travestied freedom, as the film disallows the horrors of slavery from congealing into a redemptive or pornographic tableau. In its minimal staging and theatrical deconstruction, it traverses the fantasy of immersive historical spectacle (an immersive verisimilitude that Steve McQueen's *Twelve Years a Slave*, for instance, still strives for). And yet *Manderlay* still presents abstractly what *Mandingo* exploits viscerally: how violent white craving for black flesh ungenders *and* differentiates blackness. This "and" is important, insofar as some readings of Spillers have concluded (quite unpsychoanalytically) that her account of the violent ungendering of flesh somehow obviates the need to account for sexual difference. The absurd taxonomy of Mam's law, upon which the freed people erect a folklore of fictive ethnicities that they are never too concerned to be consistent about, suggests otherwise.

While the antisentimental *Manderlay* can unveil the inhuman mechanism of the law of slavery as the basis for the *personae ficta* of slave ethnicity, it cannot, however, release the kind of utopian affect that a true counter to the pornotropic would provide a glimpse of. For that, we will have to turn from cinema and look elsewhere in our screen cultures.

Afrofabulation and the *Mandingo* Pornotrope

If black ethnicity, as I have argued, is not a new problem in the representation of slaves on screen, but has always been an affective and effective part of the cinematic apparatus of motion capture, then can such ethnic tropes be used to render that apparatus inoperative? This question leads beyond the scope of this chapter, but a final case might illuminate the counter-pornotropic terrain that such a speculative question opens up. This case (ongoing as of this writing) has been most thoroughly reported and interpreted by Steven Thrasher, on whose work I rely in what follows.[41] It concerns Michael Johnson, a black, HIV-positive college wrestling star who ran afoul of harsh Missouri laws that criminalize the failure to disclose one's HIV status to a partner before mutually engaging in consensual unprotected sex. Thrasher's impassioned reporting, which I can do no more than inadequately summarize here, powerfully counters the racist and homophobic image of Johnson as a predatory monster that continues to circulate in both mainstream and social media. That Johnson has been largely known in both of these contexts by the nickname "Tiger Mandingo" places his story within the fraught genealogy of fictive slave ethnicity and pornotroping that I have sought to delineate in this chapter.

Suggested to Johnson by a friend on the vogue ballroom scene (in which Johnson participated in the "butch queen" category), the name "Tiger Mandingo" clearly positions the images of Johnson that circulate on the TV and computer screens of our postcinematic era within the iconography of the Mandingo slave. The fictive flesh of the Mandingo slave trope structured how others saw Johnson, and how he showed himself to others, across a range of intimate and public settings. Interviewed by Thrasher, Johnson professed ignorance of the actual film, but was well aware of its place in the racial-historical schema, telling Thrasher "there was a brave black slave fighter, he's got the title of Mandingo . . . nothing negative about it. . . . I know what it means to me—a black slave that's a fighter. I consider myself a fighter."[42]

Johnson's response to Thrasher circles around a formulation he never explicitly arrives at: "I consider myself a slave." In his response to Thrasher, Johnson "lingers in the hold," as Wilderson might put it, in order to locate a performative response to the slave fighter image he is captivated by. After Muñoz, we can say that Johnson's act of *habeas ficta* effectively *disidentifies* with the "title" of the Mandingo slave. Muñoz describes the act of disidentifying as follows: "Instead of buckling under the pressures of dominant ideology (identification, assimilation) or attempting to break free

of its inescapable sphere (counteridentification, utopianism), this 'working on and against' is a strategy that tries *to transform a cultural logic from within*, always struggling to enact a permanent social change while at the same time valuing the importance of local or everyday struggles of resistance."[43] Johnson's claiming of "Tiger Mandingo" as a screen name on multiple social media sites, I argue, was such a strategy of struggle "on and against" the terms of his ontological capture. It was a counter-pornotropic production of fictional flesh: a twisting of the tropes of black hypersexuality and depravation towards the fantasy and enactment of another way of life.

Such a claim for the disidentificatory power of the counter-pornotropic might be dismissed as endowing too much political significance to Johnson's actions and statements. Alternatively, my argument might be criticized for ignoring the context within which Johnson made those statements to Thrasher: from inside the bars of a prison cage. I am under no illusions that his performative transvaluing of the fictive ethnicity of the Mandingo fighter had any immediate effect on his criminalization or that of others caught in the dragnet of the state's ongoing war against poor black people. To the contrary, understanding him as disidentifying with a fictive slave ethnicity can surface elements in his testimony that a hostile or dismissive reading would miss, opening out an encounter between the tight space of his incarceration and the "true memory" of a different mode of existence.

Consider, in this respect, Johnson's deliberate crosscutting of the vocabulary of contemporary sports (modern-day gladiator games?) with the afterlives of slavery. In claiming that "Mandingo" was not just an ethnicity or category of slave, but a "title" won by a "brave fighter," Johnson performed an act of *afrofabulation*: he drew out from the past a myth whose performative power was *larger* than its historical truth or falsity. In accepting his friend's sly designation of him as a "Mandingo," Johnson transformed its meaning *within* the terms of black male pornotroping. Keeping the trope of the "big black buck" in continuous double rotation permitted him "to fully inhabit the flesh" and point towards "a different modality of existence."[44]

What such a counter-pornotroping of the fictive ethnicity and affectivity of the slave on screen can teach us is the unexpected ways in which history continues to *matter*; the way it continues to hurt, certainly, but also to bind up that hurt in a healing that may leave us, not so much whole, as *wholly other* than who we were. Such a binding may sometimes be as simple as the sympathetic, three-dimensional portrayal of Johnson we

receive in Thrasher's humane reporting, in contrast to the alarmist moral panic that prevailed elsewhere in coverage of his story. Certainly, it can be nothing less. Such fact-finding work, where it can contest the homophobic and antiblack terms under which black people currently appear as empirically knowable objects of knowledge under present ideology, is itself an instance of "the future in the present."[45] It suggests to me the insufficiency of any politics, or postpolitics, that strives to force a choice between antagonism and agonism: we will never know in advance which situation we are in.

One can only remain haunted by Johnson's fabulation of a lineage of brave slave fighters for whom ethnicity is not inherited but claimed and won. At stake in this affective image of this *persona ficta* are the prospects of freedom from the conditions of ontological capture in which Johnson, and persons like him, will stand always already accused and convicted. That such a freedom is literally unimaginable to our present condition does not negate but to the contrary underscores the value of such instances of afrofabulation.

Notes

1 Linda Williams, *Playing the Race Card: Melodramas of Black and White from Uncle Tom to O. J. Simpson* (Princeton, NJ: Princeton University Press, 2001).

2 On the pornotropic, my thinking is indebted to Alex Weheliye, *Habeas Viscus: Racializing Assemblages, Biopolitics, and Black Feminist Theories of the Human* (Durham, NC: Duke University Press, 2014).

3 Frank B. Wilderson, *Red, White and Black: Cinema and the Structure of U.S. Antagonisms* (Durham, NC: Duke University Press, 2010).

4 Fred Moten, "Taste Dissonance Flavor Escape: Preface for a Solo by Miles Davis," *Women and Performance* 17, no. 2 (2007): 234. My emphasis.

5 Étienne Balibar and Immanuel Wallerstein, *Race, Nation, Class: Ambiguous Identities* (London: Verso, 2011); Stuart Hall, "New Ethnicities" in *Stuart Hall: Critical Dialogues in Cultural Studies*, eds. David Morley and Kuan-Hsing Chen (London: Routledge, 1996); Kara Keeling, *The Witch's Flight: The Cinematic, the Black Femme, and the Image of Common Sense* (Durham, NC: Duke University Press, 2007); Weheliye, *Habeas Viscus*.

6 See, for instance, Kelley L. Carter, "The Rise of the Black British Actor in America," *Buzzfeed News*, January 5, 2015, accessed February 2, 2015, www.buzzfeed.com/kelleylcarter/the-rise-of-the-black-british-actor-in-america.

7 Two recent texts powerfully demonstrate the necessity and insufficiency of a "skin deep" analysis of race: Nicole Fleetwood's *Troubling Vision: Performance, Visuality, and Blackness* (Chicago: University of Chicago Press, 2011); and Michelle Stephens's *Skin Acts: Race, Psychoanalysis, and the Black Male Performer* (Durham, NC: Duke University Press, 2014).

8 Leigh Raiford, *Imprisoned in a Luminous Glare: Photography and the African*

American Freedom Struggle (Chapel Hill: University of North Carolina Press, 2011); Maurice Wallace and Shawn Michelle Smith, *Pictures and Progress: Early Photography and the Making of African American Identity* (Durham, NC: Duke University Press, 2012).

9 David Marriott, "Waiting to Fall," *New Centennial Review* 13, no. 3 (2013): 176.

10 "Beneath the body schema I had created a historical-racial schema. The data I used were provided not by 'remnants of feelings and notions of the tactile, vestibular, kinesthetic, or visual nature,' but by the Other, the white man, who had woven me out of a thousand details, anecdotes, and stories." Frantz Fanon, *Black Skin, White Masks* (New York: Grove, 2008): 91. The interior quote is from Jean Lhermitte, *L'image de notre corps* (Paris: Éditions de la Nouvelle Revue Critique, 1939): 17.

11 Fanon, *Black Skin*, 131.

12 Jean Copjec, "The Sexual Compact," *Angelaki* 17, no. 2 (2012): 37.

13 Marriott, "Waiting to Fall," 164–65.

14 In 1989, Stuart Hall influentially posed this as the task of bringing into play "the recognition of the immense diversity and differentiation of the historical and cultural experience of black subjects"; Hall, "New Ethnicities," 443.

15 Hall, "New Ethnicities," 449.

16 Hall, "New Ethnicities," 443.

17 Hall, "New Ethnicities," 444. My emphasis.

18 Balibar, *Race, Nation, Class,* 96. The *persona ficta* of ethnic-national belonging, as an institutional fabrication, can also be thought of as an *agencement* or assemblage in the Deleuzean sense.

19 Balibar, *Race, Nation, Class,* 49.

20 Keeling, *Witch's Flight*, 148, 143.

21 Keeling, *Witch's Flight*, 152.

22 See especially the "Fantasy in the Hold" section by Fred Moten and Stefano Harney, *The Undercommons: Fugitive Planning and Black Study* (Wivenhoe, UK: Minor Compositions, 2013).

23 José Esteban Muñoz, *Disidentification: Queers of Color and the Performance of Politics* (Minneapolis: University of Minnesota Press, 1999).

24 Thomas Kelso, "The Intense Space(s) of Gilles Deleuze," in *The Force of the Virtual Deleuze, Science, and Philosophy*, ed. Peter Gaffney (Minneapolis: University of Minnesota Press, 2010), 124; Peter Gaffney, "Superposing Images: Deleuze and the Virtual after Bergson's Critique of Science," in *The Force of the Virtual Deleuze, Science, and Philosophy,* ed. Peter Gaffney (Minneapolis: University of Minnesota Press, 2010), 98.

25 Fanon, *Black Skin*. For more on "tense muscles," see Darieck Scott, *Extravagant Abjection: Blackness, Power, and Sexuality in the African American Literary Imagination* (New York: New York University Press, 2010).

26 Fred Moten, *In the Break: The Aesthetics of the Black Radical Tradition* (Minneapolis: University of Minnesota Press, 2003).

27 Nathan Widder, *Political Theory after Deleuze* (New York: Continuum, 2012).

28 The four modes (really two modes and their corresponding antitheses) can be defined in terms provided by James Baldwin, on the one hand (the critique of the sentimental), and Hortense Spillers, on the other (the critique of the pornotropic).

29 Weheliye, *Habeas Viscus*, 111. I also am indebted to the reading of *Manderlay*

in Frank Wilderson's lecture, "The Lady with the Whip: Gendered Violence and Social Death in *Manderlay* and *Django Unchained,*" given at the Barnard Center for Research on Women, March 6, 2013. The published text of this lecture was not available at the time this chapter went to press.

30 For more discussion of the fraught history of accusations of cannibalism in the history of slavery and the slave trade, see Vincent Woodard, *The Delectable Negro: Human Consumption and Homoeroticism within U.S. Slave Culture* (New York: New York University Press, 2014).

31 Hortense Spillers, *Black, White, and in Color: Essays in American Literature and Culture* (Chicago: University of Chicago Press, 2003).

32 Spillers, *Black, White, and in Color.*

33 Weheliye, *Habeas Viscus,* 90.

34 Here I am thinking of Saidiya Hartman's work on the "ruse of seduction"; Saidiya Hartman, *Scenes of Subjection: Terror, Slavery, and Self-Making in Nineteenth-Century America* (New York: Oxford University Press, 1997).

35 Christina Elizabeth Sharpe, *Monstrous Intimacies: Making Post-Slavery Subjects* (Durham, NC: Duke University Press, 2010).

36 Weheliye, *Habeas Viscus,* 91.

37 Hall, "New Ethnicities," 447. My emphasis.

38 It is thus relevant to my argument that Weheliye shares my interest in staging an encounter between Balibar (here, his collaborative work with Louis Althusser in *Reading Capital*) and Spillers. He notes, "For Althusser, Balibar, and Spillers *there exists no real object without the vehicular aid of particular modes of knowledge production.*" Weheliye, *Habeas Viscus*, 18. Emphasis in original.

39 Weheliye, *Habeas Viscus*, 31. Emphasis in original.

40 Sylvia Wynter, "Beyond the Word of Man: Glissant, the New Discourse of the Antilles," *World Literature Today* 63, no. 4 (1989): 637–48.

41 Steven Thrasher, "How College Wrestling Star 'Tiger Mandingo' Became a HIV Scapegoat," *Buzzfeed LGBT*, July 7, 2014, accessed January 6, 2015 www.buzzfeed.com/steventhrasher/how-college-wrestling-star-tiger-mandingo-became-an-hiv-scap.

42 Thrasher, "Tiger Mandingo."

43 Muñoz, *Disidentifications*, 11–12. My emphasis.

44 Weheliye, *Habeas Viscus*, 112.

45 In addition to pointing out the counterproductive nature of the laws under which Johnson was charged, and the absence of free condoms on his college campus (even after the HIV scare), the double standard of holding only one party to an act of consensual unprotected sex responsible for HIV safety, Thrasher goes on to paint an evocative picture of a world in which, as one informant says, "Everyone wanted a piece of [Johnson], until he had HIV"; Thrasher, "Tiger Mandingo."

17

The Black Body as Photographic Image

Video Light in Postcolonial Jamaica

KRISTA THOMPSON

In the late 1980s, Jack Sowah (Courtney Cousins), a local videographer working in Kingston, Jamaica, popularized the video camera and accompanying television screens in the space of the island's main urban entertainment venues, its dancehalls.[1] Sowah did not simply videotape the proceedings in these sites; the bright glare from his camera's light as it moved swiftly around the arena dramatically transformed the experience of the space, making the music-centered events increasingly about visual spectacle. This technology became widely known locally as *video light*, which refers quite literally to the light that some videographers mount on top of their handheld video cameras. A distinguishing feature of video light is that, because videographers do not use filters or diffusers on their lights, its visual texture is harsh and burning white. The camera scopes around the venue, at times moving in synergy with the music, casting its bright light on dancers and spectators. *Video light* also encompasses a broader set of related performative and representational practices, social interactions and transactions, through which dancehall attendees seek to achieve visibility and transformation through the state of lightedness. Since the 1990s, and reaching new heights of popularity in the early 2000s, numerous videographers have replicated the video light. Performers vie to be illuminated by the camera's bright white light, which can be seen and felt as it saturates the visual senses of congregants (figure 17.1, plate 20). Sometimes a closed-circuit system projects what comes into the light of the video camera within screens placed within the dancehalls. Video light, I maintain, has been intrinsic to the creation of a sense of community—locally and transnationally—among dancehall participants through the modes of seeing and of blindness that it produces and makes visible.

17.1.
Videographer Jack
Sowah at Uptown
Mondays dancehall,
Kingston, 2010.
Video still by Krista
Thompson.

This essay offers a history of this visual technology, which is one of the most widespread forms of visual representation in Jamaica's urban communities and its diaspora. I will look at the development of this genre, concentrating in part on Sowah. He was central in the popularization of video light and has uniquely used the video camera in the dancehalls for over thirty years. I call attention to some of the various businesses, markets, and networks through which images produced through video light travel (or are imagined to circulate), as well as the ways different participants come to see their own social and economic mobility as possible through the momentary capture by the video light or the subsequent circulation of their images on DVDs or through the Internet. For many participants, the light of the camera represents or seems to assure a virtual audience. It becomes a material and ephemeral means through which dancehall participants seek to constitute a national, diasporic, and global community.

The recent rise in the practice of skin bleaching among women and men in Kingston's dancehalls is, I postulate, related in part to video light. While skin bleaching had occurred in Jamaica and other geographic locations before this time, it became prevalent in the space of the dancehalls precisely as male performers began to seek the attention of videographers in the early part of the twenty-first century.[2] This controversial practice, in which dancehall participants make their faces and other exposed parts of their bodies lighter and light sensitive through chemical means,

stems in part from an effort to be more visible in the scope of the video light, to be rendered legible through videographic technologies and technologies of light.[3] Skin bleaching, I suggest, makes the effect of being in the light of the camera semipermanently visible on the skin of dancehall participants.[4] It is an embodied way of taking the visibility, invisibility, and status afforded one in the dancehall into the broader black public sphere and into practices of everyday life.[5] In this way the dancehall participants who bleach their skins make their bodies into photographic surfaces, which manipulate the reflection and absorption of light. Their practices might be viewed as responses to the ways light complexions have been privileged historically in Jamaican society and more broadly and the way social hierarchies based on skin color have been reinforced and reproduced through photographic and videographic technologies. As such, skin bleaching may be interpreted as a visual technology that intercedes into and literally reflects and records histories where photography and race intersect, while remaking and relocating the material constitution of the photograph. These practices also destabilize notions of the skin as an index of race.[6] Through skin bleaching, the "skin" of video (the material and multisensorial experience of film) and the flesh of black urban subjects come into intimate proximity.[7]

Dancehall and the Fashioning of Modern Urban Subjects in Postcolonial Jamaica

Dancehall refers to entertainment spaces within urban communities in Jamaica and the forms of music, dance, and sartorial styles that these social groups cultivate and produce. Numerous dancehalls take place in a variety of spaces every night in communities surrounding the Kingston metropolitan area (which includes the parishes of Kingston and St. Andrew) and around the country. Many of them occur on neighborhood streets that dancehall participants repurpose, using a tower of speakers and turntables.

Dancehall has been a part of the Jamaican landscape since at least the 1950s and 1960s, when a form of toasting or talking over music generated in sound systems began.[8] These spaces resounded with the musical genres of mento, ska, dub, rocksteady, and roots rock reggae throughout the 1960s and 1970s. The music and the associated modes of self-fashioning enunciated the desires of a new generation of black modern subjects, who celebrated individualism, consumerism, and "slackness,"

an overt approach to sexuality that ignored middle-class rules of decorum.[9] Women from Jamaica's urban communities were central in the performances of dancehall in the 1980s through the early 1990s. They often arrived at the venues together, formed their own performance circles, and constituted a semiautonomous community among other dancehall attendees.[10]

Visual Technology and Dancehall Culture

In the late 1980s, three men—Devon Clark, Victor Johnson, and Jack Sowah—began to use video cameras in the dancehalls.[11] By the mid-1990s, these men were part of an increasing number of invariably male videographers—including Night Rider and Scrappy—who worked in these venues. Sowah notes that the demand for VHS videotapes took off in the early 1990s in part because of interest in the dancer known as Bogle (Gerald Levy).[12] Bogle became one of the first male performers in the dancehalls to create a name for himself locally and globally on the basis of his innovative dance moves. The reigning dancehall queens, such as Carlene, also increased the clientele for the dancehall videos.[13] But these early tapes also came to be sought after for their more salacious subject matter. Some women seeking to attract the attention of videographers started to perform in sexually provocative ways, sometimes flashing—revealing breasts, buttocks, and crotches—for the cameras.[14]

The VHS videos that featured Bogle, dancehall queens, and other dancers circulated widely in the 1990s. Indeed Sowah credits his videos with "exporting" local dancehall participants "to the world."[15] "If video light don't touch him," Sowah muses about Bogle, "he'd still be nobody."[16] Videographers peddled the tapes on roadsides in Jamaica. Sowah initially sold his videos, for instance, in Mandela Park. On the morning following a dance, Sowah promptly couriered the tapes to businesses and emcees in different cities, including JDs, a record store in Toronto, and Moody Records in New York.[17] Beth-Sarah Wright, one of the few scholars to examine the videotapes of dancehalls, describes encountering the footage of the dances in Brooklyn, where they were played on the outdoor screens of a music store.[18] Through these sources, dance venues in Kingston gained public visibility on the streets of Brooklyn. Videographers also distributed the tapes in other cities, especially those with substantial populations of Jamaicans, such as Miami, Nassau, and Brixton, England.[19] Jamaicans living abroad who came to town for several days to attend the

dancehalls provided another means through which the footage circulated quickly transnationally, Sowah highlights.[20] Dancehall events in Jamaica could be available for visual consumption in several cities within twenty-four hours, before the widespread use of the Internet and digital technologies.[21] These tapes in their heyday in the 1990s cost approximately fifteen hundred to two thousand Jamaican dollars, but by 2011 they could be found locally for as little as fifty Jamaican dollars.[22]

The Internet later provided another medium through which the proceedings of the dancehall circulated globally. Websites, such as www.dancehallreggae.com or www.Dancehalltv.com, developed in the late 1990s. They catered to Jamaicans living abroad, offering them a view of the latest trends in the dancehalls.[23] The footage also provided a way for Jamaicans resident in the island to send images of themselves and shout-outs to relatives elsewhere. These websites, explains Felicia Greenlee (who spent decades around the business of video light), allowed "people who were illiterate, who can't read or write on a postcard, to send images abroad."[24] Dancehall researcher Sonjah Stanley Niaah, writing in 2010, notes that dancehall DVDs also circulate globally and may be purchased in Germany, Brazil, South Africa, Kenya, Canada, and Japan.[25]

As a result of the copying of VHS tapes and more recently their distribution on Internet sites, it has not been uncommon for the community of viewers of dancehall videos to experience footage marked by image deterioration, a visual "noise" produced through repeated processes of reproduction (figure 17.2). When dancehall traveled primarily through VHS tapes, it often did so as copies and copies of copies, which at times bore visible traces of their transnational and transgenerational reproduction histories.[26] Such processes continued even after the Internet offered a means of distributing dancehall content. Beginning in the early days of the Internet, video footage on the Internet was often compressed. Internet users accessed low-resolution files over slow bandwidths. This had particular repercussions for the viewership of dancehall footage online. As video producer Richard Delano Forbes Jr. explains, heavily compressed files are particularly sensitive to the camera's movement or shaking.[27] The swift movements of the camera that are common when it is used in the dancehalls often did not translate well. The result was pixilation, literal gaps in the translation of the image onto the screen or a skipping of frames—of time, as it was presented in the videos. The very processes and networks that allowed transnational viewership also produced image loss, disruptions in visual translation. This is an example of *bixelation*, the visual modes of practices of diaspora in which emphasis is placed on the

pixels, the grain, the composite parts of the image, in this instance on the surface appearance of and in the material makeup of video and its digital reproduction. I call attention to this because the notion of the screen's and the photograph's surface may inform expressive practices, such as skin bleaching, surrounding the camera.

While some of the dancehall videos have active social lives and transnational viewership, for a number of reasons, Sowah explains, "many things [have] never been shown."[28] Certain dons, who sometimes sponsored the dancehalls, would on occasion confiscate Sowah's master tapes and his equipment.[29] Thus, while the video camera could afford a broader audience through local and transnational circulation, the only audiences that are assured are the videographers and the witnesses to the activities before the camera's spectacular light.

Camera, Screen, and the
Emancipated Spectator in the Era of Video Light

By the late 1990s and early 2000s, the videographers had gone from being visual recorders of the dancehalls to even more central instigators of their happenings. Indeed, the term *video light* came into currency to describe the video camera and its interaction with its subjects in these spaces. It is unclear who coined the phrase video light, but the dancehall artist Frisco Kid used the word as the title of a popular song he performed in 1996.[30] The term did not gain currency in the local press, however, until around 2002.[31] It was used to characterize the video camera and the illumination from its mounted camera light and was associated with a desire, willingness, and readiness to be seen.[32]

By the early twenty-first century, the ephemeral illumination of the video camera had reoriented the dancehalls. In this period it was common for dancing to take place only after the videographer turned on the

17.3.
Wedi Wedi
dancehall,
Kingston, June 2010.
Photograph by
Krista Thompson.

light to his camera or after the proceedings seemed activated in the space delineated by the camera's light. The 2000s was a period marked by fierce competition for the cameraman's attention. Many dancers debuted creative moves to lure the video light. On occasion fights broke out between rivals who sought the camera's illumination.[33] An informal payola system even existed through which some videographers received contributions (in dollars and pounds) from dancehall attendees seeking the touch of the camera's spotlight.[34] Many people who crowded before the videographer's camera often addressed or talked into the video light (figure 17.3). They offered a series of shout-outs to audiences far and wide, living and dead, in the present environment and in the future. The light seemed itself to represent and bring audiences into being. It also represented elsewhere, locations way beyond the island nation.

The very term *video light* calls attention to the importance of the technology of light in the dancehalls. Sowah, when asked what accounted for his popularity as a videographer in the dancehalls, identified the intensity of his camera's light.[35] He powers his camera's light—a three-hundred-watt bulb—through electricity. The light from Sowah's video camera and that of many other dancehall videographers is an electrifying bright white light not tempered by a filter (figure 17.4). In commercial videography and still portrait photography, filtering equipment is typically attached to the front of video camera lights or standing lights to soften and diffuse lightening and shadows.[36] Without such diffusion, video light is relentless in its intensity. One journalist aptly described the video light as "a lance of bright light . . . [that] cuts the darkness like a white knife."[37]

KRISTA THOMPSON

17.4.
Wedi Wedi
dancehall,
Kingston, June
2010. Photograph
by Krista
Thompson.

Video light is often so intense that it cannot be directly looked at for very long. It demands visual attention, yet it can induce blindness. It creates a form of visual experience that is felt and experienced in the body, sometimes painfully so (as suggested in the description of the video light as a type of visual "knife" within the space of the dancehalls). If the still camera and video camera had previously played a role in recording the activities of the dancehall for the purpose of memory, video light functioned in part by burnishing images, afterimages, in the body.

The videos produced in the dancehalls have a particular material character because of the videographers' use of the bright video light, which adds further to the visual noise evident in some dancehall footage. In these videos, light blurs and streaks across their subjects as well as across the screen, affecting the subsequent viewing experience of the footage. This is in part the result of video technologies that are "optimized" to focus on Caucasian skin. Light-based cameras can flatten darker-skinned complexions because of a narrow chromatic range designed for white skin, a technological constraint whose effects seem to be exacerbated by video light. This is evident in a video still of the La Roose dancehall taken by Sowah in 2000, in which Bogle directly engages the video camera. A light from a second video camera appears in the lower left of the darkened frame, registering as an impressionistic stroke of light. Bogle's face reflects the bright lights. It is so saturated with illumination that only the slightest contours of his eyes, nose, and mouth remain decipherable between bixelated planes of white and mauve that represent his skin. His jewelry is the most legible feature of his body. His

upper body is captured in blurred movement in the still. The image is but one instance of the distortions, the blurriness, the visual disruptions effected by the video light and video technologies. In the image the skin of the subject and the surface of the video conveyed through light merge.

Another challenge the video light poses to the production of footage is that even more recent digital video technologies have not been calibrated to achieve color balance promptly in conditions when black and white colors appear in close proximity.[38] Such ever-shifting contrasts in light and darkness are often produced through the use of video light. Resultantly, from the moment of production, the video cameras capture black subjects in the dancehalls at night in ways that produce visual distortions and image loss. The strains and the limits of the technology are visually evident in the footage. In the dancehall videos, often "detail is destroyed as realist representation fades into pulsating light," to quote Brian Larkin's words describing pirated videos in Nigeria.[39] Laura U. Marks's characterization of "the skin of the film" seems literalized in some dancehall footage. Marks uses the term "the skin of the film" to characterize the way film and video created by artists living in diasporic communities evoke the memory of their cultural experiences through an appeal to the senses or through a haptic visuality, a mode of visual perception that can exceed and extend sight alone to create a sense of touch.[40] She argues that certain transcultural videos and films can produce a form of contact with viewers through the materiality of film, its skin, which can be touched "with one's eyes."[41] Such a description seems an apt characterization of the visual experience of video light and footage from the dancehalls, which create a form of haptic visuality. The presence of undiffused bright light on black skin of varying hues and the reflection of light from some types of clothing and accessories all draw attention to the multiple surfaces in the dancehall. These shining elements appear across the material surface of the screen on which the footage is viewed.

Another component of video light—one innovated by Sowah—is the use of screens, or what he describes as "live video," to project the camera's view within the space of the dancehalls. Sowah recollects that initially he "suffered many embarrassments" because people did not want to be recorded or were annoyed by his bright video light.[42] What was eventually key to the acceptance of and integration of his video's light in the dancehalls, he believes, was his introduction of televisions and later video screens into the venues. Sowah notes that he would put up two televisions, one near the entrance and another directly across from the selector. It was the combination of the video camera, its light, and the

public display of the television screen that led to the popularity and pro-liferation of video light.

Video light was intrinsic not only in recording and projecting the vari-ous spectacular appearances and occurrences in the dancehalls but also, I would maintain, in the creation of a community formed around the experience of seeing, the visualization of the process of seeing and being seen. It allowed many people to experience themselves on television or projected on a larger-than-life screen. Persons before the video light went from feeling themselves being seen within the heat of the video light to almost instantaneously seeing themselves being seen on screen. The trio of visual technologies offered a doubled sense of one's visual pres-ence as well as a view of a broader network of representation of which dancehall attendees were at the center. It brought a prestige, becom-ing "a paparazzi thing," as Prince Sowah (Jack Sowah's son and fellow videographer) describes it.[43] The selector, located directly across from the screen, at times offered further verbal affirmation of the person loom-ing large within the screens, "bigging up" that person over the speakers. It made individuals in the dancehalls momentary celebrities and likely offered some people the first opportunity to see themselves represented on television or on a "big screen."

Sowah stresses that the video light did not solely focus on the queens of the dancehall but captured everybody: "It highlight a whole set of people."[44] The street woman Medusa, who became famous in dancehall videotapes and would receive remittances from abroad from people who viewed her in the footage, highlights how video light was in many respects democratic in whom it featured in its frame.[45] The dancer Kendrick Brown (known as Sick in Head) noted too that through the screens, notions of center and periphery were constantly destabilized.[46] The screens made people share the same visual space, often making those on the margins more visible and shifting those in the center of the dance floor to the periphery.

But what is strikingly evident in the screens in the dancehalls is that in addition to providing dancehall-goers with technological confirmation of their visibility, the projected images call attention to the very process of seeing. On the night I met Sowah, for instance, at the dancehall Stone Love before the event reached its height, the videographer from his company scoped around the side of the dance floor's ill-defined perimeter, apprais-ing dancehall attendees one by one. The cameraman literally scanned the woman next to me, who turned her face slightly to the side, simultaneously appearing to ignore and confidently invite the attention of the camera. The camera moved slowly up her body, taking in and showing everything

from her stylish shoes to her pierced glossy lips, and then lingered on her face. It then turned to a young man next to her, moving from his alligator boots to the brim of his cowboy hat, which somewhat shielded his face. He did not physically acknowledge the camera, but the second it left him he glanced at the screen, seemingly hoping to catch a glimpse of himself. Just then the selector's voice started to boom over the loudspeakers and the videographer's attention seemed lost. The screen showed an erratic moment of the camera across people, parts of their bodies, the ground, the wall, blurred objects that appeared too close to be rendered legible on the screen. When Sowah arrived and took ownership of the camera, dancers seemed to gravitate toward him and his light and he and it toward them, in part because he is an affable and recognized figure in the dancehalls. In his hands the camera was even more mobile and projected a view that moved in response to the sonic experiences of the space.

While the video light often centers on individuals or groups of dancers, a part of what the video camera and screens do is to make the very process of viewing visible to the people in the dancehalls. It makes the process of looking, of scoping out, of selectively focusing in or cropping visible in the venues or in the transformed public streets. The bright light from the camera also further enhances this awareness of the camera, of the technology of video, by calling attention to the process of seeing through its searing illumination. Makeshift projection screens, wrought sometimes out of loosely secured plastic, also draw attention to the surface of the projected image. In these ways, the video camera and screen unite dancehall attendees in this active process of looking, inscribing themselves into the simultaneous and constantly changing roles of videographic subject and communal spectator.[47] Jacques Rancière's description of the emancipated spectator, coined in his analysis of critical modes of engagement in contemporary art, may have bearing here. Video light produces a mode of "emancipation," which according to Rancière means "the blurring of the boundary between those who act and those who look; between individuals and members of a collective body."[48]

Male Crews, Skin Bleaching, and the Body as Photographic Surface

Several transformations happened in the space of the dancehalls precisely as video light reached its new ascendancy in the early 2000s. When videographers illuminated the dancehalls in the early twenty-first cen-

tury, they cast a spotlight on venues that were increasingly dominated by numerous groups of male dancers (figure 17.5, plate 21).[49] These men started to perform choreographed dance moves and often dressed in a coordinated fashion.

That fashionably dressed male performers started to "shark" and "overcrowd" the video light drew criticism from DJs of an older generation and from female dancers. In 2007 the DJ Admiral Bailey, for one, maintained that in the past "men were seen as rude boys. Dem a stand up inna di darkest corner of the fete. Back then women tek centre stage, nowadays men a tek over the dance and video light."[50] In addition, Bailey and other dancehall DJs accused some male performers of not dressing in masculine ways and of wearing "tight pants, pink shirts, and with bleached out skin."[51] They associated such aesthetic and sartorial practices with women. Such public policing of appropriate male dress and concerns about men not looking masculine reflect in part an entrenched homophobia that animated dancehall music and performance practices, as well as a broader fear—as Donna Hope suggests—of the "feminine."[52] Rather than narrowly interpreting the video light as historically focused on women, as some critics did, however, one might understand the history of the visual technology as one in which societal norms and expectations of gender, race, and class have long been reconfigured. The space of video light, too, is the site of the new and the now. It creates the possibility of alternate forms of embodiment.

If baring skin had previously dominated the dancehalls, from the late 1990s to the contemporary period, another skin-related phenomenon

became foregrounded in the venues: skin bleaching. Some men and women used a variety of epidermis-transforming means to lighten their skin. Products ranged from manufactured ones, like Ambi, Nadinola, and Neoprosone, to homemade recipes composed of toothpaste, bleach, cornmeal, curry powder, or milk powder.[53] The practice of skin bleaching was so pervasive that Jamaica's Ministry of Health initiated public health campaigns against the practice in the late 1999s and again in 2007. They warned of "killing the skin"—the dangers of chemicals on the body's surface—and banned the sale of some skin-bleaching creams.[54] The medical dangers of lightening products ranged from severe aches to stretch marks, increased risk of cancer, lesions, and interference with skin cell growth.[55]

Skin bleaching has a long and complex history across different geographic contexts where social status and the rights of citizenship and personhood have been bestowed or denied based on skin color. In Jamaica and other parts of the West Indies during slavery, British colonialists, colonial officials, and plantation owners institutionalized white hegemonic social hierarchies, which privileged fair skin.[56] The very justification for plantation slavery rested on the ideology that race existed, was visually discernible, and was readable on the body's surface. But skin bleaching cannot be reduced simply to a desire for a white appearance and the prestige it afforded historically. As Natasha Barnes persuasively maintains, in the context of Jamaica, many people who bleach often aspire to be "brown," or to become a "browning"—a racial designation associated with the upper classes and with the appearance of mixed-race Jamaicans. Brownings garnered many privileges not available to black people in the social structures in colonial Jamaica, and they continue to enjoy more access to jobs in the banking and retail sectors and more opportunities for social mobility.[57] Two persons quoted by Donna Hope who bleached and who aspired to browning status said they did so because brown skin brought social visibility: "Yuh get more attention," and "[It's a] way out of the ghetto, cause people see you more when you brown."[58] Or, as another one young woman, who appeared in the video "Skin Bleaching and the Dancehall," opined, "people no look pon black people again."[59] While being a browning may be a desired ideal related to color and class aspirations, many persons who bleached their skin thought they achieved a state of racial mutability because the bleached epidermal surface temporarily unfixes skin as a racial signifier.[60]

Skin bleaching was more than an aesthetic practice that could be seen on dancehall attendees; it was a mode of preparation for the events and

for the video light in particular. One dancehall-goer, for instance, explained to a *Gleaner* reporter that she only bleached her skin for the big dances and stopped immediately afterward: "Mi do it only like when mi a go a one big dance and mi know she mi have three weeks fi bleach and then from the dance cut mi just stop bleach."[61] Dancehall queen Stacie matter-of-factly explained, "Ah girl haffi look good, and if she not hot, she affi bleach and go all out, x-rated clothes, loud ting and all just to get attention."[62] In her description, bleached skin seems just another accessory to be worn to gain recognition in the dancehalls. Niaah found that bleaching was a "technology of the body" focused specifically on being in the video light: "If you bleached your skin, it was thought that you would become more ready for the video light. That you come into the light, almost, with the clearing of whatever pigment that was . . . darker in tone or whenever—it was thought to be obscuring the image, in a sense."[63] Greenlee noted too how some people who bleached would concentrate on the face only (and not their necks), where they thought the video light was most likely to linger.[64] These observations suggest that skin bleaching might represent a desire not simply to become "lighter" but to be more legible as a subject for the video camera. Bleaching allows dark skin to be more fully visible in the unfiltered video light that searches through the dancehalls at night. It allows black skin to be read through videographic technologies calibrated to focus on and represent an ideal of white flesh.[65] Such strategies for becoming legible under the intense illumination of the video light call attention to the broader un-visibility of darker-skinned subjects in contemporary Jamaican society. The term "*un*-visible" comes from Ralph Ellison.[66] Un-visibility describes the state of not being seen or not being recognized, as well as the "moral blindness" toward the "predicament of blacks." Sowah noted, though, that bleached black skin sometimes did not show up well on camera. Rather, the bleached faces (surrounded by darker hair and necks) and harsh video light resulted in a "white out," an illegible glare, on video.[67]

Might skin made "bright" by bleaching, as it is sometimes described, enable dancehall-goers to carry the momentary visibility affected by the video light beyond the space of the dancehalls?[68] Does bleaching reproduce and inscribe the effect of light on the skin's surface? A member of the bleaching community, identified as Winston in a television interview, indeed explicitly described the effect of bleaching in the following terms: "It mek yuh look like yuh come inna di light."[69] Bleaching in his estimation reproduced the effect of being in the video light on the bodies of dancehall participants.

Taking Winston's words a step further, I would postulate that chemically treated skin not only reproduces the effect of light from the video camera but also indeed becomes like a photographic surface. The process of bleaching makes the body into a medium that absorbs, reflects, reproduces, and records the impressions of light. Indeed, as health professionals have warned, many of the products used in bleaching literally make the skin light sensitive. Some bleachers had to cover their skin in the daylight because of this heightened sensitivity to the sun.[70] Different bleaching treatments also control the way the body reflects light. Through these practices dancehall attendees not only readied themselves for the video camera but made their skins into photographic surfaces, into visual technologies in their own right, that manipulated and recorded light. They made their bodies into a form of corporeal photograph. Bleached black skin became its own means and unit of photographic representation.

Much has been written on skin bleaching among Jamaica's urban communities as a form of self-hatred, as a manifestation of a racial inferiority complex or an expression of loathing the lived experience of having black skin.[71] Lightening the body's surface has been interpreted as a response to the cultural memory of skin color prejudice, or colorism, a reaction that arguably reinscribes racial hierarchies and ideals of beauty that privilege whiteness and brownness.[72] Some scholars maintain, however, that people who engage in different bleaching practices have high self-esteem and construct a range of nonwhite identities. They transform their skin rationally to attempt to secure and maintain power, and destabilize understandings of race as naturally manifest on the body.[73] I want to expand the frame in which one might understand these practices by suggesting that they engage and intersect with a history of visual technologies and commodities and their production of ideologies of race. Skin bleaching appears to embody and reconfigure the ways bodies have often been racialized and gendered through the flesh and through the technologies of light, like photography and video, and the techniques of lighting.[74] These skin bleaching practices surrounding video light represent "a redirection of what those technologies were supposed to be and the subjects they were supposed to produce," as Jamaican filmmaker Esther Figueroa (who worked with me as a videographer in Jamaica) has put it.[75]

Skin bleaching, I am contending, may be viewed as a process of making the body into a visual technology, in which the skin functions as negative and print, source of and recorder of light, subject matter and material of the photograph. But what does it mean to achieve a photographic objecthood, to have skin marked by the light of visibility or a body

functioning like a photographic surface? What kind of subject comes into being in the glare of the video light? What is the desired effect of such strategies in the broader public sphere?

Many dancers invested in their appearance in the video light because they believed it to be the most viable means to transcend their geographic environments and social status. Some expressed a fervent belief that if their images were transmitted globally and were seen by the right person—a potential lover, local or foreign music video producers, stage show organizers, overseas suitors, commercial directors, or remittance givers—they could dramatically transform their fortunes. They identified several levels of possible social ascent through video light, from being featured in a local music video to appearing in stage shows on the island outside Kingston (one of the few opportunities for dancers to get financial rewards immediately) to touring in Europe. As such, to use Sowah's words, investing in being in video light was like "putting money in the bank."[76] Indeed, a part of the reason some dancehall participants transformed their bodies through light and became like photographic images stemmed from a recognition that photographic and videographic images have a mobility that bodies do not. By becoming like a unit of representation, a visual technology, they could transcend the constraints of daily life and be transmitted and transported elsewhere, to other spaces and states. They could become diasporic subjects by becoming photographic. Skin bleaching is an example of what we might describe as a body of photography, the result of and transference of the effect of photographic technologies on the body and part of a broader creation of a social body through vision, light, and visual media.

The Proliferation of Dancehall on
Screen and Its Abatement in the 2000s

In the 2000s, as dancehall music gained increasing attention locally and internationally, the screens on which the street-based dancehall sessions appeared multiplied exponentially, through local television, in Jamaican society.[77] In the 2000s, as the cultural expressions of the dancehalls were transmitted nationwide through television, DVDs, and the Internet, they were increasingly subject to scrutiny and cast in an unflattering spotlight, particularly in the local press. By the 2000s, dancehall was the subject of ongoing criticism and debate and was often viewed as both a precipitator and a product of many societal ailments, most crucially crime, violence,

sexism, and homophobia.[78] The critiques also reveal how dancehall was often framed in the press for what it was not, for its departure from a national script.

The venues also increasingly caught the attention of the state in the era of video light. Dancehalls became subject to another form of light, one directed on them by law enforcement officers. The dancehalls had been subject to surveillance and raided by the constabulary forces since the 1960s.[79] Such practices intensified in the 1990s and 2000s with the imposition and enforcement of curfews on the dancehalls. In 1993, Buju Banton described raids with officers "wid helicopter inna air, bright light a shine a ground."[80] Some of these very raids were videotaped and shown on television.[81]

The 2000s saw the active enforcement of the Noises Abatement Act (1997), which provided a legal framework for the curtailment of dance-halls.[82] (One wonders, however, whether "noise" as described in the legislation refers not only to the sonic but also to the visual—whether dancehall's aesthetic practices represented the visual equivalent to an incomprehensible noise.) In particular, during the course of my research in 2010, authorities frequently shut down the dancehalls. The sound system would fall silent, the video light would be extinguished, and dancehall-goers would file out of the space. The frequent raids took a toll on the events. One promoter, Wayne '2 Gran Barley, ended the popular Dutty Fridaze dancehall for a time because of police raids in which officers "come one o'clock, dem kill di video, and for the past four weeks, the video ting get a blow."[83]

Given the ways that dancehall culture is often rendered un-visible in mainstream media in Jamaica, it is striking that one of the phenomena video light produces is the process of seeing and being seen. The camera moves through space, zooming in, focusing, blinding, and projecting, all of which might be interpreted as a dramatic enactment of visibility, an almost extreme insistence on being seen and seeing oneself being seen. The community in the dancehall is constituted as such through that experience. The ways many people talk to the camera, addressing an audience that cannot be seen, also seem to insist on an audience, on a community of viewers that transcends the nation-state, and on a recognition and visibility that is often denied dancehall participants in the mainstream. The transformation of the skin through bleaching so as to permanently mark the body as visible, as representable (and extending the temporality of the photographic), also speaks to dancehall participants' desires for recognition within and outside the spaces of the dancehalls.

The broader practice of video light may indeed offer a popularly con-strued system that allows widespread access and is responsive to and reflective of communities who have been disenchanted by the system of representative democracy. The video cameraman, his camera and its light, and the screens have installed an entire system of representation in the dancehalls in which different people have shared access to the technologies that represent them, which reflect their presence in and through a transparent visual feedback loop. Through the video light in the dancehalls, boundaries of center and periphery, local and the diasporic, race and gender, the body and photographic image, and the visible and un-visible remain in a state of suspension.

Notes

Some of the material in this essay has appeared previously in *Shine: The Visual Economy of Light in African Diasporic Aesthetic Practice* (Durham, NC: Duke University Press, 2015).

1 Jack Sowah, interview with author, Kingston, August 21, 2011. See also Sonjah Stanley Niaah, *Dancehall: From Slave Ship to Ghetto* (Ottawa: University of Ottawa Press, 2010), 168.

2 On the predominance of male dancers in the dancehalls, see Donna P. Hope, "*Passa Passa*: Interrogating Cultural Hybridities in Jamaican Dancehall," *Small Axe* 10, no. 3 (2006): 119–33; Donna P. Hope, *Man Vibes: Masculinities in the Jamaican Dancehall* (Kingston: Ian Randle, 2010); and Nadia Ellis, "Out and Bad: Toward a Queer Performance Hermeneutic in Jamaican Dancehall," *Small Axe* 15, no. 2 (2011): 7–23.

3 On the legibility of black subjects in moving camera technologies, consult Brian Winston, "A Whole Technology of Dyeing: A Note on Ideology and the Apparatus of the Chromatic Moving Image," *Daedalus* 114, no. 4 (1985): 105–23.

4 Skin bleaching temporarily changes the surface of the skin. Products must be reapplied to maintain changes in pigmentation.

5 I use the characterization of "black public sphere" offered by the editors of *Public Culture*: "The Black public sphere is primarily concerned with moder-nity and its relation to Black people through culture, politics, law and econom-ics. Modernists, from W. E. B. Du Bois to the present, have been concerned with how to adopt modernism and modernization to Black ways of life. They have sought to make Blackness *new* and remove it from the pathological spaces reserved for it in Western culture, to define their own version of modernity so as to provide a quality of life for Black people and to legitimize Black ways of life as modernist expressions." Moreover, commodities and their circulation and their relationship to markets, freedom, identity, property, and pleasure are key in the articulation of the black public sphere. Arjun Appa-durai, Lauren Berlant, Carol A. Breckenridge, and Manthia Diawara, "Editorial Comment: On Thinking the Black Public Sphere," *Public Comment* 7, no. 1 (1994): xii–xiii.

6 As Winnifred Brown-Glaude persuasively argues, "bleachers betray or at least destabilize popular conceptions of blackness that rely on an understanding of the body as given, fixed, permanently and naturally marked by race"; see Winnifred Brown-Glaude, "The Fact of Blackness? The Bleached Body in Contemporary Jamaica," *Small Axe* 11, no. 3 (2007): 35.

7 I am using "flesh" of video here as Laura Marks does in *The Skin of the Film: Intercultural Cinema, Embodiment, and the Senses* (Durham, NC: Duke University Press, 2000), xi–xvii. I discuss this concept later in the chapter.

8 DJs and promoters set up sound systems, consisting of turntables and large speakers, which became central sites for the playing of the latest local and international music; see Donna P. Hope, *Inna di Dancehall: Popular Culture and the Politics of Identity in Jamaica* (Kingston: University of the West Indies Press, 2006), 10.

9 On "modern blackness," see Deborah A. Thomas, *Modern Blackness: Nationalism, Globalization, and the Politics of Culture in Jamaica* (Kingston: University of the West Indies Press, 2004), 230–62. On the notion of slackness, consult Carolyn Cooper, *Noises in the Blood: Orality, Gender, and the "Vulgar" Body of Jamaican Popular Culture* (Durham, NC: Duke University Press, 1995), 136–73. Cooper writes: "Slackness is a metaphorical revolt against law and order; an undermining of consensual standards of decency. It is the antithesis of Culture" (141).

10 Hope, "*Passa Passa*," 133; Norman C. Stolzoff, *Wake the Town and Tell the People: Dancehall Culture in Jamaica* (Durham, NC: Duke University Press, 2000), 206; and Bibi Bakare-Yusuf, "Fabricating Identities: Survival and the Imagination in Jamaican Dancehall Culture," *Fashion Theory* 10, no. 4 (2006): 465.

11 Sowah, interview, 2011.

12 Sowah, interview, 2011.

13 Sowah, interview, 2011.

14 As a Portmore resident, Simone Ainsworth, explained, "When they see the video man, they just go crazy, trying to outdo each other. They 'jam off' together, dancing and talking, but once the video lights fall on them, they transform. They rival each other for the attention of the cameraman. . . . And the cameraman makes the rounds, ignoring the men and dismissing the girls who are fully clad. He goes in pursuit of exposed skin. And he goes in close with the lens. The men at a dance stand aside and look. They profile in the latest designer wear and don't sweat. When they get on the video, they pose in one position, nursing a Heineken or a Guinness bottle. They hardly breathe, so frozen is the pose"; quoted in Claude Mills, "Girls and 'Dem Crew," *Gleaner*, April 6, 1998.

15 Sowah, interview, 2011.

16 Sowah, interview, 2011.

17 Sowah, interview with author, Kingston, August 9, 2013.

18 Beth-Sarah Wright, "Emancipative Bodies: Woman, Trauma, and a Corporeal Theory of Healing in Jamaican Dancehall Culture," Ph.D. diss., New York University, 2004, 217.

19 Ras Tingle notes that on a trip to Nassau he became aware of the widespread viewership of dancehall footage from Jamaica when local people in Nassau (having viewed videos from Kingston) used the name of a police officer in

Jamaica to refer to the presence of law enforcers in Nassau. Ras Tingle, interview with author, Kingston, June 11, 2009.

20 Sowah, interview, 2013.

21 Gina A. Ulysse writes: "During my fieldwork in the mid 1990s, bootleg copies of Biggie's fashion shows (he was one of dancehall's top designers at that time) made their way to Brooklyn in one day, or the latest Video Soul or MTV buzz clips could be seen before record companies formally released these albums on the island"; Gina A. Ulysse, *Downtown Ladies: Informal Commercial Importers, a Haitian Anthropologist, and Self-Making in Jamaica* (Chicago: University of Chicago Press, 2007), 106.

22 Sowah, interview, 2013. In 1995, the Jamaican dollar was worth about U.S. $0.0308, and in 2011 about U.S. $0.0116.

23 Pamella Fae Jackson, "Dancehall Site: A Hit in Cyberspace," *Gleaner*, July 10, 1999.

24 Felicia Greenlee, interview with author, Kingston, August 9, 2013.

25 Niaah, *Dancehall*, 168.

26 Every copy of a copy of VHS tape represents a generation and displays what is often referred to as "generation loss," the loss in quality.

27 Richard Delano Forbes, interview with author, Kingston, August 9, 2011.

28 Sowah, interview, 2011.

29 Dons are nonelected figures who often govern in garrison communities through a system of patronage and intimidation.

30 The chorus of the song comments that "some gals not ready for the video light yet" because they lack an "upfront appearance." Frisco Kid, "Video Light" (single), Cell Block Studio Records, 1996.

31 The earliest reference I have found is Claude Mills, "Heat in the City: The Layers of the Dancehall Queen," *Flair Magazine*, April 22, 2002, 8.

32 On occasion, videographers have a detached, handheld light.

33 "Women Fight for Video Light," *Jamaica Star Online*, August 12, 2008, http://jamaica-star.com/thestar/20080812/news/news1.html (page discontinued).

34 Richards, interview with author, Kingston, June 6, 2009; Sowah, interview, 2013.

35 Sowah, interview, 2011.

36 The diffuser or scrim is a "translucent material attached to the front of a lighting fixture to disperse and then soften the light quality, or to reduce its intensity. Pun-glass sheet and frosted plastic sheeting are widely used"; see Gerald Millerson, *Lighting for Video* (1975; repr. Oxford: Focal Press, 1991), 148.

37 Mills, "Heat in the City," 8.

38 Marc Ogden, a video engineer at CBS, quoted in Lorna Roth, "Looking at Shirley, the Ultimate Norm: Colour Balance, Image Technologies, and Cognitive Equity," *Canadian Journal of Communication* 34, no.1 (2009): 129. See Roth, too, on the technical challenges of representing non-Caucasian skin.

39 Brian Larkin, *Signal and Noise: Media, Infrastructure, and Urban Culture in Nigeria* (Durham, NC: Duke University Press, 2008), 237.

40 Marks focuses on how filmmakers working between cultures use cinema and video to translate a physical and multi sensorial sense of place and culture; Marks, *Skin of the Film*, xi, 21–22.

41 Marks, *Skin of the Film*, xi.

42 Sowah, interview, 2011.

43 Sowah, interview, 2013.

44 Sowah's sense that everyone deserved to be in the video light made the technology democratic in the sense that it was all-inclusive, available, and accessible to all. Sowah, interview, 2011.

45 Johann Dawes, interview with author, Kingston, June 19, 2009; Radcliffe Roye, interview with author, Brooklyn, October 12, 2012; and Sowah, interview, 2013.

46 Kenrick Brown ("Sick in Head"), interview with author, Kingston, June 8, 2009.

47 The dynamics of the dancehall recall Rancierè's description of emancipated spectatorship, which "challenges the opposition between viewing and acting"; Jacques Rancière, *The Emancipated Spectator*, transl. Gregory Elliott (New York: Verso, 2009), 13.

48 Rancierè, *Emancipated Spectator*, 19.

49 On the emergence of male dancers in the dancehall, see Niaah, *Dancehall*, 125; Hope, "*Passa Passa*"; Hope, *Man Vibes*; and Ellis, "Out and Bad."

50 Krista Henry, "Dancehall Grows Away from Roots," *Sunday Gleaner*, September 24, 2007.

51 Krista Henry, "Dancehall Grows Away from Roots," F1.

52 Hope, *Inna di Dancehall*, 63–64; and Hope, *Man Vibes*, 20–25.

53 Popular skin-bleaching ingredients include potent topical steroids, like betamethasone and clobetasol. On skin-lightening products, see Donna P. Hope, "From *Browning* to *Cake Soup*: Popular Debates on Skin Bleaching in the Jamaican Dancehall," *Journal of Pan-African Studies* 4, no. 4 (2011): 41; Derron Wallace, "Lighten Up Yu Self! The Politics of Lightness, Success, and Color Consciousness in Urban Jamaica," *JENdA: A Journal of Culture and African Women Studies* 14 (2009): 27–28; and Athaliah Reynolds, "'Proud a Mi Bleaching': 'Skin-bleachers' Defend Their Action Despite Health and Cultural Warnings," *Sunday Gleaner*, November 15, 2009.

54 Reynolds, "'Proud a Mi Bleaching.'"

55 Serge F. Kovaleski, "In Jamaica, Shades of an Identity Crisis," *Washington Post*, August 5, 1999.

56 See Diane J. Austin-Broos, "Race/Class: Jamaica's Discourse of Heritable Identity," *New West Indian Guide* 68, nos. 3–4 (1994): 213–33; Natasha Barnes, *Cultural Conundrums: Gender, Race, Nation, and the Making of Caribbean Cultural Politics* (Ann Arbor: University of Michigan Press, 2006); and Ulysse, *Downtown Ladies*.

57 For a critique of contemporary color privilege in Jamaica, see Melville Cooke, "Blaming the Bleacher," *Daily Gleaner*, January 26, 2006.

58 Hope quotes participants in the panel discussion "Loving the Skin You're In," including final year students at the Caribbean Institute of Media and Communication and held at the basic school in the Mona Commons community, 1999; Hope, *Inna di Dancehall*, 42.

59 See interview in Kamila McDonald, "Skin Bleaching and the Dancehall," YouTube video, posted by Kamila McDonald, June 19, 2012, www.youtube.com/watch?v=Jb5aasZEBX4.

60 Brown-Glaude, "Fact of Blackness," 34–51.

61 Reynolds, "'Proud a Mi Bleaching.'"

62 Mills, "Heat in the City," 8–9.

63 Niaah has also noted: "One particular interviewee said, yeah, you bleach your skin on Thursday, there's a certain process, so that by the weekend you would

be ready for the light." Niaah, interview with author, Kingston, August 15, 2011.

64 Greenlee, interview, 2013.

65 Winston, Dyer, and Roth note that film stocks, cameras, and lighting were not developed to focus on black skin. Winston, discussing technologies developed by Kodak, makes the important point that photographic technologies represented an "optimum" culturally determined ideal of white skin tones, preferring "a whiter shade of white"; Winston, "Whole Technology of Dyeing," 121; Richard Dyer, *White* (New York: Routledge, 1997), 90; Roth, "Looking at Shirley."

66 The African American writer Ralph Ellison describes blacks in U.S. society as so hypervisible that they have been rendered *un*-visible—a phenomenon that has increased exponentially since the 1980s. Ellison writes, "Thus despite the bland assertions of sociologists, 'high visibility' actually rendered one *un*-visible—whether at high noon in Macy's window or illuminated by flaming torches and flashbulbs while undergoing the ritual sacrifice that was dedicated to the ideal of white supremacy"; Ralph Ellison, Introduction, *Invisible Man* (1952; repr. New York: Random House, 1981), xv. For a discussion of Ellison's use of the term "un-visible," see Avery Gordon, *Ghostly Matters: Haunting and the Sociological Imagination* (Minneapolis: University of Minnesota Press, 1997); my thanks go to Tina Campt for this reference.

67 Sowah, interview, 2013.

68 "It brights them up and makes them look pretty," one interviewee states in McDonald, "Skin Bleaching and the Dancehall." See also Kovaleski, "In Jamaica, Shades of an Identity Crisis."

69 "Winston," interview on *Our Voices*, CVM TV, Kingston, April 7, 2003, quoted in Niaah, *Dancehall*, 135.

70 Reynolds, "'Proud a Mi Bleaching.'" In McDonald, "Skin Bleaching and the Dancehall," one interviewee describes how sun "activates" the skin, and the video includes footage of people protecting their skin from the sun's rays by various means.

71 See Christopher A. D. Charles, "Skin Bleaching, Self-Hate, and Black Identity in Jamaica," *Journal of Black Studies* 33, no. 6 (2003): 711–28; Melville Cooke, "Blaming the Bleacher," *Daily Gleaner*, January 26, 2006; Kovaleski, "In Jamaica, Shades of an Identity Crisis"; Ken Jones, "Bleaching Is More Than Skin-Deep," *Gleaner*, January 9, 2011; Paul H. Williams, "Bleach Boys," *Gleaner*, February 26, 2012.

72 On skin bleaching (in Ghana) as "an expression of a cultural memory anchored in colorism and its antecedent colonialism," see Yaba Amgborale Blay, "Yellow Fever: Skin Bleaching and the Politics of Skin Color in Ghana," Ph.D. diss., Temple University, 2007. On its manifestation in Jamaica, see Wallace, "Lighten Up Yu Self"; and Cooke, "Blaming the Bleacher."

73 See elaborations of such arguments, in the order mentioned, in Charles, "Skin Bleaching, Self-Hate and Black Identity in Jamaica"; Wallace, "Lighten Up Yu Self!"; and Brown-Glaude, "Fact of Blackness," 35.

74 Dyer, *White*, 122.

75 Esther Figueroa, interview with author, Kingston, August 15, 2011.

76 Sowah, interview, 2011.

77 About the early broadcast of popular music, Niaah writes: "The irony is that Jamaican popular music and culture, its purveyors and their lifestyles, did not feature in the media before programmes such as *Teen Age Dance Party*, pro-

duced by Sonney Bradshaw, were initiated at the former Jamaican Broadcasting Corporation in 1959 and became popular in the early 1960s. That single programme featuring Jamaican music and dance culture was broadcast on radio from Mondays to Fridays, and on television on Fridays, then moved out of the studios on Saturdays. The first venue was the Broadcasting Corporation itself, but then it moved to the Rainbow Club (formerly Skateland in Halfway Tree), the Glass Bucket Club, and Johnson's Drive Inn"; Niaah, *Dancehall*, 11.

78 See "Freddie McGregor Finds UWI Lecturer Off-key on Crime," *Gleaner*, November 9, 2008; and Denise Reid, "Dancehall Not Fuelling Violence," *Gleaner*, November 5, 2008.

79 Niaah, *Dancehall*, 63.

80 Banton quoted in Niaah, *Dancehall*, 63.

81 As dancehall historian Niaah describes, such incidences are so common that it is widely believed that a British film crew once orchestrated a raid because such frequent incursions had become associated with the experience of the dancehall; Niaah, *Dancehall*, 9, 63.

82 The act made it illegal to operate a loudspeaker between "(a) 2 o'clock and 6 o'clock in the morning on a Saturday or Sunday; and (b) midnight on a Sunday, Monday, Tuesday, Wednesday or Thursday and 6 o'clock in the following morning"; Noise Abatement Act, March 26, 1997.

83 The police were also not granting permits; see Teino Evans, "Night Noise Act Casts Shadow: Promoters Protest Regulation: Dutty Fridaze on Hold," *Jamaica Star*, April 18, 2008, http://jamaica-star.com/thestar/20080418/ent/ent1.html (page discontinued).

18

The Not-Yet Justice League

Fantasy, Redress, and
Transatlantic Black History
on the Comic Book Page

DARIECK SCOTT

We rarely call anyone a *fantasist*, and if we do, usually the label is not applied in praise, or even with neutrality, except as a description of authors of genre fiction. My earliest remembered encounter with this uncommon word named something I knew well enough to be ashamed of—a persistent enjoyment of imagining and fantasizing, and of being compelled by representations of the fantastic—and it sent me quietly backpedaling into a closet locked from the inside, from which I've only lately emerged. My favorite film critic, Pauline Kael, in her review of Spanish auteur Pedro Almodóvar's *Law of Desire* (1987), one of my favorite films, declares, "*Law of Desire* is a homosexual fantasy—AIDS doesn't exist. But Almodóvar is no dope; he's a conscious fantasist."[1] Kael's review actually offers very high praise of Almodóvar, but Kael's implicit definition of *fantasist* via the apparently necessary evocation of its opposites and qualifiers—Almodóvar is *not* a dope, Almodóvar *is* conscious, presumably unlike garden-variety fantasists—was a strong indication to me that in the view of the culturally, intellectually, and politically educated mainstream United States, of which I not unreasonably took Kael to be a momentary avatar, fantasy foundered somewhere on the icky underside of the good. The work of thinking and acting meaningfully, of political consciousness and activity, even the work of representation, was precisely not what fantasy was or should be.

Yet a key element of what still enthralls me about *Law of Desire* was something sensed but not fully emerged from its chrysalis of feeling into conscious understanding: the *work* of fantasy. I began to understand this intuition as I read Kael's quote of Almodóvar articulating a point he's made

many times in interviews over the years about *Law* and his early films: "My rebellion is to deny [General Francisco] Franco. . . . I refuse even his memory. I start everything I write with the idea 'What if Franco had never existed?'"[2] Almodóvar may be the most globally recognized artist, and indeed public figure, associated with the Movida, the cultural efflorescence that took place in Spain after fascist dictator Franco's death in 1975. Thus this statement and its many reiterations certainly do illustrate the *conscious* nature of Almodóvar's fantasizing, which Kael finds praiseworthily singular among fantasists.[3] But they also shimmer with questions worth asking:

When is any elaborated fantasy *not* conscious, and when is such a fantasy *not* responsive to, and *not* somehow working with the material consequences of the political and historical events and conditions we understand to be "real," and that we understand to be the object of serious, meaningful inquiry? Might conscious, responsive working be what fantasy is and does? And does not, or might not, a fantastic gesture like refusing the memory of Franco operate suggestively, even in something so apparently trivial as filmic representation and entertainment, in ways that exceed the specific dream-world content of the elaborated fantasy? (For one thing, a world without AIDS isn't just a "homosexual" fantasy alone, as it may have appeared to Kael in 1987; it is a fantastic goal and desire of millions on the globe not remotely identified with gay European and North American worlds.) Almodóvar meticulously, laboriously chooses not to remember Spain's recently (at the time) entombed fascist history and not to acknowledge AIDS deaths and illness; these are the foundational moves of an imperious act of creation, rather as if he were building a house on top of a hole he had dug into the earth. But surely we can see that such gestures mimic the world-building moves of hegemonies: erasing through the tricks of naturalization whole swathes of history, or intentionally failing to render historical events lived in the past; not acknowledging the deaths and suffering of any it deems its enemy or its instrument. In this light, Almodóvar's fantasy is as much work *in* what we call reality (which we never name with more pleasure than when using it as a bludgeon to dismiss or silence those we think of as dopes) as it is an assault *on* the injustices and tragedies of the reality that always abuses us.

The most trivializing common notion of fantasy entails the idea that it's about childish or naive wish fulfillment. Lauren Berlant says in *Cruel Optimism*, "Fantasy recalibrates what we encounter so that we can imagine that something or someone can fulfill our desire."[4] I quote this definition almost at random (the sentence leapt to my attention as it was quoted

by one of my dissertation students) to indicate the pervasiveness of an understanding of fantasy as suspect deception, as diversion from reality. In this view, the dominant commonsense and intellectual view, I think, *fantasy* is another word for what is not happening, what we are not doing, or what is at best merely the inchoate precursor of a doing. Fantasy as an object of intellectual analysis names the antithesis or serves as the antonym of authentic relations to the temporal past (history) and the temporal present (reality), and has meager, if not dangerously opiate-like, purchase on the temporal future.

These are of course understandings I want to problematize in this essay, as I begin to ask what kind of recalibration fantasy works on the world—and to think further about whether the fantastic pathways of desire always lead us to a cruel end. In particular as I follow Almodóvar and leave the closet and take up the banner of fantasist, I am interested in how the wish that underlay many of my fantasies and my interest in fantasy genres was always for the world to be different—for it not to be an antiblack world, for it to be some kind of pro-black or maybe just anti-antiblack world, and presumably therefore, for me to be different as that different world's product. My ur-fantasy then and perhaps now was and is a fantasy recalibrating two of the great fantastical chimeras of the real world: "blackness" and its cognate, "Africa." Thus I'm proposing here, heuristically, that the practice of African Diaspora, black politics—black *study*, if we try to take up Fred Moten's challenge—is not without, and indeed very much needs, fantasy.

My primary questions, for which I can only begin to survey answers, are: How and in what ways might a deliberately shaped unreality (fantasy) un-realize the devaluation of blackness or the power of antiblack racism? How might such fantasy make visible, even as an evanescence, black power or black triumph, or, in the visual realm, black beauty? How can the histories of the Black Atlantic that produce the meaning of blackness and the regimes for seeing black bodies be *fantasized* differently?

Fantasy of course is a vague and capacious term that functions in common usage as a synonym for the vague, flimsy, and meaningless, but it is also a term denoting genres of representation in film and publishing, and a term encompassing or inflecting elements of the political, social, cultural, and economic. I intend to touch on all these inflections, but to focus on a genre steeped in the fantastic—graphic narratives, or comic books—and to try to read this work, and fantasy itself, in conversation with political and psychoanalytic theoretical concepts. I'm going to meditate on one fantastic moment—I'm choosing provisionally to call it a "moment"

(though in truth it is not temporally bounded or defined) in order to distinguish it from a fantastic narrative or even a fantastic image—though this moment *is* made up of images appearing in a narrative. This is a narrative where we don't expect fantasy to appear, or to have any proper or significant function: a depiction of "true" historical events in a graphic novel adaptation of literature, Kyle Baker's *Nat Turner* (2008).

Du Bois and the Guide of Beauty

Typically of course we think of the relation between fantasy and blackness in the way that Frantz Fanon diagnoses so convincingly in *Black Skin, White Masks* (1952). As he writes, "Good-evil, beauty-ugliness, black-white: such are the characteristic pairings of the phenomenon that . . . we shall call 'delirious Manichaeism.'"[5] From such an Afro-pessimist *avant la lettre* point of view, as blackness is hewn from the material of pernicious fantasies, no fantasy taking blackness as its subject can actually overcome, undo, or effectively ameliorate the ontological object-status that blackness is created to signify and to materialize/effect.

While acknowledging the persuasiveness of this argument, nevertheless in this essay I want to pursue the idea that fantasizing against antiblackness and fantasizing the African Diaspora is highly significant, even if we cannot precisely measure such fantasies' effectiveness, and even though the wildest fantasy cannot free itself from the constraints of fantasizers' immersion in a racialized "real" world.

I take as a guiding notion and a possible counter to the trivialization of fantasy the idea that what distinguishes the paraliterary genre of fantasy, and fantastic gestures of representation, from the conventions of realism (and from fantasy's supposed twin, science fiction) is that in a fantasy narrative, justice is done. The mark of the genre is that the demand for justice of the characters positioned as victims of injustice—who are thus also the narrative's protagonists—is met, in defiance of the "laws" of nature or physics (hence the fantasy) and in defiance of how we know "real" juridical law operates, since rarely or only accidentally do either have anything whatsoever to do with justice (this if nothing else is what graduating from Yale Law School has taught me). This is why I am interested in fantasy: it is a (generic) mode, perhaps really the only one, for representing and perhaps experiencing the satisfactions of justice.

"All fantasy is political, even—perhaps especially—when it thinks it is not," declare Mark Bould and Sherryl Vint, writing about the fantasy genre

of literature.[6] Rosemary Jackson argues that fantasy "characteristically attempts to compensate for a lack resulting from cultural constraints: it is a literature of desire, which seeks that which is experienced as absence and loss."[7] Fantasy disrupts the smooth surface of the bourgeois social order as it is constructed in the mimetic novel: the fantastic functions in the literary traditions of the West as that which illuminates the shadow side of realism (as a mode of representation) and the various forms of disciplining that structure bourgeois capitalist/industrialist society and modernity. At least potentially then fantasy reveals the price paid for the rigidity of social, sexual, and racial categories that comprise our epistemological limits.[8]

This is fantasy as *critique*—which is not precisely where I want to land in this essay; I want to make the argument for fantasy on other grounds. But I need to start here in thinking about fantasy as critique, and I'll begin complicating what we understand to be the relationship between fantasy and reality, and fantasy and blackness, by turning to one of the primal theorists of the African Diaspora, the Black Atlantic, and African Americanness—who rarely or never used these exact terms, nor did he use the term "fantasy" in these excerpts I'm taking from his 1926 essay, "The Criteria of Negro Art," though I think what he says very much pertains to how I am thinking about black fantasy.

W. E. B. Du Bois is famously quoted as saying that "All Art is propaganda and ever must be, despite the wailing of the purists."[9] Especially since these words were written in the context of the New Negro Renaissance, and given Du Bois's role as a moving force in the first wave of publications and publicity involved in that artistic movement, we not infrequently suppose that Du Bois having his druthers would subordinate the content of a work of art to the political demands he would make on it, and that for him there is little question of which is the chicken and which the egg when it comes to politics and art: following this Du Bois we might believe that art is either a deceiver (propaganda for political oppression) or a revealer (propaganda for political fights against oppression), and its measure lies in its proper reiteration of reality, whether it pacifies through a false fulfillment of desire or it maps the lack of fulfillment crying out for redress in the present.

But the sketch of the relation between the real-political and the imagined-artistic in "The Criteria of Negro Art" actually indicates that the causal and temporal relations between chicken and egg are more complex. Just as Du Bois proposes (and we have taken up as gospel since) that the American Negro both suffers and enjoys the unique perspective

endowed by double-consciousness, he argues that the doubly conscious African American, "pushed aside as we have been in America," attains the clarity of "a vision of what the world could be if it were really a beautiful world." In a beautiful world we would have "to be sure, not perfect happiness," but it would be "a world where men know, where men create, where they realize themselves and where they enjoy life."[10]

Beauty thus names not an aesthetic quality alone, but either a quality describing or the very substance of "infinite" "variety" and "endless" "possibility" in a world where humans are one of the bounties of nature. Du Bois writes: "In normal life all may have [Beauty] and have it yet again. The world is full of it; and yet today the mass of human beings are choked away from it, and their lives distorted and made ugly. This is not only wrong, it is silly. Who shall right this well-nigh universal failing? Who shall let this world be beautiful? Who shall restore to men the glory of sunsets and the peace of quiet sleep?"[11] Du Bois then goes on to investigate what Beauty *is*:

> What has this Beauty to do with the world? What has Beauty to do with Truth and Goodness—with the facts of the world and right actions of men? "Nothing," the artists rush to answer. They may be right. I am but a humble disciple of art and cannot presume to say. I am one who tells the truth and exposes evil and seeks with Beauty and for Beauty to set the world right. That somehow, somewhere eternal and perfect Beauty sits above Truth and Right I can conceive, but here and now and in the world in which I work they are for me unseparated and inseparable.[12]

And finally, he writes: "The apostle of Beauty thus becomes the apostle of Truth and Right not by choice but by inner and outer compulsion. Free he is but his freedom is ever bounded by Truth and Justice; and slavery only dogs him when he is denied the right to tell the Truth or recognize an ideal of Justice."[13] Du Bois thus suggests that it is the ability to recognize Beauty, and in a sense to thereby free Beauty from bondage, that enables the establishment of a universally good society. This proposes Beauty as a guide (I seek with Beauty), a mode of access, which gets us to justice on a broad political level as well as to enjoyment in everyday experience. This is a justice and enjoyment merely "normal" and "everyday" in a world that has achieved the Beauty immanent in it (I seek for Beauty: in which *Beauty* names an aspiration not for a sui generis creation, but for the restoration of an already-present *reality*). Contra the Western separation of beauty, or

art, from truth and right, Beauty (in and as art) is actually the form of living truth and experienced "right" (justice); in the absence of such beauty, we are dogged by slavery.

We can flip the equivalencies Du Bois outlines in various fruitful ways: Truth is what is beautiful, Right (justice) is what is beautiful; Beauty is what is truthful, Right is what is truthful; Beauty is what is right (just), Truth is what is right. Perhaps, to better behold these beauteous connections, I should propose that "Truth" is a semi-scientific term, denoting the achievement of an apprehension of the world-as-it-is, as close to unmediated reality as we can capture in signification, *and* it is a fact invested with the value of being incontrovertible. We see too that Du Bois's "Right" and "Justice" are interchangeable terms: "Right" thus is almost a term following from notions of "natural right": that which is *inherently* appropriate (natural), necessarily then connoting a notion of some kind of universal endowment or distribution of good or good possibilities. We can detect also here a hint of the *mystical*; it would appear that Du Bois's thinking is dancing along that thread of mysticism in the German Idealist philosophical tradition that informed his various analyses. But if this is mystical thinking—if it is underpinned by a conviction (or an experience) of the mind's direct apprehension of a universal unity—this is a *political mysticism*: by which I mean that the encounter of the mystic is not with God but with the otherwise unseen *structure* of the human world, which it would seem in Du Bois is an indivisible amalgam of human perception, human making, and "natural" (but this is itself invested with human values) phenomena, and thus inherently a product of politics broadly conceived.

For Du Bois, without Right/Justice we don't have Truth; nor do we recognize Beauty. In the unjust world where gorgeous sunsets have been stolen and hoarded by European colonizers and enslavers rapaciously plundering Africa, Asia, and the Americas, Beauty is *as yet* only realized (and thus not realized fully) in the lesser dimensions in which it appears when it is amputated from Reality: the aesthetic and imagined. But the aesthetic or imaginary, whatever form or genre they take, are not actually aesthetic or imaginary *only*. They cannot be separated from the realization of the Truth and the Right: and it may be that Truth and Right are *only* realized as and with Beauty. This makes sense if Beauty, Truth, and Right are not only "inseparable" but also "unseparated": Du Bois goes to the trouble to both link and distinguish these states or modes.

This then may be the work of Afro-Diasporic fantasy, as set forth by an apostle of the African Diaspora: to reveal, or rediscover, the lack of separation, the connectedness that already exists but is aggressively

concealed—we are "choked away" from the recognition of it—between the Beauty that is (it is reality, and thus to reveal it is to reveal Truth) and the Beauty that must become (the recognition of Right, the achievement of Justice). Fantasy as a mode might be the means to uncover a hidden reality and hidden possibility—the latter seemingly foreclosed by a misapprehension of reality, a conspiratorial misrecognition motivated by exploitative greed.

There is an evocative and paradoxical phrase in psychoanalytic theory, pertaining to the operations of fetishism and hysteria and symptomatic responses to trauma, wherein the analyst discovers in the patient's discourse or in cultural discourse, despite our mighty attempts to repress and obfuscate, *how things really appear*.[14] The gambit of fantasy-in-art from this Du Boisian perspective would be—ironically, given our commonsense notions of the frivolousness or opiate-of-the-masses quality of fantasy—to discover *how things really* are, which is simultaneously: *how things really might be.* As Bould and Vint say, "The tensions between fixedness and contingency, formula and innovation, . . . the world-as-it-is and the world-as-it-might-be are common to fantasy texts of all types."[15]

The Fantastic History of Nat Turner

To consider revelations of the beautiful connections between fantasy and justice, I'd like to look now at a comic book moment.

African American cartoonist Kyle Baker is a celebrated artist, the winner of multiple Will Eisner Comic Industry Awards as well as the illustrator of a range of superhero comics, including *Truth: Red, White and Black* (2004)—a revision of paradigm superhero Captain America—and *Deadpool Max* (2011). In 2006, Baker serialized an adaptation of *The Confessions of Nat Turner* ("as fully and voluntarily made to Thomas R. Gray"), which was published as a complete graphic novel called *Nat Turner* in 2008. I want to examine here a couple of the storytelling strategies Baker uses to adapt Turner/Gray's written account into a graphic narrative.

In *The Confessions*, Turner tells Gray that he was considered unusually gifted and a prophet in the making from a young age. Turner states: "Being at play with other children, when three or four years old, I was telling them something, which my mother overhearing, said it had happened before I was born—I stuck to my story, however, and related somethings which went, in her opinion, to confirm it—others being called on were greatly astonished, knowing that these things had happened, and caused them

to say in my hearing, I would surely be a prophet."[16] We might read this recollection in comic book superhero terms as Turner's origin story, or in vulgar psychoanalytic terms as Turner's recitation of the primal scene of his self-creation. Turner says nothing further about this particular event, and does not recount what true story of the past he told his playmates that his mother overheard.

Baker in his adaptation of *The Confessions* imagines for us the content of the story Turner told as a child. Throughout *Nat Turner,* the text that accompanies Baker's images is composed of direct quotations from *The Confessions*; characters don't speak in conventional word balloons (though sometimes they do in symbol balloons), but only "say" in the excerpted text lying alongside Baker's illustrations what Turner (via Gray) reported they said (though the testimony of Thomas Gray and a slave-ship captain are also reproduced in the text). The first 45 pages of the 189-page graphic novel have no reproduced text from *The Confessions*; they unreel before us almost like a silent film. And it is in these pages that the story Turner's mother overheard him telling—of an event she herself also appears to have witnessed—is told.

The images-only story is of a village somewhere in Africa raided by slavers (figures 18.1a–b). The villagers fiercely resist, killing at least one of the raiders, but at least a few villagers are captured. The story focuses in on one woman, who is captured while diverting the raiders from kidnapping her son. We see the woman branded (without representation through sound effects of her screams, though we have had sound effects of guns firing); and then we see her aboard a ship in the hellish Middle Passage, where among other things she witnesses a baby being born in the holds. When the kidnapped Africans are taken on deck for the crew's sadistic entertainment, the mother of the baby takes advantage of another moment of diversion to throw her child overboard into the sea, where a huge shark waits with open mouth and bared teeth to devour it (figures 18.2–4). Later we learn that this is the story the child Turner recounts in Baker's reimagination of *The Confessions,* by the word-balloon bearing the image of the baby falling into the mouth of the shark (figure 18.5).

Since the medium here is a graphic novel—but especially because this sequence (again, the origin story, as it were, of Nat Turner) is entirely visual, without text—we analytically have to take account of how Baker works with the challenge of the always-spectacular black body: nowhere more readily a spectacle than in scenes such as these of the black person suffering, as Saidiya Hartman reminds us.[17] A surfeit of signification attends the *image* of black bodies in the visual field. This of course is what

18.1a.
Slaving raid in the "origin story" of Kyle Baker's *Nat Turner*. Kyle Baker, *Nat Turner* (New York: Abrams, 2008), 19.

18.1b.
As imagined by Kyle Baker, a character who is probably Turner's mother rescues her son—apparently Turner's elder, African-born brother—from the attack of the slavers. Baker, *Nat Turner*, 19.

18.2.
A mother escapes
from the slavers'
clutches . . . Baker,
Nat Turner, 50.

18.3.
. . . and tosses her
newborn child
overboard to
freedom . . . Baker,
Nat Turner, 51.

18.4.
. . . and to apparent
death in the mouth
of one of the sharks
that routinely
followed slaver-
ships during the
Atlantic crossing of
the Middle Passage.
Baker, *Nat Turner*,
55.

18.5.
A young Nat Turner
recounts the story
of what his mother
witnessed during
the Middle Passage.
Baker, *Nat Turner*,
57.

Fanon discusses so bracingly: the sense in which the black image always *appears* in such a way as to disappear as baseline human; it is enmeshed within the various overdeterminations which produce it as replete with readable meanings—it is always bearing a story, an explanation, always flaunting its valence as *different/difference*, evoking the familiar but largely inescapable assumptions of hypersexuality, hyperphysicality, monstrosity, and criminality that shape visual representations of blackness in Western culture.

In traversing this minefield Baker has made a risky wager by relying far more heavily on images than on text throughout *Nat Turner*. Any graphic novel or comic of course tends to do the same, but not to the extent that Baker does here. The withholding of text in favor of images of black characters is especially striking in the case of the initial forty-five pages, which are Baker's invention and not guided in content by Turner's reported confessions. Of course *The Confessions of Nat Turner* text itself is already shaped in unknown ways by Thomas Gray, the editor/reporter. The absence of text therefore seems on the one hand to figure for us the paucity of historical textual accounts of kidnappings of Africans and the Middle Passage—the familiar outrage in the guise of an archival problem, the archival gap that the neo-slave narratives of African American late twentieth-century and early twenty-first-century literature constantly confront. Baker arguably thus by suggesting that the story Turner told *can't* be told or isn't available in our language, figures the outrageous absence of the history of the enslaved, much as Toni Morrison does with her unpunctuated hallucinatory monologue of the Middle Passage in *Beloved* (1987), and as Tom Feelings does in his completely text-less children's book, *Middle Passage* (1995). On the other hand, the lack of language in the early scenes also risks enmeshing the African characters in the hungry spider's web of black spectacularity, and lends itself to a perception of the Africans as mute, dumb (i.e., not civilized, like animals).

Significantly the story "told" to Baker's Turner as though through a cross-generational telepathic transmission of images is a story about death. It suggests perhaps that a person enslaved is like a baby being eaten by a great white shark (vulnerable, without recourse other than to be consumed). The image/story seems to teach that death is preferable to enslavement; that courage to resist slavery is the courage to violently end your life and the lives of those you protect: it is a kind of lapel-pin-image summation of the idea that blackness equals both literal and social death. At the same time, being eaten by a shark before you're old enough to know you are enslaved is—something: what, we don't fully know. How

do we understand the image of the child in the maw of the shark? How are we to respond to it? Certainly with the moral outrage beckoned by abolitionist imagery of enslavement since the nineteenth century—though other images might promise to evoke this response more smoothly and automatically, like that of the mother being branded. Do we respond with the queasy titillation typical of horror images? Probably this, too. But the context, especially because *this* is the image/story that marks Turner's difference from his fellows and sets him on his insurrectionist, messianic, proto-revolutionary road, asks us to do more with this image, to read it more fully.

What are we to understand that Baker's Turner takes from it? As Baker represents it, Turner derives some understanding of what is True and what is Right from this story, even if by envisioning what stands as Truth's and Justice's opposite. Might this be an image illustrating and transmuting the elements of the vision Turner tells us in *The Confessions* that he received from God: "I saw white spirits and black spirits engaged in battle, and the sun was darkened—the thunder rolled in the Heavens, and blood flowed in streams"?[18]

The message of the image/story is ambiguous. It is *graphically silent* or *quiet*: in the same way that we think of "graphic violence" as explicit, heightened violence that may have some overweening effect on the viewer to witness, the silence here (which only deepens the quiet of reading and "hearing" in your thoughts) is expressive, it is generative of visceral effects. It is graphic too in that like a graph it encodes information, and issues a call to interpretation: specifically interpretation in its mode as translation, from image to word-concepts.

I think of the ambiguity and mystery here as valences summoned to this historical account by the necessary use of fantasy. Logic, physics, linear temporality dictate that Turner cannot know in detail what happened before he was born; that he does know it, and is in sufficient control of the information to tell it at three or four years old is the mark of his superhumanity. (In Du Boisian terms, that he *knows* is also the mark of his being on some level able to "see" and experience Beauty along with its triumvirs Truth and Justice—remember that a beautiful world is for Du Bois "a world where men *know*."[19]) But Turner's knowing is also a *figure*, both in *The Confessions* and in Baker's reimagination of it, that reaches for a connection, a revelation, a way of seeing reality that neither Turner nor Baker sees as available to conventional language or narration (Turner does not tell us the story's content, and perhaps cannot remember it as an adult; Baker renders it without text)—just as Turner's knowledge is not avail-

DARIECK SCOTT

able to rational explanation. The story and its meanings are not *outside* or *beyond* language, but seem to exist in para-position to conventions, as the fantasy genre exists as a paraliterature beside "realism" and mimetic fictions. The fantasy is necessary to perceive the reality, and at once the form of a perception of an unseen, demanded Justice Truth Beauty that uncorks the possibility of action—action like rebellion.

The fantastic is especially heightened in Baker's retelling by the flow of events—the context—in which the story/image appears: the unspecified setting of the village, the unspecified language the characters speak (which is unheard, as it were, and textless), underline how Baker's is an imaginary "Africa" from the point of view of a son of the Diaspora. It is an imaginary home, an imagined origin, and thus an imagined past, with little in the way of the proof of historical accuracy, though endnotes in the novel recite (without specific reference) explanatory or color-commentary facts like "Packs of hungry sharks routinely followed slave ships, to feast on the hundreds of dead bodies that went overboard."[20] Baker's reimagination is short on the proofs but meaningfully shorter on the pretense of history: we are not in the realm of artificial historical-period reproduction as in cinema, but in graphic novels and comic books, where caricatures and Superman-like iconic heroes abound: we are in the territories of unreality and the cartoonish.

The past, even the historical past, and fantasy are *both* imagined, as Leo Bersani reminds us. In his essay, "Psychoanalysis and the Aesthetic Subject" (2006), Bersani writes, "To remember events is to recognize ourselves in their imaginary presence . . . the past is what has passed from the phenomenological to the virtuality of the imaginary."[21] And: "Memory is an illusion of consciousness, as there is no past to remember."[22] In this vein Bersani writes that fantasy figures "are the possibility of the act that may of course precede the act, but that can also follow the act, when the latter moves back from the real, so to speak, in order to become always present, permanently imaginary" as the past.[23]

Thus, according to Bersani, "Fantasy is not the symptom of an adaptive failure . . . it is the sign of an extremely attentive, highly individuated response to external reality Fantasy is thus on the threshold between an invisible (and necessarily hypothetical) inner world and the world present to our senses In this regime, the distinction between inner and outer is wholly inadequate."[24] And: "*Psychic fantasy is a type of unrealized or derealized human and world being*, the figure, not for a taking place, but rather for all taking place—for all relationality—in its pure inherence."[25]

This is part of a complex argument I cannot fully explore here, but the

point I wish to bring to our attention is that fantasy and the past are psychi-cally, and perhaps neurologically—even ontologically—indistinguishable: fantasy is the figure not for an act that will be only be significant when it is real or material, but rather for the very process of the relation between the real and unreal, between the inner and outer, a process (or *the* pro-cess) which is inherent *to* the world as the world, and which constitutes the world, or at least the world as human beings move in it and are of it.

In Baker's imagination of the past—an imagination of the virtual, an unrealized and/or *derealized* mode of human *being*—Nat Turner's acts of resistance or pursuit of redress for antiblack injustice depend upon how well he translates the legacies and memories of African ancestral experience and culture, legacies and memories which have been ren-dered difficult to access, their messages difficult to decode, by the gaps in knowledge and understanding instantiated by the Middle Passage and reinforced by conventional language, narration, and history. The counter to this gap, the un-*thinkable* (at least, rationally unthinkable) articulation (in the Stuart Hall sense) that connects the unknown story to the hearer or witness who can understand it, is a kind of desired or aspirational fantasy of a great pan-Africa.

"Africa" is thus in Baker's African Diasporic America constructed as the repository for techniques (spiritual, telepathic, superhuman, magical) of empowerment and the acquisition of knowledge that offers salvation if only it can be properly evoked, decoded, or propitiated. Is then the work of fantasy towards justice a work of *redeeming* the past, of effecting—insofar as it effects anything—a return to past pain and past triumph that the passage of time otherwise renders impossible? Certainly it is true that injury and redress/recovery are the axes along which any contemporary reimagination or self-consciously fictive engagement with the history of slavery (and the black past generally) is graphed or plotted in African Americanist and Afro-Diasporic scholarship analyzing artistic mappings of the afterlife of slavery. Read in this light, we might think of Baker's *Nat Turner* as a perhaps-dangerous obfuscation of "real" history, a substi-tution of what we recognize as historical excavation by the fanciful and irrational.

But I think that Baker usefully challenges the very reality of history, by not just recognizing but also working with the fantastic aspect—the fantastic nature?—of historiography. Baker stages the impossibility of crossing the bar between present and past via cloaking his story's return to the past and its possible redemption in the vestments of the unreal. In the generic conventions of fantasy, these vestments might take the shape

of trolls and elves; in Baker's *Nat Turner*, they appear as an "Africa" that clearly maybe never-was, and of memories from the Middle Passage that take the form of gnomic lessons. This staging of the impossible knowledge of the past, the impossible return and redemption, is a *making* of the impossible as an unrealized or derealized mode of human being: a making of the impossible within the realm of, and using the material instruments of, the what-is, of consensual reality: a form of world-making. Such a making of unrealized or derealized being lies in para-position to our hegemonically prescribed world-making, which presents itself in the cloaks of the "real" and "natural." Such a making of unrealized or derealized being thus neither promises nor necessitates a future enactment or realization of its content—but it doesn't foreclose such enactment or realization either.

In *Nat Turner* I propose we find a *black fantasy* or a fantasy *in* blackness: that is, a fantasy defined by its black-positioned perspective, or a fantasy from within black positions that does not look at blackness from a white-defined outside but presumes its centrality and infinitude—a more metaphoric understanding of fantasy that emphasizes its taking place *in the dark*, as it were, via the invention of immaterially fleshed-out worlds from the material of shadows. This would be where fantasy is the mode of *seeing* and *making* and *being* connections (or being seen, made, and connected) across time and space, in despite of hegemonic power, a mode facilitated by blackness: by that black, Du Boisian seeing of Beauty immanent to our world but unrecognized by our protocols of seeing—not yet.

Both the not-yet deferral and its surpassing are offered in *Nat Turner* to us as readers, since we appear—in a sense, perhaps only in the sense of things as they really *are* and *might be*—within the graphic narrative. In Turner's apotheosis-via-hanging at the novel's end (figures 18.6a and 18.6b), we see Turner's body giving off a celestial light that awes the previously jubilant white onlookers. But then, as though magically summoned by Turner's death in the story—his body's autopsy inaugurates this character's almost non sequitur arrival on the stage—there appears a hitherto-unseen enslaved woman. She seems to work in a house where Thomas R. Gray's book has been left on a table (by a master whose facial expression suggests he is disturbed by the book's content). The woman takes the book and runs off with it into a fade-away panel of blackness; at the center of the novel's last panel as she disappears there floats a leaf that fell from a tree just before Turner's hanging, and which we must therefore suppose is some marker of his continuing presence (figure 18.7).

Here again we have a sequence that is not a part of Nat Turner's narration, but a part of Nat Turner's story, as Baker renders it. This woman

18.6a.
The carnival-atmosphere jubilation of white spectators at Turner's lynching-style execution gives way to awe and confusion as Turner's death defies their expectations. Baker, *Nat Turner*, 196.

18.6b.
A supernatural white light surrounds Nat Turner as he is executed. Baker, *Nat Turner*, 197.

18.7.
An apparently enslaved woman makes off with an account of Nat Turner's rebellion, while the leaf that fell from the tree used to hang Turner in 18.6a marks her fugitive disappearance from the scene. Baker, *Nat Turner*, 200.

is, I think, a figure for us as readers, since she takes the book to "read" it and glean what she can from it. Though of course we don't know whether she is literate, this is no obstacle. Baker's adaptation has suggested that the story can be transmitted otherwise or elsewise than through words, just as Baker's rendition of Turner's confessions does: it's as though the fantastical passing along of a fantasy is what we are witnessing and participating in as readers. Perhaps the story and its message don't need words because the "hearing" and understanding of them are ultimately a matter of perceiving, for which our readiest metaphor is "seeing"—a matter of seeing the Beauty immanent in the world, of seeing and participating along the nigh-unimaginable temporal arcs bending toward that Justice and Truth from which Beauty is "unseparated and inseparable."

Notes

1 Pauline Kael, *For Keeps* (New York: Dutton, 1994), 1133; ellipses in original quotation.
2 Kael, *For Keeps*, 1132.
3 One example of this oft-repeated statement appears in an interview with Frédéric Strauss about his film *Live Flesh* (1997). Discussing differences between his later and earlier films, Almodóvar says, "Things change over time Twenty years ago, my revenge against Franco was to not even recognize his existence, his memory; to make my films as though he had never existed. Today I think it fitting that we don't forget that period, and remember that it wasn't so long ago." See Frédéric Strauss, ed., *Almodóvar on Almodóvar*, trans. Yves Baignéres and Sam Richard, rev. ed. (New York: Faber and Faber, 2006), 180.
4 Lauren Berlant, *Cruel Optimism* (Durham, NC: Duke University Press, 2011), 122.
5 Frantz Fanon, *Black Skin, White Masks*, trans. Richard Philcox (1952; New York: Grove, 2008), 160.
6 Mark Bould and Sherryl Vint, "Political Readings," in *The Cambridge Companion to Fantasy Literature,* eds. Edward James and Farah Mendlesohn (New York: Cambridge University Press, 2012), 102.
7 Rosemary Jackson, *Fantasy: The Literature of Subversion* (New York: Methuen, 1981), 3.
8 I'm paraphrasing this succinct discussion of the fantastic mode of representation from Helene Moglen, "Redeeming History: Toni Morrison's *Beloved*," in *Female Subjects in Black and White*, eds. Elizabeth Abel, Barbara Christian, and Helene Mogle (Berkeley: University of California Press, 1997), 201.
9 W. E. B. Du Bois, "The Criteria of Negro Art," in *Du Bois: Writings*, Library of America Edition, ed. Nathan Huggins (New York: Literary Classics of America, 1986), 1000.
10 Du Bois, "Criteria," 994.
11 Du Bois, "Criteria," 995.

12 Du Bois, "Criteria," 995.

13 Du Bois, "Criteria," 1000.

14 For further discussion of this formulation in psychoanalytic theory, see "How Things Really Appear," a section of chapter 3 in my book *Extravagant Abjection: Blackness, Power, and Sexuality in the African American Literary Imagination* (New York: New York University Press, 2010) 129–38.

15 Bould and Vint, "Political Readings," 108.

16 Nat Turner, *The Confession of Nat Turner, The Leader of the Late Insurrections in Southampton, Va., As fully and voluntarily made to Thomas R. Gray* (1831: public domain), Amazon Kindle edition, loc. 83.

17 Saidiya Hartman, *Scenes of Subjection: Terror, Slavery, and Self-Making in Nineteenth-Century America* (New York: Oxford University Press, 1997). See especially the Introduction, 3–14.

18 Turner, *Confessions*, loc. 126.

19 Du Bois, "Criteria," 994; emphasis added.

20 Kyle Baker, *Nat Turner* (New York: HNA, 2008), 204.

21 Leo Bersani, "Psychoanalysis and the Aesthetic Subject," in *Is the Rectum a Grave? And Other Essays* (Chicago: University of Chicago Press, 2010), 147.

22 Bersani, "Psychoanalysis," 149.

23 Bersani, "Psychoanalysis," 148.

24 Bersani, "Psychoanalysis," 148.

25 Bersani, "Psychoanalysis," 149; emphasis added.

List of Contributors

Rushay Booysen is a photojournalist from Port Elizabeth, South Africa. His work includes the photo exhibition "Coloured: A Collage of a Hybrid Society" and has been featured on CNN, in a digital library in Barcelona, and at the African American Art and Culture Complex in San Francisco. His work was included in the first series of African art exhibited in the Middle East, at Dubai's Mojo Gallery. In June 2010, he spoke at New York University, California Lutheran University, the University of Michigan, and San Francisco's Museum of the African Diaspora, where he presented a documentary focused on the work of educators and artists in his home town, Port Elizabeth. He also hosted a discussion at San Francisco State University where he spoke on the role and power of the Internet in advocating for and educating the world about African culture.

Kiersten Dunbar Chace is an award-winning filmmaker from San Diego, California, who has focused her lens on the Coloured communities of South Africa for the past twenty-one years. Her first feature-length film, *I'm Not Black, I'm Coloured: Identity Crisis at the Cape of Good Hope*, was released in 2009 and has won several international awards, including the Audience Choice Award at the Africa World Documentary Film Festival. She recently finished a sequel film, *Word of Honour: Reclaiming Mandela's Promise*, which focuses on the first twenty years of democracy in South Africa and on government legislation threatening to impose forced migration on 1.5 million Coloured South Africans. In 2015, Chace was a United Nations observer in the submission of a shadow report to the International Convention on the Elimination of All Forms of Racial Discrimination in Geneva, which identified human rights violations committed by various institutions within South Africa's government through its affirmative action policies.

Cedric Essi is a doctoral candidate in American Studies at FAU Erlangen-Nürnberg, Germany. He graduated from the University of Würzburg in 2009 with a Staatsexamen (teaching degree) in English and French as well as with a *magister artium* in American studies and currently teaches in the English-speaking cultures program at the University of Bremen. In 2011, he received the Harvard Research Fellowship and in 2013 the Yale Research Fellowship (Gilder Lehrman Center) from the Bavarian American Academy. His dissertation project, "Interracial Family Memoirs: (Re)Constructing Genealogies across the Color Line," creates a critical typology of contemporary autobiographical works on cross-racial kinship. In 2012, he co-organized the Nürnberg exhibit and program of "Home-story Deutschland: *Schwarze Biografien in Geschichte und Gegenwart*," a multimedia exhibit on the Afro-German experience.

Cheryl Finley was trained in the history of art and African American studies at Yale University and is associate professor and director of visual studies in the Department of the History of Art at Cornell University. She has spent more than fifteen years researching historical and contemporary images of the transatlantic slave trade; her seminal study *Committed to Memory: The Slave Ship Icon in the Black Atlantic Imagination* will be published by Princeton University Press in 2017. Her prolific critical attention to photography has produced the coauthored publications *Teenie Harris, Photographer: An American Story* (Carnegie Museum of Art, 2011), *Harlem: A Century in Images* (Skira Rizzoli, 2010), *Diaspora, Memory, Place: David Hammons, Maria Magdalena Campos-Pons, Pamela Z* (Prestel, 2008), and numerous catalog essays and journal articles on artists such as Lorna Simpson, Hank Willis Thomas, Walker Evans, Joy Gregory, Carrie Mae Weems, Roshini Kempadoo, and Berenice Abbott. Her current research includes the interdisciplinary project "Re-Imagining the Grand Tour: Routes of Contemporary African Diaspora Art," which examines the current global art economy, focusing on the relationship among artists, museums, biennials, and tourism, and a monograph on the artist Maria Magdalena Campos-Pons. Dr. Finley's wide-ranging intellectual interests include modern and contemporary African American and African Diaspora art history and visual culture, cultural memory theory, the history of photography, the art market, museum studies, African American cinema, and cultural heritage tourism. She was named one of Cornell University's Young Faculty Innovators by the Office of the Vice Provost for Research in October 2009. She is the recipient of numerous awards and grants; her research has been supported by the Hutchins Center for African and Afri-

can American Research, the Ford Foundation, the Center for Advanced Study in the Visual Arts, and the American Academy of Arts and Sciences, among others. Together with Leigh Raiford and Heike Raphael-Hernandez, she was awarded an American Council of Learned Societies Collaborative Research Fellowship for 2015–17 for their joint research project "Visualizing Travel, Gendering the African Diaspora."

Robeson Taj Frazier is the author of *The East Is Black: Cold War China in the Black Radical Imagination* (Duke University Press, 2015) and associate professor at the Annenberg School for Communication and Journalism at the University of Southern California. His research explores the experiences, intellectual history, and political and expressive cultures of the people of the African Diaspora in the United States and in twentieth- and twenty-first-century China. His scholarship centers on making interventions in African American cultural and social history, critical cultural studies, Black popular culture, and urban history and on interrogating the multidimensional formations and conditions of globalization.

Sonja Georgi is assistant professor in American Studies program at the Johannes Gutenberg-University Mainz, Germany. She received a master's degree in American studies, applied linguistics, and economics and a doctorate in American studies from the University of Siegen, Germany. From 2008 to 2010 she was lecturer in American studies at the University of Siegen. Her dissertation, *Bodies and/as Technology: Counter-discourses on Ethnicity and Globalization in the Works of Alejandro Morales, Larissa Lai, and Nalo Hopkinson*, was published by Universitätsverlag Winter in 2011. Her postdoctoral research project focuses on Black-Native encounters in American literature and culture. Her major research and teaching interests include ethnic studies, African American literature, science fiction, and film studies.

Robin J. Hayes is assistant professor of media studies, international affairs, urban policy, and management at the New School in New York City and executive director of Progressive Pupil. She wrote, directed, and produced the award-winning documentary *Black and Cuba* and has published articles in *Black Camera; Souls: A Critical Journal of Black Politics, Culture, and Society*; the *Journal of African American Studies*; and the *Atlantic*. Thanks to a series of scholarships, this East Flatbush, Brooklyn, native graduated from New York University at the age of twenty, then became the first person at Yale to earn a joint doctorate in African

American studies and political science. With the grassroots organization Inter-religious Foundation for Community Organization/Pastors for Peace, Hayes led over fifty human rights delegations and aid shipments to Cuba, Chiapas, and Central America. The Ford Foundation and the National Endowment for the Humanities have funded her work. In addition to completing her book project *A Love for Liberation*, Hayes has acquired representation for the television series she is developing based on the prize-winning novel *In the Land of Love and Drowning*. She is also writing, directing, and producing the documentary *9 Grams*, executive produced by Emmy Award winner S. Epatha Merkerson, which examines the impact of mass incarceration on Black women and the LGBTQ community.

Carsten Junker is visiting professor and acting chair of the American Literature Department at Leipzig University. Previously, he was assistant professor in the English-speaking Cultures/American Studies program at the University of Bremen. For research on his second book on early abolition, he received the Christoph Daniel Ebeling fellowship, jointly sponsored by the German Association for American Studies and the American Antiquarian Society. Junker obtained his doctorate in North American Literature and Culture from the Humboldt-Universität zu Berlin, with a study on the essay as genre of cultural critique. His recent publications include *Patterns of Positioning: On the Poetics of Early Abolition*, (Winter Verlag, 2016); and *Postcoloniality—Decoloniality—Black Critique: Joints and Fissures*, coedited with Sabine Broeck (Campus, 2014). He is also the coeditor, with Marie-Luise Löffler, of two special issues of the online journal *Black Studies Papers* (2014 and 2016).

Charles I. Nero is professor of rhetoric, African American studies, and American cultural studies at Bates College, where he teaches courses in film and literature. A pioneer in African American queer studies, his 1991 essay "Toward a Black Gay Aesthetic: Signifying in Contemporary Black Gay Literature," was the first essay to provide a systematic critical framework for the analysis of black gay texts. His essays on film, literature, and queer studies have appeared in the academic journals *Camera Obscura: Feminist Media Studies*, *Public Culture*, the *Howard Journal of Communication*, and the *Journal of the History of Sexuality* and in the anthologies *Brother to Brother: New Writings by Black Gay Men; Black Queer Studies in the Millennium; Out in the South; Queer Representations: Reading Lives, Reading Cultures: A Center for Lesbian and Gay Studies Reader; Our Voices: Essays in Culture, Ethnicity, and Communication;*

Radical Teacher: A Socialist, Feminist, and Anti-Racist Journal on the Theory and Practice of Teaching; African American Literary Theory; African American Literary Criticism; African American Women in American Music; and *Blacktino Queer Performance*. Nero wrote the introduction for the Cleis Press edition of Essex Hemphill's *Ceremonies: Prose and Poetry* (2000).

Irina Novikova is professor of humanities and chair of the Literature and Culture program at the University of Latvia. She is also the director of the University of Latvia Center for Gender Studies. Her research and teaching interests include intersections of race, gender, and class in comparative literary and visual studies. Her recent publications in this field are "(In) Visibilities of Race, Ethnicity and Gender: Baltic Contexts," in *A Litmus Test Case of Modernity: Examining Modern Sensibilities and the Public Domain in the Baltic States at the Turn of the Century*, ed. Leonidas Donskis (Peter Lang, 2009); "Imagining Africa and Blackness in the Russian Empire: From Extra-textual *Arapka* and Distant Cannibals to Dahomey Amazon Shows: Live in Moscow and Riga," in *Social Identities: Journal for the Study of Race, Nation and Culture* (2013); "Modernity, 'Race,' and Images of Africa in Soviet Cinema," in *Another Africa? (Post-)Koloniale Afrikaimaginationen im russischen, polnischen und deutschen Kontext*, ed. Jana Domdey, Gesine Drews-Sylla, and Justyna Golabek (Universitätsverlag Winter, 2016). She is currently finishing a book manuscript on the visual construction of race, blackness, and Africa in Soviet cinema.

Tavia Nyong'o is professor of American studies and theater studies at Yale University. His areas of interest include black studies, queer studies, critical theory, popular music studies, and cultural critique. His first book, *The Amalgamation Waltz: Race, Performance, and the Ruses of Memory* (University of Minnesota Press, 2009), won the Errol Hill Award for best book in African American theater and performance studies. Nyong'o has published articles on punk, disco, viral media, the African diaspora, film, and performance art in venues such as *Radical History Review; Criticism; TDR: The Journal of Performance Studies; Women and Performance: A Journal of Feminist Theory; Women's Studies Quarterly; The Nation*; and *n+1*. He is coeditor of the journal *Social Text*.

Joachim Östlund is associate professor in the Department of History at Lund University. His research interests include captivity, slavery, diplomacy, and travel writing in the early modern Mediterranean. Östlund is the

author of two monographs, *Lyckolandet: Maktens legitimering i official retorik från stormaktid till demokrtins genombrott* (2007) and *Saltets pris: Svenska slavar i Nordafrika och handeln i Medelhavet 1650–1760* (2014). His articles have appeared in *Scandia, Historisk tidskrift, WerkstattGeschichte, Historical Social Research*, and elsewhere. His research has been generously funded by the Swedish Foundation for Humanities and Social Sciences and by the Wallenberg Foundation. His current research focuses on suppression of slavery in the Mediterranean and the Red Sea and on colonial objects in a Swedish cabinet of curiosities.

Leigh Raiford is associate professor of African American studies at the University of California at Berkeley, where she also serves as affiliate faculty in the Program in American Studies and in the Department of Gender and Women's Studies. She is the author of *Imprisoned in a Luminous Glare: Photography and the African American Freedom Struggle* (University of North Carolina Press, 2011), which was a finalist for the Berkshire Conference of Women Historians Best Book Prize. She is coeditor, with Renee Romano, of *The Civil Rights Movement in American Memory* (University of Georgia Press, 2006). Her work has appeared in numerous academic journals, including *American Quarterly, Small Axe, History and Theory, English Language Notes*, and *NKA: Journal of Contemporary African Art*, as well as in popular venues including *Aperture, Ms.* magazine, Atlantic.com, and Al-Jazeera.com.

Heike Raphael-Hernandez is professor of English at the University of Maryland University College, Europe. She is also professor in American cultural studies at the University of Würzburg, Germany. In 2009, she was a visiting professor in the African Diaspora Studies Department at the University of California, Berkeley, where she taught courses on Black Europe. Her research interests include Black diasporic cultures in intercultural and interracial contexts. She is the editor of *Blackening Europe: The African American Presence* (Routledge, 2004) and, with Shannon Steen, of *AfroAsian Encounters: Culture, History, Politics* (New York University Press, 2006). She is author of *Contemporary African American Women Writers and Ernst Bloch's Principle of Hope* (Edwin Mellen Press, 2008) and *Fear, Desire, and the Stranger Next Door: Global South Immigration in American Film* (University of Washington Press, forthcoming). In her newest research project, she deals with documents from the eighteenth-century Moravian church's slave mission in the Danish West

Indies and Suriname. Her essay "Black Caribbean Empowerment and Early Eighteenth-Century Moravian Mission Documents" was published in the journal *Slavery and Abolition* in June 2014. Together with Pia Wiegmink, she is publishing a special issue for the journal *Atlantic Studies: Global Currents* on German entanglements with slavery in the Americas (forthcoming 2017). Together with Cheryl Finley and Leigh Raiford, she was awarded an American Council of Learned Societies Collaborative Research Fellowship for 2015–17 for their joint research project "Visualizing Travel, Gendering the African Diaspora."

Alan Rice is professor in English and American studies at the University of Central Lancashire. He has worked on the interdisciplinary study of the Black Atlantic for the past two decades and is the author of *Radical Narratives of the Black Atlantic* (Continuum, 2003). He has been academic advisor to the Slave Trade Arts Memorial Project in Lancaster, editor-in chief of Manchester's *Revealing Histories* website, and a co-curator of the Whitworth Art Gallery Manchester's 2007–8 exhibition "Trade and Empire: Remembering Slavery." His latest monograph is *Creating Memorials, Building Identities: The Politics of Memory in the Black Atlantic* (Liverpool University Press, 2010), and his latest edited collection is a special 2012 issue of *Atlantic Studies*, "The Slave Trade's Dissonant Heritage," edited with Johanna Kardux. He has also continued the work on Black abolitionists in Britain started in his coedited *Liberating Sojourn: Frederick Douglass and Transatlantic Reform* (University of Georgia Press, 1999) with the special issue *African Americans and Transatlantic Abolition 1845–1865* (coedited with Fionnghuala Sweeney) in the journal *Slavery and Abolition* (2012). He is an advisor to museums in Liverpool, Lancaster, and Manchester, and his latest museum publication is a catalogue essay for Manchester's 2012 collaborative museums' project "We Face Forward," an exhibition of West African art. His articles have appeared in a wide range of journals, including *Slavery and Abolition*, *Atlantic Studies*, *Patterns of Prejudice*, *Journal of American Studies*, and *Research in African Literatures*. He has organized landmark events on issues in Black history in Britain, including a 2013 event commemorating the mutiny of African American GIs in Bamber Bridge. He has given keynote presentations in Britain, Germany, the United States, and France, and in January 2012 he gave the Martin Luther King Memorial Lecture in Hamburg. He has contributed to documentaries for the BBC, Border Television, and public broadcasting in America and also appeared on BBC's *The One Show* in February 2013.

Julia Roth is a postdoctoral fellow in the "Americas as Space of Entanglement(s)" project at Bielefeld University in Germany. Prior to this appointment, she was a postdoctoral fellow at the interdisciplinary "DesiguALdades: Interdependent Inequalities in Latin America" research project at the Free University Berlin and was a lecturer at the Latin American Institute at the Free University and at the Center for Transdisciplinary Gender Studies at Humboldt University in Berlin. Her doctoral thesis dealt with occidental and gendered constructions of Latin America. Her current research project focuses on knowledge of resistance in Afro-Caribbean feminisms, with a special focus on Afro-Cuban hip-hop. Alongside her academic work, Roth organizes and curates cultural-political events, most recently the theater festival/symposium *"Grenzgängerinnen: Frauen/ Bilder der Amerikas in Bewegung"* at Haus der Kulturen der Welt (Berlin, 2010), and the symposium "Black Diaspora + Berlin: Decolonial Narratives" (Berlin, 2015). She is also an author and editor for the magazine Polar and has written the dramatic dialogue *Salmas Brüste . . . Frida Kahlo trifft Rosa Luxemburg*, directed by Susann Neuenfeldt (2010).

Reginold A. Royston teaches courses on digital diaspora, Black technoculture, and civically engaged new media at the University of Wisconsin, Madison. He received his doctorate from the University of California, Berkeley's African Diaspora Studies program. In his current research, he examines cosmopolitan identities and African media through ethnography with Ghanaian social media users and digital humanities work on platforms such as Twitter and YouTube. His interests cover issues of race, identity, and modernity, particularly as they relate to historic, vernacular, and contemporary technological innovation in the African diaspora.

Karen N. Salt is a tenured assistant professor of Caribbean and African diaspora studies at the University of Nottingham, where she codirects the Centre for Research in Race and Rights (with Zoe Trodd and Sharon Monteith) and leads Europe's first Black studies doctoral program. She has published articles on Haiti, black sovereignty, and racial ecologies in *Journal of American Studies*, *J19*, and *Resilience: A Journal of the Environmental Humanities*. Her essays have appeared in a number of collections, including *American Studies*, *Ecocriticism*, and *Citizenship: Thinking and Acting in the Local and Global Commons*, ed. Joni Adamson and Kimberly Ruffin (Routledge, 2012), and *Black Lives Matter: The Past, Present and Future of an International Movement for Rights and Justice*, ed. Zoe Trodd

(Oxford University Press, forthcoming 2017). She is the recipient of nearly £3 million of funding support from United Kingdom–based research councils, enabling her to lead or colead interdisciplinary research teams. A frequent national speaker, she has appeared as a panelist on BBC Radio 4's *In Our Time* and the BBC World Service's *Newshour Extra*. She is the author of the forthcoming *The Unfinished Revolution: Haiti, Black Sovereignty, and Power in the Nineteenth-Century Atlantic World* (Liverpool University Press, forthcoming).

Darieck Scott is associate professor of African American studies at the University of California at Berkeley. He is the author of *Extravagant Abjection: Blackness, Power, and Sexuality in the African American Literary Imagination* (New York University Press, 2010) and the winner of the 2011 Alan Bray Memorial Prize of the Modern Language Association GL/Q Caucus. He is also the author of the novels *Hex* (2007) and *Traitor to the Race* (1995) and the editor of *Best Black Gay Erotica* (2004). His fiction has appeared in the anthologies *Freedom in This Village* (2005), *Black Like Us* (2002), *Giant Steps* (2000), *Shade* (1996), and *Ancestral House* (1995), as well as in the erotica collections *Flesh and the Word 4* (1997) and *Inside Him* (2006). He has published essays in *Callaloo*, *GLQ*, the *Americas Review*, and *American Literary History*.

Krista Thompson is the Weinberg College Board of Visitors Professor and professor in the Department of Art History at Northwestern University. She is author of *An Eye for the Tropics* (Duke University Press, 2006), *Developing Blackness* (National Art Gallery of the Bahamas, 2008), and *Shine: The Visual Economy of Light in African Diasporic Aesthetic Practice* (Duke University Press, 2015) and the recipient of the Charles Rufus Morey Award for distinguished book in the history of art from the College Art Association (2016). Thompson is the coeditor (with Claire Tancons) of *En Mas<apos>: Carnival and Performance Art of the Caribbean* (Independent Curators International and Contemporary Art Center, New Orleans, 2015); her articles have appeared in *American Art*, *Art Bulletin*, *Art Journal*, *Representations*, the *Drama Review*, and *Small Axe*. Thompson is currently working on *The Evidence of Things Not Photographed*, a book that examines notions of photographic absence and disappearance in colonial and postcolonial Jamaica, and *Black Light*, a manuscript about Tom Lloyd, electronic light, and its archival recovery in African American art.

Pia Wiegmink is assistant professor in the American studies program at Johannes Gutenberg University, Mainz. Together with Birgit Bauridl (Regensburg), she heads an international research network studying cultural performance in transnational American studies (2015–17), funded by the German Research Foundation. Her current research project examines the interdependencies between abolitionist narratives, transnationalism, and conceptions of personhood in the nineteenth-century United States. For this research project she received an ECCLES Center fellowship in North American studies from the British Library (2011) and a postdoctoral fellowship from the German Academic Exchange Service as visiting scholar at Georgetown University (2012). She is the author of *Theatralität und Öffentlicher Raum* (Theatricality and Public Space) (Tectum, 2005) and *Protest EnACTed* (Winter Verlag, 2011) and has published numerous articles on political performance as well as essays on the American dramatist Naomi Wallace, Barack Obama's 2008 presidential campaign, and the Boston Female Anti-slavery Society. Together with Heike Raphael-Hernandez, she is publishing a special issue for the journal *Atlantic Studies: Global Currents* on German entanglements with slavery in the Americas (forthcoming 2017).

Lyneise Williams is associate professor of art history at the University of North Carolina at Chapel Hill and received her doctorate in 2004 from Yale University. Her research interests lie at the intersection of sports, fashion, performance, and early twentieth-century Latin American culture and representation in Latin America and in other parts of the world. Her first book, *Visual Imperialism: Latin American Blackness in Paris, 1922–1933* (Bloomsbury, forthcoming 2018), focuses on the visual imagery of the circus entertainer Chocolat, the world welterweight champion Alfonso Teofilo Brown, and depictions of Black Uruguayans by the Uruguayan painter Pedro Figari in early twentieth-century Paris. Her second book project will explore the intersection of beauty and the black male athlete in 1920s and 1930s Paris. She has published articles on the paintings of Pedro Figari, the depictions of Alfonso Teofilo Brown, and on African art and hip-hop jewelry. Williams recently received a Getty Scholar Fellowship and she has curated exhibitions on African art. She is a member of the team selected from an international competition to design the North Carolina Freedom Monument Project in Raleigh, North Carolina.

Index

Piper, Adrian, 200
Pippin, Horace, 202n12
Poitier, Sidney, 215–16, 220n28
police brutality, 154–55
portraiture, 30–51, 71–91. *See also* photography
Portugal, and Caribbean, 196–97, 198
posters, 3, 92–113
Powell, Richard J., 74
Pred, Allan, 73, 84
primitivism, 143
propaganda: art and, 333; Chinese, 92–113;
 Cuban, 153–69
Pushkin, Alexander Sergeyevich, 32

Quarles, Benjamin, 202n12
queer resistance: Cuba and, 162; in films by Pedro
 Almodóvar, 329–30, 347n3; in Franco's Spain, 329–31
queer studies: African diaspora and, 236; dancehall
 culture and, 306–28, 323n2; homoerotic fascination,
 38–39, 40, 42, 45–46, 102–3, 108, 116–32, 295–96,
 323n2; homoerotic racial fantasy, 38–39, 301–5, 329;
 homophobic image, 301–5; pornotropic fantasy,
 294–305. *See also* black masculinity, gender
Queloides: Racism and Race in Cuban Contemporary
 Art (exhibition), 166. *See also* Fuente, Alejandro de la
quest narrative, 170–84

racial discrepancy, 154–55, 221
racial discrimination, 154, 218n10
racial hierarchies, 141, 208, 217, 240, 308, 320
racial profiling, 154
racial stereotyping, 57–64, 79–83, 88, 110–11, 121, 129,
 142, 212–13, 216–17, 219n11. *See also* advertising;
 vernacular, African American
racism: scientific, 54, 290; in Russia, 46; and colonialism,
 237; postcolonial, 238
Raiford, Leigh, 54, 289, 303n8
Rancière, Jacques, 316
Rastrelli, Bartolomeo, 33
Rediker, Marcus, 13, 16–17
refugees, 185–203, 256–59, 260–65, 297
reggae, 217, 308
Rehn, Jean Eric, 82–83, 87, 89
resistance: against slavery, 14–29, 52–70, 217, 236,
 242–44, 255–56, 300, 336–48; social movements
 and, 155; against white supremacy, 217; through
 visual art, 52–70, 71–91, 180, 185–203, 329–48
return narrative, 170–84, 238
Richardson, David, 255
right, Du Bois on, 334–47
Robertson, Bruce, 118
Robeson, Eslanda Goode, 134–52, 164
Robeson, Paul, 92, 134–52
Robeson, Paul, Jr., 134–52
Robinson, Cedric J., 154

Rodriguez, Besenia, 154
Rolando, Gloria, 162
Roots (Haley), 172, 180, 294
Roots Germania (Asumang), 170–84
Rossellini, Roberto, 212–13, 217
Rothberg, Michael, 259, 264
rotogravure, 123–27, 132n27
Rousseau, Jean-Jacques, 72, 77, 80, 297
Russia, 30–51, 76

saints, Catholic, 207–20
Sanders of the River (film), 142
Sankofa (Gerima), 236, 242–44, 300
Sa Panasco, João de, 76
Sawyer, Mark, 157
Schoenebeck, Adriaan, 33, 49n7
Schwartz, Joan M., 59
Senegal, 201n3, 214–15, 244–50, 251n28, 270
serfdom, 35, 37, 42, 43
Sergel, Johan Tobias, 83, 87, 89
sex tourism, 191
sexual violence, 178, 248–49, 251n28
Sharpe, Christina, 174, 297
Shaw, Ronald, 278
Sheridan, Jim, 207–20
Shields, David S., 118
Shinning, Gao, 262
Shipley, Jesse Weaver, 276
Shonibare, Yinka, 188, 190–93
Sigh of the Sea, The (Eden), 256–57
Signs of Empire (novel), 166
Sissay, Lemn, 257–58
sites of memory, 250n6, 255–58, 343–47
skin bleaching and whitening, 306–28; in photography,
 118–32, 132n27, 327n65
skin color prejudice, 318–20
slave castles, 238, 242–43, 244, 249–50
slave ports, 244–45, 249–50, 257, 260–61
slave rebellions: in film, 242–44, 295; in Haiti, 56; and
 Nat Turner, 194, 329, 336–48
slavery: and abolition, 13–29, 75; societies and, 15; and
 art representations, 185–203, 255–56; in cinematic
 representations, 236–52, 287–305; in Cuba, 153–69;
 in graphic novels, 336–48; in Haiti, 52–70; images of,
 122–23, 336–48; and legacy, 141, 154, 170–84, 208–9,
 231, 242–44, 253–56; John Brown and, 185–203;
 and memory, 215–17, 237, 241, 243, 297, 336–47; and
 profit, 198, 253–56; and resistance, 6, 13–29, 52, 54,
 233, 242–44, 253–56, 295, 300, 336–48; and social
 death, 174, 297; and South Africa, 221, 234; Thomas
 Clarkson, and, 16; and trauma, 236–37; in United
 States, 170–84, 290, 287–300, 336–48; and violence,
 121, 174, 287–300, 336–48
slave trade, 72–73, 329–48: in Indian Ocean, 229; ships,
 186, 292, 49–50, 253, 323n1; transatlantic, 6, 13–29,